THE TWENTY-FIRST-CENTURY
LEGACY OF THE BEATLES

The Twenty-First-Century Legacy of the Beatles

Liverpool and Popular Music Heritage Tourism

MICHAEL BROCKEN
Liverpool Hope University, UK

ASHGATE

Published by
Ashgate Publishing Limited
Wey Court East
Union Road
Farnham
Surrey, GU9 7PT
England

Ashgate Publishing Company
110 Cherry Street
Suite 3-1
Burlington, VT 05401-3818
USA

www.ashgate.com

British Library Cataloguing in Publication Data
A catalogue record for this book is available from the British Library

The Library of Congress has cataloged the printed edition as follows:
Brocken, Michael.
 The twenty-first-century legacy of the Beatles : Liverpool and popular music heritage tourism / by Michael Brocken.
 pages cm. – (Ashgate popular and folk music series)
 Includes bibliographical references and index.
 ISBN 978-1-4724-3399-2 (hardcover) – ISBN 978-1-4724-3400-5 (ebook) –
ISBN 978-1-4724-3401-2 (epub) 1. Beatles – Criticism and interpretation. 2. Liverpool (England) – Social life and customs. 3. Tourism – England – Liverpoool. I. Title. II. Title: twenty-first-century legacy of the Beatles.
 ML421.B4B75 2015
 782.42166092'2–dc23

 2014045783

ISBN 9781472433992 (hbk)
ISBN 9781472434005 (ebk – PDF)
ISBN 9781472434012 (ebk – ePUB)

Printed in the United Kingdom by Henry Ling Limited, at the Dorset Press, Dorchester, DT1 1HD

Contents

General Editors' Preface

Popular musicology embraces the field of musicological study that engages with popular forms of music, especially music associated with commerce, entertainment and leisure activities. The *Ashgate Popular and Folk Music Series* aims to present the best research in this field. Authors are concerned with criticism and analysis of the music itself, as well as locating musical practices, values and meanings in cultural context. The focus of the series is on popular music of the twentieth and twenty-first centuries, with a remit to encompass the entirety of the world's popular music.

Critical and analytical tools employed in the study of popular music are being continually developed and refined in the twenty-first century. Perspectives on the transcultural and intercultural uses of popular music have enriched understanding of social context, reception and subject position. Popular genres as distinct as reggae, township, bhangra, and flamenco are features of a shrinking, transnational world. The series recognizes and addresses the emergence of mixed genres and new global fusions, and utilizes a wide range of theoretical models drawn from anthropology, sociology, psychoanalysis, media studies, semiotics, postcolonial studies, feminism, gender studies and queer studies.

Stan Hawkins, Professor of Popular Musicology, University of Oslo and
Derek B. Scott, Professor of Critical Musicology, University of Leeds

Introduction

'We Can Work it Out' – Ideas, Places, Spaces

John Lennon spent more time in his life in his birthplace Liverpool than anywhere else.

(Bill Harry, 2011: 9)

The geography of Liverpool is remarkably simple: the city sits on a sandstone ridge along the banks of a great boundary river ebbing and flowing from the north. The majestic river Mersey flows past one of the largest dock systems ever created, past the glass towers and statues of 'great men' at the Strand and Pier Head, and past verdant swards of green at Otterspool; it moves unceasingly towards the narrow crossing between Widnes and Runcorn, where it travels on again at speed towards Warrington, Stockport and ultimately the Pennines. This geographical shibboleth is imprinted upon thousands of peoples' brains. But superimposed over the cartography are the pleasures, successes and failures of various streets, communities and ethnicities in the city: landmarks of cultural geography and experience as much as place, per se.

My own Liverpool experiences mostly took place a little east of the city centre in Stoneycroft, Liverpool 13 – a largely Edwardian suburb bounded by the elegant Newsham Park on the river side and the equally flowing Queens Drive ring road, on the other. Intersected by the eastward routes radiating out of riverside Liverpool (West Derby Road and Prescot Road), the district of Stoneycroft was divided into territories of claustrophobia. As a youth I was forever wandering around the district, wary of certain streets and roads where I was not welcome (e.g. Moscow Drive), feeling safer down the side roads (e.g. Tynwald Hill). To be honest, I don't think I quite belonged there so became fascinated by, not only the goings-on at the Carlton and Regent cinemas, but also the window-dressing in the Tuebrook and Old Swan record shops (all of which gradually tempted me away from the Cubs, the Scouts and the St James' church choir). St James' was on the other side of Queens Drive in West Derby; the ring road was a kind of Styx between two different worlds.

By 1971, my by-then-self-employed father had become upwardly mobile and we had removed to Prenton, Birkenhead ('over the water'). I initially missed Liverpool; however, I soon came to love the Wirral peninsula: motorcycle rides to New Brighton, folk club nights in Wallasey, Parkgate and Chester. It seemed to me at that time a better place to be, one where people were trying to follow their natural feelings and not trying to imitate anyone. I suppose it felt less ferocious and, behind the myth of placid suburbia, there existed on the Wirral a cornucopia

of weird Viking histories and popular music activities partially hidden from view by Liverpool's 1960s popular profile. I returned to Liverpool in 1976 for the love of a woman, but also came to love a district: Toxteth, where people smiled and said 'hello'. Four years later, the seemingly interminable dereliction of this beautiful quarter facilitated my evacuation from Liverpool one last time. Shortly before the death of my hero John Lennon in 1980, we left for Chester. It was the end of something: I still don't quite know what. I have not lived in Liverpool for over thirty years, but have worked there on and off for the past twenty. So, ask me what it's like to live in Liverpool in the twenty-first century, I would have to reply 'I don't really know, I'm not part of it'. But I do know Liverpool is a city full of reassessment, reinvention and understanding – which for me is a great combination.

The principal aim of this work is to demonstrate that popular music tourism can help reshape and display vitally important identities and aesthetic values and meanings in a postindustrial city. The work also exists, theoretically to draw a spatio-historical perspective of Liverpool's relationship with the Beatles. Previous research by this author has revealed that, in Liverpool, the relationship between all popular music narratives and the city fathers has been highly complex, and those between certain Liverpudlians and the cultural legacy of the Beatles at times deeply contested. All attempts to attach music to place are central to our understandings of relationships between popular music and localities, but they are highly convoluted. In the case of Liverpool, these attachments can be seen to have existed in many different spaces, places and incarnations, and according to many different paradigms of authenticity. Further, rebuttals of Beatles' authenticities regarding their relationship with Liverpool are also worthy of note, for the very syntax surrounding any repudiation involves complex configurations of roots, legitimacies, class, race, place and space, and are thus historically significant. We might describe many such syntagmatic articulations as 'spatial dialectics' derived from a tension between music as meaning and music as product.

All attachments of popular music to place are, argues John Street, highly complex forms of rhetoric drawing upon myriad selected discourses. Street has considered whether popular music helps to create oppositions within cities and their populations, also whether it might 'reflect the circumstances in which the music was made'. Street suggests that, while communities can be place-specific, the make-up of identities may not be so and, in popular music terms, 'there is no simple relationship between place, taste, and identity';[1] such factors are directly related to the variegated histories of Liverpudlians and all popular music. At times diametrically-opposed factions have created socio-spatial histories of popular music to serve very specific purposes, some of which reflect a Beatles authenticity and authority, but others which most certainly do not. There is, then, a need to

[1] Street, John (1995), '[Dis]located? Rhetoric, Politics, Meaning and the Locality', in Will Straw et al. (eds), *Popular Music, Style and Identity*, Montreal [Canada]: The Centre for Research on Canadian Cultural Industries and Institutions, pp. 257–61.

understand the spectrum of relationships between the aesthetic and the spatial (especially during the period which corresponds to Mandel's description of 'Late Capitalism'[2]) and how (in Liverpool) deep formative influences exist behind much of the debate surrounding popular music aesthetics and authenticities. Thus perhaps one salient point to consider throughout this work is the fact that aesthetics surrounding the currency of all popular music in Liverpool are usually imbricated with issues concerning political authority (or a lack, thereof).

Fans of the Beatles are myriad, each having equally countless stories to tell about their love of the group. However, via the direct comments and latent influences of the Frankfurt School, popular music aficionados have been viewed variously as submissive, obsessive and fanatic, living in a world far from reality. John Storey suggests that, for Frankfurtian-influenced theorists, 'mass culture' meant: 'hopelessly commercial culture. It is mass produced for mass consumption. Its audience is a mass of non-discriminating consumers. The culture itself is formulaic, manipulative [...] and is consumed with brain-numbed and brain numbing passivity.'[3] The suggestion is therefore that fans are in fact 'fanatics' and that fandom exists outwith societal norms and social mores. Even though the spaces in Liverpool occupied by Beatles and Merseybeat fans have breathed life into the city, both spatially and culturally, both ideas conjoined tend to reflect the opinions of many Liverpudlians concerning Beatles fandom. When one looks at Beatles fans collectively, as commentators tend to do, one receives the illusion of a mass. However, one does not convert individuals into mass people with the simple coining of the word 'mass'. One might actually argue that perhaps of greatest significance to the lovers of Beatles music visiting the city of their birth are the spaces and places of the imagination whereby a tourist or fan might invoke an imagined place, which is then confronted by the reality of tangible habitation from which a matrix, an imagined 'thirdspace' can be brought into focus. Perhaps through such a spatial model, individual fans – and specifically tourists-as-fans – might be better understood, and regarded far less as holders of fantasist, pathological tags.

Indeed, one might argue that a consideration of such matrixes in relationship with perceptions of space rather than simply time, might be a fundamental requirement of popular music histories.[4] Related to any spatio-matrix enquiry are three conceptual questions: how is social space perceived? how is it conceived?

2 Mandel, Ernest (1978), *Late Capitalism*, London: Verso.

3 Storey, John (2000), *Cultural Theory, Popular Culture: An Introduction*, London: Longmans, p. 8.

4 Popular music histories can be far too linear; one might argue that spaces such as studios, venues, networks, cities, villages, and so on and so forth, have all contributed to the history of popular music since at least the emergence of recorded sound (if not before); however, the tendency is to prioritize time over space, thus creating a somewhat episodic version of the popular past, which tends to reflect the modernist trajectory of 'onwards and upwards' rather than the more spatial one of 'this way, and that'.

and how is it 'lived'? For example, for this writer, such questions have helped to explain how Marxism became an important correlative of a perceived and conceived modern culture. By placing the labouring body at the spatial interface between consciousness and material history, Marxist thought divided human consciousness from material power. However these three questions can also exist at the heart of a cultural and spatial re-evaluation. As new perceptions, conceptions and lived experiences in specific places have come to be recognized, there has been an associated suggestion that Marxist theories concerning 'the masses' have been theoretically unable to withstand our human capacities for valuing enjoyment, or indeed our desires to cohabit with the rest of nature. So it came about in recent times that a rethinking of dialectic materialism and its relationship with affective labour and spatial ecologism was called-for. Micro-political, non-oppositional strands of thought, largely brought about by non-predicated contingency, have delivered recognition of individual values and authenticities through space and time.

However, Liverpool's development through such re-evaluations has been dogged not only by long-standing ideological oppositions, but also by issues directly relating to its built environment. As buildings age, they become reused. This reuse can be fascinating to record, for margins are created; and among margins of space we often find great creativity (ex-warehouses, factories, shop fronts, and so on). This creativity can then work 'against the grain' of a building's intended meanings. The creativity, however, can be short-term (as in the case of popular music night clubs such as the Cavern, the Iron Door, the Sink, Eric's, Cream, among others), therefore such marginal activities also suggest to the onlooker that popular music activities can represent a decline, rather than a development, in our urban built environment infrastructure. As a city, Liverpool was placed in an invidious dimensional position via central government from at least the 1950s: as the city's financial fortunes and its working population dramatically declined, so the rateable values of its impressive commercial buildings and warehousing remained fixed, thus placing enormous financial pressures upon successive local administrations. For example, the spaces surrounding what is now the 'Ropewalks' district bear witness to this: as warehouses emptied they were either left to rot or were reoccupied by often transient night clubs. While the latter might have been useful for popular music activity and creativity, they did little to assist the city's built environment to pay its way in the long term. So buildings fell into cycles of disuse, reuse and abuse, as signs with 'no trespassing' and 'keep out' helped to alienate and dishearten locals who felt themselves strangers in their own backyards. A downwards-spiralling syndrome reached a critical stage by the early-to-mid 1980s and contributed to a city divided by ideology: neo-Marxist thought mutated as a kind of inoculation; a 'check' or a conscience on unscrupulous behaviour concerning the decline of the commercial built environment, with popular music as a matrix. But another consequence of such approaches was a damaging introspection where opportunities were ignored.

Such critical and oppositional thinking therefore came to surround the popular music legacy of the Beatles. Certain Liverpudlians came to arbitrate meaning about

their relationships with all popular music in some very complex ways: somewhat loose, yet didactic, 'Frankfurtian' models of the popular were mixed with living issues to do with place and urban decay. The upshot for some was hostility. Via a combined thesis of the Beatles as static matrixes seen through a limited spatial sphere, many Liverpudlians came to be engaged in negative dialectics about the lack of value and authenticity of not only the Beatles, but all representations of popular music as an appropriate all-embracing to Liverpool.

Redaction

This work will attempt to bring together several diachronic strands of activity and thought in an assemblage of information intended to show how discourses have led us to the present-day representations surrounding the Beatles in Liverpool. These strands are not intended to be either labyrinthine or absolute, but there is an attempt throughout to align historical diachrony via case studies concerning spatiality and redaction. While the first of these concepts has already been briefly introduced, it is worth discussing the latter a little in order to orientate the reader further in this writer's methods and approaches. Redaction in this case connotes the methods and approaches whereby a researcher investigates how creators of texts of any description express outlooks by means of arranging and editing pre-existing information. As such, it is suggested here that assertions woven into narratives concerning the Beatles are frequently tacitly directed to variations of canonic authenticities related to how the Beatles *should* be perceived: a way of doing things that represents authenticity and Beatles-related cultural capital, specific to the city of Liverpool's past and present. For example, more generally across Beatles fan literature, writers have specific points to make. Bob Spizer addresses the impact of the Beatles from the perspective of an authentic US record-collector, whereas ex-Beatles drummer Pete Best's texts attempt to deal with the absence of 'authentic facts' in previous chronicles concerning his time with the group. Spencer Leigh likes the reader to consider the authenticity of British popular music cultures before the emergence of the Beatles, whereas (for example) Bob Neaverson considers the Beatles' films to be authentic historical documents in their own right. Therefore the motivations of any 'tellers' are connoted via their own collection, arrangement, editing and modification of materials; also via the composition of such new materials or the creation of new forms of 'telling' within the cultural capital-cum-traditions of popular music narratives. Beatles-related prejudices and authorities can be seen as a kind of movement of strata, a play of spaces, where the receiver's interests are acknowledged *by* the 'teller', rather than the other way around. This makes the text, and the 'telling' of the text an integral part of the 'habitus' of both Beatles fandom *and* Beatles rejection.

More specifically, in Liverpool, we can estimate from which pre-existing sources and patterns of legitimacies a 'teller' is working. Patterns disclose a principle of selection and this principle of selection may be a clue to the (e.g.)

political interests of the 'teller'. How a 'teller' organizes materials chosen from the sources are of great interest: a researcher might consider how a writer or 'teller' arranges previously disparate ideas or rearranges material from sources to suit his/her own purposes. Continuity across 'tellers' can also be examined: where the same or a similar idea is repeated and/or modified probability increases the proposal that an urban myth concerning the 'Beatles story' is being amplified. Changes in meanings from original contexts can also be noted. If it can be established that a 'teller' alters or ignores contexts (e.g. the significance of Black Liverpool), the possibility of why or how such changes were made, can be explored. The seams used to join together fragments of accepted or 'given' Beatles materials (at, say, local museums and galleries) are also of great interest: for example, local Beatles photograph exhibitions and books create false 'transitions' from one fragment of history to another via the *post hoc ergo propter hoc* fallacy.[5]. The way that photographs are positioned in a museum or exhibition can be used to connect time and space via a linear ease of 'telling' ('after this, came this') when, historically such connections should not necessarily be made. Therefore, many of the aims of redaction criticism are not only historiographical, but also sociological in the sense that we might be able to view 'tellers' reflecting, or even opposing, certain Beatles representations.

Précis

The first chapter of this text will introduce popular music tourism from a perhaps slightly different perspective, in that it will attempt to place at the heart of the discussion the notion of individual imagination and (conversely perhaps) cultural capital. The chapter will also discuss how and why Liverpool's fractious relationship with Beatles heritage might have emerged. Chapter 2 will examine Liverpool as a place in the immediate pre- and post-Beatles era; first via a conversation of popular music's reuse of space and place, then though a consideration of the oppositions created by club-land and Liverpool's decaying built environment. Here, a study of the Cavern Club as a useless space (in contradistinction with the Shakespeare Theatre Club) and rock music as a marginalized discourse in the city, will be discussed. This will be followed in Chapter 3 by research into the

[5] *Post hoc ergo propter hoc* is Latin meaning: 'After this therefore because of this'. Events of type **A** happen immediately prior to events of type **B**. Therefore, events of type **A** cause events of type **B** and event **B** is somehow linked to event **A**. In the case of narratives via photographs, there is a fallacy that that all photographs of [e.g.] the Beatles are inextricably linked to each other and that an authentic narrative can be created via such a selected linear chronological chain. One problem is that photographs are taken by people who are usually not in the photographs, thereby creating a fallacious impression of continuity through their subjects' presence; also that, of course, such linear narratives are historically untenable.

Cunard Yanks myth of origin. It will be suggested that this organic root to the 'Mersey Sound' was actually invented at a seminal moment: when the fledgling Beatles tourist industry started to take flight. Chapter 4 considers diachronically several small case studies in relation to the growth of Beatles tourism in the 1980s, including the International Garden Festival, the development of the Albert Dock, the Militant Tendency in Liverpool, and Transworld's failed tourist initiatives. This is followed in Chapters 5 and 6 by a related two-case study concerning Beatle City, its manager Mike Byrne, and the attraction's removal to Dallas in Texas, followed by his tortuous efforts to launch his own Beatles attraction, The Beatles Story. Further case studies follow in Chapter 7, where discussions take place concerning the National Trust's 'telling' of the 'Mendips' and Forthlin Road stories, and the recent 'Save Madryn Street!' campaign. Chapter 8 further considers the act of 'telling' from within the kinetic matrix of FAB Tours' Phil Coppell, the growth and development of Cavern City Tours, and the significance of spatial relationships within their replica Cavern Club. Finally Chapter 9 will consider twenty-first-century Beatles 'branding' and the very latest approaches by Liverpool City Council to create a city brand linked to this global phenomenon. A failed attempt at a strategic review will be discussed, and a future projection will be posited concerning how a model might be constructed to act between the Beatles' legacy and future generations of Liverpudlians.

Overall, the argument put forward is that there has existed an entire body of constraints, a set of conventions, even within popular music fandom itself, that have 'paraphrased' Beatles images and imaginings, authenticities and authorities into orthodoxies and traditionalisms of representation. One might argue that, during a large part of the mid-to-late twentieth century, such limitations (disguised as ideologies) guided many Liverpudlians towards an agreed set of rules concerning 'the popular', Liverpool and the Beatles. The organic successes of Beatles heritage tourism have been at times part of a battle against such ideologies and binarisms: a triumph over the limitation of space by ideology. This now increasingly creatively-managed landscape was for years a space where decades of fighting over oppositions of anti-populist, foundational logics took place – and yet the scars are healing remarkably quickly. It is becoming clear through the emergence of Beatles-as-heritage, and popular-as-discourse, that the contrapositions previously adopted between foundation and horizon have been challenged, and emancipatory ideas have emerged victorious. Beatles heritage tourism is now what Soja might describe as:

> [a] transactional tapestry efficiently knotted into a series of flexible manufacturing and service complexes, great swarms of businesses tied up in hive-like clusters to capture the new 'scope' economies of postfordist technology. No longer bound by the rigid hierarchical demands of mass production and assembly lines.[6]

6 Soja, Edward W. (1996), *Thirdspace: Journeys to Los Angeles and Other Real-and-Imagined Places*, Oxford: Blackwell p. 246.

The transition from modernity to post-modernity is at times an extremely difficult trajectory to follow, but via various spatial histories of Liverpool's relationship with the legacy of the Beatles one can at least begin to see an increasingly more egalitarian logic develop. Oddly, one is still often faced in the twenty-first century with the question in Liverpool: 'What did the Beatles ever do for us?' In reply, one might suggest that the Beatles have offered Liverpool a horizon, an empty locus, a point from which Liverpool can engage in a new and exciting groundlessness. The Beatles have provided Liverpool with a basis for one of the most potentially important musical and social paradigm shifts of the twenty-first century within which the city can form new relational contingencies from its previous concrete totalities. The very absence of the Beatles helps Liverpool to affirm the remarkable significance of popular music. This legacy – a horizon-based freedom developing from the kinetic matrixes of popular culture – is perhaps the most significant bestowal of contingency of our time.

Chapter 1

'There's a Place': Travel, Tourism, Liverpool and the Beatles

It is the heart of a rambling metropolitan wilderness they call Merseyside [...] And now they've been asked to sell Merseyside to the tourists.

(Ian Craig, local government editor, *Liverpool Echo Citizen's Guide '78*)

Travel has always existed, and although 'tourism' is a relatively new word it does not by any means represent a new activity. In the days of the apostle Paul, pilgrims would visit Ephesus in what is now Turkey specifically to worship the pagan god Artemis; a thriving trade in pocket-sized icons as mementos of the visit even existed. During the Renaissance the idea of the European Grand Tour developed and can be credited to the appearance in seventeenth-century Western Europe of law and order, and the emergence of echelons of statesmen, merchants, and scholars, who became interested in educating themselves via the medium of travel. At the core of 'the Tour' was a notion of Culture, which tended to emphasize the literary, archaeological, religious, and artistic superiority of European culture and Christian historiography. Travel, it seemed, improved one's mind – as long as one's mind thought the right thoughts in the right geographical places. Sometimes music was involved: for example, if tourists attended a concert or acquired a new musical skill, but it appears that music was not usually the central focus of 'the Tour', for the wealthy were able to commission their music from craftsmen musicians who for a fee might (according to Koch's instructions) produce a recognizable sonata or minuet or two. Gradually, 'the Tour' began to focus on recreation in addition to education and these conventions continued relatively unabated for those who could afford such pleasures. By the eighteenth century the Grand Tour had become a prominent feature of English upper-class education. C.P. Hill writes:

> The 'grand tour' of Europe [was] undertaken by young men of wealth, accompanied often by learned scholars as their tutors. It was a long and leisurely enterprise of many months or years; it took them especially to France, the most civilized country in the world, and to Italy with its Roman remains, its Renaissance traditions and its opera; and it made the rulers of 18th century England citizens of Europe in a way that few Englishmen have been since.[1]

[1] Hill, C.P. (1985), *British Economic and Social History 1700–1982*, London: Edward Arnold, pp. 202–3.

Napoleon Bonaparte's domination of Europe put a temporary halt to this; however, in England the cult of the 'picturesque' gathered momentum. There was an apparently almost inexhaustible appetite for designing, viewing, drawing and writing about ruined abbeys and castles, which during the Regency period almost reached cult status. Humphry Repton became renowned for his picturesque landscape designs and was commissioned by the Duke of Bedford to create a garden 'wonderland'. He also designed gardens at Russell Square and many would travel to see his work. But such reworkings of the English landscape into idylls was seen by some as faintly ridiculous and Thomas Rowlandson's 1812 satirical engravings issued under the title of *The Tour of Dr Syntax in Search of the Picturesque* attained a fifth edition by 1813 (this was followed in 1820 by *Dr Syntax in Search of Consolation*, and in 1821 by the *Third Tour of Dr Syntax in Search of a Wife*).[2]

Literally the very day following Bonaparte's defeat at Waterloo tourists were making their way from Brussels to the battlefield; post-Waterloo, European tourism began again in earnest, supported by innumerable travelogues. As such, by the nineteenth century, spas and spa towns became important tourist destinations and those in more remote areas of Europe were especially popular with the British. Once the shift had taken place from 'enlightenment' and 'education' to recreation and health, music began to play a greater role in tourism and spas, and resorts came to offer a wide variety of musical presentations (e.g. at Sydney Gardens in Bath, where subscribers might be entertained by breakfasts, illuminations, and music for 7/6d).[3] The health benefits of travel and leisure were evident and, via the growth of railways in the 1830s, even a few of Britain's working classes were able to travel, if not abroad, then (with a degree of employer enlightenment) certainly at home. For example, John Dodgson Carr, the Carlisle biscuit-maker had commenced such outings for his workers in 1840. His entire workforce, together with his own family, would set out via rail to enjoy a day in the country entirely at Carr's expense. John Carr's travel-based philanthropy illustrates in one sense that, at least in the United Kingdom, a growing democratization of leisure-based travel became associated with certain aspects of the Industrial Revolution (some writers even refer to the UK as perhaps the first European country to promote ideas

[2] Of interest here is a 1931 perambulation-style text concerning the city of Liverpool: *Liverpool Ways and Byeways*, written by local journalist Michael O'Mahoney. It has on its cover an artist's impression of (presumably) Liverpool's dockside area that depicts two sailors passing by a public house named the 'Doctor Syntax Inn'. The text was local to Liverpool: an assemblage of articles previously appearing in the *Liverpool Echo*.

[3] See Hembry, Phyllis, edited and completed by Leonard W Cowie and Evelyn E. Cowie (1997), *British Spas from 1815 to the Present*, Cranbury [USA]: Associated University Presses. See also A.B. Granville (1841), *The Spas of England, Vol. 1. Northern Spas*, London: Henry Colburn, published after he had toured all of Britain. (Granville had previously praised European waters in his *Spas of Germany* (1837) and raised English indignation; to redress the balance, he wrote several volumes after touring the UK in 1841).

about the relationship of time with leisure[4]. This might be further emphasized by the development of 'mass' printing techniques and its connections with popular music and leisure. For example, the infamous murder of Maria Marten in 1828 was publicized throughout England not only by means of gory newspaper articles, but also via 'broadsides' – printed songs ('ballads') sold on the streets for pennies. For the hanging of Marten's murderer William Corder at Bury St Edmunds, a huge crowd of tourists flooded into the town. Thereafter the 'Red Barn' where the murder had taken place in the village of Polstead also became a tourist attraction and the barn was stripped by souvenir hunters. The music ballads remained popular throughout the next century and one in particular, entitled 'The Murder of Maria Marten', continues to be performed to this day.

A landmark in the history of British tourism history is that snapshot of Britain in the 1860s, *Bradshaw's Handbook*. This volume was produced just as the British railway network was reaching its zenith. It was the first tourist guide to specifically encompass railway journeys and to this very day offers a glimpse through the railway carriage window of an at times ghostly and occasionally still locatable British Isles. Such publications concerning the promotion of 'leisure time' were initially aimed at the owners and beneficiaries of the means of production; however, as rail travel became increasingly cheaper, such tourist-based oligarchies came to dissipate, furthering the need for 'Bradshaw's'. The various volumes of George Bradshaw's works (which also included a guide to Britain's canal network) were used and imitated across all echelons of British society at least up until the outbreak of the Great War. *Bradshaw's Handbook* is particularly interesting as far as Liverpool is concerned, for it can clearly be seen that by the 1860s Liverpool was attracting hundreds (perhaps thousands) of tourists. In his entry concerning Liverpool, Bradshaw not only draws attention to the city's fine civic buildings, churches and 'excellent libraries at the Athenaeum and Lyceum news rooms', but also describes St James Cemetery as 'a really attractive spot' and suggests that the docks are 'grand lions of the town, [which] extend in one magnificent range of 5 miles along the river',[5] and worthy of any visitor's attention. One might suggest that via Bradshaw we have evidence that Liverpool was a railway tourist attraction a full century before (e.g.) popular music had enticed ITV documentary-maker Daniel Farson[6] to explore this (by 1963) declining city. Indeed it could be argued that, at least up until WWI, Liverpool's very wealth was in some part *sustained* by tourism.

For example, so much had Liverpool's tourist trade developed by the turn of the century that excursions to the city were *de rigueur* for many factories. In

[4] Singh, L.K. (2008), 'Issues in Tourism Industry', in *Fundamental of Tourism and Travel*, Delhi [India]: Isha, p. 189.

[5] Bradshaw, George (1863), *Bradshaw's Handbook 1.2.3.4.*, Oxford: Old House: 2012 reprinted edition, section III, pp. 42–3.

[6] Farson, Daniel (1963), *Beat City*, London: Rediffusion, broadcast 24 December 1963.

1904, Bass, Ratcliff & Gretton – the renowned brewers from Burton-upon-Trent – produced a near 100-page brochure for their workers' excursion to Liverpool and New Brighton on Friday 15 July of that year. As part of the monograph, an expanded pull-out map of the Liverpool Overhead Railway was included, so that visitors could take advantage of the panoramic views over the docks. Furthermore, the editor stated: 'Bold Street is perhaps the fashionable [street] where the ladies spend much time inspecting the splendid displays of dresses, millinery etc, in the really fine Establishments – *second only to Regent Street, London.*'[7] Moreover, John Belchem, in his discussion of the celebrations surrounding the 700th year of Liverpool's Royal Charter in 1907, describes the accompanying historical pageant as 'an early exercise in heritage leisure and tourism, the pageant festivities placed commercial success and enjoyment above authenticity'.[8] In fact, by the late nineteenth century many UK coastal towns and resorts had become popular for tourism and an integral part of this experience was musical entertainment. On England's south coast, Brighton was known for its musical beaches, where all kinds of both organized and ad hoc musical activities took place. Brass bands became an important part of many coastal towns' entertainment programmes, and since brass and silver instruments allowed some mobility, professional bands were formed to tour the country's resorts.

The railway network expanded dramatically in the 1840s, making the Lancashire coastal towns of Southport, Blackpool and Morecambe prominent as centres of tourism in England. Railway companies were primarily concerned with connecting the industrialized towns and cities of Lancashire and Yorkshire with the Midlands and South; however, passenger lines were soon linking (say) West Yorkshire with the Lancashire coast, making it far easier and cheaper for visitors to travel as holidaymakers. This, in turn, triggered an influx of entertainment-based settlers in such towns. For example, by 1876 Blackpool was incorporated as a borough, governed by its own town council and aldermen, and by 1881 the town was a booming resort with a population of 14,000 and a promenade complete with piers, musical attractions, fortune-tellers, public houses, trams, donkey rides and theatres. By 1901 Blackpool's population had risen to 47,000, by which time it was cemented in the British psyche as the archetypal seaside resort with an exciting and profitable sound-scape to match. By 1951 the town's population had grown to 147,000; it was during this post-WWII era that music giant EMI purchased both the Blackpool Tower Company and the Winter Gardens in an attempt to dominate the lucrative music entertainment industry, there.

Paid holidays for most manual workers during the twentieth century came about in various stages between the wars. For example, in 1937 the Holidays-with-Pay Committee began its enquiries. It was found that only 1.5 million

[7] Unaccredited editor (1904), *Bass, Ratcliff & Gretton Ltd Excursion to Liverpool and New Brighton Friday July 15th, 1904*, p. 31 [my emphasis].

[8] Belchem, John (2006), 'Celebrating Liverpool', in John Belchem (ed.), *Liverpool 800: Culture, Character and History*, Liverpool: University Press, p. 9.

workers received paid holidays under recognized collective agreements. Although it would also have to be stated that, in the 1920s, a week's holiday was standard and most workers were already receiving some kind of paid leave from their work, such arrangements were open to abuse on both sides. The following year (1938) the Holidays-with-Pay Act came into force and by the end of WWII the numbers entitled to one week's paid holiday under collective agreement or statutory order had reached 14 million. By 1951 the campaign for two weeks' paid holiday (in addition to six paid public holidays) was in full swing and the latter years of the 1950s witnessed an all-but-universal fortnight's paid holiday (although many shop workers still struggled to obtain more than a week).

Back in 1945, the general conception of a holiday or tourism for the war-torn British was a week or so to stay within one's own country, perhaps visiting relatives, or staying in bed-and-breakfast accommodation or a boarding house in a coastal resort such as Blackpool, Frinton, Great Yarmouth, and so on. Such activities probably amounted to a small social revolution in its own right as more than half the adult population of Britain travelled away from home for their holidays, spending an average of £20–25 per head. But even by 1964, issues to do with class were still rearing their ugly head. Harry Hopkins stated:

> The furthermost reaches of Devon and Cornwall quickly fell before the new invasion, and as Lancashire accents rang out in some once 'select' Devon combe or Cornish cove, the 'upper middles' who were determined to remain 'upper middles' without defilement or dilution, gathered up their dogs, lavender water and nannies, and began the long retreat to the recesses of Skye or Connemara.[9]

Actually, for some, holidays were not always easy to come by, finance, or indeed accommodate.[10] At Talacre in North Wales, disused British Rail rolling stock, pre-existing temporary buildings and even converted buses were transformed into makeshift holiday accommodation for visiting working-class Liverpudlians, Mancunians and others; Allanah Van El informs us that:

> [for example] residences were mainly summer cottages, caravans, or converted buses, not designed to withstand harsh southwesterly gales. Material from the old boathouse was used [post-WWII] to build the New Boathouse Café in the village of Talacre, which was a financial success and the next big step towards creating my family's pre-war dream: The Point of Ayr Holiday Camp.[11]

[9] Hopkins, Harry (1964), *The New Look: A Social History of The Forties and Fifties in Britain*, London: Secker & Warburg, p. 342.

[10] For example, my own father as a bread roundsman could not afford to take regular holidays; later, after he became a self-employed wholesaler, he could not afford the time.

[11] Van El, Alannah (1993), *Growing Up on Talacre Beach: unique experiences of life in the old boathouse on the Dee Estuary in North Wales*, Vancouver [Canada]: Seas Star Press, p. 94.

Similar scenes could be found near Canvey Island in Essex, whereas hop-picking in Kent continued unabated as an example of an improvised holiday for many of London's East Enders, at least up until the late 1960s. So, while many people's idea of a good time might be a seaside holiday with bucket and spade and enjoying the attractions on the Victorian or Edwardian pier, it should always be noted that leisure pursuits were not available carte blanche during this 'boom' period.

Hence, perhaps, the need for Allanah Van El's holiday camps; once within a holiday camp, campers were not expected to leave the site during their holiday, apart from organized tours, for all accommodation, food and entertainments (including the ubiquitous popular music), were provided, for the price (it was advertised) of a week's wage. For example, the first Butlins holiday camp was opened in Skegness by Billy Butlin in 1936 following his prior successes in the development of amusement parks. A second camp quickly followed at Clacton in 1938 and construction of a third began at Filey in 1939. With the outbreak of WWII, the sites at Skegness and Clacton were given over for military use and building work at Filey was temporarily halted. During wartime the development of camps at Ayr, Filey and Pwllheli recommenced, but only for military purposes. Following the end of the war in 1945, however, all camps were speedily redesigned for holiday purposes and that year Filey was the first to open as a holiday camp. Further sites opened as holiday camps in 1946 at Skegness and Clacton, with the Ayr and Pwllheli camps appearing in 1947 and Mosney on the east coast of Ireland in 1948. Butlins camps were later joined by those of entrepreneur Fred Pontin and there were also myriad small-time holiday camps dotted around the British coastline (such as the 'Robin Hood' camp at Prestatyn in North Wales).

Popular music became vitally important in all such holiday camps: not only as a consequence of the youthful all-singing, all-dancing and general factotum Butlins Redcoats,[12] but also via ubiquitous talent competitions, where many would-be performers attempted to 'cut their teeth' in the assorted bars and ballrooms of the Butlins camps. Becoming a Redcoat was seen by some as a way into show business, allowing a budding performer to 'get his/her musical chops together' and also become established as a professional for the purposes of joining the Equity trade union. By the late 1950s there was even some evidence that Redcoats were moving up the show business ladder. In 1957, Liverpudlian Redcoat Russ Hamilton recorded a number 2 smash hit in the UK with 'We Will Make Love'; following which he recorded a number 4 success on the US Billboard charts with the song 'Rainbow'. During this period Hamilton continued to entertain Butlins guests, and some have suggested that it was Billy Butlin himself who asked Hamilton to record 'We Will Make Love'. Furthermore, shortly after completing his final summer season as a Redcoat at Pwllheli, part-time Merseysippi Jazz Band vocalist Clinton Ford reached 27 in the UK singles charts in 1959 with a version

[12] 'Redcoat' is the name given to frontline staff at Butlins. The Redcoat's duties ranged from adult and/or children's entertainer to stewarding – the 'Yellowcoat' was the Pontins equivalent.

of the song 'Old Shep'. Famous British comedians such as Des O'Connor, Jimmy Tarbuck, and Michael Barrymore and comedy writer Jimmy Perry went on to find great success in the entertainment industry, building on the skills they learnt as Redcoats. Many others experienced some degree of success, or at the very least invaluable experience, following appearances at myriad talent competitions at Butlins camps. Liverpool's Rory Storm and the Hurricanes (featuring drummer Ringo Starr) were booked for a summer season at the Pwlhelli camp after winning the same talent competition from which a young Georgie Fame (Clive Powell) had withdrawn, following his being spotted by reputed London popular musician Rory Blackwell. Fame withdrew from the competition because he felt he was on his way to becoming a professional, and should leave such contests to the 'amateurs'. In the case of the Hurricanes, so popular were they at Butlins, that their live set was as much a product of the requirements of holidaymakers in Wales, as it was of the 'cave dwellers' back at the Cavern in their home city.

A parallel boom in air travel undoubtedly led to more specialized forms of tourism. During the mid-1970s, thanks in part to entrepreneur Freddie Laker, the cost of flying from the UK to the United States and Canada was reduced, making US popular music, for some, a prime motivator for travel. In this writer's case, the West Coast of the United States had always been musically alluring although it was previously far beyond my financial means to experience it all 'at first hand', as it were. By the mid-1970s however, my aspirations were achieved as I (accompanied by my girlfriend and future wife) visited San Francisco to see what remained of the venues where my favourite artists (Quicksilver Messenger Service, Love, Jefferson Airplane, Flamin' Groovies, among others) had played, such as the Fillmore West and the Avalon Ballroom. I purchased psychedelic posters and music paraphernalia of all kinds, even though I realized I was about ten years too late to catch any kind of West Coast psychedelic 'scene', as such. In my imagination I considered myself a popular music researcher as I walked in the footsteps of my musical and counter-cultural heroes.

By this time (in my case 1976) popular music had become a significant motivation for travel; affiliations with different genres of music had effectively created different types of music tourists. For example, travellers to (say) New Orleans or Chicago might visit such cities because of interests in associated genres and sub-genres of popular music. Visitors to New York might be specifically interested in Broadway shows; while other visitors to Europe or North America might be attracted by jazz festivals such as those at Montreux in Switzerland or Montreal in Canada. However, in all such places there existed little (if any) organization structures to evoke such interests and visitors were largely responsible for their own pilgrimages. In the case of the Beatles, visitors to Liverpool were even faced with a city which, for a wide variety of reasons, wished to jettison the Beatles in geo-cultural terms.

Music tourism can today be associated with many different genres of music, and linked to different places of performances, births or deaths. For some, it still has roots in an 'establishment'-based set of values concerning 'important'

music, and can still be seen to have emerged from within class-based erudition and discrimination, while for others it can be 'oppositional' in such terms. Many of the contradictions in contemporary British society still tend to reflect tensions between pre-existing cultures of high art and modernity and the apparent detritus of the popular and postmodern. It has only been in relatively recent times that popular music tourism has been accepted by some as an enduring and authentic pursuit with a legitimacy of purpose, rather than merely the actions of an obsessive in search of what might be described by some as a state of 'false consciousness'. While discourses concerning what might be a genuine popular music heritage continue to rage, such arguments encourage significant questions about our journeys to real and imagined places to find idealized music scenes. Does a city, for example, 'await' us? Is it essentially being redesigned for us? And which 'us' might that be, exactly? Have all of the above tourism initiatives (and more besides) been organized around social and economic repression (especially, given our on-going global economic restructuring, which appears to work for some but not for others)? Is popular music tourism 'real' work or are such jobs merely transitory elements that have appeared as contingencies while the economic and political restructuring of the urban takes place on a global scale?

Further, how has tourism actually helped shape our collective sense of identity? How has it affected our involvement with or understanding of the people and places of socio-musical interest (such as in the city of Liverpool)? How does tourism affect the lives of those within these places of interest? In this latter case, the wide expansion of a low-wage, often temporary and/or part-time economy, with a focus on affective labour, appears to provide evidence that social and economic polarization has taken place in Liverpool. While such new economic circumstances revolving around popular music heritage have, on the one hand contributed to the amelioration of the city, on the other it might be argued that this no longer reflects the 'feel' of the city from which (say) the Beatles once emerged – might this be a good or a bad thing? (Or does it perhaps not matter either way?) It is probably visible to most researchers that an unequal synergy has emerged in Liverpool between visitors, high-income groups, and low income groups: while for the latter their affective labour creates an entry point for work, it also illustrates how the ability to enjoy certain facilities is restricted to only those who are financially able to take advantage. As one current trades union official put it to this writer 'welcoming visitors to the city on a wage below the minimum rate does not engender much enthusiasm'. Diversity and change in modern British society are the very materials it seems of political debate. So while there exists in Liverpool a remarkably complex service industry surrounding the heritage of the Beatles, with great diversity and growing interpersonal skills concerned with the recomposing of the city of Liverpool, the gaps between the realities of Liverpool's lived space and the perceptions of that reality in the minds of those visiting may yet be far apart. Maybe we have at least two 'Liverpools' in action: one of a low-wage service space, another of an imagined hyper-space. Additionally, in order to fully consider the city's immediate and long-term futures, it is essential to posit as

modes of enquiry questions concerning the lack of quality affordable housing, an ageing community, the environmental, social and economic contexts and impacts of Liverpool's changing visage, the desire to preserve the built heritage of the city while maintaining a recognizable and distinct sense of a 'new' place.

The imaginings and experiences of travellers are also of considerable significance, for visiting such spaces evidently contributes not only to the economy of place, but also to the accumulation of a model of knowledge for the visitor about the place being seen. Space and place appear to most of us to actually constitute knowledge ('travel broadens the mind', and so on), and travellers feel that they 'know' things via their travels – as if travel is almost the ultimate way to achieve gnosis ('swimming with the dolphins', as it were). But is it? A tourist's knowledge of space might be merely an inventory (as often as not seen through the windows of a travelling vehicle). Might such knowledge be one imagined space viewing a real geographical space from the corners of one's cultural 'givens' – more a kind of geographic parallax of the mind? As Edward Soja reminds us, 'how easy it has been to attach a similarly infinite scope to the historical-cum-sociological imagination, to see everything that exists in the present or ever existed in the past as potentially knowable, at least in large part, through its embracing historicality and sociality'[13] – perhaps, a little bit too easy, one might argue. In contrast, however, it should also be acknowledged that the interpretation of experience is itself a field for creativity and invention. Harvesting and utilizing one's own expressive interpretations without seeking for them the safety of collective and political confirmation is at the heart of a creative cognitive activity such as tourism. We actually witness spaces and places being filled with references that reveal to us the inability of languages, texts, discourses, geographies and historiographies to fully define meaning. The more we allow affects to speak to us, the less we allow one ideology to rule us. Liverpool can bear testimony to the production and reproduction of space via popular music; what this has come to mean from both ends of the continuum surrounding the lived and imagined urban environment ought to be more seriously studied. The current Head of Visitor Economy Development at the Liverpool City Region Local Enterprise Partnership is Pam Wilsher, who (as will be seen later in this work) played an intrinsic part in the development of Beatles tourism in Liverpool. She stated in 2014:

> When I first came to Liverpool in the 1980s I thought that the rise of Beatles-related tourism might be a fad, that it might last ten years at the most. I'm delighted to have been proved wrong and that we continue to see young people – born years after Beatlemania – from all around the world, visiting the city purely to retrace the footsteps of John, Paul, George, and Ringo.[14]

[13] Soja, Edward W. (1999), *Thirdspace: Journeys to Los Angeles and Other Real-and-Imagined Places*, Oxford: Blackwell, p. 311.

[14] The Editors (2014), 'Interview with Pam Wilsher', in *Imagine: The Value of Music Heritage Tourism in the UK*, London: UK Music, p. 12.

It might be argued that, unlike the city which Pam Wilsher came to know in the 1980s, Liverpool is a now a modern heteropolis with a wide variety of authentic discourses (not exclusively those surrounding the Beatles) at play at one and the same time. There are myriad spaces occupied by our perceptions as workers and/or residents in the place, endless mind-based perceptions of the visitor, innumerable conceived spaces, realistic spaces ('definable' according to certain matrixes), 'other spaces', curious spaces, and so on. There are also polysemic 'thirdspaces' and marginal spaces where realities and internal spaces collide, creating a lack of centrality. As I write, one such border space in Liverpool directly concerned with popular music historicity is the exhibition of artefacts re the 1970s art-rock group Deaf School (held at the John Lennon Building at the Liverpool School of Art October–November 2013). Assembled in the main by Bluecoat Art Centre curator Bryan Biggs and former Art School lecturer Steve Hardstaff, the exhibition tends to speak from the borders of accepted popular music historiography. Deaf School have been variously described in popular music monographs over the years as one of Liverpool's 'lost' or overlooked bands – which of course is a matter of opinion. But the exhibition exists to analyse all debates concerning value and authenticity, to question and perhaps even transgress received opinions about popular music hierarchies in the very city from which many such formalized hierarchies came to be. This means that through such discourses we bear witness to the work of the *bricoleur*, which at one and the same time questions Liverpool's musical histories, its evidently multifarious present, and its future as a postindustrial city which concerns itself both culturally and economically with the relationships between our consciousness and our man-made environment.

Beatles and Liverpool: '[…] and here I'll stay'[15]

Unlike Stuart Sutcliffe, who was born in Edinburgh, and Pete Best, who was born in Madras, India, each of the four young men who came to be 'recognized' as the Beatles were Liverpudlian, by birth. However, the relationship between the Beatles, their legacy, and the peoples of the city of Liverpool has been at times, strained. Several tensions exist between locals and their viewpoints of the group. Some Liverpudlians, for example, continue to accuse the group of deserting the city for the South of England. One Liverpool-born taxi driver only recently repeated this enduring mantra to this writer:

> They left us; you know, they left us all behind. They were never what I would describe as good scousers in any case. They never said whether they were red or blue. They came from the south end of town; as soon as they could they upped

[15] From 'Ferry Cross the Mersey' by Gerry and the Pacemakers.

and went to London. And their own stuff was never as good as the covers; they were stuck firmly up their own arses - that just about summed them up for me.[16]

Complex pejoratives are redolent in such comments. For example the North–South divide in the UK, indigenous chauvinism, and an overpowering discourse regarding the negative contemporary effects of the power of popular culture (and by association the popular music industry), all contribute to Vince Mather's comments. They are in part representative of a generation shaped by openly-spoken ideological rhetoric concerning deeply-embedded Liverpudlian-based authenticities (which are of course not exclusive to the city of Liverpool). In military terminology, desertion constitutes the abandonment of a duty or a post without permission and is done with the intention of not returning. 'Absence without Leave' (AWOL) can refer to either desertion or a temporary absence. This appears very close to Vince's suggestion that the Beatles left an embattled city on the verge of collapse without a 'by your leave'.[17] The great American myth is that the hero leaves home to remodel him/herself in another place: Kerouac hitched rides whereas Dylan rambled his way to New York City, and so on. However, one US myth, that of Dorothy's flight in a tornado, is perhaps more closely related to the Liverpool myth of 'return'. Dorothy actually returned to Kansas, promising never again to leave. It should come as no surprise that, by singing 'Ferry Cross The Mersey' in 1965, Liverpool's Gerry and the Pacemakers (the Beatles' first rivals for national popularity if one excludes Cliff Richard) secured an enduring loyalty from fellow-Liverpudlians. Not only does group leader Gerry Marsden (who also wrote the song) sing of a land of eternal welcoming happiness ('we don't care what your name is boy, we'll never turn you away'), but also reiterates the important mantra 'here I'll stay, here I'll stay'; the recording even fades on these repeated words. The ferry in this case is very symbolic, for it is a recognizable Liverpool icon that never leaves the river, merely repeatedly crossing and returning, crossing and returning. The release of this record accompanied a film of the same name, set in and around Liverpool, and followed the Pacemakers' 6/8-time hit version of the show song 'You'll Never Walk Alone' (actually taken from a Pattie LaBelle reinterpretation), which was adopted by Liverpool Football Club 'Kopite' supporters as their anthem. Further, when his chart successes ceased, Gerry Marsden did not in fact leave and to this day continues to live in the area (on the Wirral). Therefore, his renown within an openly place-based matrix forever awarded him and his group an indigenous authenticity which, for certain locals, the Beatles could never match.

[16] Vince Mather to Mike Brocken, March 2013.

[17] One is also reminded of local opinions concerning ex-Liverpool FC footballer Kevin Keegan, who 'abandoned' the city for the sake of a career in Germany. Local opinion differs about Keegan as a footballer; however, he is not always held in high regard 'as a person', due to his act of 'desertion'.

Historically, unlike Gerry and the Pacemakers, the Beatles were also negatively associated with stereotypical sex-and-drugs images surrounding the rock music of the 1960s and '70s and the accompanying counter-culture. This was all deemed unacceptable by Liverpool's city fathers, and unworthy of their support throughout the entire decade prior to John Lennon's death in 1980. For example, it was speculated in 1979 by *Merseyside Late Extra*, a free paper concerning leisure in Liverpool circulated to over 90,000 local readers every month, that the Beatles might re-form in an effort to relaunch Merseyside as a major tourist centre (some hope). In the same article it was also reported that the Beatles had 'become political dynamite in the Liverpool Town Hall':

> There are various officials, in addition to politicians, who are horrified by the idea. One important official, who asked not to be named, said: 'After that disgusting *book* which revealed what went on in Hamburg in their early days and their use of filthy language, the Beatles should in no way be linked with the civic name of Liverpool.[18]

In defence of the group, Merseyside County Tourist Development Officer Ron Jones stated in the same article that 'nothing would give tourism a bigger boost than the publicity arising from a re-union of the Beatles which would focus world-wide attention on the city'. 'But', the article continued, 'it is certain that the Beatles will never again appear on the Town Hall balcony as they did [previously].'[19]

The 'book' to which this local official referred was Allan Williams' seminal text *The Man Who Gave The Beatles Away* which, one might argue, was one of the great fomenters in the development of Beatles tourism in Liverpool. However, the above comments are very interesting and, along with our taxi-driver's observations, are all rooted, wittingly or otherwise, in elitism, dialectic materialism, and regional chauvinism. They are also constituted in not only a misreading of the musical genres employed by the group (they were not really a 'rock band' in the late-1960s sense), but also their political and counter-cultural profiles. For example, while both John Lennon and Yoko Ono were indeed somewhat burdened with counter-cultural iconography in the United States, they were not really considered 'political' in the same way in the UK (and the other Beatles were rarely considered at all, in this respect). One might therefore argue that, subsequent to the demise of the group (indeed right up to the present day), some have continued to 'compose' a culture of the 1960s, the Beatles, and John Lennon as a spectacle linked to sets of images rather than realities of the past. Local musicians do have a tendency to see through such images, considering the musical legacy of the Beatles to be a burden, especially when the British music industry continues to brand the latest (white) male group to emerge from Liverpool as 'the next Beatles' (e.g. the La's, Cecil,

[18] Unaccredited staff writer (1979), 'Beatles May Come Home – Officials in Turmoil', *Merseyside Late Extra*, 1 June, pp. 1–2 [my emphasis].
[19] Ibid.

the Coral, the Zutons, and numerous others). Vicky Edwards, former member of Liverpool group the Aeroplanes, informed this writer:

> I honestly and truly love the Beatles but I'm sick and tired of the national music press calling every new band with something to offer from this area being called 'the next Beatles'. I find it doubly frustrating as a female bass player because apparently I'm not supposed to be in a band with men and apparently I shouldn't be playing a bass either. I was told this, in so many words, by a 'hack' from a national music weekly. I think that he lost interest in the group because he couldn't pigeon hole us in the usual way.[20]

Furthermore, locals of perhaps differing ethnicities find images of 'four white boys with guitars and drums' not only problematic in a 'musical roots' sense, but for them culturally devoid of meaning and musically generic (at least as far as the black–white musical spectrum is concerned). My late friend and former BBC colleague, deejay James Klass informed me several years ago that he didn't find any of the Beatles tourist initiatives helpful to him as a Black British musician because it was 'not a fair or honest history of popular music activity in the city'. In the same vein, researcher Ferdinand Dennis was also informed:

> The Beatles? We got no time for the Beatles 'round here. They're just another example of the white music industry ripping off Black music. Where do you think the Beatles learnt their craft? They come from up Penny Lane way. There are no night clubs up there. They learnt it round here, in Liverpool 8. John and Paul were taught to play the guitar by a Trinidad guy, Woodbine. He used to own a night club that played Stateside music. He was a musician himself. John and Paul used to hang around him. That's where they picked up their style from. But nobody ever mentions Woodbine. Nobody! When Woodbine opened another night club he invited them to the opening. They didn't go – they were too big to know him then. So round here we don't have any time for the bloody Beatles.[21]

Much of the supposed 'information' cited here is actually historically inaccurate. Embedded within it, however, are several truisms that can be defended from both a spatial and a historical perspective. They invite the researcher to consider living issues in Liverpool's history, such as the relationships between locality and race. Ferdinand Dennis further stated that the very ferocity of the comment was in point of fact its most startling feature. Music will always be contentious and will continue to play a major symbolic role in expressing a creative sense of community and place. For music historians such issues are perplexing, for we have to continually

[20] Vicky Edwards to Mike Brocken, July 2013.

[21] Unaccredited interviewee to Ferdinand Dennis (1988), *Behind the Frontlines: Journey into Afro-Britain*, London: Victor Gollancz, pp. 57–8.

reassess how views of music are considered within environments of appearance, movement, and disappearance.

In recent years, talk concerning the authenticity of popular art and its relationship with subjective identities has been increasingly explicitly interdisciplinary and eclectic. However this was not always the case, for by the mid-twentieth century a significant basis for establishing an understanding of identity as transmitted via popular culture lay in Marxist thought. Paramount to this understanding was the acknowledgement that our identity was predicated by other subjects of our consciousness, and that we should constantly question what we see as our identities through an ongoing examination of the relationship between our consciousness and the inhuman environment in which we live our lives. Therefore freedom became a pressing issue and was articulated throughout the mid-to-late twentieth century in a variety of Marx-inspired ways: from the existentialism of Sartre through to the feminist discourses of Mulvey; via the Green lobby which alerted us to the victimization of the environment to the identification of meaning and value in art. It should be noted that a legacy of Marxism reached its peak in the city of Liverpool, during the decade following the dissolution of the Beatles. In Liverpool's more recent past, two linked philosophical Marxist-inspired questions have been repeatedly raised, thereby colouring many discourses in the city towards popular culture. First: what happens when developments in trade and technology in a trade-based city such as Liverpool actually reduce the amount of employment possible? Second: what happens when structural unemployment is in itself developed as a central feature of business and political ideology? Partly as a consequence of these questions, and inspired by Marxist thought some, Liverpudlians controlling the city in the 1980s attempted to answer these two important questions via a rejection of mass-produced popular music. This left a kind of enduring cosmology on the city: a perfected model of an imperfect world in which popular music could be reinvented as part of an authentic workers' culture game with laws codified by 'Adornian' misinterpretations of Marxist discourse. As suggested above in the introduction, arguably the entire debate concerning popular music's value still has its roots within a rather twisted treatise of Marxism itself: a discourse which is still acknowledged by some to hold one of the most significant explanations of 'life, the universe, and everything' currently available. In Liverpool, rightly or wrongly, a political pessimism persevered, while at the same time the enigma of the popular (and the world of objects rather than subjects), has helped the city to prosper.

As far as tourism is concerned, another scrap of local mythology in Liverpool proposes that between the end of WWII and at least up until the mid-1980s, the only tourist companies to exist and profit from tourism in Liverpool did so mostly by taking people out of the city. Certainly, throughout most of the second half of the twentieth century, and as the city gradually depopulated, Liverpool was decidedly *not* regarded as a tourist destination. The growth and development of a Beatles heritage tourist industry in Liverpool therefore arose in stages in response to the growing significance of popular music and its heritage, and is directly related to Liverpool's repositioned cultural and spatial environment. What brought about

great changes in Liverpool's approaches to popular music tourism over the past twenty years or so was a series of social factors that helped to realign city space with a 'new' affective labour market. With this in mind, it is probably important to inform the reader at this early stage that historically it has been largely the role of i*ndependent* businesses to take advantage of the popular music legacy of the Beatles, rather than the city's council (or in fact, any other government-funded organization). In spite of such entrepreneurialism reflecting for many a truly authentic Liverpool visage, it was at times, regarded suspiciously by those who cleaved to oppositional ideologies. It has been argued by John Connell and Chris Gibson that much popular music tourism can be seen as a 'historical accident',[22] perhaps even unwelcome in some cities, as it gradually and organically developed against the grain of canonic musical and architectural histories – such was the case with Beatles tourism in Liverpool, as it became the proverbial 'political football'.

Cultural Capital

Perhaps the development of all music tourism needs to be understood within the matrix of cultural capital. As the originator of the concept of cultural capital, Pierre Bourdieu was notoriously disinclined to elaborate any meanings and significances of his theories beyond his primary concern of education. However, he did appear to emphasize that all forms of what he described as competencies are converted into kinds of capital via helping to facilitate society's understandings concerning what is or isn't cultural heritage. At the beginning of this chapter it was suggested that the Grand Tour was one such affirmation: 'the Tour' was in a way an affirmation, via life's theatre, of 'realities' which confirmed the grand cultural narrative. The very 'existence' of the Christian world substantiated and re-enforced the hagiographical cultural capital 'givens' of the Tour – a kind of circular hierarchical anthropology of religion, in which the world was viewed as a confirmation treasure: clear evidence of God's (thus enlightened man's) intervention.

British society is full of contradictions, thus tensions, and nowhere can such tensions be more apparent than within the British education system, for educational institutions create and express social divisions, especially surrounding music. Educating people entails selection and differentiation: some appear to be 'made' into successes and others into failures. Schools continue to create inequalities between individuals by preparing their pupils differently by class, gender and ethnic groupings. This is evidently paradoxical when British schools are expected to transmit a common culture, and to educate young people to be members of a national community. Such challenging complexities brought about by kinetic societies are the very building blocks of understanding cultural capital, for we

[22] Connell, John and Chris Gibson (2003), *Sound Tracks: Popular Music Identity and Place*, London: Routledge, p. 10.

can see that schools uniformly fail to focus accurately: their cultural matrix is static rather than kinetic and an academic model dependent upon static British institutionalized social mores is frequently recruited. It is perhaps here in the music classroom (rather than via the oft-quoted supposedly heinous popular music industries) that young people are effectively manipulated to 'fit'.

Differing forms of cultural tourism have blossomed within differing formulae of cultural capital, creating provisions for those with an a priori mixture of knowledge concerning the value and authenticity of the particular heritage/s under observation and combining this mixture into a formula of 'telling'. Thus an institutionalized heritage industry at first developed to cater for such cultural capital, in the names of observational knowledge as power, romanticism and nostalgia as knowledge, and the mystical or spiritual as an 'explanation' for something lying outside of de facto categorization. Such tourism provoked interest in those aspects of culture which were already regarded as having elevated society to that very position of enquiry. Music became a niche, or a series of niches, within an affirmative and reaffirmative echelon system. Even terms such as avant-garde became a matrix for culture with a capital 'C', for the obverse view of society was created by and through its confirmative 'other'. In other words, concepts concerning alternative music were as much a consequence of the culture to which it was reacting, as it was the music it appeared to be. These cultural formations of specific musical niches-as-capital should motivate music historians to examine the ways in which historical narratives are put together (they are imperative within music tourism settings, for example), because pieces of narrative are always constructed in specific ways, for specific audiences, using specific historical fragments, to make specific points.

Fragments

The notion is that in all cases of music tourism one is now required to create a story, a story which is both rooted and restructured using certain selected information, to appeal to certain audiences, which in the process validates both niche and audience – we might describe this as a matrix: something which attempts to bring into focus that which was previously unfocused. By doing this, authority and authenticity is radiated. Musical-historical fragments are therefore interesting to examine because they give us specific images of the niches as they appear to exist in the minds of those in the present. It is impossible to get all of the facts exactly correct, or to even get close to all of the viewpoints held at any given time re what happened, because they are not 'with us'. Instead, strands of history are included which make the greatest sense to those in the present, and the fragments chosen are affirmative to whichever forms of cultural capital bring them about.

Texts of affirmative nostalgia-compounded-as-folklore are of great importance for they can assist our understanding of the cultural mores which lead to the assemblage of music historiography. Niche heritage will always be dependent

upon the present-day ordering of historical fragments within the cultural capital of any given society. Such ordering dictates that a heritage is always older than the immediate past, thus 'preferable' because 'lost'. Therefore the endorsement of a heritage implies that the present is intrinsic, yet detached. What we have witnessed in Liverpool and its relation with Beatles and popular music heritage is a gradual shift in cultural capital rules: from ideological consciousnesses determined by static interpretations of time, place, and value, to those more latterly determined by the horizontal integration of space: the contingency of the 'here and now' in which predetermined cultural and political semiotics are no longer freely accepted as 'givens'.

Beatles Fragments

Via a series of debates concerning the value of Beatles-related heritage, a continuum of practical and procedural crafts can be seen to have gradually questioned elitist forms of cultural capital in the city. These historical and contextual narratives have been put into place by systems with their own authorial powers and have been cemented via recognizable syntagmatic vocabulary. This suggests that musical/historical cultural capital can be challenged and dismantled if fragments are syntagmatically placed in the correct order. The growing seriousness of collecting Beatles artefacts and of visiting Beatles places have linked together to authorize events, opinions, methods and approaches administered from within a cultural field systems that are not simply musical, but also linguistic and cultural. The presence and circulation of information from within such networks of providers and users approves certain types of texts, particularly those that establish the Beatles as a 'gift' to the world, and via interlocutors creates a contract by and through these networks.

Thus specific narrators (or 'tellers'), individuals with key roles, and places conveying authenticity have emerged as important social cultural-heritage actors in their own right, authenticating in some very specific ways. For example, some 'tellers' attempt to give us insights into the Beatles as individuals, and how they intermingled with other 'interesting' characters expressing 'local colour' – such as Allan Williams, Bob Wooler, Sam Leach, Joe Flannery, amongst others. Local tour guides often merge their Beatles portrayals with contextual cultural histories, such as a personal knowledge of a specific character, or a particular discussion of political radicalism during the 1960s; perhaps a vignette or two concerning specific places 'off the Beatle track', as it were ('nudge, nudge, wink, wink'). In all cases a Liverpudlian-accented voice helps, as long as it is comprehensible and authoritative. Of course, how such texts relate to a historian's demand for accuracy is at times anybody's guess, but perhaps more importantly, how such Beatles 'fragments' are regulated to serve specific narrative functions continues to be of great historical significance. These forms of (sub)cultural capital from which such ordering of fragments stem are long and complex and involve precise authenticity tropes which make equally precise diachronic and synchronic points. Such tropes

might be based within popular music, socio-cultural or political histories; or they might be based upon local authenticities and understandings of place, space and real people. In the annals of authenticities, however, place always 'trumps' words, and the way in which Liverpool has effectively come to understand popular music heritage, and has then written itself into that trope in order to pursue a form of cultural capital (both in continuance of, and in contradistinction with fragments of history which make-up the city's various identities), will continue to be fascinating, as tourism continues to expand.

For Lars Kaijser,[23] fragments appertaining to Beatles-related cultural capital appear to be best viewed as kinds of synecdoches or metonyms: in other words, they syntagmatically and processually connote variable, larger (and at times even more interesting) contexts. These might be links into the trend of Beatles narratives, or to the context-based rock discourses of authentication; they might be geographical dialogues of geographical-political significance, or representations of social changes during the late twentieth century, and so on. All such relational logics can be found in practically *every* Beatles/Lennon text, whether written or spoken, literary or visual. So, while all heritage fragments connote historical worlds for us, they are also publicly functional and contextual sources of reference in a cultural capital kind of way. How fragments emerge, how they are paradigmatically and syntagmatically ordered, and how they contribute to structuring both the cultural and economic development of the Liverpool-based tourist industry discloses a great deal about the contextual policies of the Beatles folklore equation. For example, Green Badge Guide Charlotte Martin informed this writer how she has:

> very recently witnessed guides change narratives mid-stream according to the atmospheric response from visitors. On one tour I experienced an experienced Magical Mystery Tour guide move quite subtly from a Lennon-biased discussion to a McCartney-biased one because he had sensed that he had a bus full of Paul, rather than John, fans. Nothing was said openly, but the atmosphere on the bus clearly dictated that he had to do it or lose them – I felt it too.[24]

Discovering and recording how such orderings and reorderings take place is an almost 'archaeological' field of enquiry, for fresh fragments can be brought to the table. For example, as with an archaeological dig, items still crop up: for example, a new photo, a new recollection, an old piece of music, a new book. So, for the creators and guides of Beatles histories there is an unspoken definitive document from which questions and answers can be set forth and determined. In effect, constructing histories about the Beatles has become an almost 'biblical' pursuit and

23 Kaijser, Lars (2010), 'Authority Among Fragments; Reflections on Representing the Beatles in a Tourist Setting', in Jerzy Jarniewicz, and Alina Kwiatkowska (eds) (2010), *Fifty Years With The Beatles: The Impact of the Beatles on Contemporary Culture*, Lodz [Poland]: University Press.
24 Charlotte Martin to Mike Brocken, April 2014.

a certain fragment configuration takes place so that any 'new' fragments 'fit' within the ruling order of Beatles cultural capital and hagiography. Unquestionably, there are rules: a body of constraints and sets of conventions exist in the creation and continuance of Beatles historiography in Liverpool. Precisely how each historian or guide paraphrases Beatles images and imaginings and how authenticity is connoted depends on many things – such as who is telling the story, how it is put together, and for whom the story is intended. With the Beatles as subject, there exist amongst 'tellers' quests to have the 'last word'; this is, of course, deeply ironic for in popular music cultures no one has either the first or last word about anything.

Beatles Authenticities

Throughout the course of the following investigation of Beatles narratives, people and places there are many important terms that might already be familiar to the reader. It is crucial to note that many of the expressions can be used in a broader context, but will have specific meanings here. To begin with, 'authenticity' should be further clarified in a local sense. In general, an authentic object is of undisputed origin. In a historical context, such as an artefact in a museum, to be authentic means to have been proven to have originated from a particular place and be genuinely what it claims to be. However, popular music authenticity can be proven via the active identification of communities and individuals with lasting connotations that emerge in a discourse. Popular music authenticity is kinetic, a constantly moving target. Therefore, discussions of musical authenticity consist of 'interpretations of the validity of music from particular contexts and in certain modes of consumption'.[25] In this way the authenticity of popular music for Beatles tourism is forever socially reconstructed, and values and meanings depend upon prescient connotations. Authenticity is constructed in such a way as to connotatively authorize the constructors; each facet of Beatles tourism has developed over decades and has therefore found ways of surviving, gaining authority, or else has disappeared. As Pam Wilsher states:

> Culture and heritage is a key theme for the city and absolutely forms the cornerstone of our visitor strategy. The city is awash with cultural attractions and we believe is only second to London in this area. The Beatles and music obviously forms a key element of this, but it is the combination of all the different strands of heritage which really does make us stand out from other cities, not only in the UK, but around the world.[26]

All heritage entrepreneurs in Liverpool have been required to gain and express significant authenticities and authorities in order to legitimize themselves and

[25] Connell and Gibson, *Sound Tracks*, p. 27.
[26] The Editors (2014), 'Interview With Pam Wilsher', p. 12.

Liverpool as a Beatles place, within the cultural capital of Beatles fandom. Even though popular music tourism is an individual experience, what any individual experiences, and what any social group shares, are significantly constrained by the ways in which information is structured. In the history of Beatles tourism in Liverpool there is both diversity and structure. Entrepreneurs need to gain a type of semiotic authority via their unique 'take' on the Beatles, but they also need to subscribe to an agreed mono-history in order to be seen as legitimate. One might even go so far as to say that, within the models of Beatles tourism discourse, there are (as Julia Kresteva and Roland Barthes might have suggested) 'pheno' and 'geno' texts, with, for some receivers, signification conforming to a phenomenological expressive level whereas, for others, specific instances of communication moving beyond such signification into particular forms of intense pleasure and appreciation.

In conclusion, it is also important to consider whether, historically, such tourist-based cultural capital initially met receptive or deaf ears. Whether it was at first born to live and bear fruit or to be reviled and forgotten did not solely depend on any intrinsic value in (say) the music alone; rather it depended upon the cultural conditions of the ground on which it at first fell. Liverpool's popular music tour guides are now able to illuminate to the researcher instances in which new ideas have been readily absorbed and applied. In turn, popular music researchers, via an examination of the variegated musical contexts of (e.g.) 1970s Liverpool (with the remnants of the counter-culture on the one hand, and the rise of the 'hard left' on the other) are able to see that that popular music tourist initiatives in the city were actually allowed to lie fallow and/or disseminate very slowly. The reasons for this kind of fate are as manifold as the reasons for something's birth or imaginings. What becomes clear, however, from any investigations into Liverpool's cultural climate during the 1970s is that our present-day mono-history of the Beatles in Liverpool has been assembled from curiously diverse contextually-diachronic strands.

At this early stage at least three important interweaving discourses might be posited for the reader to consider throughout this presentation of Liverpool's relationship with the legacy of the Beatles. Firstly, that many Liverpudlians have long supported the notion that the city has a mono-history of collective struggle against the ruling powers of the South-East, therefore 'desertions' are greeted with ambivalence and at times disdain. Secondly, the city's musical history concerning popular music activity is actually at times very conservative; therefore 'rock discourses' emerging from counter-cultural activities can be viewed with thoughtful suspicion. Thirdly, histories of white working-class radicalism have taken ownership of Liverpool 'contra histories', so narratives of (e.g.) racial inequality and aggressively-pursued working-class entrepreneurialism are at times completely ignored. Only by tracing how these three (and other) strands interweave and become knotted together within the remit of tourism, can we understand the complexities of the different forms of cultural capital produced by different cultural constituencies surrounding the presentations to visitors of the 'histories' of popular music and the Beatles in Liverpool.

Chapter 2

'No Reply': Ideas and Identities – a 'Rocky' Context for Popular Music Tourism in 1970s Liverpool

Thousands took the pledge and joined the anti-rock wagon. There are people now
[...] whose musical digestive systems would probably collapse if they were to be
inadvertently fed a powerchord.

(Simon Reynolds, 1990, *Blissed Out*)

New ideas, whether they support or oppose customary trends of thinking, tend to represent characteristics embedded in the period in which they came into being. Although ideas might be reformulated for future contingencies, the popular music historian should always attempt to locate such ideas, attitudes and opinions within the periods of time and localities from which they have at least appeared to have emerged. This we might describe as an understanding of context, and context is everything. In paraphrasing Louis Althusser, eminent historian John Tosh suggests that: 'all historical documentation is tainted by the structure of thought and language, prevalent at the time of writing: the "real" facts of history are beyond our reach, and the distorted images we have of the past are an irrelevance'.[1] Tosh acknowledges Althusser's concerns about the appearance of so-called 'facts' and, at the same time, recommends the researcher to actively participate in unpacking variegated discourses. Tosh argues that by doing so, reductionism so often found in a priori theory-bound histories, can be avoided. Within contexts, and discourses about varying contexts, we recognize the strengths of the varied and variable associations that we all carry with us. Such understandings and approaches reveal an incredible number of diminutive contexts within which decisions are made (for better or worse).

These contexts allow us space for research-based questions. For example, in the case of popular music in Liverpool, one might ask how the rhetoric of place in the city might affect legitimacies in a popular music sense (something with which I have attempted to deal elsewhere[2]). This question further asks whether in certain places, pre-existing rhetorics of place may have posited that some genres of music were authentic, while others were not. As a consequence, one might also

[1] Tosh, John (1984, 1991), *The Pursuit of History: Aims, Methods and New Directions in the Study of Modern History*, London: Longman, p. 176.

[2] Brocken, Michael (2010), *Other Voices: Hidden Histories of Liverpool's Popular Music Scenes, 1930s–1970s*, Farnham: Ashgate.

ask whether and under what circumstances a popular music heritage space in the city might have possibly struggled to emerge, and within which discourses and contexts. A place, properly researched, tells us about certain people who lived there, what they might have believed, and how they might have organized their lives. From within such cultural organizations, we can view popular music's interaction with ideas, and it is only by considering as much of the package that we can find, that something about where ideas might have come from, may possibly be pieced together. If we take an idea out of its context, the information about its maker is lost, so too are the motives, the inspirations and the variable oppositions.

During our chosen period (broadly speaking, from the end of WWII to the 1980s) the drive of modernization in and around Liverpool came to some kind of thought-provoking end, and industrial production ceased to expand in the ways many had become used to. One symptom of this significant paradigm shift was almost immediately manifest: old ideas needed to be rethought during a period in which austerity was overtaken by the 'long boom', which, in turn, was supplanted by a white goods consumer culture which then, fell away as new ways of making money gradually came to dominate. Traditional ideological oppositions gradually ceased to relate in quite the same ways as they once did, and the processes of recognizing change, acting upon it, and then valuing that change came to create important differentiations. Those willing to embrace culture, capital, and contingency were different from those who found it nigh on impossible to move away from culture-bound authenticities and oppositions created during the dominance of industrial production. Embracing contingent struggle rather than a predetermined history was core to the change in Liverpool's make-up, not its 'exceptional character', as Belchem puts it. One might argue that all popular music heritage tourism has been bound up in this dichotomy, as the processes of communication- and information-based ways of making a living have slowly, unevenly, but surely illustrated a migration from industry to service, it has represented in the process, a key economic shift in all advanced capitalist countries across the globe.

The word 'services' here covers a wide range of activities from education to entertainment, and historically one thing that has stood out is how networks and alliances of the production of affects reveal that such processes of social and economic constitution are here to stay, repositioning identities and subjectivities, and awarding us what Homi Bhabha calls the 'social articulation of difference'. To paraphrase, Babbi suggests that such articulations require comples and unending renegotiations; these help us to understand the variable discourses emerging from hybrid cultures at times of crisis. Such discourses, he suggests, are not based upon preconceived 'traditions' but are actually constitutive of contingent and contradictory reinscriptions of minority identies in specific times and places.[3]

Such, one might argue, is the case for Liverpool.

[3] Bhabha, Homi (1994), *The Location of Culture*, London: Routledge, pp. 1–2.

In an evaluation of the above spatially-related issues, Edward Soja's work *Thirdspace: Journeys to Los Angeles and Other Real-and-Imagined Places* develops an important theory of 'Thirdspace' in which 'everything comes together [...] subjectivity and objectivity, the abstract and the concrete, the real and the imagined, the knowable and the unimaginable, the repetitive and the differential, structure and agency, mind and body, consciousness and the unconscious, the disciplined and the trans-disciplinary, everyday life and unending history.' Soja maintains: 'I define Thirdspace as an-Other way of understanding and acting to change the spatiality of human life, a distinct mode of critical spatial awareness that is appropriate to the new scope and significance being brought about in the rebalanced trialectics of spatiality-historicality-sociality.'[4] Effectively, Soja broadens previous dialectics of materialism into a trialectic discourse which includes the merger of one's imagination with ideas of place as a meeting point for creativity: what might be described as affective and creative space. Like the development of recorded sound which preceded the post-WWII era by approximately a half-century, the production and reproduction of popular music affects and their collective subjectivities have provided space for a historical paradigm shift. This placed Liverpool into either an invidious or opportunistic position, depending upon one's ideological perspective. Liverpool's understanding of 'itself,' and in turn of the Beatles, as potentially exploitable by 'thirdspace' capital took almost a half-century to work out. This was probably inevitable, for an understanding of the power of any cultural communication of the subjective within an asymmetrical affective capital climate conducive only to an 'imagined' (not imaginary) space, takes a great deal of understanding.

Thirdspace is a radically inclusive concept that encompasses epistemology, ontology, and historicity in continuous movement beyond oppositions and dualisms and towards the potentiality of 'an-Other'. As Soja explains: 'thirding produces what might best be called a cumulative trialectics that it radically open to additional otherness, to a continuing expansion of spatial knowledge'. The concept of thirdspace therefore is transcendent and constantly expanding to include 'an-Other' thus enabling the contestation and re-negotiation of boundaries and cultural identities. Soja's ideas closely resemble Homi Bhabha's theories surrounding on-going and un-ending cultural hybridization, in which:

> all forms of culture are continually in a process of hybridity [that] displaces the histories that constitute it, and sets up new structures of authority, new political initiatives [...] The process of cultural hybridity gives rise to something different, something new and unrecognizable, a new area of negotiation of meaning and representation.[5]

[4] Soja, Edward W (1996), *Thirdspace: Journeys to Los Angeles and Other Real-and-Imagined Places*, Oxford: Blackwell, p. 57.
[5] Ibid.

This 'cultural hybridity' which 'gives rise to something different' actually describes well Liverpool during the era in which rock 'n' roll, jazz, skiffle and folk music all emerged and took control of taste cultures, renegotiating meaning and representation, along the way. By the 1950s imagination began to take hold as an entire stratum of society in many cities across the UK began to change. One consequence of this was that a fascinating spatial argument came to emerge from within Liverpool concerning the value and the historical meanings of its varied places in relationship to popular music.

Liverpool Identities

We were living in Stoneycroft, Liverpool 13, between the 1950s and 1971, after which we moved to Birkenhead: 'over the water'. But my father was born and raised in Everton, Liverpool 5, and in the late 1930s moved with his parents to a new council estate in the Norris Green area of the city. We came to work together in the 1970s and he occasionally discussed with me his mixed sense of identity as a young Liverpudlian growing up in the inter-war period. He used to tell me that Liverpool was a very different place to the one in which I grew, and stated to me, on occasion, that local accents, 'in his day' could be very different from the 'scouse' accent I had come to know in the 'Merseybeat' era of the early 1960s. He further stated that, while many different brogues could be heard on the streets of 1930s Liverpool, there existed a 'generic' accent: perhaps more Northern than anything, and certainly less 'Scouse' in the modern sense of the idiom. This he likened to a 'Lancashire accent without the use of the curled "r"'. Both Irish and Welsh accents, he would tell me, were also commonplace. He also informed me that my ideas of being Liverpudlian were not altogether indicative of his experiences in the pre-war era, and that, for him, a jumble of identities (that the city was too opaque to pin down) and experiences (that, for him, greater imperatives such as earning a living), tended to resonate. At least according to my dad, a fixed, pre-WWII Liverpudlian[6] identity was difficult to locate. My father's accent resembled that of Liverpool comedian Tommy Handley, but I recall my maternal grandmother, also born and raised in Everton but living on the borders of West Derby and Norris Green, having one of these 'generic' Lancashire accents.

Indeed, Liverpool as a place was culturally less fixed than one might at first imagine because by the twentieth century it was still a relatively modern city barely 200 years old. In fact, the celebrations in 1907 of the 700th year of its charter were as much to do with *providing* the city with a sense of identity via an element of invented nostalgia as it was endorsing an old-established city (which of course it was not). Ramsay Muir, the academic historian based at the 'new' University of

[6] In fact the very word 'Liverpudlian' does not appear to exist unchallenged across the decades. For example, Peter Howell Williams refuses to use the expression in his 1971 text *Liverpolitana*, preferring the term 'Liverpolitan'.

Liverpool, wrote a *History of Liverpool* as a companion to the celebrations but, according to John Belchem:

> [Unlike fellow local historians, he] refused to invent a suitably venerable 'ancient and loyal' history for the occasion. Where earlier antiquarians such as J. A. Picton had sought 'the elements of medieval romance', Muir encouraged his fellow citizens to accept their city's former insignificance and obscurity, to take inverse pride, as it were, in its inauspicious distant past. For Muir, this was the benchmark by which to appreciate (and celebrate) the remarkable progress and achievements of modern Liverpool, 'no mean city'.[7]

We should not be amazed that Liverpool attempted to invent its own mythologized past and/or space, for any urban culture in its relative infancy deals in an imagined rooted antiquity. Over time, such artificial chronological ways of recording a past are discussed, but then perhaps dismissed (Beatles chroniclers, take note) as the mechanisms of the marketplace come to mirror far more accurately the dispositions of the urban dwellers.

Outwith the city, Liverpool was described by some as the 'New York of Europe' and Liverpudlians were occasionally identified via the moniker 'Dickie Sams'; but while the former portrayal was an attention-grabbing description of this provincial British city, the latter tag seemingly held little meaning within it (its definitions varied according to whom one asked). Liverpool, therefore was known across the UK to be an important 'place', but was viewed more as a gateway than a homogenized entity. Its direct links with London further bamboozled any fixed sense of place: it was not a Royal Navy city, but was an important mercantile maritime centre;[8] it had direct links with the capital, both physically via the railways and metaphorically via money, but was geographically 'in the north', carrying with it certain stereotypes that might apply. In short, Liverpool did not have what we might describe these days as a straightforward image of legibility, and could not easily be transformed into a set of textural signifiers, able to compound into one singular homogenous image.

By the mid-twentieth century, Liverpool's places existed largely as a consequence of commerce and empire but changes came about in such a way to gradually transfigure the relationship between the city and many of its inhabitants. For example, the designated places for music and leisure – such as ballrooms, theatres, public houses and even the living room – came to be challenged by coffee bars, the rearticulation of pubs into folk clubs, the uses of Co-Operative meeting rooms as venues and the development of new-style 'hangouts' for teenagers such as the Cavern and the Mardi Gras clubs (at first, little more than member-based

[7] Belchem, John (2006), 'Celebrating Liverpool', in John Belchem (ed.), *Liverpool 800: Culture, Character and History*, Liverpool: University Press, p. 9.

[8] Fourteen warships appeared on the river Mersey during the 1907 celebrations, as if to 'invent' a military-maritime history for the city.

coffee bars). These reinvented and rejuvenated places and spaces appeared at a time when many workplaces across the city were changing and reconfiguring, and the cultural ingraining of understood space was coming under severe pressure. Popular music came to challenge conventional city and suburban spaces by re-forming or reclaiming both performance and listening spaces through the uses of literally 'different' genres of music.

Such rearticulation also affected peoples' imaginary spaces; young Liverpudlians were at times living in a world of their imaginations. Mick O'Toole recalls a recurring experience concerning his father:

> not understanding me in the slightest as I moved from job-to-job with consummate ease. He had used his influence to get me into a white collar job at Littlewoods, which he probably thought would be perfect for me – I suppose it could have been in many ways, but all I wanted to do was buy records and chase girls. My experiences as a teenager in Liverpool were also a mystery to the Christian Brothers who tried to teach me at De La Salle. My entire world revolved around Elvis Presley and Lonny Donegan. Both of these represented freedom and the generation gap in Liverpool. I loved to wander around the city centre, going into record shops and music shops, looking at women, buying the *NME* or *Hit Parader*, spending time at Beaver Radio on Whitechapel, listening to records in the booths, ordering them. Liverpool became a city of the imagination for me – I was kind of here, yet not here. Little wonder I eventually joined the merchant navy, I suppose.[9]

Even the river Mersey itself was, for some, linked to this discourse; according to musician Les Parry whose older brothers were active 'teenage rebels' in the 1950s:

> This was one of the real roots of the Cunard Yanks story: these guys were regarded by certain parts of Liverpudlian society almost as folk heroes (but not by others, it must be said). They held all the right qualifications: they seemed to understand the difference between using time and having time imposed on you, so they stood for a sort of scouse entrepreneurialism. They were also a bit 'fly' and this was a feature greatly admired by some during the Liverpool of the post-war era such as my brothers – which was an unstable period in any case as jobs began to change. There wasn't a shortage of jobs, there were loads of them but jobs were changing even by that time. Think of the amount of work that came to be created by electronics in Liverpool. I don't just mean BICC in Prescot, or English Electric in Kirkby, but think of the amount of shops jobs there were just selling record players, records, radios and TVs! The Cunard Yanks appeared to some to be part of this 'New World' but they also appeared to be mentally very strong and able to 'hold their own'. For me, that explains why most of them became self-employed or managed pubs or clubs. They have been tarred with a

[9] Mick O'Toole to Mike Brocken, January 2014.

collective history, unionized and that kind of thing, but for me that's wrong: they represent how things were changing for potentially self-employed young men in the post-war era; that's why they hold a strong narrative re bringing records back to Liverpool, *not because the story is actually true*.[10]

Liverpool perhaps unwittingly became for some a space for 'Thirdspace' discourses via an assortment of hybridities emerging from pre-existing approaches to time, work, place and space, and the re-evaluative opportunities provided by popular music. Such animations were also taking place at a time in Liverpool's history when the city as a place was losing its recognizable cultural capital. Therefore many of Mick O'Toole's imaginary spaces were actually diametrically-opposed to the very patriarchal meanings foisted upon those places (and the city), in the first place. For example, the Cavern was previously a wine warehouse but by 1957 a jazz club, Whitechapel was a generic shopping street, but by the late 1950s full of record shops, the Locarno was previously a dance-band ballroom but by the late-1950s was a bingo hall and a rock 'n' roll venue with a curious lack of knowledge about socialization processes: 'when I went to the "Loc" there was a sign stating "no jiving" – this must have been about '56 or '57. There was even a guy standing there watching in case any jiving took place, but we "took over", I suppose.'[11] In the mid-1950s even the Picton Library reading room became a jazz venue of some significance, while various church halls were colonized as jive hives. By 1960, from Lark Lane in the south to Walton Road in the north, coffee-bar culture had democratized most major shopping streets in Liverpool; so much so, in fact, that socialization processes for the young had irrevocably and visibly changed from the days of my father's youth. Spatial etiquette was being challenged from the very bottom layers of popular culture: popular music was intrinsic with the long road to spatial re-examination and re-evaluation. This was an era in Liverpool in which practically all spaces came to be redefined (even domestically) as house ownership came to present new imaginary places of suburbia. There were physical changes to the city as entire streets were knocked down and new estates were constructed. 'New' finance came to the fore via mortgages, rents, hire purchase and credit. One might argue that the 'old' (let us say pre-war) Liverpool had become so shorn of meaning that for a younger generation it was beginning to be regarded as 'strange'. The responses were to reinstall meaning in different places and in different ways. My own father had taken his time coming back to the UK after the war – he returned in 1947 – but once home, wanted (in his words) 'a quiet life' while also longing for the old Liverpool to be replaced by the new ('they should flatten it', he would often suggest).

Given such a diverse scenario, by the 1960s the Beatles found themselves central to an emerging discourse. The group was, probably without realizing it, a part of a logical drive towards what might be described as an era of *non*-material

[10] Les Parry to Mike Brocken, October 2013 [my emphasis].

[11] Mick O'Toole to Mike Brocken, January 2014.

labour (and with it, non-material capital). They were indeed part of industrial production by virtue of their dealings with global entertainments and recording industries, long-established throughout the early parts of the twentieth century to serve what were seen as 'mass' production and consumption. But they were also (importantly) helping to drive a nascent service sector within the information economy. For example, Beatles tourist literature goes back to the beginnings of Merseybeat itself. As early as 1963 John Haslam and Michael O'Leary assembled *Mersey Beat Spots: A Guide to Liverpool's Beat Clubs*,[12] Local Liverpool popular musician and historian Kevin Murphy noted to this writer in 2012:

> John Haslam tells me that the artwork was completed in 1962 [!] and it was published in February or March the following year. 'XYZ Press' was simply a partnership of John and his writer friend Michael O'Leary. He recalls that another friend (Peter Halligan, a poet) used to sell it from his shop Pete's Papers on the corner of Hackin's Hey and Dale Street. Haslam also told me that after it was published, he had a visit from the police. They asked him why he was advertising brothels – he didn't realize that the Lord Nelson and other hotels of 'The Phoenix Hotel Group' were the places for short term female company. I suppose the police would know all about that![13]

The work is a decisive historical document, published far earlier than the popular music heritage researcher might at first expect, and it is in all likelihood Liverpool's first ever tourist brochure directly concerned with Merseybeat and the Beatles. It initially suggests to the researcher that, as the Beatles and Merseybeat popularity grew across the United Kingdom in 1963, so too did visitors to the city. This might have been the case, although there are no figures to justify such thoughts. Perhaps instead the presence of this guide suggests that the odd entrepreneur might have considered this to have been a money-making possibility. Certainly visits to the Cavern Club from outside the city were being made at this time. According to former Cavern deejay, the late Bob Wooler, many such pilgrimages were made by fans of the Beatles:

> they would arrive at Lime Street or on the bus at Skelhorne Street bus station and make their way to the Cavern. They would always be talking about how far they had travelled. I have a particular memory of two girls – they must have only been about 16 – coming to the Cavern bedraggled, soaking wet. They told me they had hitched from Shrewsbury.[14]

12 Haslam, John and Michael O'Leary (eds) (1963), *Mersey Beat Spots: A Guide to Liverpool's Beat Clubs*, Liverpool: XYZ Press. Printed by Knowsley Press, 85b Myers Road East, Liverpool, for the publishers XYZ; with half-tone blocks by the Palatine Engraving Company, Liverpool 1; price 3/- [three shillings].
13 Kevin Murphy to Mike Brocken, June 2012.
14 Bob Wooler to Mike Brocken, November 1999.

Local popular music entrepreneur Joe Flannery also recalled to this writer several years ago how George Harrison's mother and father (whom he knew well) would generously offer fans tea and toast after they had practically 'camped out' in the front garden of their Speke home. Joe would attempt to discourage the Harrisons from doing so, but they would not be put off, suggesting to him that they were all 'good kids who loved George'.

The understanding that social informationization and identity is relational has been acknowledged, but often misunderstood by popular music studies researchers. Perhaps this is because many such scholars have emerged from a modernist (and perhaps concomitant quasi-Marxist) failure to appreciate how information technologies have irrevocably transformed the industrial production process and questioned what our 'normality' was supposed to be. The Beatles helped to present an outstanding example of non-material labour and capital in three interconnected and transformative ways: firstly, they personified the incorporation of the aforesaid information technologies; secondly, they symbolized creative and intelligent production; and thirdly, because their work was in the realm of affect, they re-emphasized the importance of our imbalanced and vulnerable human agency. These three types of affective informational capital helped to recreate the immediate age, forcing change to accommodate different social pre-requisites. Consequently, the group played a very significant part in the move towards the informationization of the global economy.

The evidence for the Beatles as harbingers of a non-material spatial evolution is also clearly visible. The Beatles continued to foster new forms of prose of the imagination, begun in the post-WWII era, that inevitably replaced the old. In popular music terms, alone, their embracing of musical continuity and discontinuity, diachrony and synchrony was vital. They were part of a vanguard of those who were abstracting expression within and from what were previously meaningless spaces. One can clearly see this in their compositions; travelling past seemingly ordinary spaces such as the roundabout at the junction of Smithdown Road and Penny Lane probably came to signify far more to a young Paul McCartney than, let us say, the city's nineteenth-century civic heritage. Throughout the song 'Penny Lane', McCartney structurally recalls his repeated bus journeys to and from Forthlin Road; like the song, these journeys were punctuated by the iconic calls from the bus conductor, of 'Penny Lane!' McCartney's musical richness in identifying cultural synecdoches is evidence for us that both he and John Lennon[15] drew great compositional strength from the conventional architecture and cartography of Liverpool, juxtaposing everyday objects in vivid plays between old and new associations, exploring the everyday interdependence of context and meaning. They were not alone in this, for many British popular music artists during this time awarded listeners new interpretations of twentieth-century cultural artefacts.[16] The spatially-familiar made strange will always inculcate a

[15] See also the first draft of Lennon's song 'In My Life'.
[16] For example, works by Syd Barrett of Pink Floyd and Ray Davies of the Kinks.

fascinating and revealing allure. As a consequence, some of our most cherished and time-honoured conceptions about the combined natures of culture and cultural politics might find themselves, at times, 'outmoded'.

In a kind of completion of this spatial circle, entrepreneurs in the Beatles heritage industry have been able to capture this logic of imagined places, recontextualizing and re-presenting them via their own fragmented constructions of combining archetypes, half-remembered myths, and the reconfigured built environment of Liverpool. They have recreated a new discourse concerning spaces and places in Liverpool. Via a kind of enigmatic allegory, disassociated and partial memories, combined and harmonized, have created for Liverpool a consonant aura which not only contains, but has 'become', the subject matter. The Beatles tourist now searches amongst remnants such as the bus route from Allerton Road to Parliament Street for possible relations between their own imaginations and the places of such imaginings. Because of the Beatles and their rock 'n' roll chums, the changing spatiality of Liverpool has become a working reality and links to previous representations of place have been weakened as the years have passed.

Counter-Culture, Local Politics, Rock

During the latter half of the twentieth century a tremendous increase in music-making took place across Britain and it should be emphasized that the vast majority of this music-making was non-formalized in a musical composition sense. In terms of quantity alone more people than ever before were brought, via popular music activities into contact with what was previously the domain of elitists. Consequently, by the twenty-first century more people probably listen to, and hold opinions about music; more have come to validate their musical tastes, consider music mediations, and rhetorically use locality, value and authenticity in relation to music, than at any other time in modern history. In the city of Liverpool, a rhetorical intensity has come to pervade all forms of music-making and appreciation; so much so, in fact, that some very diverse genres of music, representing equally diverse scenes, have come to represent analogous forms of authenticity. In turn, this has meant that the very relationship between Liverpool and the Beatles has become ambivalent, ambiguous – in fact downright confusing.

So, although the Beatles were popular in the most authentic sense of the word (i.e. more people probably heard them than any previous popular music artist up to that point), by the early 1970s, when all popular music (but especially rock 'n' roll) was increasingly being acknowledged as repertory and holding heritage, in Liverpool certain popular music visages – especially those surrounding rock music (to repeat: not, that the Beatles were in the strictest sense a *rock* group by 1970s definitions) – remained somewhat marginalized. This was in contrast to a period of time in popular music history when, following the disintegration of the group, the 'Beatles decade' of the 1960s had become an historical 'era' of authenticity: a special 'place' in time. It was also during an important phase in

British popular music when subsequent popularities came to be compared and contrasted with the, by then defunct, Beatles. In the British music press, artists such as David Bowie and Marc Bolan were 'weighed' against the Beatles. John Lennon even 'authorized' David Bowie and Elton John, whereas Marc Bolan was 'sanctioned' by Ringo Starr via the *Born to Boogie* movie. The outputs of the solo ex-Beatles were also reassessed, at times unfavorably, against their own 'canonic' works as Beatles. In Liverpool, however, it appeared that popular music in the city had effectively moved on ('grown up', even). The 1973 demise of the once-famous Cavern Club, in comparison with the rise of the Shakespeare Theatre Club is an illustrative case in point.

The 1970s Cavern: A Culturally Worthless Space?

Many of us have possessed at one time or another, a once-valuable commodity such as a video recorder or a 'brick-like' mobile phone of which we were proud to be the owner. A special device can make us feel good, being part of the modern society that had created such marvels. Yet both time and technologies move on, making once-treasured objects redundant, no longer wanted. Similarly, we all know the feelings of experiencing current trends and being in a place that was thrilling to enter: the atmosphere of a venue, hearing music pulsating through hot and sweaty air. Furthermore, meeting friends before, or in selected venues, often added to this 'specialness' of place. All such feelings (and more besides) generate a deep sense of nostalgia for times and places-past and ask us to question why such places (in our case, those linked with popular music authenticities) frequently and repeatedly vanish – should they not, we ask, last forever?

In the case of Liverpool, such a question is frequently asked regarding the demolition of the original Cavern Club. Indeed, this is supplemented by further rhetoric statements: How could anyone in their *right mind* have allowed the Cavern's demise? Who was responsible for such a wanton act of seeming urban terrorism? For example, I have stated elsewhere that:

> The council's actions did, at times, seem baffling: the building housing the Cavern was knocked down for a ventilation shaft that never materialized; other venues such as the Flying Picket were forced to close through a deplorable lack of funding. Still more such as the Royal Court Theatre were mutilated, with its stalls seating removed, and allowed to fall into disrepair – the Watch Committee even banned the showing of the movie Woodstock in the city centre in 1971.[17]

While such remarks certainly have their point, it should also be stated that place-based rhetoric tends to resonate and re-resonate through time and space, changing imaginings, creating 'different' places in the newly informed recipient's mind

[17] Brocken, *Other Voices*, p. 2.

and, in turn, allowing subsequent mythologies to grow and develop. However, the popular music historian has a responsibility to acknowledge that any city is a complex phenomenon in which buildings and building typologies play significant yet changing roles in the construction and idealization of place. Our collective behaviour profoundly conditions the lives and deaths of buildings. Therefore we might ask how popular music can contribute to the dismemberment of the urban.

The 1970s are a turning point in this respect, for the great myth of the city equation – that a city = progress, therefore development = well-being – was well under way, yet at the same time being challenged. In Liverpool the life-spans of certain nineteenth-century buildings were visibly coming to an end and buildings in a state of deterioration in the city centre came to be reused: imaginations, micro-cultural spaces and counter-cultural authenticities took over, here and there. For example, the Cavern, linked as it was to a small hippie culture in the city, came to be redefined. The crumbling building in Mount Street which housed Probe Records also came to be counter-culturally redefined. Around the corner in Hardman Street, a former overall factory with a partially demolished roof became the vegetarian restaurant 'Food For All'; while, opposite this, O'Connor's Tavern was reinvented as a hippie-cum-student hangout (it was here, for instance that this writer saw a young Freddie Mercury perform: I had gone to the venue to 'score' marijuana). By 1970 the Liverpool Boxing Stadium had become an 'underground' rock performance space. During 1974 Pilgrim Street alongside O'Connor's, was unofficially closed for a small rock festival, meanwhile the *Le Metro* club behind Castle Street had become an important space for Liverpool's marginalized post-hippy community. All such places and activities (and a few more besides) were financed by very little capital and all weredirected from a counter-cultural perspective. It was a minority activity, but importantly expressed a lack of alignment with the primary meanings and uses of the buildings. Indeed, several buildings were effectively 'colonized' and 'squatted', in the name of the counter-culture. For example in the abandoned warehouses to the rear of Paradise Street illegal 'raves' (as they were called in the mid-to-late 1970s) took place. Food, drinks and music were supplied by bohemian 'promoters' who charged a small entrance fee. But it would have to be stated that 1970s Liverpool largely ignored its bohemian communities. As far as the Cavern Club was concerned, it too was largely ignored and, both as a venue and as a going concern, in early 1970s Liverpool it had long outlived its usefulness.

Several texts already exist concerning the life and times of Liverpool's Cavern Club; one presumes they will be joined by even more, as time moves on. This writer has discussed elsewhere the Cavern at different times in its complex history and has especially considered the club from a 1970 standpoint when 'what heavy bands there were in Liverpool could usually be found at the Cavern, but that by 1970 the Cavern had become a split-level club – catering on the upper floor for a more soul-oriented fan and in the original basement venue, live rock music'.[18] This might give us an indication that a purely rock-based club in Liverpool during 1970

[18] Ibid., p. 225.

was probably uneconomic. Spencer Leigh, on the other hand, has attempted to discuss the entire life of the Cavern via oral testimony, plus a week-by-week link reporting on the club's successes, failures, and gigs. For example, he records for the date of Friday 31st December 1971 that while Confucious (ex-Hideaways) and Strife were playing the venue, British Rail who owned the building in which the Cavern was housed (and several of the surrounding properties in the Mathew Street area), 'served notices to quit as they wanted to create an extraction duct for the underground rail loop. The letter was addressed to then proprietor Alf Geoghegan, who, it seems, kept quiet about it. When selling the club, he had not informed future owner Roy Adams that this was a possibility, and who could blame him? *Caveat emptor*, and all that.'[19]

Leigh acknowledges the work of Phil Thompson as a major source. In *The Best of Cellars*,[20] Thompson similarly charts the club's existence from 1957 to closure in 1973 and also attempts to list every artist who had played at the club during that time. For this part of his research Thompson trawled diligently through Cavern advertisements and listings from the *Liverpool Echo*. Thompson's work is extremely important and is valuable in a variety of ways, illustrating the changes of genres considered authentic at the club over the 16 years of its existence. However, his sources are a little problematic, for the *Liverpool Echo* often omitted lunchtime sessions from their listings and many gigs did not happen 'as advertised'. Further sources such as original copies of *Mersey Beat*, Mark Lewisohn's *The Beatles Live!*, Spencer Leigh's oral history concerning The Merseysippi Jazz Band, and other materials such as the files on the Cavern still held at the offices of the *Liverpool Daily Post and Echo*, John Firminger's 'inkies' cuttings texts, and the diaries of Ray McFall (to which Spencer Leigh gained access), all provided Leigh with varied and variable evidence, where perhaps none was thought to previously exist. In addition to the above, Leigh and Thompson both use oral testimony; and, although problematic for the historian, such histories can be of use. Word-of-mouth histories of popular music can shed light on recent social contexts and (especially now that the very early days of the Cavern are moving beyond living memory) offer interesting perspectives for the popular music researcher. Such fragments of the past should not be ignored; however, one must also take into account the ways in which time helps us to centralize and magnify our own experiences in relation to the story we are relating. Oral testimonies should therefore be weighed against other evidence. In this respect we do have one or two problematic areas re the 'given' mono-history of the Cavern Club.

Firstly, the idea that it was essentially a 'working-class' place representing a kind of proletariat at play can be challenged by more thorough research. The deeper one delves into the social strata colonizing the venue, the more clearly it

[19] Leigh, Spencer (2008), *The Cavern: The Most Famous Club in the World*, London: SAF, p. 176.

[20] Thompson, Phil (1994, 2007), *The Best of Cellars: The Story of the World-Famous Cavern Club*, Liverpool: Bluecoat Press; reissued by The History Press, Stroud.

can be seen that this was not the case, and the club more usually represented the class echelons of the day as they, in turn, represented themselves via genres of popular music. For example, genres such as modern jazz and progressive rock can be seen to have played major roles in the life of the venue, which represents a class-based framework for reference. Secondly, although there appears to exist a popular music success story re the Cavern, a more representative economic history of the club informs the researcher that successes were at best periodic, and the history of the venue consists of varying degrees of economic failure. For example, the club's generic move in 1960 from jazz to rock 'n' roll was in rock terms belated, and its failure to fully capitalize on the popularity of pre-recorded soul and Motown (rather than loss-making live rock) in 1970 represented a failure to recognize Liverpudlian antagonisms towards rock and the counter-culture. So, one might argue, failures across time to tune in to popular music authenticities in the city were linked to fluctuating financial fortunes. The venue's partial colonization by Liverpool's hippie community represented valediction.

The life of the club began with Alan Sytner, whose memories of visits to jazz clubs on the bohemian West Bank of Paris while on holiday with his family as a teenager had created a lasting impression for him. Sytner was a young jazz fan who wished to share his experiences with others, while also (perhaps naively) seeing jazz as a possible opportunity for make a living. Sytner later informed Spencer Leigh:

> I had spent most of my school holidays in France, and most of that time in Paris, so that I could go to jazz clubs and see the bohemian life. I was only a kid, 14, when I first went, but was dazzled by it and it was all part of the glamour of Paris after the war.[21]

We can possibly detect almost immediately from this quote, a somewhat middle-class perspective. For Sytner (the son of a local doctor) in the post-WWII era, to be able to spend summer holidays in Paris is not without significance given Liverpool's geopolitical landscape. Further, the fact that he was a modern jazz fan displays the increasing co-option of modernist and avant-garde art by middle-class British youth.

All small businesses have to make a profit to survive and income has to exceed expenditure; mere enthusiastic speculation does not pay the bills. But enthusiasm and foresight in a project is contagious; the correct vehicle for a vision in terms of a building, together with perhaps a little luck, can be rewarded with some success. This was initially the case in Liverpool's jazz venue, the Cavern. Sytner (21 years old, with a life insurance policy having matured to the tune of £400) had previously experimented with a jazz venture: the aptly titled 21 Jazz Club in Croxteth Road, in Liverpool 8. This had, reportedly, flourished and led to Sytner's considering

[21] Alan Sytner to Spencer Leigh, see *The Cavern: The Most Famous Club in the World*, p. 18.

a city-centre venue. I have written elsewhere that the club opened its doors in January 1957 after Alan Sytner had noticed that the Mathew Street premises were empty. Over the next couple of years many of the biggest names in British jazz appeared at the Cavern, making it a focal point for local enthusiasts. Thompson suggests that 2,000 people turned up for the opening, although a maximum of only 600 could enter the club. Arguably the venue might have been uneconomical from the start, with such a limited capacity, small membership and admittance fees, and only soft drinks for sale. During these 'jazz years' the club's capacity was only periodically reached. Rock 'n roll music was vetoed, for Sytner did not approve; his musical programmes tended to consist of either traditional or modern jazz, with occasional skiffle and folk nights thrown in for good measure. Thompson[22] suggests that neither the owner nor his members much cared for skiffle, but that Sytner was aware of the popularity of Lonnie Donegan (and the music's roots in Trad Jazz), so therefore it was tolerated.

It was on 7 August 1957 that the Quarry Men featuring a young John Lennon first appeared there. It is also believed that Ringo Starr had appeared a week earlier with the Eddie Clayton Skiffle Group. In an attempt to increase cash flow, lunchtime sessions were introduced by Sytner, ostensibly aimed at attracting office workers in the city. However, after little over a year the Cavern was financially untenable. Even though the club claimed an implausible 25,000 members, it was by 1959 low on footfall, with an appalling ventilation system that fell short of legal requirements, and facing a raft of expensive repairs. Additionally, Sytner had lost money on his 'Riverboat Shuffles' on the Mersey Ferries. He duly sold the club in October 1959 for £2,750 to one of its auditors Ray McFall. I have suggested elsewhere that evidence for the Cavern's parlous financial state is thin and that Sytner proceeded to run and receive profits from the Cavern while in London. His great financial stumbling-block was the 'Riverboat Shuffles' promotions rather than periodic Cavern losses; however, he could not make enough money out of the venue to make it viable; in any case, as he informed me, he was hoping to spread his wings into club ownership in the capital city.

McFall was not a jazz fan, as such; indeed he felt that jazz and skiffle were responsible for low attendances. He therefore began to nurture rock 'n' roll. The popularity of the Cavern duly increased and in due course McFall was persuaded by Mona Best (mother of then-Beatle drummer Pete Best) and enthusiastic emcee Bob Wooler to book the Beatles for a lunchtime session on 21 February 1961. The Beatles' first evening session took place a month later and, in all, the group played 292 Cavern Club dates up until August 1963. The 9 November 1961 lunchtime session was reportedly the day Brian Epstein first watched the Beatles on stage, before signing them to a contract in January of the following year. The Cavern Club thus ascended to worldwide fame during 1963 and 1964 and McFall attempted to cash in on the venue's meteoric rise from obscurity by introducing new projects at

[22] Thompson, *The Best of Cellars*, Stroud, p. 14.

the club. He utilized the enormous fan base and media attention that existed, in an attempt to increase cash flow.

For example, for a while, the club had its own weekly radio show on Radio Luxembourg, for which McFall was paid a retainer. He installed a recording studio and for a very short period ran record label 'Cavern Sound'. However, 1964 was an interesting transitional year for public taste and came to be dominated by R&B. Although up-and-coming acts such as the Rolling Stones and the Yardbirds appeared at the Cavern (as did John Lee Hooker, Howlin' Wolf and Memphis Slim – even a 16-year-old Stevie Wonder), the Beatles had long departed the club (and Liverpool), tastes and opinions had moved on somewhat, and income streams were diminishing. Furthermore, artists' fees had risen during that year and without an alcohol licence McFall was unable to cover costs.

The club just about staggered through 1965 but by the early months of 1966 it was rumored by those 'in the know' that the Cavern was ready to close. Despite a 12-hour benefit show by local artists including the Scaffold, the Spinners, and the Undertakers, the Cavern closed its doors on 27 February 1966. Faced with a £3,500 bill to repair the club's sewerage system, and encumbered financially by the Cavern studio expenses, McFall was forced to declare bankruptcy with debts amounting to something in the region of £10,000 – he had evidently been bailing out the club for some considerable time. An appeal fund was established and an offer by Liverpool bar owner Joe Davey was accepted; he and partner Alf Geoghegan acquired the lease, and reopened the 'new' Cavern on 23 July 1966. By this time it had a licence to sell alcohol, which was seen by the owners as a deft move to fit in with the changing entertainment tastes in the city; club-goers were now responding to more sophisticated cabaret lounges such as the Shakespeare Theatre Club (see below). However, the Cavern's reputation had been eternally damaged by its closure and the licence merely turned the club, by 1969, into a rather dank and dingy version of myriad other clubs to be found on Merseyside. By the end of the decade the Cavern was beginning to outlive its usefulness. Both the Beatles and Merseybeat were faded memories, and there was little interest within the city of Liverpool for this once-acclaimed venue. In December 1971, with the ownership of the lease about to pass to Roy Adams, the aforesaid order to close the club finally came via property owners British Rail. Leigh suggests that Adams was offered £5,000 by British Rail to relinquish his incoming ownership, but he was either not aware of this offer, or else declined. The Cavern therefore continued to grind out a little trade for the following year or so. The Birkenhead-based heavy rock trio Strife was practically resident in the cellar space, catering for the local hippies who tended not to spend much money; a perhaps more popular disco was run in an upstairs room for more soul-oriented dancers and the Mod and skinhead subcultures.

The last night at the Cavern took place on Sunday, 27 May 1973, with an all-night session featuring local bands Strife, Supercharge, Bilf Slat, Caliban and Harpoon, London-based Hackensack and a visiting North American band, the Yardleys. This writer has personal memories of the last night of the Cavern which somewhat contradict the nostalgic representations of its worth. Any 'Cavern

magic' had all-but disappeared by this time and, at least as I recall, while the closure did attract a little coverage from the national media, it was not substantial. On 28 May 1973, the front page of the *Liverpool Daily Post* featured an article by reporter David Hope in which he quotes the then-Cavern Club manageress Freda Mullins stating what is now an interesting point:

> There is no doubt about it, people from outside Liverpool feel more strongly about the closure than people living here. They just can't understand why Liverpool is allowing the Cavern to be pulled down. They say it should be preserved.[23]

Actually I recall asking, in 1972, a girlfriend who lived in Birkenhead whether she would like to go with me to the Cavern; she replied that she had thought it had already closed. That same year a pen pal from Nottingham came to visit and excitedly asked whether we might visit the Cavern; a Beatles fan, she was absolutely delighted when I informed her that it was still open.

Such popular music pathways, and the various ways popular art is negotiated, consumed and understood should always be taken into consideration when we consider the realities of our popular pasts. Tracing the varied historical eras of the Cavern Club requires researchers to place themselves into different musical and economic environments. By 1973 discos were increasingly important for the younger generations (even though 'disco' as a genre was yet to be codified), a wealth of cabaret and social clubs were catering for the 'twenty-somethings', and the Liverpool Boxing Stadium was garnering a strong rock music reputation among the minority of rock fans in the city. For many Liverpudlians, the Cavern no longer provided a relevant musical space, significant musical rhetoric, or even carried any kind of recognizable musical reputation. That last night of the Cavern bears witness to this: the event was actually set up so that an LP could be released to commemorate the evening. However, for Alan Richards, the sound engineer that night, the quality of the music was 'more than a bit dire' and he informed me that, even though a handful of the bands would not sign waiver agreements with the organizers of the recording London Music and Management (thus stymying any chance of an album release), this was no great loss:

> This refusal probably didn't matter too much because the quality of the music, the dreadful sound in the Cavern, and the overall ambience of the place mitigated against a good vibe. It was an odd night, all-round: truly disappointing and I remember thinking at the time what a missed opportunity it might have been. I had my own label Stag Music and I thought I might have been able to get the last night of the Cavern on disc myself. As it turned out, legally there was no chance of that happening, but I reckoned there might have been a few thousand sales,

[23] Mullins, Freda in Hope, David (1973), 'Cavern Club to Close', *Liverpool Echo*, 28 May, p. 1.

and I was bitterly disappointed. Looking back now, I'm probably glad it didn't happen because the bands were really not at their best and it would have been a bad thing to have signalled the end of the club by a recording like that. Also, though, after all these years, I wonder whether anybody cared enough at that time about the end of the Cavern to buy an album's worth of third-rate rock music.[24]

The live-recording producer that night was Liverpudlian Wayne Bickerton, who had previously been a member of Lee Curtis and the All Stars and the Pete Best Four, before moving into production and songwriting work at Decca with fellow ex-All Star Tony Waddington. By the last night of the Cavern they were house producers and songwriters at Polydor, and had created the successful pop group the Rubettes, ostensibly as a vehicle for their own not inconsiderable pop songwriting talents. That evening Bickerton utilized Pye's mobile recording studio (*not* the Rolling Stones' mobile studio, as has occasionally been written). However, although successful chart-wise (and a local), Bickerton did not hold the correct cultural capital for either the groups or the audience. Quite simply, he was not an authentic 'rock' producer in 1970s rock and album-oriented popular music terms. Not one recording of this last night was ever commercially released and later investigations by this writer regarding the whereabouts of the tape remained fruitless. It has probably disappeared – and a good thing, too. In some respects this lost tape mirrors the Cavern's fate.

My own personal memories of that evening reflect Alan Richards' recollections of anticlimax. It was an incredibly disappointing affair, with bands sounding utterly disinterested. My friend Les and I had planned to stay until daylight, however the event was so lacking in atmosphere that we left at about 2am. The club was duly demolished, much to the latent dismay of protestors across the globe. But such remonstrators did not perhaps have sufficient local knowledge of the Cavern's lack of homology, worth, value, or immediate contexts within Liverpool's built environment and genre affiliations of the early 1970s. By this time the Liverpool Boxing Stadium gigs, mostly organized by Oxford-born R&B fanatic and deejay Roger Eagle, had already recodified what was left of the local counter-culture. For these Liverpudlians, bands such as Mott the Hoople, Quintessence and Amazing Blondel, amongst others, came to temporarily rival the Beatles as 'local heroes' (even though they were not 'locals' as such). For others across Merseyside, the authenticity of endless rounds of Tamla Motown music continued relatively unabated up until – and well beyond – the advent of disco.

In Contradistinction: The Shakespeare Theatre Club

A mention is perhaps required here of how the Cavern was essentially 'disabled' spatially by the demographic requirements of upwardly mobile genres and

[24] Alan Richards to Mike Brocken, May 2013.

places in Liverpool in the early 1970s; the Shakespeare Theatre Club is perhaps one of Liverpool's best examples of this spatial ascendancy. The Shakespeare Theatre in Fraser Street, Liverpool was built by J.H. Havelock Sutton and opened in 1888. (Sutton also built the Park Palace, Liverpool, which is still standing albeit in a very sorry state.) The Shakespeare had a huge capacity on opening of over 3,500 thousand people. *Kelly's Directory of Liverpool* of 1894 tells us that the Shakespeare Theatre was lit by electric light and ventilated behind and before the curtain, and that during the winter months the theatre was heated by hot water. The foyer was lined and panelled with carved oak representing scenes and characters from Shakespeare plays. The stage was separated from the auditorium by a patent asbestos and iron fire-proofed curtain weighing five tons, and by iron doors.

Renowned US actor, blacklisted by the McCarthy purges, Sam Wanamaker came to the UK in the 1950s and took over the Liverpool-based theatre in 1957, renaming it the New Shakespeare; it was he who intended to produce what he saw as 'legitimate' theatre there. According to MI5, however, Wanamaker was up to no good during his time at the Shakespeare. His 'New Shakespeare Theatre Club' was reputedly a vehicle for disseminating extreme left-wing propaganda under the guise of culture, at least according to files compiled by Special Branch. The director general of MI5 duly alerted the chief constable of Liverpool in a letter dated 26 November 1957. 'We understand that Sam Wanamaker has recently opened a theatre in Liverpool', he wrote. 'As he is one of those "un-American Americans" [...] we should be glad to know if either he or his wife comes to your attention in any way.' During this time the venue was also briefly known as the Pigalle Theatre Club, yet despite Wanamaker's best endeavours (and apparently partially a consequence of the attention of the local constabulary), neither venture lasted very long and Liverpool's cabaret scene came to the venue's rescue, as the need for a sophisticated cabaret club for upwardly mobile Liverpudlians was identified and duly exploited. By at least the late 1960s the Shakespeare Theatre Club, as it was renamed, had become the most important cabaret venue in Liverpool. Ownership had passed to George Silver of the 'Banqueting Suites of Oxford' company and Silver ran the club extremely efficiently for several years – booking national and international stars along the way and pulling in punters in their thousands.[25]

By this time, Mike Byrne was a member of one of Liverpool's most popular post-Beatles rock bands, Colonel Bagsot's Incredible Bucket Band (later shortened to simply 'Colonel Bagshot's') but he left the group at the turn of the decade to pursue a career as a more 'mainstream' vocalist. As such, Byrne is an interesting case study, for he was not only part of the earlier Merseybeat scene at the Cavern from which the Beatles emerged, but also a professional with a group connected to the emergent counter-culture in late-1960s Liverpool. His practical decision to move into a more adult-oriented popular music scene is a signifier of the trajectory

[25] The 'Shakey', as it was known locally, was one of the most highly regarded cabaret venues outside the Home Counties, but was eventually demolished in 1976 after a major fire destroyed much of the building.

of Liverpool's changing musical and spatial authenticities. He described to me this transition from Colonel Bagshot's rock band (frequent gigging visitors to the Cavern and the countrywide student's union circuit), to emcee at the 'Shakey' as a 'relatively rapid but confusing transition'. It came about ostensibly because local journalist Elton Welsby had penned a glowing full-page article for the *Liverpool Weekly News* on Byrne as a new 'sophisticated' solo artist. The mic at the Shakespeare had previously belonged to local comedian Pete Price,[26] but Price had been poached by the famous Manchester night club Fagin's and had not given the Shakespeare management a great deal of notice concerning his departure.

Colin Morpeth, the 'Shakey's' general manager went to see Byrne perform at Reece's club in the city centre and the position was offered and accepted on the same night. Byrne thinks Morpeth had already sufficiently made up his mind about him and merely wanted to confirm his capabilities. By the autumn of 1971 Mike Byrne began his emcee work at the 'top line' Shakespeare. He describes this as a 'real baptism of fire', not only because he had to follow in Pete Price's footsteps (although Price was a comedian, not a singer), but also because of the different musical cultures at the venue. As a hitherto rock and R&B vocalist, he recalled to me his difficulties working with the Mal Craig Trio. According to Byrne, they were essentially 'Price's band'. Price, like Byrne was not a music reader, but Craig's trio 'read the dots' and immediately expected paper copies of his repertoire. 'It was a test', stated Byrne and 'created a tension when they were not forthcoming!' The trio had to grudgingly 'vamp' their way through his repertoire in rehearsals. To top it all, none other than Tommy Cooper was the headliner for his first week as emcee: a complete sell-out with 900 people on the three levels of the club. Byrne remembers:

> It was a completely different space to what I was used to; I was shitting myself, to be honest – I was supposed to tell jokes – I was a pretty good ad-libber but not a joke-teller. There were four acts in total: two singers, one was a resident girl singer Samantha, and a speciality act, and then there was the top of the bill. On the ground floor were the drinkers who watched your every move – this was where some had reserved their own tables. One or two of Liverpool's hardest men were right in your face all evening. On the first balcony was a French restaurant, and on the second balcony were more punters watching your every move and drinking all night. There was waitress service everywhere so people's attention was on the stage all night. You might even have the same audience on

[26] After a couple of years as the cook on a cruise ship, Welsh-born Pete Price became a deejay-cum-presenter for BBC Radio Merseyside at the age of twenty-one. Shortly after, Price made his first appearance at The Shakespeare Theatre Club and became the MC there. Following his departure to Fagin's in Manchester Price also worked at a number of venues including The London Palladium, the QE2 and various television shows. In the 1980s, he became a presenter on the rival Liverpool radio station, Radio City, and has remained there through its several incarnations since that time.

the same night, each week – real regulars, some of whom were 'pally' with the management, of course. You might also get, in this first case, real fans of Tommy Cooper who would book the whole week but had no interest whatsoever in the support acts or the emcee! On my first night I came out of the basement onto the stage singing 'Great Balls of Fire'. I was never really sure that this was the right thing to do, but in the long run, I guess it went down OK – I got away with it in any case.[27]

Mike Byrne came to change his introductory set so radically that his entire *raison d'être* as a performer was transformed. It came to consist of medleys of part-songs, moving seamlessly (usually via the bridge) through different musical moods. He quickly learnt that a three-minute song was far too long in front of an 'eating-and-drinking audience who had ostensibly come to see someone else', so he carefully timed each medley to include only perhaps a minute or so of recognizable hooks and melody lines from each number:

> I had to find material that I liked (otherwise what's the point?) but that I could also put over in a way that would please the audience in short samples. For example, 'What a Difference a Day Makes' mixed with 'Our Day Will Come', with a 16-bar break in the middle to introduce the groups/artists for the evening worked very well. Other material used was 'Old Man River', 'Bridge Over Troubled Water' with the semitone lift, 'Lady is a Tramp', 'Wives and Lovers', 'Yesterday When I Was Young', 'Spinning Wheel', a little later 'She', 'Rhythm of Life', and 'Dance in the Old Fashioned Way', were all very popular songs across cabaret-land. I segued them together so as not to lose the audience's interest or distract them from the headliner or their food and drink: it was quite a balancing act and very different from a students' union on a wet Wednesday.[28]

Following the initial stand-off over notation, Fred Lloyd of the trio agreed to write out the dots for his musicians. Meanwhile Byrne continued to learn his arrangements by ear. He recalls the group eventually respected him for his dedication, and remembers an element of relaxed pleasure coming from them because they could follow his key far more easily than him following theirs! They also discovered that Byrne was a Lambert, Hendricks and Ross fan, which suited their cabaret style somewhat. It developed into a successful partnership within a successful and valid popular music environment. This small vignette concerning musical place and within that place practice and material, is significant because it contrasts dramatically with the musical and economic fortunes of the Cavern Club. By this time 'The Shakey' was an incredibly successful venue in Liverpool and two central issues were at stake. The first was to do with the relative consequences of the collapse of the counter-culture and its musical associations

[27] Mike Byrne to Mike Brocken, March 2012.
[28] Ibid.

with self-indulgence and nihilism. Byrne had consciously moved, musically, from jazz/rock, R&B and progressive rock (via Them Grimbles, the Roadrunners, and finally Colonel Bagshot's) into this apparently 'inauthentic' musical spectrum because he felt that a professional career lay in one musical direction, but not the other. He therefore came across more formal methods of musical practice and listening, than he had previously been accustomed to. The second refers to the apparent unity of the experiences offered by cabaret lounges such as 'The Shakey'. By the 1970s the visible and audible plurality of popular music experience in Liverpool had eroded, creating smaller and uneconomic factions of interests surrounding certain genres of popular music participation and enjoyment. For some, the revolutionary aspects of 'rock culture' (which might include the Beatles and ex-Beatles) had ceased to reflect freedom of choice and represented little but revolutionary homilies, rendering the Cavern ineffectual and economically non-viable.

Repertory Rock?

In contrast with the above account, by the early-1970s the non-material historical legacy of the Beatles and 'rock' music was being activated across the world. For example, via serialized part-work magazines, such as Phoebus Publishing's *The Story of Pop*, the Beatles and other Merseybeat groups were being catalogued and re-presented. The appearance of this magazine in 1973 tied in with not only a Radio 1 series but also immediately-preceding popular music texts such as those by Dave Laing (1968), Nik Cohn (1969), Richard Mabey (1969),[29] and cultural commentaries by (e.g.) Stuart Hall and Paddy Whannell (1964), Jeff Nuttall (1968), and George Melly (1971),[30] all of whom were by the late-1960s viewing popular culture as something worthy of study. Across all of these works, there was an implication that important socio-cultural issues could be raised by and through an examination of the historical narrative of rock. Not only was the music evidently of more importance than at first given credit, but so too were popular discourses surrounding (for example) fandom, subcultures, the counter culture, the generation gap, etc. These publications were, in turn, supported in the UK by TV and radio programmes and documentaries such as *Anatomy of Pop* (1971) and *All You Need is Love* (1976 onwards). UK Movies such as *That'll Be The Day*

[29] Laing, Dave (1968), *The Sound of Our Time*, London: Sheed and Ward; Cohn, Nick (1969), *AWopBopaLooBop ALopBamBoom: Pop From The Beginning*, London: Paladin; Mabey, Richard (1969), *The Pop Process*, London: Hutchinson Educational.
[30] Hall, Stuart and Paddy Whannel (1964), *The Popular Arts*, London: Hutchinson Educational; Nuttall, Jeff (1969), *Bomb Culture*, London: Paladin; Melly, George (1970), *Revolt into Style: The Pop Arts in Britain*, Harmondsworth: Penguin.

(1973) and *Stardust* (1974)[31] also contributed to the growing repertory status of rock, rock 'n' roll, and 'beat' music. During the 1970s the number of British and American texts dealing specifically with the Beatles also gathered pace, as discussions concerning the 1960s, the Beatles as originators, the *post hoc* activities of the former group members, and similar topics, all emerged from a new generation of rock writers who had grown up during the 1950s and 1960s – for example, Lester Bangs, Peter Frame, Lenny Kaye, Greil Marcus, John Tobler, Chris Welch, Jann Wenner, to name a few. This was in part brought about by the underground press already existing in both countries: magazines such as US titles *Rolling Stone, Crawdaddy* and *Creem* and, in the UK *Let it Rock, Zig Zag,* together with the British 'inkies'[32] *Melody Maker* and *Sounds*, becoming arbiters of taste.

In Liverpool, however, following a Deep Purple concert on 30 January 1971, the Philharmonic Hall banned all rock music and, as we have seen, by May 1973 the Cavern Club was closed to make way for a ventilation shaft which did not transpire. Local rock musician Joan Bimson recalled that:

> At the time it was like every move we made in the rock scene was anti-establishment and the Establishment *was* Liverpool. It was bad enough being a female bass player because you'd get all of that 'rock chick' stuff from within the scene. But we all knew that we seemed to be totally 'at odds' with those around us and just getting a scene together, seeing a band we liked was really, really difficult at times. That's why the rock gigs at Liverpool's Boxing Stadium became so important. Sometimes, looking back after all these years I can see several problems with Liverpool and rock music in the early '70s: The city was running out of steam and music came to occupy once prosperous buildings; the Beatles era was well and truly over, rock fans could be visibly different, and women were not supposed to be bass guitarists! – so in some respects, to reverse Dr John's comments, I was in the right time, but the wrong place – things appeared to be stacked-up against me in Liverpool.[33]

[31] Cash, Tony [prod.] (1970), *Anatomy of Pop*, BBC Television, a series of five programmes, broadcast on BBC 1, beginning 10 January 1971; Palmer, Tony [dir] (1977), *All You Need is Love: The Story of Popular Music*, London Weekend Television, first broadcast 1977; Putnam, David and Sanford Lieberman (prods] (1973), *That'll be the Day*, London: Goodtimes Enterprises; Putnam, David and Sanford Lieberman (prods] (1974), *Stardust*, London: Goodtimes Enterprises.

[32] The expression 'inkies' with reference to the British music press relates to newspapers such as *NME* [*New Musical Express*], *Disc* (later *Disc and Music Echo*), *Melody Maker* and (later) *Sounds*. These weekly newspapers were initially thinly disguised trade papers, but they evolved into important mouthpieces for music fans during times of rapid change. Their 'inkie' tag came from that fact that they were produced exactly like a weekly newspaper (i.e. 'hot off the presses'), and were printed on low-quality paper, thus making their readers' hands 'inky' as the papers were read. These days, the only survivor is NME.

[33] Joan Bimson to Mike Brocken, March 2011.

By the time the Cavern closed its doors in 1973 the growing literary gravitas which enveloped the ex-members of the Beatles was making calls for a Beatles reunion commonplace. Liverpool City Council, however, stuck by its anti-popular culture 'guns' via a distinct lack of interest and non-intervention. While in the UK progressive rock, jazz/rock, folk, and the singer-songwriters of the US West Coast tended to dominate 'serious rock journalism', at least up until 1977, and Lennon and Harrison (but perhaps not McCartney or Starr) were awarded a level of rock cultural capital from such genre-based writing, being seen as more 'upscale' musically (perhaps even intellectually) than not only their former colleagues, but also their own 1960s incarnations, the very history of the Beatles in Liverpool was running the risk of fading away. Corporately, the city did not recognize the social value of affective capital, showed no interest in nurturing popular music-as-heritage, and was unconcerned about material activities concerning the legacy of the Beatles and Merseybeat. John Lennon's re-emergence into the popular music arena via, at first, a single ('Just Like Starting Over' – 24 October 1980), and then an album (*Double Fantasy* – 17 November 1980) – both initially considered by the UK music press to be somewhat lacking, musically – was shortly followed by his tragic death on 8 December of that year. It was only at this point that Liverpool as a city began to re-evaluate its relationship with the group as a whole, and Lennon as an individual.

We must, however, take care not to be overly a priori in our criticisms of what appears now to have been Liverpool's shortsightedness towards the Beatles and 'rock culture' at this time. In the first case, the value of affective capital can be very difficult to immediately recognize and even more difficult to support, especially during times of mnemonic recollections in which the divisions of labour via industrial production were still seen as transparently real. Further, one would also not wish to overstate the contemporary significance attached retrospectively to musical 'movements', for those involved are seldom aware of the contemporary cultural status of their activities, while others who consider themselves to be outwith a coterie are often considered by others to be willingly within. The Liverpool-based remnants of the rock counter-culture were tiny, lacking in economic 'clout' and highly fluid. Rock fans barely filled the 'downstairs' Cavern. So, we should recognize that, while the cultural resonances of rock music of the late 1960s and early-to-mid 1970s in the UK were substantial, such reverberations were not always reflected across Merseyside in the same way. In fact, to examine these iconic histories from the perspective of the rites and rituals of Liverpudlian 'habitus' (the dispositions which generated practices and perceptions through which identity was conventionally expressed) awards the historian a different consideration of how music is placed in such articulations. In the case of Liverpool, certain genres, class-based distinctions and dispositions came to dominate all considerations of musical authenticity. Accepting that this was indeed the case, helps us to see how on a local level the Beatles can be seen to have at one stage reflected, then refracted local cultural tastes, but were then at least partially rejected by such articulations via the genres and lifestyles they embraced, in comparison to those lived by many local Liverpudlians. Mick O'Toole reminded me that he:

was never a Beatles fan, as such; I thought they were OK to begin with, but didn't like the way they 'ponced' about and didn't feel that they were Liverpudlians in the same way. By the 1970s, they never really entered into my mind, to be honest. I was right into country music by this time, and the local country scene was so vibrant that the Beatles appeared to me to be a thing of the past – even an aberration, you might say. Even by the late-60s my lifestyle was more represented by my tastes in country music – I certainly had little time for hippies – and I wasn't the only one in Liverpool, I can tell you![34]

Rejecting a 'Beatles' World View?

While it could be argued that for some (such as this writer) a counter-cultural 'world view' had developed into a quasi-utopian pattern of belief systems, for many Liverpudians it contained too many paradoxes. By this time 'white' Liverpudlian districts were being demolished, solidarity was growing as a consequence of the break-up of traditional ways of life, while many middle-class Liverpudlians were either casting their spatial net into the new suburbs, or else leaving Liverpool altogether. In and around Liverpool the interplay between musical loyalties and a residual working-class consciousness helped to formulate authenticities around country & western, and soul music (amongst other variations). My own identifications with genres associated with alienation from the status quo – such as West Coast, folk, folk-rock – were not a substantial part of Liverpool's musical generic coding. Occupying what was becoming a distinct and largely self-contained social sphere, the rock and folk-rock ends of the counter-cultural continuum in Liverpool were at times very marginalized; as one ex-girlfriend reminded me many years later:

> Male or female, you might walk through the streets of Liverpool and be sworn at for having long hair and wearing 'Loons' [flared trousers]. I was constantly called horrible names walking along Derby Lane. Eventually I found ways of walking to a friend's house or to Edwards' record shop through back entries and side-streets so that I didn't have to bump into any 'Skins' or bear the brunt of all of this hostility on Prescot Road. It was a bit depressing to tell the truth and it was one of the reasons I was glad to leave Liverpool in 1971[35]

A combination of 'traditional' working-class authenticities and middle-class suburban counters to the counter-culture reinforced suspicions of change. On the whole, therefore, it could be argued that, in the main, Liverpudlians did not fall for hippie rhetoric, recognizing that such rhetoric was largely 'at odds' with recognizable working-class paradigms of legitimacy, from (perhaps genuinely

[34] Mick O'Toole to Mike Brocken, January 2014.
[35] Val Smith to Mike Brocken, April 2012.

felt) freedoms concerning work-based time-management, and evolving ideas concerning entrepreneurial personal development.

However, it is historically vital to acknowledge that the initial narratives concerning a Beatles legacy came to be at least partially articulated from within this marginalized group of rock fans. Within this element of local society and culture, the legacy of the Beatles came to be articulated, rearticulated and re-evaluated, but such revisions were not accepted, by and large, by all Liverpudlians as part of their collective sense of identity or place. Nationally, popular music revisionists were by this time writing of the achievements of rock-based artists, but such revisions were by no means universally accepted in the city of Liverpool. For all of its latent affects upon mainstream society over the decades following the 1960s, hippie-dom and the confusing ideologies of those associated with such a movement (if indeed that was what it was), by and large fell upon stony ground on Merseyside and it would have to be stated that what were often seen as bourgeoisie-created dialectics and 'fluffy' ideologies are still treated with a great amount of cynicism half a century later. However, such collective cynicisms also store problems. By the late 1970s, proponents of radical politics in Liverpool such as the Socialist Workers Party were suggesting that the Beatles legacy was a world-historical event that had foisted upon us an illusory revolution, and that it was inevitable that such a self-obsessive illusion should founder on the very success of those who were at the so-called vanguard of it. According to some, popular culture had reversed into a reactionary cul-de-sac and had not emerged from it politically sound. But these comments were not culturally or economically viable for a city on the verge of bankruptcy.

'Twas ever thus in 1970s Liverpool; 'the sixties' were over, the Cavern was for some a useless space in an even less useful building, and few grounds remained for its continued presence, even among rock fans. Instead, venues such as the Shakespeare represented different demographics and offered contrasting effects and comparisons with such places and venues. Moreover, rock music and the remains of the counter-culture were not something with which the average Liverpudlian identified. It is true that important lessons had been learnt via the intervention and impact of the counter-culture, but such lessons were largely viewed within the city as representative of a white bourgeoisie, rather than authentic working-class experiences. As far as Black Liverpool was concerned, nothing could be further from lived experiences in (say) Toxteth than images of John Lennon sitting at his all-white piano, in his all-white room in his Surrey mansion singing 'imagine no possessions'. For many Liverpudlians, Black or white, very little could be garnered from the confused dialectics of a suburban (post-)hippie ex-Beatle. By the 1970s, the popular music revolutions of the post-WWII era had for some come to represent historical changes, but these changes were seen by some locals to be part of a 'rock' *status quo:* recognizable as hagiographical. Under such circumstances, neither the Beatles' nor the 'rock' legacy carried much cultural currency, empowerment or legitimacy.

'I'll Follow the Sun': The Cunard Yanks Narrative and the Beginnings of 1970s Beatles Tourism

For some of the protagonists within the film, they followed the historical narrative itself, then inserted more of their own historical claims without ever supplying any evidence. In effect, one could argue this film documentary then became a myth about a myth, due to the very 'Warholian' concept of seeing and being on a film screen, thereby creating one's own 'Fifteen Minutes of Fame' without ever having to authenticate statements of time and place

(Steve Higginson, email 2013)

Once hagiography takes over any narrative, the worship of place and space almost naturally follows: apostles and disciples are seen to have ventured from a place of significance and this tends to be followed by pilgrims and authenticators travelling to that place. Furthermore, although iconographic discourse initially tends to surround a few 'chosen' individuals, in due course the presence and importance of such key players is extended to contemporaries and progenitors, usually from that same geographical (thus symbolic) place or space. It is from such layers of representational explanation that the validation and celebration of such progenitors within some very specific contexts emerges. Their appearance/s are given shape by virtue of a cultural geography that cannot be found elsewhere (at least in the same proportions) and via a way of life which has emerged in an almost Presbyterian manner – from 'the bottom up', as it were – thus enriching itself and endowing those involved with an organic mandate. Yet ironically, and as a consequence, a pantheon of validation also develops and solidifies in which hierarchical structures of legitimacy come to represent and corroborate all such processes of pre-history. Within such hierarchies, indigenous chauvanisms come into play: seemingly unambiguous places assume increasing emblematic and singular significance, and identifiable individuals come to dominate discourses. Even though both dominions might lack the necessary historical evidence, they carry with them required amounts of indigenous credits so that credo status is alleged, accepted, and authorized – such, one might argue, are the uses of the Cunard Yanks narrative on Merseyside.

Before proceeding any further, it should be clearly stated and categorically confirmed that Cunard Yanks *did* exist and that they are *not* simply mythological figures. However, it is this collector-cum-researcher's contention that their seemingly collective contribution to the histories of both Merseybeat and the Beatles

has been retrospectively exaggerated and in some cases contextually fabricated to support a specific, somewhat 'puritan', hierarchical narrative. It is argued here that this narrative actually emerged in the early-to-mid 1970s as a repudiation of artifice, and was part of a Liverpool 'politic' that relegated popular music (beneath authenticity, dogma and social realism) as mere fantasy, pleasure, and style. Such aggressive approvals of non-artificiality abounded in the UK of the 1970s[1] and historically can be seen to have pronounced disapproval to all mass-produced pleasures or charms. The Cunard Yanks myth in relation to the Merseybeat myth[2] fits such a pronouncement: one that suggests that indigenous authenticities explain all (and defeat all), that the pleasures of mass-cultivated enjoyment are matters of political evaluation, and that the aesthetic consensus concerning the origins of the Beatles and Merseybeat is one of being misled by associations with 'the popular'. Arguably, therefore, the appearance of account of the Cunard Yanks' links to Merseybeat (rather than their actual presence per se) is of the greatest historical significance here, featuring as it did as a local *1970s* (rather than a 1960s) discourse concerning authenticity of progenitor and place. This narrative was in direct opposition with other perhaps more logical, national, international and business-related narratives, none of which carried compatible authenticity tropes. The relevance of the Cunard Yanks-into-Merseybeat story was one borne of the early stages of Beatles tourist heritage. One might even suggest that the surviving Cunard Yanks might not recognize themselves as portrayed via such representations and links. After all, indigenous chauvanisms promulgate mythological pasts which, in turn, serve to legitimize power or win support for particular guiding principles; function myths serve important purposes but are not always easily identifiable, for people tell legends because other people listen to them.

Cunard Yanks, Record-Collecting

So, who were the Cunard Yanks? They are those seamen credited with having fuelled musical activity in Liverpool by returning home to the port with copies

[1] While during the 1970s myriad discussions concerning the validity of popular culture emerged, and led in part to (amongst other things) the academic study of popular music, much discourse was negative and generated by neo-Marxist ideology that considered all popular-based mass production as part of a superstructure generating a 'false consciousness'. In the UK, a maelstrom of intellectual activity surrounded the meanings and values of popular culture during this decade (and beyond).

[2] I suggest that 'Merseybeat' is also mythological because it perhaps suggests propaganda as much as history. A pursuit of historical group identities does not *necessarily* lead to myth-making. However, while one principle of selection is inherently no more true than another, overriding commitment to a belief in any historical group identity might just produce a mythical version of history – there are actually many such cases in the annals of popular music (subcultures such as Mods, Hippies, Punks, metagenres such as soul, rock, and jazz).

of US recordings; this, of course is a well-ploughed 'historical-musical' furrow of vast proportions across Merseyside. Historically, the term 'Cunard Yanks' stands for, mostly unionized, men working out of the port of Liverpool as waiters and catering staff for the Cunard shipping line. This was a job, it must be stated, already in some decline by the mid-1950s and the Yanks' attitudes towards work of any description were strictly casual-ist: they did not 'belong' to the Cunard line. For example, for both ship-owners and trades unions-alike, their propensity for 'jumping ship' was in essence a negation of both industrial and trades union disciplines; no amount of agreements between these two parties concerning working practices were ever able to stick. 'Jumping ship' was in effect a way of putting 'two fingers' up to both organizations, as neither was going to be allowed to 'own' the time of such seafarers. Once ashore (either back in Liverpool or elsewhere), Cunard Yanks tended to continue an essentially freelance existence by moving in and out of areas of casual employment and self-employment.

But there remains a level of confusion concerning the term. I have conducted many interviews over many years with local seafarers and it has been stated to me by some that the expression 'Cunard Yanks' was created for any merchant seaman working aboard ships plying between Liverpool and North America. Other interviewees, however, believed that it was coined for those only working on Cunard vessels. Occasionally the moniker was not even known to those being interviewed, in spite of them being merchant seamen themselves. One 'old salt' informed me more recently that 'I'd never heard the expression, to be honest, at least until people started linking it with the Beatles, you know, after they'd split up; I don't know when that was exactly because I never had much interest in music'.[3] The only authentic Cunard Yanks to be found by Liverpool historian Steve Higginson, chief researcher for the *Cunard Yanks* documentary film (2007),[4] were sailing *by and large* before the advent of rock 'n' roll (one might cite the year of 1955 as an important point in time). Higginson could find only one of these men, Richie Barton, who was able to a) disclose to the researcher that records were definitely brought home to Liverpool, and b) provide evidence to that effect. Indeed, Higginson personally informed this writer that (to paraphrase) the deeper he delved into searching for substantive evidence for the Cunard Yanks being a major influence on (e.g.) the Beatles, the less he actually found. By the time the aforesaid documentary was finally presented at Liverpool's Philharmonic Hall during European Capital of Culture year 2008, he had in effect disowned it as a work of part-mythology.

According to Higginson, those recordings, which are still owned by Richie Barton, are copious and impressive (there are it seems thousands of them), but they appear to be mostly of the jazz or jazz-oriented variety, and they are in the main LPs. There are also still in Mr Barton's possession several US doo-wop

[3] Retired seaman and docker Walter Williams, to Mike Brocken, June 2010.
[4] Cotterill, Dave, Mike Morris and Paul Lysaght (2007), *Liverpool's Cunard Yanks*, Liverpool: Souled Out Films, www.souledoutfilms.co.uk.

78rpm recordings housed in an old-style (i.e. pre-vinyl) record album. But, for the most part, Higginson could only view (at a little distance) jazz (i.e. rather than rock 'n' roll) LP recordings. This makes perfect sense, for Barton was actually an active reviewer for a small UK jazz journal during his time at sea in the very late 1950s, early '60s (importantly *post* the advent of rock 'n' roll and *post* most of the rock 'n' roll initially sourced by the Beatles[5]). Barton also took time out to visit jazz clubs in Greenwich Village such as The Village Vanguard: an activity not replicated by the rest of his seafaring colleagues. From this evidence presented to us, Richie Barton appears to have been a genuine jazz record-collector and connoisseur – which, as every student of popular music collecting will tell us (from Evan Eisenberg to Roy Shuker[6]), would make his acts of accumulation exceptional, unusual even, rather than a 'rule of thumb' via which we should consider the habitus of other Cunard Yanks. Let's face it, collectors of all kinds are often viewed as 'nerds', and their enthusiasms can be belittled and mocked by colleagues (as a fellow Liverpudlian record-collector, I was frequently accused of being 'up my own arse' by my peers). It is not known to this writer whether Barton had to run any such gauntlet.

So, what of the records that supposedly appeared on the streets of Liverpool and changed the direction of popular music history? According to a few local sources (such as Liverpool-born Elvis Presley expert Mick O'Toole), there once existed a little evidence that '*o*riginal *s*ound*t*rack' LPs (OSTs) from Hollywood musical films (e.g. *Carousel*, *South Pacific*, *My Fair Lady*) were brought back to Merseyside from the USA by the Cunard Yanks. Because of copyright issues OSTs tended to be released earlier in the US than in the UK. The story goes that some Cunard Yanks were under orders from their wives and girlfriends on Merseyside to return home with recordings of this kind, along with baby clothes and various 'white goods' such as vacuum cleaners and hair dryers. If correct, especially in the case of these latter items, one might suggest that another, perhaps more significant, partially-hidden narrative exists concerning Liverpool's matriarchal society, for the importance of the female in the city, faced with a constant and/or intermittent absence of the male, is never far from the surface of everyday life within Liverpool's variegated histories (and, one might argue, is of far greater relevance to, say, John Lennon's early historical diachrony than semi-mythologized taste makers). All of this might be true (although *South Pacific* is hardly rock 'n' roll);

[5] For example, it has been recorded that the Beatles were renowned in Liverpool for effectively playing not only obscurities, but also oldies. According to some sources they wished to recapture the essences of more primal (i.e. 1956–58) rock in contrast with the later, more seemingly anodyne forms emerging from (e.g. the Brill Building) circa 1960-onwards (UK: Cliff Richard, Adam Faith; US: Bobby Rydell, Jerry Keller, etc.) – such statements are, of course, also potentially mythological.

[6] For example, Evan Eisenberg (1987), *The Recording Angel: Explorations in Phonography*, New York: Yale University Press; see also Shuker, Roy (2010), *Wax Trash and Vinyl Treasures: Record Collecting as a Social Practice*, Farnham: Ashgate.

however, as a record dealer for at least two decades, I never once came across one single verification of this story via the existence of a US soundtrack LP – even in the ubiquitous car-boot sales.

The Cunard Yanks-into-Merseybeat narrative continues to be a fascinating story, but is difficult to discuss in an evidence-based historical sense. This is because, underneath what appears to be a manifest history, there actually exists another latent historical narrative of complex parochial processes about which many contemporaries who readily adopted the narrative as 'real' were probably only dimly aware. It is partially a view of a local past which serves to raise consciousness about the authenticity of the home-grown, using the place and the people of Liverpool and the river Mersey. However, it simply must be suggested that a great deal of this kind of story-telling, while inspirational, is romanticist in its nature. It specifies heroism, individuality, authenticity, and distinctiveness – all of which are problematic postulations, rather than historical evidence-based facts. To further complicate matters, this 'heroic' CY>M narrative can be associated with not only a degree of political radicalism and entrepreneurialism in Liverpool, but also that previously mentioned, vital history of casualism in the city.[7] Of course, such tropes of authenticity awarded *post facto* to these 'cagey' seamen who, on the face of it arrived back in port with armfuls of (let us say) Johnny Ace records, has its own place in history. If nothing else, by the mid-1970s Cunard Yanks came to carry far more cultural capital concerning the place and people of Liverpool than the rather boring, but perhaps more accurate depictions of spotty-faced teenagers finding potential covers in the deletion bins of largely ambivalent record stores (not to mention descriptions of seemingly rather seedy local managers and agents using young men as musical factotums.

Evidence

One of the most telling pieces of modern historical evidence concerning the *lack* of evidence re involvement of the Cunard Yanks with the Merseybeat matrix is their absence from two highly significant contemporaneous British television documentaries from the winter of 1963. The connotations attached to film and television portrayals of Liverpool regarding the advent of Merseybeat are fascinating in their own right. The wartime bombings of Liverpool did far more than scar its city centre and docks physically, for they transfigured the city for voyeurs. These days it is not generally realized that the Luftwaffe's destruction of inner-city Liverpool was not widely publicized across Britain, for it was considered by the government that doing so might lower morale. Of course, such devastation could not be kept a secret; however, the bombings were not openly discussed ('careless talk costs lives') and the British population attempted to 'get on with things' as much as possible. Furthermore, wartime broadcasts concerning

[7] The dockers' 'welt' system, for example (see Chapter 5).

all bombings across Britain tended to downplay destruction through this 'all in it together' tone, thereby creating, rather than reporting, an immense texturology of place with cities used as optical resources. Following the end of the war in 1945 this lack of the directly knowable became part of a national register of supportive distance. The British gaze was transformed so much that many came to 'know' Liverpool, but only as a text created from a fiction of knowledge. Clearly, the histories of broadcast narratives are what broadcast narrators make and are assembled via specific contexts. They are also inevitably interpretive and, while they appear to present reality and neutrality, they do so only according to contemporary matrixes which consider both the real and the neutral as contextual issues. In our case, via the significance of a wartime audiovisual compact, which was continued as a post-WWII contingency, Liverpool as a place (and then the Beatles as people) came to be reduced to statice rather than kinetic images.

Audiovisual histories are assembled on the basis of phenomenologies: there are mutual profiles in the sounds and in the visuals which award us a type of reality. This, one might describe as isomorphism: a creation of the designer or director that comes to be identified by the viewer as real. Genres of imagery and sound are vital, and the integration between sound and visual genres operates through mapping, schema and interpretation. One result should be that we are reminded that history is always there to represent someone, rather than some thing; but this is not always the case, for audiovisual narratives if presented through the 'correct' balance of ingredients, can present us with a *sine qua non* – that together they are 'real' because of their synchronization. An audiovisual compact exists, from which an understanding of reality emerges. The primacy of the eye and the ear informs us of the 'truth' and therefore the human tendency is to ascribe special correlations to sounds and visuals on the basis of interrelated sensory veracity.

By late 1963 British televisual and filmic representations came to enhance a series of pre-existing rhetorical signifiers concerning place, into which the Beatles (and others from Liverpool) were manoeuvered. Yet, not only is their *no* discussion of any links between (e.g.) the Beatles and waiters from the Cunard liners in either the BBC's *The Mersey Sound* or ATV-Rediffusion's *Beat City* TV documentary programmes; neither documentary actually mentions the term 'Cunard Yanks' at all. (One is even left wondering whether it was common parlance at the time and, if it were, amongst whom exactly.) When considering the historical veracity of any relationship mooted between Liverpool's Cunard Yanks and the Merseybeat pioneers, academic scholarship should be concerned with the search for the origins of such hegemonic discourses (for that is what they are); it is within an investigative light that the emergence of the Cunard Yanks narrative as a viable critical signifier at a key stage in Liverpool's popular history (the early-to-mid 1970s), might be better understood.

One interviewee of mine, Les Johnson, informed me that his father was a publican. Les is a musician rather than a 'Cunard Yank' and lived for most of his youth in a variety of public houses across Merseyside. He recalled that recorded country music was played on a record player in one of these pubs, located in Old

Swan, Liverpool (presumably before juke boxes had been installed 'across-the-board' in such establishments). Les remains to this day convinced that these were American and/or Canadian recordings brought back 'under orders'. He particularly remembers recordings by the Canadian Hank Snow (from Liverpool, Nova Scotia, in fact) being very popular among the locals. Les also made a point of stating that, as far as he could remember, these records were LPs rather than 45rpm singles and that time-wise this was perhaps the mid-to-late 1950s. Between March 1952 and October 1955 Hank Snow released five LPs on the US RCA Victor label. However, Snow's music was also readily available at this time in Liverpool on LPs and EPs. By the 1960s and the advent of the RCA Camden imprint many Hank Snow recordings were re-released on this budget label and were available right across the city.

Joe Flannery, one of Brian Epstein's closest friends in the Liverpool of the late 1950s and early 1960s also remembers a little country music being made available via the ubiquitous record player in a particular city-centre pub colloquially named the 'Duck House' (adjacent to the Playhouse Theatre), but this recollection was from the pre-rock 'n' roll era (actually 1952). Flannery states that prior to his leaving Liverpool for National Service that year he was:

> listening to honky-tonk music for my long goodbye – how apt that now seems. By this time the scene in the Duck House had developed even further and was very exciting. Not only was this Hillbilly country and western music being played, still attracting several US airmen from Burtonwood, but also other odd styles of music were being performed in the pub.[8]

Here, Flannery brings to mind hearing recorded country music played on this pub's gramophone player, and in a later discussion with this writer he presumed (but did not actually know whether) the recordings were of US origin. One wonders whether the time between the event and the recollection actually played a part in 'making' these recordings American.

Joe Flannery does not discuss in his work (and, in interview with this writer was not aware of) the formats of the recordings in the 'Duck House', so we do not actually know whether they were 78, 45 or 33rpm recordings (or perhaps even a radio behind the bar broadcasting American Forces Network). However, the year cited (1952) is something of a historical signifier, for one might suggest that the majority of gramophone recordings were still likely to have been those of the shellac 78rpm variety. LPs and 45s were not available for general sale in the UK at this time and most pre-existing gramophone players would in all likelihood not have been equipped (at least immediately) to play them even if they had 'made it' from the US to Merseyside (furthermore, to be played on UK machines, all US 45rpm recordings required spindle adaptors). As a consequence, perhaps one

8 Flannery, Joe, with Mike Brocken (2013), *Brian Epstein, the Beatles and Me: Standing in the Wings*, Stroud: The History Press, p. 67.

should ask how fragile shellac US 78s might have made the journey from the US to a Liverpool pub. Richie Barton's small collection of US 78s testifies that some *certainly* made it: but how many, from which genres, and in which pubs?

Myth often implies that all Liverpool pubs were 'special' places where all different kinds of music could be heard. This is a useful historical device to suggest uniqueness and to over-dramatize and romanticize places and spaces from the past. 'Oirishness' in Liverpool has also been used to support such dramatizations. However, such homogenization neglects the real complexities of (in this case) the growth and development of city spaces, suburbia, and their multifarious uses, meanings and peculiarities. I have written previously that stories of widespread music-making in public houses across Liverpool are inaccurate, to say the least.[9] Music in Liverpool pubs was by no means widespread and was largely dependent upon whether the pub was licensed for music in the first place, and/ or whether the brewery preferred silence and/or a gentle 'masculine' hubbub. It also depended upon whether a room was available that could be given over for music and whether a landlord expressed an interest in music. For example, it was a policy of the Liverpool-based Higson's brewery not to allow much, if any, music in their pubs. Indeed most licensed premises in Liverpool were owned by the breweries of Bents, Walkers, Higsons, Whitbreads and Threlfalls, and therefore were 'company houses' with company policies. Free-houses (pubs owned by proprietors who could access whichever beer was popular with his/her customers) were not over-common. Some public houses across the suburbs of Liverpool (e.g. along the length of Queen's Drive) were more like bourgeois roadhouses than pubs and attracted the ubiquitous commercial travellers of the day. In these places music was not *de rigueur*. Other pubs, of the more parochial street corner variety, might encourage sing-a-longs from regulars because they might not own a record player and because 'ten-to-ten' singing was something of a tradition. 'Ten-to-ten' songs might be started-up just to keep the pub open a little longer than usual (the still-standing Olympia opposite the Grafton Rooms on West Derby Road was an example of a ten-to-ten pub).[10] The permutations are in fact almost endless and one cannot generalize.

Liverpool-born bass guitarist Les Parry informed me that, in 1956, his brother Jim returned home to Moscow Drive, Liverpool 13, from his maritime travels with two 10" vinyl LPs. The two albums in question were recordings by the late Hank Williams and Les, evidently knowing his brother well, suggested that they had probably come from a New York deletions bin (in other words Jim was not the kind of man to have paid full price for such items); however, this could not be verified. Les recalled one of these Williams LPs was the *Luke the Drifter* album. This album contained recordings made between 1950 and 1952 and was released posthumously on MGM in the US in 1953 (Williams had died on 1 January that

[9] Brocken, Michael (2010), *Other Voices: The Hidden Histories of Liverpool's Music Scenes, 1930s–1970s*, Farnham: Ashgate.

[10] In the early-1950s pubs were only licensed to serve drinks until 10pm.

year). Upon his return to Liverpool, Jim immediately gave these two LPs to their father (a Williams fan) and shortly afterwards purchased a cheap Spanish guitar to pursue his own musical interests while at sea. According to Les this was more practical, for his brother stated to him that it kept him amused aboard ship. To my knowledge Jim was not a 'Cunard Yank' as such, but sailed hither and thither from his Liverpool base for a few years on different shipping lines. It should also be stated that Les was born in 1953, so such 'memories' are not really first-hand, as such. These were ageing (perhaps even deleted, or second-hand?) country music LPs, rather than contemporary rock 'n' roll items. I actually recall scrutinizing these two albums in the summer of 1970. Les' father kept them in a 'special place' in his Moscow Drive home and one day graciously allowed me to view them. I was not aware that they were American copies and so cannot claim that I knew these recordings to have been of US origin, at that time.

It has been variously suggested by the gamut of Merseybeat historians that, if any US 45s did arrive in Liverpool during the late 1950s, the source might have been the PX at the Burtonwood US Airbase in Warrington, near Liverpool, from whence Black airmen might escape to 'shebeens' and blues parties in Liverpool 8. Ray 'Sugar' Deen, formerly of the Liverpool group the Harlems, suggested to Sara Cohen and Kevin MacManus[11] that he first heard one or two of his favourite R&B songs via recordings conveyed by Black US Airmen to L8 shebeens. Might we presume that Ray was discussing 45rpm records? or albums? Without at all wishing in any way to doubt Deen's reliability as a source, in all the time I have been interested in this topic – casually as a collector, entrepreneurially as a dealer, and academically as a researcher (since, at least the mid-1970s) – I have never once come across in Liverpool a US 45 that was *known* to have been brought into the city from America, either by a 'Cunard Yank', *or* an American airman (white or Black) during the 1950s. Since the age of 15 (1970) I have at no time come across an imported rock 'n' roll LP *known* to have been purchased by a 'Cunard Yank' or US Airman. Naturally, one should accept that the survival of said 45s is far less probable, given their possible uses and abuses at shebeens (one should also remember that 45s were regarded even by devoted popular music lovers as ephemera – i.e. 'here today, gone tomorrow'). However, it remains difficult for this writer to consider that an elusive (let us say) Ray Charles LP might not have been preserved by somebody at some stage. Full-priced LPs were expensive luxuries; they were often cherished and were not normally cast aside on a whim. Of course it is entirely possible that, even as a collector, dealer, and bootlegger of 40-plus years standing, I might have been looking in entirely the wrong places for such materials, although the aforementioned Mick O'Toole also perhaps correctly informed me that 'as a dealer, *they* should have found *you*, if they had existed!'

I do recall one incident when two US rock 'n' roll LPs came to my attention in Liverpool (as above, in 1970). When I was 15 a school colleague of mine at

[11] See Cohen, Sara and Kevin McManus (1991), *Harmonious Relations: Popular Music in Family Life on Merseyside*, Liverpool: National Museums & Galleries.

West Derby Comprehensive School was selling a couple of albums, one of which was the first Bill Haley and the Comets LP (the *Rock Around the Clock* album with the sock on the cover!) and the other was *Here's Little Richard* – and they were both US copies: on Decca and Specialty respectively, and both had belonged (I presumed) to his father. The boy's name was Brian Howe and he lived in the Barnfield Drive area of West Derby, Liverpool 12, but I did not know whether his father or any other members of his family went to sea. I thought later that this might not have been the case given the middle-class, suburban locality of the family. But I simply did not know whether this was accurate, and would have been guessing, either way, because we were far from close. Therefore I have never jumped to any conclusions concerning this myth of importing even when evidence was seemingly before my eyes (or not, as the case may be). Apart from the fact that these two albums were definitely of US origin, I do not know where they came from, even though I ended-up owning one of them. I actually wanted to buy the Little Richard LP but ended up with the Bill Haley one because I couldn't quite raise the required capital (ten shillings [10/-] for Richard, five shillings [5/-] for Bill, as I recall). The fact that I was, by 1970, even interested in incorporating old rock 'n' roll records into my modest collection of Fairport Convention, Pentangle, and Simon and Garfunkel albums should be noted: a rock 'n' roll revival had commenced that year and popular music was by this time becoming repertory and fragmented.

Research and Rhetoric

Sara Cohen highlights popular music's unique role and significance in the making of all cities, and illustrates more specifically how de-industrialization encouraged efforts to connect popular music to the city of Liverpool; to paraphrase Cohen, categorization, ownership and promoting popular music as a singular local culture, and harnessing it as a local resource, were paramount. These points are of vital importance when considering the growth of the 'Cunard Yanks' narrative; it is here that one can see apparent musical origins and so-called originators being marshalled into position to suit specific ideological purposes. We have seen in Chapter 2 that, nationally, by the mid-1970s a nostalgia quotient for Merseybeat music had started to interest the new popular music historians, becoming in the process, a social and symbolic resource encompassing specific roles and characteristics. Popular music as a culture came to be distinguished, locally, by local social and ideological conventions and class consciousnesses. Merseybeat (but not 1970s 'rock' music) became codified as speech and discourse about popular music and the local grew exponentially. As Beatles music gradually became a heritage commodity outwith the city, a nascent tourist industry grew around it within with a level of *Ur*-historical authority awarded to the Cunard Yank. It has already been suggested that, following the publication of the aforementioned Allan Williams text *The Man*

Who Gave The Beatles Away,[12] Allan Williams and Bob Wooler began to promote Beatles-related events at the Top Rank, Mr Pickwick's and Pez Espada night clubs as early as 1975. At these events questions were invited from the floor and, as I recall, both Williams and Wooler publicly refuted the Cunard Yanks story. Bob Wooler much later informed me that he was actually a little hurt at the suggestion that all of his own research into obscure recordings as resident deejay at the Cavern was being reallocated to 'a bunch of sea-going waiters'. The testimonials of both men were of course fascinating to hear, but they were challenged by the aforementioned organic authority which represented an alternative history to that of Williams and Wooler and which, in order to cement itself, had appropriated the Cunard Yanks narrative. This account compared favourably via a recognizable organic root against the inauthenticity and rootlessness of the local, early-1960s music business (at least as represented by Williams, Wooler and Sam Leach). Battle-lines were therefore drawn in Liverpool by the mid-1970s concerning the historical authority and authenticity which surrounded the roots and flowering of Merseybeat.

Renowned BBC broadcaster and writer Spencer Leigh began to elevate his profile during that year by interviewing Williams in front of a paying audience at both Crosby Civic Library and Southport Arts Centre. This writer was present at both of these events and I can recall that at no time did Allan Williams confirm a Cunard Yanks story; neither did he mention any Cunard Yanks in his book. Williams' outspokenness concerning the outwardly fly-by-night characteristics of local music businesses and club-land, together with his denial of the more folksie, unprocessed root to the emergence of the 'Liverpool Sound', did not sit well with a neo-Marxist, chauvinistic, local historian 'take' on what it meant to be Liverpudlian. For some, it was as if Williams and Wooler were 'mocking' local working-class lives, and encouraging a history of the ephemeral, while at the same time representing by association the transience of Liverpool 8's Black culture via Williams' own alliance with Lord Woodbine, and the proximity of the Jacaranda to the frontiers of Toxteth. The Cunard Yanks were more genuine, rooted, and recognizably *white* stereotypes. Whichever side of the narrative one subscribed to, it was becoming clear that the Beatles heritage orb had started to revolve and create oppositions.

Such historical dog-fighting assisted in enhancing a *post facto* Cunard Yanks narrative link with rock 'n' roll music within some very specific contextual circumstances in the decade *following* the dissolution of the Beatles. It can be seen that, perhaps in contradistinction with Allan Williams' somewhat fragmented, uneven 'voice of dubious authority' (a seemingly dodgy nightclub and 'buttie' bar owner who fell out with groups, claiming they owed him money) and Bob Wooler's erudite yet for some rather phoney tones (it was known that Bob was always a Sinatra fan, in spite of his vast knowledge of rock recordings), the

[12] Williams, Allan and William Marshall (1975, 1976), *The Man Who Gave the Beatles Away*, London: Elm Tree; reprinted by Coronet, New York: Macmillan, Ballantine.

Cunard Yanks became a symbolic hagiographical and historiographical lynch-pin for a period in which an appropriate popular music mono-history of Liverpool (i.e. representing the place as a westward-looking 'edgy' city with a specific cultural capital of collectivity, community and continuity) was absolutely essential as an important identity-giving narrative. Additionally, this was taking place at a time when rock 'n' roll record-collecting was gathering pace. The advent in the UK of *Record Collector* magazine, originally issued as a supplement to the 1976 reissues of the *Beatles Monthly* magazines is an important signifier of the codification of the growing historical nature of Beatles fandom via value being placed upon various recorded formats. *Record Collector* arranged and organized Beatles influences into assets of rules, principles and organized systems of codes. Questions were asked such as 'how did people in Liverpool actually hear this stuff?'

It might be argued that the 1970s 'Yanks' narrative was also a classic function myth constructed to deal with local institutionalized opposition to any form of popular music heritage representing the city of Liverpool (rather than its renowned but by then declining civic heritage). If such a pop history was to be tolerated, then the Cunard Yanks at least made it more authentic, recognizable (white, again) and of course romantic (rather than the aforementioned record-collector deletion bin and L8 realities). That it was part of a creation of authority concerning a narrative of local authenticity (in a way, 'anti' the voice of the seemingly evidently dubious Williams, Wooler and Leach axis, possibly anti-capitalist to a certain extent, but also pure in a 'folksie-rocky', 'Maggie May' kind of way) is almost undeniable. One might argue that it was an example of E.H. Carr's[13] historical dilemma of social forces being brought together by (in this case) Allan Williams and Bob Wooler, which resulted in actions at variance with, and even in opposition to their initial objectives.

Therefore the Cunard Yanks became, as John Street might have suggested 'a *rhetoric* of place as political experience [...] localities can take on an overt political dimension, becoming the site of struggles that inspire the music [...] it is the local which constitutes the foundation of the "real"'.[14] He continues: 'the rhetoric of the local over-simplifies the nature of the locality. And in doing this, it obscures the ways in which the consumption and production of music is subject to a complex political network in which the "local" cannot be reduced to physical geography.'[15] In the case of the Cunard Yanks, Liverpool's popular music history was bestowed with a constant rhetorical trope of the 'real': a powerful, persuasive response to other narratives, gaining more power the more it was expressed. One might argue therefore that, despite Richie Barton's evident historical veracity as a jazz expert, the Cunard Yanks became perfect *Ur*-history for the development of a 1970s retro 'rock 'n' roll[ist]' rhetoric of Liverpool. US Beatles expert Melissa Davis states:

[13] Carr, E.H. (1987), *What Is History?* Harmonsdworth: Penguin, p. 52.

[14] Street, John (1995), '[Dis]located? Rhetoric, Politics, Meaning and the Locality', in Will Straw et al. (eds), *Popular Music, Style and Indentity*, Montreal [Canada]: The Centre for Research on Canadian Cultural Industries and Institutions p. 256 [my emphasis].

[15] Ibid., p. 259.

It is useful to note that the first legit biography of the Beatles, Hunter Davies' work published in 1968, doesn't mention it, and he had more than enough time with the Beatles and access to them talking about the early days. The following year Nik Cohn's seminal text about pop music *Awopbopaloobopawopbamboom* doesn't mention Cunard Yanks as part of the Beatles origins and so far I have yet to uncover *any* reference at all from the Beatles themselves, in literature or otherwise, mentioning it during the 1960s.[16]

In email correspondence with this writer, Liverpudlian Beatles and West Coast music connoisseur Bill Hinds declared: 'It was obviously a myth. As to when I first heard it, I've really no idea, though like you I don't associate it with the 1960s, although at that time perhaps people were more concerned with current events rather than looking back to how we got there, I think.' This is of course a valid point for the imminence of popular culture in the 1960s is as undeniable as the 1970s modes of inquiry into rock's corpus. Hinds continued with the fundamental questions asked by record-collectors then and now: 'the thing that occurs to me about it is – where are all these records? Were we aware of large quantities of US records about? those funny singles you had to put an adaptor in to play? did Edwards' Record Shop[17] have lots of second-hand US ones? I think not.' He also re-stated two important points made earlier: how many people were actually employed on Cunard liners in the 1950s (for casual jobs became increasingly scarce as Cunard's interests slowly but surely moved to Southampton)? and how many of these were evangelical rock 'n' roll fans (and/or collectors) in any case? Hinds continued:

> Perhaps 'Occam's razor' applies [a principle stating that among competing hypotheses, the one that makes the fewest assumptions *should* be selected]: although a romantic, convoluted story is postulated there is nothing to doubt in the obvious explanation – that records were purchased in Rushworth and Dreaper's and NEMS like everyone else? [Stuart] Maconie's reporting of this as fact [in the *Love Me Do* documentary – which was repeated on BBC4 in 2013] (and worse, as a fact you'd never heard before) was absurd (although he was backed-up by Gerry Marsden!).[18]

Blue Badge guide Phil Coppell also sheds light on the issue via his own experiences at sea:

> I do not support the Cunard Yanks theory purely from my ship board experiences, there is not enough profit from bringing records ashore to make the exercise

[16] Melissa Davis, managing director of The Beatles Works Ltd, in email correspondence with Mike Brocken December, 2012

[17] This was an extremely important second-hand shop in Kensington, Liverpool – see Brocken (2010), *Other Voices*.

[18] Bill Hinds, email correspondence with Mike Brocken, December 2012.

worthwhile. I have met people in Liverpool and a lady I know on the Wirral, who all had white goods from America, you had to have a big transformer to operate them, but that was a way of making good money selling a washer or a fridge, you would be surprised how easy it was to bring a large object ashore. I sold printers and all kinds of photographic equipment, apart from cameras. Oddly an LP was not easy to bring ashore. One might be, but a lot of them? and another thing that may have been overlooked: no-one played records at sea, ships move, weather gets rough, seas get choppy, record players move, records get scratched. Tape-to-tape machines were far too big to be practical on ships, so not many people had them. It was not until the later arrival of cassettes that people (crew) had music on ships. Remember it was live bands on board, even in the crew quarters it was live music, when I was aboard ships in the late-'60s to early-'70s it was cassettes and live music, not records.[19]

Pioneer of the local *Mersey Beat* newspaper Bill Harry maintains that:

pub singalongs were a standard form of Liverpool entertainment and the musical heritage was strong. This is where the truth and myth part, for maritime heritage had no direct influence on the development of the Mersey Sound. *Writers in the 1970s* began to suggest that the reason Liverpool groups were different from groups in other parts of the country was that Cunard Yanks brought them records that couldn't be obtained elsewhere in Britain. [...] Sounds nice, but it's something of an exaggeration. The Cunard Yank theory remains something of a myth. A study of the Beatles repertoire from the time [...] proves that every song they played was available on record in Britain through the normal channels.[20]

Ron Ellis concurs with Harry. Ellis was Albert Goldman's primary UK researcher during the 1980s and claims to have supplied the Beatles (principally John Lennon) between 1962 and 1963 with US LPs, as a consequence of his correspondence with an American pen pal. Writing to pen pals was an extremely popular activity in the UK during the post-WWII era. However, it seems Ron's friend was a little different, for he actually knew Jerry Lee Lewis and, like Ellis, was a rock 'n' roll buff. Ever the entrepreneur, Ron would ask for lists of US LPs from his pal, knowing that, although many US singles were released in the UK, albums were always more difficult to find (and many did not receive a UK release at all). As a freelance press photographer Ron would often 'blag' his way into the backstage areas of local theatres, whereupon he would take the odd photo and then offer up the list of US recordings and promptly take orders. He would then send his pen pal a money order and await the albums. In this way began a lucrative cottage industry that Ron operated for a couple of years amongst Merseyside's leading

[19] Phil Coppell to Mike Brocken, June 2012.
[20] Harry, Bill (2009), *Bigger Than The Beatles*, Liverpool: Trinity Mirror, p. 12 [my emphasis].

beat groups, including the Beatles, at least until 'some of the bands started letting me down, financially'.

Renowned Liverpool blues musician and songwriter Alan Peters maintains he purchased US records from adverts in American comics for sale in Liverpool and surrounding districts, so too does local jazz and blues player and academic Bob Hardy. Bob also suggested to me in interview some years ago that local guitarist of note Lance Railton did the same. Together with further investigations into the US Burtonwood Air Base PX, perhaps this story is a more realistic mode of inquiry. After all, notwithstanding claims to the contrary, it is often the popular media of any era which unwittingly both 'educates' and achieves its financial goals at one and the same time. The historical study of all popular media forms usually enlarges the scope of historical investigation and provides much-needed continuity to balance against the usual 'discontinuous' breaks with history offered by many popular music historians ('never before had the world experienced [...]', and so on and so forth).

It is true to state that at times US comics were used as ballast on the New York–Liverpool run. DC (National), Marvel and other US comics and magazine producers such as those published by ACG (e.g. *Forbidden Worlds*) were imported into the city of Liverpool at a relatively cheap wholesale cost and were distributed across the city by local wholesalers. The adverts for American products in these comics are of course legend to those of a certain age: the Charles Atlas fitness programme ('I can make you a new man, too, in only 15 minutes a day!'), 'How to Hypnotize', 'Hatch Your Own Sea Circus', spectacles that could see backwards, sets of plastic US civil war and war of independence soldiers, and, according to some, budget-priced US LPs ('3 for $1'?). However, this narrative has also been questioned. Aforementioned Elvis aficionado Mick O'Toole stated to this writer that he did not remember any US comics carrying such LP adverts; Bill Hinds recalled *all* of the above-mentioned adverts apart from those to do with LP records (Bill would have been buying US comics circa 1962–64). The afore-quoted Les Parry, also an avid American comic reader of the early-to-mid 1960s, does not recall any such adverts for LPs, but stated that they might have been placed in the more 'adult' imported magazines of the era such as the Macfadden-published *True Detective* or even Kinney's (at least from the early 1960s) *Mad* magazine. The research evidently continues, but it is clear yet again that competing storylines have important roles to play in Merseybeat historiography. As an avid DC and then Marvel collector of the early-to-mid 1960s my own memories are somewhat hazy, but I do half recall in the recesses of my mind that LPs were advertised in some such publication, but perhaps not in either Marvel or DC comics.[21] However, such 'memories' might also be merely my own contemplations of a vanished era,

[21] I currently have in my possession three copies of *Forbidden Worlds*: one from 1963 (no. 112) and two from 1965 (nos. 126 and 130) and none of these contain any adverts for LPs.

partially brought about by others informing me that they did this, so I cannot confirm this to be correct – mythology, once again, perhaps?[22]

One interesting piece of primary source material from 1963 places the Cunard Yanks story into some considerable doubt. The article 'Nashville-on-Mersey', ostensibly written by Gerry Marsden for the *Radio Luxembourg Book of Record Stars*,[23] introduces Liverpool and the 'Liverpool Sound' to British pop fans of the day. In this interesting piece, 'Marsden' (perhaps Tony Barrow?) alludes to all possible explanations for Liverpool's musical melting pot – from the tea clippers, to 'the soft calypsos of the Negroes', to 'Sinn Feiners' – but never once discusses anything remotely related to Cunard Yanks. But (and it's a big but), founder-member of the Searchers, John McNally, has categorically stated that his brother returned from his trips to sea with US recordings and, as with the recollections of Ray Deen, one would not wish at all to doubt McNally's veracity. However, any historian would have to ask whether this one example should be taken as an indicator of across-the-board importing. In fact, another member of the *same* group, the late Chris Curtis, absolutely refuted such claims and stated both to this writer and to Spencer Leigh, that most of the group's repertoire was obtained via records purchased second-hand from Young's pawn and music shop on Scotland Road (the shop is still there but now deals only in disability goods). Paul Du Noyer cites the aforementioned mail-ordering, principally via Sam Leach's crediting Ted Taylor of Kingsize Taylor and the Dominoes: 'Leach [...] credits the Liverpool musician Kingsize Taylor: like his Southern counterpart Mick Jagger he was on US mailing lists, and it was he who introduced much of the new music to Liverpool'[24] – which would be feasible if only the evidence could be made available. Paul McCartney is variously quoted as bringing to mind an abiding memory of learning new musical material via listening to records in record shop booths (such as existed in NEMS and Rushworth & Dreapers on Whitechapel, Liverpool).

If one delves into the myriad local vanity texts now abounding re the Beatles, one detects rational reasons why covering became linked to already available and occasionally cut-price deleted obscurities, rather than semi-mythologized maritime figures. For example, Beryl Adams, who was not only Brian Epstein's

[22] In any case, as far as singles (not LPs) were concerned it would have to be repeated from my own earlier work that many US singles were released in the UK on *Decca*'s *London-American* imprint, *Top Rank* or other UK labels such as *Oriole*, and were frequently to be found in deletion bins (see Brocken (1995), *Some Other Guys! Some Theories about Signification: Beatles Cover Versions*, Liverpool: IPM/Mayfield). For example, of the two dozen cover versions actually released by the Beatles up until 1966, 15 of them had previously been available in Liverpool shops on *London-American*, alone.

[23] Marsden, Gerry (1963), 'Nashville-on-Mersey', in Jack Fishman (ed.), *The Official Radio Luxembourg Book of Record Stars*, London and Manchester: Souvenir Press/World Distributors, pp. 11–14.

[24] Du Noyer, Paul (2005), *Liverpool Wondrous Place: Music from the Cavern to Cream*, London: Virgin, p. 61.

secretary at NEMS but also later married Cavern deejay Bob Wooler, suggested via her biographer Lew Baxter that:

> NEMS had […] carved out a reputation in Liverpool as one of the few outlets [for] sought-after and exotic American imports [...]. Beryl [writes Baxter] stood firm with music historians on disputing the mythology that those records were brought in by sailors. Her twin brother Ken worked on trans-Atlantic cruise liners and he hadn't picked up on this and she knew from personal experience at NEMS that the stories were nonsense. Brian Epstein simply imported them from America. He ordered them and bought them in the usual way. There was no great underground movement pushing this stuff.[25]

Baxter further stated: 'Beryl was a regular at the Cavern and other clubs and insisted she had never heard that romantic tale of the origins of the records until decades later'.[26]

Mono-Histories: Conjecture

All history writing and recording requires that a wide variety of diachronic contextual strands should be drawn together for the fullest possible appreciation of a synchronic, contextual event. But mono-histories tend not to do this: they prioritize one narrative over others for largely political purposes. Unfortunately, political narratives can oversimplify and/or ignore complexities that do not fit well into ready-formed a priori ideological positions (perhaps this is what Steve Higginson found so difficult in his Cunard Yanks research); they can erase or veneer strands that do not conform to standardized historical narratives formed from within such ideologies. The main problem with mono-histories is therefore two-fold: Firstly, as John Tosh suggests,[27] narratives can take the researcher into a rhetorical cul-de-sac. All because A (in this case the Cunard Yanks) comes before B (Merseybeat and the Beatles), it does not mean that A caused B even though the flow of a given narrative can easily suggest that it did. Secondly, and perhaps more importantly, narrative mono-histories impose drastic simplifications upon how we consider causations to have taken place. Edward Soja suggests: 'putting phenomena in a temporal sequence (Kant's *nacheinander*) came to be seen as more significant and critically revealing than putting them beside or next to each

[25] Baxter, Lew (2005), *My Beatles Hell: The Tragical History Tour of Beryl Adams*, Birkenhead: Guy Woodland, p. 33.

[26] Ibid.

[27] Tosh, John (1991), *The Pursuit of History: Aims Methods and New Directions in the Study of Modern History*, London: Longman, p. 117.

other in a spatial configuration (Kant's *nebeneinander*). Time and history thus absconded with the dynamics of human and societal development [...]'.[28]

Local histories as narratives tend to pronounce a mono-lingual world created by and through absence. Diversity is only tolerable to the mono-lingual local historian if a centrality of significance and significance by absence, emanating from the chosen locality, are created. A fictitious centrality draws the local historian back to a stipulated essence of meaning and a 'natural' presence and/or absence (i.e. 'it used to be this way, but is not anymore'). It is often argued that this essence is something that could not be created elsewhere, certainly not by a diversity of cultures, might actually not exist any longer locally, and is absent and mourned rather than present and expanded. Therefore local history-telling is by nature mono-historical because it informs us that there is always going to be a narrative of (often absent) essences, despite there being more than one historical language and myriad narrative functions. Local histories present us with clusters of irreducible 'facts' by which others are valued. The question that keeps rearing its ugly head concerning local histories is actually history's relationship with ethnocentrism. Roland Barthes reminds us that a 'text' is not a line of words on a page releasing a 'theological' meaning but a multi-dimensional space. By reducing our writings to mono (in this case, white) illocutionary acts, we do so at the expense of 'other' (perhaps Black) experiences and in doing so develop competing linear mono-histories. Ironically, while the study of the local was initially intended to level-up a culture-bound total vision of history, it has in many respects become incapacitated by the preferential narrative of the indigenousness of one's *own* world, rather than refreshed by the dispersed and uncertain 'others' in need of illuminating. The Cunard Yanks narrative is one fascinating spatial history related to Liverpool in two senses: one, to do with the river Mersey, Irish Sea and Atlantic Ocean; two, to do with the corralling of authenticity to serve specific ideological purposes. It actually has little to do with the subject matter (i.e. rock 'n' roll records), per se.

To paraphrase popular music tourism historians Connell and Gibson: in terms of heritage, musical authenticities tend to consist of layers of interpretations of the validity of a music soundtrack as provided by particular authentic-sounding contexts and in specific casual but authentic modes of transmission and consumption. How true; in the case of Liverpool, however, authority via Beatles tourism has also been constructed in such a way as to authorize the (white?) constructors, together with rubber-stamped (white?) Liverpool-approved authenticities (especially those surrounding the city's maritime history): this must come to an end. By the mid-1970s the primary issue for the very few nascent Beatles-related tourist and heritage initiatives tended to revolve around such preferred authenticity and authority. Thus, each facet of the myriad Beatles tourist narratives slowly developed over decades through finding ways of gaining important authority tropes (or else has disappeared). Authority has been granted

[28] Soja, Edward W (1996), *Thirdspace: Journeys to Los Angeles and Other Real-and-Imagined Places*, Oxford: Blackwell, p. 168.

in different ways such as via locality, artefacts and political recognition; also by re-proposing an 'imagined' (not necessarily imaginary) Beatles as representatives of both class and 'riverine'-based authenticities. Early tourist and heritage players in Liverpool were required to gain and express authenticity and authority via such a priori signifiers in order to legitimize themselves as meaningful. The Cunard Yanks, as freelancing, sea-based, organically entrepreneurial 'wide-boys' of local renown or disrepute (take your pick), were awarded a prominent position within such authorizations. It was via such authority that stakeholders could measure and value the Beatles as musicians who were identifiably conforming to 'local tastes' – even though their popularity partially stemmed from a covering of obscurities that evidently did *not* measure up to local tastes (otherwise they would not have been 'obscure' in the first place, would they?) and furthermore the Cunard Yanks were not necessarily working within the same taste cultures, and the evidence for them returning home with the obligatory recorded music does not appear to be there.

Linked with the above is the issue that most popular music tourism developed as a 'historical accident'.[29] It was, in fact, even unwanted by some cities such as Liverpool, yet gradually and organically developed in a kind of Presbyterian way (as it were, from the 'bottom up'). It was therefore frequently left to the so-called 'nerds', hippies, local historians, and entrepreneurs. So, it is within these inter-related contexts that the Cunard Yanks-into-Beatles narrative requires further study. Early (let us say 1975) Beatles tourism was partly generated by the aforesaid record-collectors, local Liverpool profile-makers and entrepreneurs, amateur historians and rock writers, all of whom detected an emerging retrospective narrative concerning the founts from which the Beatles emerged. Together with an ambivalence from the Liverpool City and Merseyside County Councils concerning anything other than a civic heritage, the Cunard Yanks as a 'rock 'n roll' narrative (rather than a more accurate one of 'jazz' and 'white goods') started to emerge. One might argue, then, that the Cunard Yanks were effectively manoeuvered into place to serve specific rhetorical and ideological functions. The first of these is understandable, the second unforgivable. The emergence of their unwitting 'voices' of organic authority was also linked, positively and negatively, to the 1970s manifestation of those who claimed to have known the Beatles during the early 1960s and were by this time attempting to cultivate both economic and rhetoric capital from their knowledge, especially once the era of the Beatles had in real terms passed into history.

Summary

The points being made here are that in more specific terms it is highly appropriate that we not only understand the conditions under which Beatles music came to

[29] Connell, John and Chris Gibson (2003), *Sound Tracks: Popular Music Identity and Place*, London: Routledge, p. 10.

be, but also how it all came to be regarded as holding great heritage folklore in the 1970s, and growing economic value in the 1980s and 1990s. Popular music historians are able to illuminate instances in which new ideas have been readily absorbed and applied, but we are also often aware that in many eras ideas have been allowed to lie dormant and/or to disseminate very slowly, in the process mutating into urban myths. The reasons for this kind of fate are as important as the reasons for something's birth or imaginings. So, this writer wishes to posit the thought that the relationship of the Cunard Yanks with the Beatles and Merseybeat only began as a historical-cum-contextual statement *after* the Beatles had broken up, but that the idea carried great hagiographical and historiographical authority. It was not a planned thing, nor was it an agreed thing, but in a relatively synchronic way came to formulate a narrative of Liverpool's relationship with the Beatles at a very specific yet important moment in the history of both Liverpool and popular music: the mid-1970s.

As far as the Cunard Yanks' relationship with the Beatles is concerned, it is worth recapitulating and rejigging the three important interconnected discourses mentioned in Chapter 1: firstly, that Liverpool has long supported the notion that the city has a mono-history of collective struggle against the ruling powers of the South-East, together with a history of maritime entrepreneurialism. Desertion (rather than absence and return) is therefore greeted with antipathy; we should place this at the top of any discussion concerning emerging heritage metaphors and synecdoches. Secondly, the city's musical history is oddly conservative concerning popular music activities[30] and any links to what might be described as the counter-culture can be viewed with disdain. Therefore certain genres (e.g. soul music) can be used as devices for expressing authenticity in opposition to not only other musical genres, but also other peoples and places. Thirdly, histories of (mostly white) working-class radicalism and maritime identities have taken ownership of the city's 'counter histories' and have converted disparate histories into a mono-history surrounding identity and struggle, authority and authenticity.

By tracing how these three strands weave and knot between each other, we can expose the complexities of the different 'truths' produced by different constituencies surrounding connections between areas of the city (including the river), so-called key individuals, and the presentations of the mono-history (or should that be mythology?) of the Beatles and their 'relationship' with Liverpool's maritime history. It should also be acknowledged that, amid the mid-1970s construction of the pantheon of rock, issues concerning 'place' and 'space' came to take on different, more-kinetic meanings as rock narratives came to discuss the rhetoric of place in co-creative rather than imposed value formations: Liverpool therefore needed its place in this growing rock canon, especially when the City Council's lack of interest in Beatles tourism effectively stymied any substantive

[30] I am reminded of Les Parry's comments to me, viz: 'In Liverpool, if you didn't like Motown in the '60s you were considered a dickhead. In the '70s it was disco, in the '80s and '90s it was House music – all very formulaic and not a little formidable!'

research *at that time*. This also contributed to the private sector and fans alike taking charge, positing narratives against each other, with the Cunard Yanks being embedded into local popular music consciousness without what might be described as 'thick' historical research taking place (and it is now almost too late).

This is all the more ironic when one of the most obvious characteristics of Liverpool's culture throughout the twentieth century has been not the singularity but the variegation of its musical activities. Within the city, diverse genres of music, representing some equally diverse scenes, came to represent analogous forms of authenticity (as Daniel Farson 'discovered' in *Beat City*[31]). In Liverpool musical folklore, the differing voices of Frank Sinatra, Billy Fury, and Marvin Gaye, the indigenously chauvinistic music of local folkie Pete McGovern, the R&B sax-playing of Supercharge's Albie Donnelly, and the light operatic tintinnabulations of Mario Lanza and country singer Slim Whitman have all come to represent *comparable* authenticities resting on Merseyside which do not require politicized 'purification' à la the Cunard Yanks. For the popular music scholar, there is evidently still much unpacking to do regarding the authenticities, authorities and legitimacies surrounding the roots/routes of the Beatles. Instead of continually attempting to refract the Cunard Yanks narrative into a historically unsustainable historical pigeonhole, Beatles tourism specialists need to 'agree to disagree'.

[31] Farson, Daniel (1963), *Beat City*, London: ATV-Rediffusion, broadcast 24 December 1963.

Chapter 4

'Day Trippers': Confronting Issues around Popular Music Tourism in 1980s Liverpool

it is debatable as to whether Liverpool ever made a complete transition to industrialization. The continuing prevalence of informal modes of employment in areas of production, distribution and circulation are rooted in the historical genesis of casualism. A desire for an independent, autonomous life, irrespective of the precarious nature was of itself a rejection of the philosophy of work celebrancy.

(Steve Higginson, email 2011)

It has been rhetorically and perhaps even counter-factually stated that, between 1966 and 1977, 350 factory closures took place in Liverpool. While this piece of data sounds similar to the number of groups allegedly formed in Liverpool during the 'beat boom' (in other words an exaggeration – Liverpool was never 'industrial' in that way), something like 40,000 jobs were indeed lost and it is almost certain that between 1971 and 1985 employment in the city fell by at least a third. By the dawn of the 1980s matters had worsened and the 'People's March For Jobs' took place in May 1981. *The Financial Times* was to report that:

> There is little doubt that Merseyside [...] will have to come to grips with a smaller workforce. Compared with just under 600, 000 in jobs now, it has been forecast that on the most favourable projections the area will be able to sustain only 575,000 jobs by 1986 and that figure could be as low as just under 300,000.[1]

At the time the blame was usually placed, not on the woeful lack of reinvestment in the city (e.g. by the ineffectual Mersey Docks and Harbour Board), but on the very people who were suffering as a consequence of losing their jobs, i.e. the 'strike happy' workforce. Workers across Merseyside had a long-held reputation for confrontational industrial relations. However, a fundamental problem underlying Liverpool's (or Merseyside's) work-related problems during the 1970s was that, post-WWII, a latter-day manufacturing base had attempted to establish itself mostly on the outskirts of Liverpool, employing locals almost entirely from these selected districts (e.g. at Speke, Halewood, Kirkby). These 'New Town' and/ or garden suburbs were barely establishing their own identities as communities, never mind developing sophisticated workforces, when 'jobs for life' were handed

[1] Murden, John (2006), '"City of Change and Challenge": Liverpool Since 1945', in John Belchem, (ed.) (2006), *Liverpool 800: Culture, Character and History*, Liverpool: University Press, p. 429.

out en masse at what were mostly branch plants of national and multinational corporations: undoubtedly a recipe for calamity ahead.

In recognition of its decline in real terms during the second half of the twentieth century, and in a mad panic to connect manufacturing with new housing, the city of Liverpool's administrators became 'hooked' upon industrial processes; something which, as we look back on Liverpool's history, was probably anathema to the very spirit of the city's growth and development from the eighteenth century onwards. Thus, by the time large-scale industrial players had come to find the global marketplace far tougher than previously anticipated, a large proportion of Liverpool's workforce – especially those who had removed themselves to these new 'fringe' areas – found themselves locked into a limited range of industrial work offered by an equally limited range of employers. Inevitably such multinationals, with so few real commitments to the area, and attempting to solve their problems during recessions via restructuring, closed down factories and retreated into their business management manuals: i.e. 'Chapter one – cost-cutting when the going got tough'.

Why so many Merseyside-based factories bore the brunt of such decisions is still open to debate (the reasons are probably manyfold), yet the aforementioned unending labour difficulties were blamed. Of course one can hardly be 'blamed' for thinking in the 1970s that a job at British Leyland in Speke was assured of a long-term future – even though many of their products (e.g. the disastrous Triumph TR7 Bullet sports car) were evidently inferior. However, what made matters far worse at the time was that much of this unemployment appeared to be aimed at and then borne by specific social groupings. For example, in 1977 more than half of those unemployed in Liverpool were between the ages of 16 and 24 years. If young people in a New Town such as Kirkby were unable to find work, what was the point of such social engineering in the first place? It was evident to most local observers that the fancy 'big is beautiful' political dreams of the previous decades were in disarray. Furthermore, it became abundantly clear that for young Black workers matters were even worse, as racial inequality in the city meant that the prospect of a young Black youth obtaining even unskilled work was practically zero. In July 1981 there were riots in Toxteth, bringing to the public's attention a partially-hidden history of Liverpool's institutionalized racism. The building formerly housing the Rialto Ballroom, a local venue which openly operated a colour bar, was razed to the ground.[2]

[2] The Rialto, built in the Toxteth area of the city, was opened in 1927; it combined a state-of-the-art (then silent) cinema with a ballroom and a cafe and was flanked by twelve proposed 'luxury' shops, six on each side of its triangularly-shaped site. Financed by a group of local entrepreneurs, the site was prominently placed at the key junction of Parliament Street and Princess Avenue on the south side of the city. British Gaumont purchased the premises and continued to trade until 1964. Glen McIver states: 'It became a kind of marker for the general decline of the city and of the neighbourhood, a reminder of the closing-off of a particular social-offer symbolised in its configuration, a symbol of a promise that had been

What? Beatles *Tourism* – Are You Kidding?

In 1981, Bernadette Byrne, wife of musician Mike Byrne, was recruited as a Liverpool City Tour Guide. She was already renowned locally for her interests in all things Beatles and Merseybeat and had even been romantically linked to both George Harrison and Paul McCartney when a teenager. Bernadette duly jumped through the required hoops to become one of the first tourist guides with specialisms in local popular music at a time when a) few tourists of any description were actually coming to Liverpool and b) Liverpool City Council expressed little or no interest in popular music or the Beatles as legitimate forms of heritage for the city. Corporately there had been no noticeable effort to identify a popular music heritage footprint, or to synchronize local authority tourism strategies – in fact the latter probably did not even exist. Bernadette was to work with Liverpool's 'dedicated' tourist staff, of whom there were only two: Ron Jones and Pam Wilsher (for whom tourism was only a part of their duties). They were housed in an office on Lime Street adjacent to the railway station. Jones and Wilsher were undoubtedly pioneers, and repeatedly ran up against an institutionalized reluctance to promote the Beatles as part of Liverpool's otherwise rather less than glowing appeal to tourists. This was despite the fact that, especially following the death of John Lennon in December 1980, a trickle of Beatles fans from across the world had commenced making their own popular music pilgrimages to Liverpool, in recognition of, not only Lennon as a cultural icon, but also Liverpool as a place where one might be able to express a significant part of one's identity by and through the Beatles.

To begin with there was very little work for Bernadette Byrne to undertake, but it remains of historical significance that Jones and Wilsher had already recognized that this small yet growing legion of Beatles fans were in need of guiding. As a consequence, Bernadette duly mixed a few civic heritage tours with occasional Beatles tours (at this early stage Beatles tours of the city were usually undertaken in a hired mini-bus, coordinated by Jones and Wilsher). But by the early 1980s the economic downturn was biting and political battle-lines were being drawn. Tory politician Geoffrey Howe suggested, in 1981, that Liverpool should be effectively 'allowed' to decline, whereas the increasing influence of the Militant Tendency in the Labour Party led Liverpool councillor Derek Hatton to declare 'We want real jobs and houses'. Both comments polarized opinion – nationally and locally – concerning the city of Liverpool and its people. According to Sara Cohen, Liverpool as a city was 'demonized by the British media which continually used the city as a symbol not just of "decay on a frightening scale" (*The Guardian* 6th September 1994) but as, "a showcase" of everything that has gone wrong

abandoned. Perhaps in line with this the site was eventually burned down and destroyed in the Toxteth Riots of 1981.' McIver, Glen (2009), 'Liverpool's Rialto: Remembering the Romance', *Participations: Journal of Audience and Reception Studies* 6/2, November, www.participations.org.

in Britain's major cities (*Daily Mirror*, 11th October 1982), representing it through shockingly narrow and ugly stereotypes'.[3] Furthermore, tourism was not regarded by many locals as a 'proper' earner for the city, but rather something of a problematic cultural development with which Liverpool as a place had to reluctantly deal. This was an unpromising environment within which a popular music tourist initiative might develop and, according to Mike Byrne, it was clear to Bernadette that her guiding job was 'going to be tough'.

Our histories of Liverpool now inform us that the years 1981–83 were of great significance. In 1981 Liverpool witnessed the aforesaid Toxteth Riots[4] and in 1984 the International Garden Festival was created by central government in an attempt to give the city a new image. In 1984 Liverpool also saw the opening of phase one of the Albert Dock, the opening of Beatle City, the 'Art of the Beatles' exhibition at the Walker Art Gallery, and the first Tall Ships visit (together with the arrival of Cavern Walks in Mathew Street). These events and this period are spatial watermarks in Liverpool's recent past: not simply because the entire city became a political 'hot potato', but because debates concerning tourism in general (and Beatles-related tourism in particular) as a serious way of attracting money and inward investment, came to the fore. Concurrently, Liverpool's popular music profile was on the rise again. Due in no small part to the music scene/s that had emerged from the short-lived but highly influential Eric's Club in Mathew Street, several Liverpudlian and/or Liverpool-based groups had become, by the early-to-mid 1980s, nationally and internationally popular. Bands such as Echo and the Bunnymen and the Teardrop Explodes led the way and they were followed by the Icicle Works, China Crisis, Frankie Goes to Hollywood, The Christians, It's Immaterial and (particularly in the USA) A Flock of Seagulls, amongst others. It did not pass without notice that these groups were from Liverpool, and that Liverpool appeared to be producing another crop of popular music artists during this period of evident disharmony. However, apart from the occasional clichés concerning the Beatles and Merseybeat, the publicity surrounding these important bands did not overly-connect this new brood with bands from the 1960s. This was because it was quite obvious to popular music observers that such groups had eschewed both the Beatles and to a degree punk as direct influences. Echo and the Bunnymen guitarist Will Sergeant much later informed Peter Guy of the *Liverpool Echo* that:

> It wasn't Gerry and the Pacemakers we were listening to. We had the Velvet Underground and The Doors, that sort of thing. That led us to the Pebbles

[3] Cohen, Sara (2007), *Decline, Renewal and the City in Popular Music Culture: Beyond The Beatles*, Aldershot: Ashgate, p. 43.

[4] The Toxteth Riots of July 1981 were civil disturbances in inner-city Liverpool, brought about in part by a long-standing insensitivity shown towards the local Black communities in the district of Liverpool 8 by not only the local constabulary but also the 'city fathers' of Liverpool. The Toxteth Riots followed those in Brixton, London, earlier that same year.

[Nuggets?] (60s rarities compilation) album, and then Eric's. They played things like 'Nobody But Me' by the Human Beinz, and the Chocolate Watch Band. It became known that this was what Norman (Killon) was playing at Eric's. We'd just think 'that's better than 999', or those crap punk bands.[5]

Therefore, unlike Sarah Cohen in her work *Rock Culture in Liverpool*,[6] I would not suggest that this 'new wave' in Liverpool was in any way a 'rock' culture, as such. In a genre sense these groups were not rock bands in the 1980s meanings of the word. Instead, one should regard this period in Liverpool as one which signified groups developing what became known as an 'indie' sound and culture.

Although this moniker can appear as vague as the 'rock' tag which Cohen attaches to them, it does contain more contextual meaning, for these Liverpool groups were not basing their sound exclusively on either guitars or the generic rock origins of 1980s heavy metal (to which many were opposed). Instead, they incorporated variations of sounds based largely on Kraftwerk synthesizers blended with those from the west coast of America (e.g. the Doors, Captain Beefheart, Love). The pop songwriting styles of David Bowie, the Velvet Underground and Iggy Pop were also sourced. Following the advice of Roger Eagle, the owner of Eric's club, not to listen to the Beatles, these artists created an interesting poly-stylism – one of the main characteristics of post-modernity at this time. Mike Badger (of the La's and Viper Records) recalled to Bill Sykes:

> One thing I will say about Eric's [club] is there was absolutely no affiliation with the Cavern club and it was literally five steps across the road from where Eric's was. It was like 'Yeah it was great and all that, but we're doing this', you're talking about the biggest musical phenomenon in the world. No one was doing Beatles songs, or talking about the Beatles.[7]

Jane Casey of the group Big in Japan (later one of the masterminds behind Liverpool's dance music super-club Cream), also stated to Sykes:

> An illustration of Roger [Eagle]'s influence – he told us all never to listen to the Beatles. He stressed it upon us all in such a big way: 'you'll all be fucked if you listen to the Beatles'. Recently me, [Pete], Wylie and Ian Mc [Cullough] were sitting in a bar talking and Ian looked across the table and said to me 'have you listened to them yet?' 'No, not consciously, have you?' He said 'no'. We both looked at Wylie, he said 'no'. Not one of us asked 'listened to who?'[8]

[5] Guy, Peter, (2009), 'Will Sergeant and The Liverpool International Festival Of Psychedelia – a beginner's guide to psychedelia', *Liverpool Echo*, 17 September.

[6] Cohen, Sara (1992), *Rock Culture in Liverpool*, Oxford: University Press.

[7] Sykes, Bill (2012), *Sit Down! Listen To This! The Roger Eagle Story*, Manchester: Empire, p. 210.

[8] Ibid., pp. 210–11.

These young groups did not therefore represent a 'rock culture' in the traditional popular music sense; instead they were part of a hybrid development of the musical and spatial fractures and contradictions suggested above ('literally five steps across the road') and in previous chapters. Liverpool groups at this time were, in sound, actually deconstructing and strategically reconstructing conventional epistemologies about popular music heritage and influence, especially in relationship with continuing stereotypes concerning Liverpool. Not one of these groups were essentially 'Liverpudlian' in a preconceived '1960s' sound sense (and when accused of being so, vehemently denied this – see later interviews with the La's), for not only did they sound different from each other, but also different from conventional logics concerning what Liverpool groups were 'supposed' to sound like. While taking some of their musical cues from the late 1960s, the music of (e.g.) Echo and the Bunnymen was a site of critical exchange where ideas about what constituted music emanating from Liverpool were expanded way beyond audiovisual stereotypes and into the realms of representation concerning music appropriate for the *next* epoch. On a literal level a song such as the Bunnymen's 'The Cutter' warns young people to avoid the dangers of modern life, but on a more symbolic level the song's story reveals the group's broader fears for our future. It certainly has little to do with Liverpool's popular past stereotype.

By 1981 that future was in the hands of a Conservative government. Minister for Merseyside Michael Heseltine MP helped to instigate the Merseyside Development Corporation (hereafter MDC), as an attempt to regenerate the Merseyside docks of Liverpool, Bootle, Wallasey and Birkenhead. Regarded by many, at the time, as a government 'sop' to the city, Heseltine's selection can now be seen as one of the most inspired appointments of Liverpool's modern history. The MDC was one of two Development Corporations set up in 1981, the other being the London Docklands Development Corporation, which also focused its attention upon disused docklands. The first Chief Executive was Basil Bean, who had previously been general manager of the Northampton Development Corporation. Activities undertaken by the MDC included the Liverpool International Garden Festival in 1984, and the redevelopment of the Albert Dock complex, which included the opening of Tate Liverpool.[9] During its lifetime something like 7.6m square feet of non-housing development and 486 housing units were built with the assistance of the MDC. Around 22,155 new jobs were created and some £698 million of private finance was leveraged in – with great difficulty, for Liverpool Corporation/ City Council was less than co-operative. Circa 944 acres of derelict land were reclaimed and more than 60 miles of new roads and footpaths were installed. The MDC was eventually wound up in 1998 and, locally, the general consensus was that it had been somewhat less than successful; in retrospect, this judgment can be seen to have been mistaken.

[9] See unaccredited article (1984), 'Bringing dead dockland to life', *The Times*, 27 January.

The International Garden Festival

The story of the International Garden Festival continues to fascinate those with an interest in Liverpool's recent past, for while it is probably correctly seen by historians as part of a new beginning for Liverpool as a postindustrial city, it (along with the Albert Dock development) was not overly welcomed by the city. The International Garden Festival (IGF) was supported by the International Association of Horticultural producers (AIPH) and the Bureau of International Exhibitions and was took place in Liverpool between 2 May and 14 October 1984. It was the first such event in Britain, and became the model for several others held during the 1980s and early 1990s (such as the following year in Stoke-on-Trent). The aim was to help revitalize the city of Liverpool via a somewhat tentative yet forward-looking tourism brief concerning space and place. The reinvention of place and the reconfiguring of affective labour specializations required far more than merely a recognition and future commitment from the city fathers, it needed a symbolic 'place' in which willingness, action and potential could be exhibited. The concept regarding the IGF was extraordinarily uncomplicated (and not unlike the songs of Echo and the Bunnymen!): to problematize previous stereotypes and suggest that, via this festival, images of Liverpool could be transformed into 'new' visual, imagined and spatial contextualizations. As such, the IGF was hugely popular, attracting 3,380,000 mostly day visitors and helping to turn the tide of negativity.

However, the festival was never politically popular in Liverpool, for the city council and many Liverpudlians were ideologically opposed to the Conservative national government in almost every conceivable way. Therefore the festival site became an interesting oxymoronic political and spatial symbol. On the one hand, it symbolized progress via the tourist pound but, on the other, was seen as neither 'real' or enduring. While parts of the site subsequently came to be used for good-quality housing, opponents continued to suggest that heavy industry rather than suburban planning should be prioritized. Sadly, its days as a festival site were to partially end in financial bluff and counter-bluff, undermining the site's undoubted contribution to the cultural environment of Liverpool. Like it or loathe it, the IGF became a physical spatial symbol for a change of Liverpool's economic trajectory.[10]

Specifically, the International Garden Festival was held on a 950,000 square metre derelict industrial site south of Herculaneum Dock, in the south end of the city, alongside the banks of the Mersey. Opened by the Queen accompanied by the Duke of Edinburgh, the site housed over sixty individual gardens, including a Japanese garden and pagodas (the pagodas are still there – a tribute to Japanese craft), an Australian bicentennial garden, a Granada TV garden from which

[10] What remains of the site is now in the hands of Langtree Developments and they have created an attractive and functional parkland. Langtree, however, are builders (they have recently completed the new St Helens RLFC stadium) and in the fullness of time it is possible that the area will be completely covered by housing.

broadcasts took place, and (of interest to us) a 'Beatles Maze'. The official programme notes regarding this 'Beatles Maze' now make for interesting reading:

> No Liverpool phenomenon has brought greater global fame to the city than the music of the Beatles so it is fitting that the feature which commemorates that success is as enticing as their songs [...] Beatles enthusiasts should take special note of some of the relatively common plants along the approach path to the garden and at the entrance. Many were planted because they correspond to the Beatles birth signs, according to romantic zodiacal plant tables drawn up in Victorian times.[11]

Evidently a great deal of thought had gone into the Beatles maze, although it was not prioritized, being merely one attraction amongst many (appropriately numbered map 'nine' in the official programme). Opposite the maze notes in the programme could be found a full-page advertisement for the Radio City-owned Beatle City attraction in Seel Street (to be more fully discussed in Chapter 5), while overleaf were two further Beatles-related advertisements: one for the 'specialty' shops at the recently opened Cavern Walks, the second for The Beatles Shop – both were in the Mathew Street area of central Liverpool. Cavern Walks was a small retail development which included a replica Cavern Club. The architect for this development was David Backhouse; in it was an interesting fresco work by Cynthia Lennon. There are no extant figures to give us any concrete ideas concerning the successes (or otherwise) of these popular music-related attractions during the time of the 'Garden Festival'; however, commercial radio station Radio City very soon let it be known that their Beatle City attraction was only able to capitalize on a fraction of the three million visitors to the festival site, because a) the gardens were so extensive that the majority of day trippers did not have time to travel from the south end of the city to Liverpool city centre during the course of their day and b) they considered the public transport infrastructure to and from the festival site to be poorly managed and inefficient. Actually, a ferry successfully ran from the Pier Head to the gardens at Otterspool, but other than taxis there was little or nothing to take tourists from Otterspool to either Mathew Street or Seel Street.

Different genres of music were intermittently featured at the Garden Festival and a semi-permanent 'Festival Hall' formed the centrepiece of the site. This pleasing venue housed numerous indoor exhibits where examples of (mostly folk and traditional) music from around the world could be heard, together with local music from the likes of renowned community musical organizations such as the Orrell Mandoliers, local brass and pipe bands, and a variety of children's choral groups. Jacquie and Bridie, the well-known local folk duo were regular performers in and around the Festival Hall and there were the usual ubiquitous (for Liverpool) Trad Jazz bands across the site. But Beatles-related concerts and

[11] Unaccredited editor (1984), *Festival Guide: Liverpool International Garden Festival: Liverpool '84*, Liverpool: Merseyside Development Corporation, p. 61.

presentations were decidedly thin on the ground. I was informed some years later by one ex-councillor that: 'rightly or wrongly the Beatles were not regarded as a music priority, although as I recall there was occasional music to be heard at the Maze and the local amateur musicians used some Beatles material in a variety of musical settings'.[12] The Royal Liverpool Philharmonic Society organized an entire programme of concerts to coincide with the International Garden Festival which included the 'Radio City Proms' in which one musical line-up, 'Sounds of The City', included the premiere of a *Beatles Symphony* (oddly unaccredited) as well as orchestral arrangements of 'Penny Lane' and 'Imagine', but that was about it. Indeed the RLPO only performed once on the garden festival site, when they presented a concert which included selections from Elgar, Handel, Granger and Tchaikovsky. It would have to be stated that such tactics were entirely consistent with the RLPO's mindset concerning popular culture initiatives, at that time.

Other attractions at the site included a Liverpool Walk of Fame, featuring numerous stars connected with the city such as the Beatles, Jimmy Tarbuck, footballer Billy Liddell and (oddly) actor Bernard Hill (who was not from Liverpool, but created a stereotype, despised and beloved in equal measure in Liverpool: 'Yosser' from the TV series *Boys From the Black Stuff*); there was also a light railway system which attracted railways enthusiasts. Public artwork included a Yellow Submarine built by apprentices at Cammell Laird shipbuilders in Birkenhead, a statue of John Lennon, a BBC *Blue Peter* TV programme ship, a 'Wish You Were Here' tourist sculpture, a kissing gate, a red dragon slide, and a large red bull sculpture. All of the 65 countries represented were invited to provide, during the festival, a week's entertainment in the style of their own culture. Not all countries participated, possibly owing to restricted budgets, but many did so, and the Japanese week was regarded as a spectacular success.

Rene Franz and Alan Richards of the local *Nite Out* magazine produced an A3 single sheet guide to the Garden Festival for visitors and locals alike. This was handed out, free of charge, across the night club sector and also outside the festival garden site. To make it pay, the pair canvassed local restaurants, pubs and clubs for paid adverts in the guide. However, they met with some resistance:

> It was one those ideas we used come up with almost every month regarding advertising and promoting the leisure and club-land scene in Liverpool and was totally 'unofficial'. We distributed it around the clubs and pubs and at the garden festival site – we gave them out free of charge. But I noticed generally there was very little interest *locally* and with some businesses they were almost anti the festival, which we both thought was a great pity. We thought the local venues and restaurants might get a bit of extra business, but we had to really sell the idea that there was a lot of business potentially coming in from the festival. I don't think some were very interested and a few only bought advertising space

[12] I recall my own two visits to the festival site being remarkably 'unmusical' affairs, therefore I cannot verify these comments.

because they knew us. Also there wasn't much promotion from the city, itself. I remember thinking that there wasn't enough music attached to the festival. [...] I didn't associate the IGF with music to be honest, least of all by that time with the Beatles.[13]

Nevertheless the whole event was judged to have been a great hit, and the parting notes from the official brochure now make for interesting reading:

The event has brought tourists to Liverpool and Liverpool to tourism [...] the money spent by visitors contributes to the security and creation of jobs – as long as it keeps coming. The Festival is making a start, opening many eyes to Liverpool's true image and demonstrating to the city the potential value of tourism in the long term.[14]

There is, however, not a word about the Beatles – evidently coordinated popular music strategies were still a long way off. But it was clear that Liverpool's recent social upheavals had created a platform for complex articulatory questions about what were increasingly being seen as unorthodox historical contexts.

The Albert Dock Company

The Albert Dock is in actual fact a complex of dock buildings and warehouses which opened for business in 1846. Designed by Jesse Hartley and Philip Hardwick, it was the first structure in Britain to be built from cast iron, brick and stone. As a result, it was the first non-combustible, and remained for a time the largest, warehouse system in the world. At the time of its construction the Albert Dock was considered a revolutionary docking system because ships were loaded and unloaded directly to and from its adjacent warehouses. It was such a commercial success that, two years after it opened, it was modified to feature the world's first hydraulic cranes. Due to its open yet secure warehousing, the Albert Dock became an increasingly popular store for cargoes of value, such as brandy, cotton, tea, silk, tobacco, ivory, and sugar. Despite its advanced design, however, the rapid development of shipping technology meant that, within 50 years, larger, riverside-based open docks were required. Although it remained a valuable store for cargo for many years, the dock gradually became redundant. What had made matters worse were the dramatic tidal flows in and out of the river Mersey, which made the dock gates subject to heavy silting. Once Liverpool's dockland expanded both north and south of the Albert Dock, these gates were only infrequently used. However, during WWII, the Albert Dock complex was requisitioned by the

[13] Alan Richards to Mike Brocken, January 2014.
[14] Unaccredited editor (1984), *Festival Guide: Liverpool International Garden Festival: Liverpool '84*, Liverpool: Merseyside Development Corporation, p. 201.

Admiralty and served as a base for the British Atlantic Fleet. It was damaged during air raids on Liverpool, notably by the May Blitz of 1941, but continued to operate. In the aftermath of the war, the decline of docking in the city, leading to the financial problems of the Mersey Dock and Harbour Board's owners, meant that the future of the Albert Dock was in severe doubt. Numerous plans were developed for the reuse of the buildings, but none came to fruition and in 1972 the dock was finally officially closed with vague ideas that it should be filled in and the site industrially redeveloped at some unspecified time in the future. Albert Dock was actually considered by many locals to be a blot on the landscape, long overdue for demolition.

Having lain derelict for nearly ten years (and having previously suffered from under-investment for decades), the redevelopment of the dock finally began in 1981. The aforementioned Merseyside Development Corporation was established to develop a tourist, leisure and lifestyle site after the fashion of the St Katharine's Dock development in London. By the mid-1980s the Albert Dock site was in the business of selling and leasing luxury apartments and retail units. The development was finally finished in 1988 and was officially re-launched under the ownership of the Albert Dock Co. and Arrowcroft Limited. As with the festival garden site, this development was not an altogether popular initiative in Liverpool, for by incorporating residential accommodation in three of the four colonnades it was viewed by many in the city during this period of intense economic decline, as a middle-class ghetto. The Albert Dock complex has since become a major tourist attraction, but it remains difficult for many traders to make a great deal of money there, for rents and services charges continue to be very high, and footfall is still seasonal, despite Liverpool gradually being seen as a tourist attraction for 12 months of the year. Regular visitors to the Dock will no doubt be aware of businesses changing hands on a more than intermittent basis; indeed there is a local gag which asks 'how do you make a million pounds out of the Albert dock?' to which the reply is: 'start with two'. Since the opening of Grosvenor Estates' 'Liverpool One' retail development on the other side of the Strand, retail trade at the Albert Dock has improved; however it is still something of an 'outpost' as far as shoppers are concerned, the majority of whom do not like to negotiate what is now a six lane highway between these two developments.

Over the years, therefore, the Albert Dock has come to rely heavily on its 'historic' and artistic attractions (such as The Beatles Story and the Tate) and its bars and restaurants, rather than its retail units and, for some locals it can never relinquish negative associations brought about by deeply felt personal values during the social and economic circumstances of the 1980s. In fact the Albert Dock continues to be for these people a visible attestation of ideology, representing the worldview of a dominant political class, an appeal to false consciousness, a symbol of coercion, and a representation of a lack of self-expression. It is also historically regarded by some in Liverpool as a 'last chance saloon': one of the few economic options left open to the city in the face of its 1980s monetary crises. In myriad interviews undertaken by myself with a range of local people right up

to the present day, a similar narrative emerges: on a matter of principle many have never visited the Albert Dock (and more specifically never intend to visit The Beatles Story). Local Green Badge Guide Charlotte Martin states:

> It's a constant concern for me – getting locals into the Albert Dock and The Beatles Story. There is undoubtedly a determination from many Liverpudlians never to set foot inside the Albert Dock or The Beatles Story. This is a long-standing problem and I'm not sure even today how it can be resolved.[15]

Education Officer at the Beatles Story, Shelley Ruck has suggested:

> […] an ethnography project for locals of a certain age to come down to The Beatles Story and have their memories recorded. I don't know if it would work, but it might go some way in helping to heal whatever wounds there might be between local Liverpudlians and The Beatles Story.[16]

Mike Byrne: Bridging the Gap?

By 1984 Mike Byrne[17] was the local entertainments reporter and promoter for *Merseymart*, one of this country's first weekly free newspapers. So interested had Byrne become in event culture that, in the previous year of 1983, he had persuaded his boss at *Merseymart*, Phil Birtwistle, to take over the running of the Liverpool Show. For decades the Liverpool Show had been a well-respected horticultural, entrepreneurial and civic occasion with attendances over the three-day event in the 1960s often exceeding 100,000 (e.g. 129,409 in 1965). However, by the 1980s the council was claiming it could ill-afford the show. Ideology was also at play, for Liverpool's ultra-Left councillors would not willingly support exhibits concerning entrepreneurialism and business. Several members of the business community (such as Birtwistle himself) expressed dismay at being linked with a Militant council. *Merseymart* therefore organized and ran the show that year, and it was a great success (apparently much to the annoyance of Liverpool's political leaders). Byrne felt inspired by this for he had been responsible for dealing with local traders to exhibit at the show. As he recollected:

15 Charlotte Martin to Mike Brocken, April 2014.
16 Shelley Ruck to Mike Brocken, May 2013.
17 Mike Byrne has a long musical history in Liverpool stretching back to his teens. He formed his first group the Thunderbirds in 1963 and went on to work as a professional with Them Grimbles and Colonel Bagshot's until the early 1970s. He then launched a solo career and became the emcee at both the Shakespeare and Russell's clubs in Liverpool. Mike replaced well-known Liverpool comedian Pete Price at the Shakespeare, whereas at Russell's he helped to launch the career of Tom O'Connor. He has also worked with Ken Dodd on many occasions. These days he still performs professionally with his group, the Sun Rockers.

It was great fun but also taught me a lesson: if you don't ask, you don't get. Most companies, especially during the 1980s, wouldn't just offer you money for no apparent reason. You needed to make the first move and prepare well. Also although I thought 'this is scary', whichever way it went, I was a winner just for asking. If I got an agreement for a company to exhibit, I won. If I didn't I knew where I stood and I learnt a lot – so I was a winner on both counts; looking back it was great fun and very, very educational about who I came to trust concerning the future of the city. I thought 'well if it's going to be in the hands of some of these guys, we have nothing to worry about'.[18]

Following this, Byrne came to write a series of articles-cum-advertising features concerning the Albert Dock, and it was during the penning of these commentaries that he came to understand the potential at the dock for (popular music) tourism. He was invited on a tour of the site and realized almost immediately that the vaulted brick ceilings in the old warehouse storage spaces were almost identical to those of the original Cavern Club. This, he states, stuck in his mind as the politicized criticism of the Albert Dock rang around him. He fully supported the dock development, and was pleased to report on a regular basis about the differing enterprises attempting to gain a commercial foothold, there. Whenever possible these businesses reciprocally supported *Merseymart* via advertising, although Byrne came to understand that most traders on the Dock were struggling. He now recalls that the spaces above the shops were 'practically empty apart from architects' offices'; indeed, one might:

Walk around the dock all day at the beginning of the week and not bump into a soul. I felt so sorry for the traders and not a little ashamed of my fellow Liverpudlians for letting these people down – after all, there was little enough coming in from the very occasional tourist at this stage. They needed local support but they weren't getting it at all.[19]

One seemingly satisfying moment for him came in 1984 during the International Garden Festival, when he was responsible for a *Merseymart* newspaper supplement entitled 'Hello Tourist', aimed specifically at the visitor, within which he was allowed a little space to discuss the Beatles' legacy to the city. This insertion was an attempt to get people to visit both the Garden Festival and the Albert Dock, although as we have seen, this was in practical terms almost a physical impossibility for the day tripper (and Liverpool's hotel provision at this stage was hopelessly inadequate).

By 1984, *Merseymart* was facing stern competition, for two other imprints were launched to compete with it. Firstly, *Liverpool Express*, a short-lived publication which came out of offices in Duke Street and did for a while plunder *Merseymart*'s

[18] Mike Byrne to Mike Brocken, April 2012.
[19] Ibid.

advertisers by offering according to Byrne 'ridiculously low rates for ads'. The paper's advertising revenue fell away because it could not circulate enough copies on such small revenues. Of greater long-term effect was the *Liverpool Star* launched by the *Liverpool Daily Post and Echo*, this had the backing of the holding company behind 'the Echo' and was allowed to lose money while accumulating cultural and economic capital. Mike Byrne's previous promotions days were therefore all but over as staffing was cut to the bone at *Merseymart*. He proof-read the paper, cut and pasted advertising, and multitasked all week. He was still writing occasional articles and could see that, for better or worse, there was something to write about at the Albert Dock development. Together with news from his wife Bernadette of a diminutive but noticeable increase in her own Beatles-related tour guiding, it was evident to him that Beatles tourism might even help the city get back on its feet. For Byrne, recalling those vaulted ceilings at the Albert Dock, Liverpool evidently needed a permanent Beatles and/or Merseybeat attraction. But, as he informed this writer, he was aware that many of Liverpool's councillors were extremely reluctant to give their blessing to any initiative that did not come from the hard Left of the political spectrum: 'they just didn't feel that popular music could successfully rehabilitate or revitalize city spaces'. Popular music was for them makeshift and permeated with exploitation. Byrne also later stated:

> To be honest, they had a point; if one looked at, say, Duke Street, or Wood Street or Dale Street where all the night clubs were you might agree. Dodgy clubs in equally dodgy buildings. It must have looked really transient - especially if you weren't a club-goer. It signified demolition not renovation.[20]

It occurred to Byrne that, in the Liverpool of the mid-1980s, capital development and popular music would never be recognized as valid collaborators in a spatial repositioning of labour.

Militant

> The geneology of Marxism [...] coincides with the deconstruction of its myth of origins
>
> (Ernesto Laclau, 1993)

Arguably, this was because by the late-1970s, proponents of radical politics in Liverpool such as the Militant Tendency were suggesting that the Beatles legacy was a world-historical event that had foisted upon people an illusory revolution, and that it was inevitable that such a self-obsessive illusion should founder on

[20] Ibid.

the very success of those who were at the so-called vanguard of it. According to Labour historian Steve Higginson:

> From memory I do recall that words like 'masses' and 'popular' were being reconsidered during what I would describe as this 'popular front' era, but it was decided, I think, that popular culture had reversed into a reactionary *cul-de-sac* and had not emerged from it politically sound. But there was an underlying questioning of classist categories, some of which I think led to a general insecurity about one's position from a Marxist perspective. I know it dawned on me by the mid-'80s that the coherence and unity I took to be the philosophy of history, was being brought under pressure by capitalist directions that could never have been predicted by Marx.[21]

In 1982, Liverpool District Labour Party had adopted Militant policies for the city. It also adopted the activist slogan 'Better to break the law than break the poor' which had been the slogan of the Poplar Council in the East End of London in 1919–20. There were at first positive outcomes: in 1984, Liverpool Council launched its Urban Regeneration Strategy to build 5,000 houses, seven sports-centres, new parks, six new nursery classes and other projects, many of which were actually seen through to completion. Furthermore, 1,200 redundancies planned by the previous Liberal administration in order to balance the books were cancelled, and 1,000 new jobs were created. But it soon became clear that Liverpool City Council did not respect government budgetary guidelines and was spending money it did not have. On 14 June 1985 Liverpool Council deliberately passed what was an illegal budget in which spending far exceeded income, demanding the deficit be made up by the government. As bankruptcy loomed and plans for all-out strike action were finally discussed, Liverpool councillors were advised in August 1985 by the District Auditor that the council was about to break its legal obligations and would not be able to pay wages to its staff. In September 1985, rather than face immediate confrontation with the law, the Labour group on the council decided on the tactic of issuing 90-day notices to their 30,000 strong workforce to campaign more vigorously on behalf of the council. For the press, these 90-day notices were seen as three months' notice of redundancy in all but name. This decision proved to be a major tactical error.

The Council finally balanced the books in November 1985 after gaining £30 million in loans: Militant called the budget an 'orderly retreat'. Yet from 1985 onwards, a series of moves led by Labour Party leader Neil Kinnock against Militant ended its influence in the Labour Party, together with the loss of its three Militant-supporting Labour MPs. Kinnock made a speech to the Labour Party Conference in October 1985 attacking Militant and their record in the leadership of Liverpool City Council. Liverpool Labour MP Eric Heffer walked off the platform and Liverpool councillor Derek Hatton repeatedly shouted 'liar' at Kinnock from

[21] Steve Higginson to Mike Brocken, January 2012.

the floor. Kinnock subsequently suspended Liverpool District Labour Party and appointed Peter Kilfoyle as an organizer with specific remit to remove Militant supporters from the Labour Party. Even thirty years on, many non-aligned Liverpudlians are still of the opinion that remnants of such attitudes towards both central government and entrepreneurialism continue to dog the city as it moves forward in a post-industrial environment. Certainly, in 1985, and despite the previous year's festival success, Militant-aligned councillors were openly refusing to co-operate with the Merseyside Development Corporation; thus the MDC took the decision not to request further co-operation from the council, but instead to run an economy-sized 'Garden Festival' on a shoestring budget just to keep the tourist kettle boiling. At this early stage the MDC still effectively controlled the site and let it be known that it was looking for partnerships and investors from the world of business.

Potential

We have seen that Mike Byrne's work as an events journalist had convinced him about the potential of music tourism, but following tour guide reportage from his wife Bernadette, he also recognized that the growing needs of music tourists were diverse and varied. For example, an American tourist might be able to legitimately sustain a sense of novelty and excitement about a Beatles exhibition, whereas (say) a German tourist might not. Representing music was all well and good but, according to Byrne, it had to take on new forms and functions in order to be seen as relevant and exciting. Byrne came to realize that nostalgia was an important part of the recipe of connotations of the admittedly few 'Beatles travellers' to the city. He much later informed this writer that he witnessed all kinds of motivations amongst those visiting the garden festival site during its short lifetime. There were noticeable physical, cultural, social and even spiritual responses to the very few Beatles materials there, and he saw these linked to socio-psychological motivations: 'worlds' created by the visitors, some of which represented those who wished to avoid the modern world, while others corresponded to a desire to create closeness with it as an important 'object'. There were in fact myriad reasons for music tourism and Byrne concluded that some kind of living dialogue or 'experience', rather than 'museum', per se demonstrated a greater symbolic authenticity to those wishing to identify with the stories surrounding the Beatles: factual lore to inspire awe.

By 1985, there was certainly a dire need to display to both Michael Heseltine and MDC chair Philip Carter that Beatles tourism was becoming a serious business, for if nothing else it was hoped that funding might have followed verifiable statistics. However, this proved to be very difficult for three important reasons. Firstly, the Beatles businesses that had opened-up in 1984 were only barely emerging and could not provide convincingly impressive throughputs; secondly, Liverpool's nascent tourism unit still basically consisted of only the duo of Ron Jones and

Pam Wilsher, and they could not provide accurate figures; thirdly, Beatles-based tourism was still very much an ad hoc affair, often organized by various Beatles fan clubs across the world, or individuals arriving by car or train, and such data could not be collated. Philip Carter made the decision to appoint Samir Rihani to head up a new tourist information unit which would attempt to gather information. Rihani had previously held responsibility for local public transport and he appeared to be steadfastly against any popular music tourism. He was intent on advertising Liverpool as a 'riverine', 'civic buildings' and sporting (i.e. soccer, golf) destination – as many of the contemporary publicity documents attest.

So while Mike Byrne's wife Bernie was seemingly at the forefront of a nascent interest in Beatles tourism, and Mike had witnessed first-hand an increasing interest in local leisure tourism at both the Garden Festival and Albert Dock sites, politics from all sides of the political fence prevailed to deny Liverpool an early stab at a popular music-based heritage market. Rather than moving tourism forward, Rihani's appointment created a stalemate. In 1985 the shoestring festival went ahead but could not deflect national attention away from the political shenanigans. As it turned out, every man, woman and child who visited the Garden Festival garden site in 1985 was subsidized by the MDC to the tune of £4.50 each; it went on to make a £2.2 million loss. Only the emergent Cavern City Tours (CCT) of Bill Heckle and David Jones appeared to understand the way forward by taking on board the concept of uniting the disparate Beatles tourists. They had already held a small 11-day Beatles festival in 1984 to coincide with the International Garden Festival and had commenced their own freelance tour guiding. Alongside the businesses in Mathew Street, CCT had decided to grasp the nettle and do it themselves. Liverpool City Council appeared at first to simply ignore this interesting development; however, it had not gone without Mike Byrne's notice.

Transworld

With MDC still looking for business partners in 1986 following their budget festival the previous summer, a certain John Anton and his company Transworld Enterprises entered the fray. Anton was a London-based property developer who wished to regenerate districts bordering the river on both sides of the river Mersey. As such, he was initially welcomed with 'open arms' by local councilors and officials. By the time of his approach to MDC he had already opened discussions with both Wirral Borough Council and the Merseyside Development Corporation concerning reviving the ageing resort of New Brighton; he felt that he could redevelop both sides of the river Mersey as two linked tourist destinations. Councillor John Hale was a member of both WBC and MDC committees and, in 1982 set up an all-party group to discuss with John Anton plans for the redevelopment of New Brighton. But 16 months later when nothing had happened regarding this regeneration and, instead Anton had turned his attention towards the MDC's site, alarm bells began to ring. Although Anton reportedly informed Hale

that 'nobody could expect a scheme like the festival site to make a profit',[22] he was guilelessly welcomed by the MDC, a deal was quickly struck, and New Brighton was left 'high and dry'.

Transworld were to crash financially in 1986, owing millions to creditors, but before this, and without due process, Merseyside Development Corporation promised Transworld a 149-year lease on the festival site, effectively giving the company licence to trade there until the year 2136. Alexander Anderson, the commercial director of MDC, was to later deny in court that the decision to allow Anton to run the site was political and due to the fact that the deputy leader of Liverpool's council, Derek Hatton, did not wish any further funds to be spent on the riverside park.[23] Anton swiftly appointed Brian Barnes as chief executive of Transworld. Barnes was formerly a local government official in charge of leisure and tourism on the Wirral; but, according to Mike Byrne, 'hadn't got a clue' about running a major tourist attraction. Yet, as chief executive, Barnes had overall charge of four under-managers: one for the gardens, one for finance, another in charge of staff and yet another with a responsibility for events. It was this latter position that Mike Byrne took up in the spring of 1986. By this time Byrne had realized that his future no longer lay with *Merseymart* and, having seen an advertisement for the position of Festival Gardens events manager, he had decided to apply for it. His application was successful and he therefore somewhat reluctantly handed in his notice to his good friend and joined the new project on the Festival Gardens site in Otterspool.

To this very day, it is not known what the actual business structure of Transworld was, although Standard Chartered Bank, who supplied Anton with a good deal of capital, must surely have looked at his books. However, we might presume that it was a classically 1980s skeletal affair with little real cash flow to show for a wealth of rhetoric. It remains interesting that Anton's inconsistent capitalist-derived logic beguiled apparent classical Marxists. Perhaps this was because (as previously suggested by Steve Higginson) the logic of capital development was not moving in the direction predicated by Marx. By February of 1986 advertisements began to appear in the local press concerning the May reopening of the Festival Gardens. Mike's speedy appointment meant that he was also under considerable pressure from Barnes, who wanted the events organization to be dealt with post-haste. However, while Mike set about his task with some gusto, revisiting many of his old *Merseymart* connections, publicity for the gardens (ostensibly Barnes' responsibility) appeared almost non-existent. Furthermore, John Anton was receiving too much bad publicity for walking away from the New Brighton waterfront development. He endeavoured to turn this adverse publicity around by making what turned out to be a financially reckless announcement that the Festival

[22] Neild, Larry (1991), 'Anton "Quizzed" Deputy Leader on Site Costs', *Liverpool Echo*, 30 January, p. 11.

[23] Neild, Larry (1991), 'Crash Firm "Promised 149-Year Site Lease"', *Liverpool Echo*, 29 January, p. 22.

Gardens were to house fun rides to rival Alton Towers. As a consequence, six high-quality expensive rides were installed (although the previously popular monorail was discontinued) therefore the 'ides of that March 1986' did not, according to Mike Byrne bode particularly well, financially. Byrne also soon discovered that only half the garden festival site was to be reused, for the other side of the road had already been sold off for housing. He realized, too, that Anton had very little infrastructure or capital at the venture's disposal.

Nevertheless, Byrne was able to produce a full programme of events and was also able to bring the six rides to the site due to a former contact Geoff Brownhut, who was an agent for such equipment in Yorkshire. Tony Hanby, an engineer, was appointed to oversee the fun rides, meanwhile Mike continued organizing seven complete days of events to run for six full months – the duration of the initial opening season. Sky divers, the Red Arrows, renowned local musicians such as folkies Jacquie and Bridie, specialized circus-like arena events, and a daily parade were among the entertainment all brought together just in time for the opening. The Gardens opened on time with Michael Heseltine MP performing the opening ceremony. But it didn't work; it was in fact an expensive disaster. The running costs were monstrously high and, with the summer of 1986 wet and cold, and publicity predictably poor (and negative), matters started to unravel. In a move that openly smacked of nepotism, Barnes appointed his own daughter as a PR consultant; according to Mike Byrne this made matters worse for 'she didn't have a clue, either. I ended up using my contacts in *Merseymart* and the radio stations to get publicity.' The circus was very poorly attended throughout the month of May, and he thought even at this early stage that, amidst all of the political and then entrepreneurial shenanigans, the Festival Gardens would struggle, having lost what little local cultural capital it had accrued: 'John Anton was – rightly or wrongly – treated with deep suspicion by the local media. It was as if Liverpool was still a political battlefield and the festival site was becoming a joke especially now that it was associated with a London yuppie stereotype.'[24] There were, however, a couple of success stories: at the Festival Hall site the James Last Orchestra played to 10,000 people, and at the same venue the *Muppets On Ice* show played to mostly packed houses. But the latter of these two events proved to be massively costly and Byrne half-recalls that the Henson Studios were possibly not paid (at least in full).

The park opened each day at 10am; this was immediately followed by a musical parade through the gardens at 10.30am. Mike Byrne persuaded ten circus acts to take part, but there were only ever a few visitors in the Park to witness their performance. There were apparently innumerable emergency finance meetings taking place behind closed doors, and each under-manager was showing concern because events were constantly being cancelled. By July artists were coming to Byrne claiming that they had not been paid:

24 Mike Byrne to Mike Brocken, April 2012.

> Now don't get me wrong, there were some busy days but they needed 5,000
> visitors each weekend day to make it pay, but there was never anything near that
> – the time hadn't really arrived in Liverpool for tourist figures like that and, as
> usual, many locals were deeply suspicious.[25]

At the end of August the financial crisis loomed even larger. Prior to August
Bank Holiday 1986, he was made aware that the gardens would close: 'Word
had got around that people were not getting paid, Barnes had also brought in
his own family to help him run things – even they ended up on the dole!' The
site officially closed mid-September throwing most of the staff out of work with
immediate effect. Preceding this sad event the inevitable meeting took place when
an announcement was made to the remaining staff. As it turned out, there was one
job going: manager of the Beatle City tourist attraction in Seel Street (see below),
which Anton had recently 'acquired'; Mike Byrne instinctively threw up his hand
and, to his great surprise and delight, was duly appointed on the spot:

> Getting the job was as kind of chance-based as it sounds; the wages were not
> much – about twelve and a half grand per year as a John Anton employee.
> I presume Radio City would have trusted Anton about the deal, but I'm not
> sure – silly them. But they would have welcomed anyone at that time because
> Beatle City was a total non-starter. In fact my first onerous duty was to inform
> Lawrence, the Beatle City incumbent manager, that he was sacked.[26]

During that September of 1986, a month or so before the demise of Transworld,
John Anton had made what appeared to be a major gesture by announcing that he
was about to 'save Beatle City'. It was by this time common knowledge that the
attraction had failed to attract visitors in the desired numbers and was teetering
on the brink of financial disaster. But at least from this historical perspective, the
idea appears reasonably sound: during the winter months the failing Beatle City
attraction would be moved lock, stock and barrel to the festival site in an attempt
to attract a 'different' type of tourist. However, Mike Byrne recalls that Anton's
announcement appeared to be as much a publicity stunt as anything else.

The uneasy co-existence of the Festival Gardens site and Beatle City suggested
that tourists appeared to be drawn to the former rather than the latter, thus 'proving'
to tourist specialists at MDC that the Beatles were not a major tourism draw. There
was the presumption that if Beatle City could become an adjunct of the Festival
Gardens site, it would at least place a majority of visitors to Liverpool in one place
at one time. However, the problem with this apparently logical stratagem was
that it was based upon inconclusive evidence. Mike and Bernadette Byrne could
clearly see that the Beatles visitor was a different animal entirely. There were
those who came to Liverpool as part of a short tour organized by foreign-based

[25] Ibid.
[26] Ibid.

fan networks and, with the help of a self-sustaining itinerary and a guide in their own language, they pretty much kept to themselves. There were also those who were 'pilgrims' wishing to tour the remaining authentic sites on an individual basis, perhaps only for the day. Numbers were an issue, for such visitors were still a small minority; furthermore, while they might wish to see some kind of visual representation, visiting a pleasure park tucked away in the south end of the city, or a Beatles 'museum' sited in a Liverpool side street might be, to them, irrelevant and time-consuming. Better, perhaps, to spend the few hours available in Liverpool, finding where the original sites could be found: the Beatles' former homes, the Cavern, Iron Door, and Grafton venues, rather than gaze at Beatles record sleeves in a display case. (Cavern City Tours had already recognized this issue and had developed their own tour.) Historically, it can be seen that, at this embryonic stage of tourism in the city, these two important groups of Beatles fans were overlooked. It can also be seen that the Beatles tourists' desire to travel around key Beatles-related sites has always been *essential* to Beatles heritage tourism experience in Liverpool. However the harmonization of local popular music tourism initiatives was still a long way into the future.

Museumification

If the aforementioned political dimensions are difficult to historicize (and apologies to those who have not been represented fully by such a short discussion re Militant), it is even more problematic to historicize popular music via an exhibition or museum space. Museums tend to rather overconfidently compress and simplify disparate activities into historical certainties. For a number of Liverpudlians in the mid-1980s, such 'certainties' were actually enormous ideological and historical differences of opinion. One might even go so far as to suggest that they existed as ontological *impasses* which could not be resolved by museum- or exhibition-based epistemologies. The museum movement has over time developed from presenting things in cases to interpreting the past, for which it should be praised. But in the case of popular music one cannot exemplify in a museum what (for example) an acid trip might involve, and how that trip can then be musically represented on record. Neither the Liverpool politician nor the museum exhibitor can presume that they have any algorithmic certainty and that an exhibition exists as a matrix for experience.

The museum is an institution at least partially-founded upon the values of a Benjaminian 'aura': the unique and magical quality of an artist, subject and/or artefact. However, as far as popular music is concerned, this places museum spaces in an invidious position, one in which individual imaginings brought about by sound are homogenized. Thus museums are only ever prescriptive galleries for popular music; they are not discursive spaces. Instead we have static descriptions, rather than kinetic offerings. One small yet significant example of static historicization via exhibition illustrates this well. In the case of ex-Beatle Stuart Sutcliffe we are

presented with an image of a young man, an artist, who features as part of the Beatles' early history. But Sutcliffe, it should be argued, has a history of his own. The time between his death in 1961 and the present day should suggest to the Beatles historian that a revision of his historical profile via an understanding of his art urgently needs to be undertaken, for by doing so, one might be able to suggest that the Beatles feature somewhere in his history, not the other way around. As things stand, Stuart Sutcliffe appears a mere transitory phenomenon, whereas the Beatles are always fixed, true, and unmoving – yet this cannot be so. Museum histories, therefore merely succeed in 'accounting for' the popular; they eliminate inherent chance (upon which popular music in point of fact thrives) and purge the influence of interpretative pasts, concomitantly presuming objective truths. Such objectivity-driven methods are deeply flawed for they present an institutional view of the popular past – something authorized, and sanitized:

> History is theory and theory is ideological and ideology [...] material interests. Ideology seeps into every nook and cranny of history, including the everyday practices of making histories in those institutions predominantly set aside in our social formation for that purpose.[27]

Summary

While all popular cultures emerge from different ways of gaining knowledge, the overall museumification of all popular culture will always be notoriously difficult to accomplish. If one presupposes that, for example, the Beatles gained their musical knowledge more or less formally, one instantly misses the entire point of their existence, thus the need for their historicization. If one similarly presumes that the music industry dangled the Beatles from puppet strings for consumers to passively 'get what they were given' then the ever-changing *raison d'être* of 'the popular' through time and space is utterly invalidated. If one presents Lennon and McCartney as two more creative geniuses, comparing them (as one might an apple with an orange) to a nineteenth-century German romanticist, one also entirely misses the point of the emergence of affective communication capital and the interactive potential of our co-creative universe. But such ideological propositions do seep into institutionalized exhibition spaces even though in the popular music sphere nobody is entitled to the first or last say on anything, and authenticities cannot be easily located.

Popular music, therefore, is a kinetic matrix and we cannot suggest that one singular matrix exists, for myriad meanings can be pulled into focus by one sound, alone. For example we know that the very act of record-*collecting* shapes identities and displays aesthetic values. The record is complicit with those very modes of expression and production which bring sounds to the listener,

27 Jenkins, Keith (1991), *Re-thinking History*, London: Routledge, p. 24.

for sounds are purloined, confiscated, appropriated, stolen even. Therefore the historical acknowledgment of such complexities demands subjective, rather than objective, historical approaches from museum-based historians. The Beatles were record collectors, yet this ordinariness is largely ignored, misrepresented or misunderstood by museum cultures. One might even suggest that the act of song-covering by means of popular music record-collecting is also misunderstood. The Beatles were not music readers, therefore exploring their different collecting experiences, recorded sound as a matrix, and what it means to compose within the realms of listening to records would make for a 'thicker' historical view of the Beatles (and popular music) in everyday life.

If one has a high evaluation of one's own ability to interpret the past accurately, one's ability to recognize new facts is debilitated. Being utterly convinced of one's approaches creates isolation from the fact that reality is not fixed. When false historical information makes an exhibition look good, the collators of such information believe it. But one cannot simply make the past look good and hope to get away with it. The past does not respond well to those in the present who place their own personalities upon the past. False mono-historical images are easily deflated. There is required, a need to take more consideration of how one should represent the countless popular pasts within the equally innumerable popular presents. It's no use hanging a picture of the Beatles in a gallery when the blank walls make just as much sense.

Chapter 5

'Across the Universe' (well, the Atlantic) – Beatle City, Dallas, and Beyond

If we really are interested in our history, then we may have to preserve it from the conservationists.

(Robert Hewison, 1987: 98)

In 1962, the same year as the Beatles' first UK single release on Parlophone, Thomas Kuhn wrote *The Structure of Scientific Revolution* and by doing so popularized the concept of the 'paradigm shift'. Kuhn argued that scientific advancement was not evolutionary, but rather is a 'series of peaceful interludes punctuated by intellectually violent revolutions', and in those revolutions 'one conceptual world view is replaced by another'.[1] Therefore Kuhn asked us to consider a paradigm shift as a change from one way of thinking to another. He suggested a transformation, a sort of cultural metamorphosis where nothing 'just' happens; shifts are driven by agents of change. In our case those agents of change, wittingly or unwittingly, were the catalysts called the Beatles. Theoretical models such as those of Kuhn can assist us in recognizing how, in a post-WWII Liverpool, differing layers of meaning concerning what it actually meant to 'work' came to emerge and gradually shift the city in a different occupational direction. Work (and authentic work) has always been a burning issue in Liverpool, largely because a trading city directly creates a transience of capital, thus employment. Consequently, the linked issues of whether jobs are 'enduring' and equitable have troubled many thousands of trades unionists and employers in the city literally for decades. In tandem there has always existed in Liverpool a cynicism towards the time-related restrictions of work. Thus many different interpretations of what work actually means, have emerged. For example one might consider the little-discussed 'welt' system, where dockers unofficially shared workloads (sometimes away from the docks in (say) one of the pub cellars on the Dock Road, or driving taxis) as a good example of this cynicism. At one stage, Liverpool dockers even went on strike in an attempt to retain such freelance arrangements. Local historian Steve Higginson states:

> Casualism on the docks has only ever been viewed through the lens of traditional labourist historians; i.e. that the system was exploitative, inhumane etc. Yet why if the system was so bad did dockworkers continually resist any changes to

[1] Kuhn, Thomas (1962, r. 1996), *The Structure of Scientific Revolution*; 3rd edition, Chicago: University of Chicago Press, p. 10.

a new system which would have given them 'permanent' work? [...] It was a system whereby agency is central about the controlling and usage of time by the individual/collective worker. Of itself it was also a rejection of labour philosophies that stated 'liberation could be found through work'. The 'welt' was the antithesis of such philosophy. By sharing workloads, a dock gang of six became three; the other three might be off driving a taxi or working the markets: it is the reason that many dockworkers considered themselves 'self-employed' when working on the docks, as the key to self-employment is that one is in control of one's own 'time'.[2]

Equally, one might consider professional musicians as potential controllers of work time. Their work can also be transient and ill-fitting to the regularities of clocking-on and clocking-off: they perhaps work in a netherworld little known by the general public (until they actually come into contact with it). In both cases we have a rejection of formalistic labour beliefs and instead have lives largely built around and representing convergences and contingencies. Perhaps we should view such workers as the co-creators and constructors of the own histories. In Liverpool, we actually have a history of ironized work-based juxtapositions constructed out of exigencies and polarities where a genuine concern over 'real' employment is mixed with a desire for the freedom of 'working for oneself'. It remains interesting that ,while the docker's 'welt' system has been acknowledged more recently as a kind of working-class oral work-based tradition, authenticities surrounding popular music enterprise, and/or self-employment via the popular, have yet to be fully historicized in the city as authentic.

This is perhaps primarily because any underlying authenticities associated with popular music have been regarded, at best, as transient; at worst, unworthy of serious attention. As elsewhere in the UK, in Liverpool popular music activity was/is regarded as both fleeting and inauthentic unless (for some) it appears to have emerged from within the ranks of the working classes. It is to a certain extent ironic that the successful myths-cum-histories surrounding the Cunard Yanks (see Chapter 3) are used as indicators of solidarity rather than (perhaps more correctly) as examples of transient enterprise within an historically-transient city. Even though one might argue that popular music enterprise has represented through history an important ingredient in Liverpool's own particular 'work and time' prescription, it did not 'fit' the communal re-creation models of the 1970s. As a consequence, the resulting oral narratives of the 1980s stereotyped and formalized all fluid work practices. One might even suggest that the oral work-related legends abounding in Liverpool during the 1980s came to distinguish stable and recognizable work-related elements from those bothersome variable units (such as popular music) that did not fit into a specific politicized matrix concerning work. While remnants of 'real' jobs (those which still expressed folklore around working class experiences) were gradually disappearing, and the city appeared to be losing

2 Steve Higginson to Mike Brocken, July 2012.

economic relevance, the stable parts of Liverpool's urban legend surrounding work came to establish sets of opposites – with, for some, the Beatles as an oppositional trope. Sets of opposites dominate during this period of Liverpool's history and can be found in many audiovisual images (or clichés) created during this time, such as in TV's *Brookside* soap opera, the TV comedy *Bread*, or in television dramas such as *Boys From the Blackstuff*, and so on. They are easy to spot: old versus young, life versus death, home versus away, good versus bad, reality versus fantasy. What we have come to know about Liverpool during this important period in its history comes over to us as fact because of the medium within which it has been presented. Too frequently, however, such presentations limit our contextual knowledge: we think we know *who* tells the stories, *when* they are being told, to *whom*, and *why*.

In the immediate wake of the advent of the Beatles in 1963 and 1964, Liverpool came to be regarded as a prescribed 'special' place; after all, the Beatles were self-evidently 'special', having seemingly risen through the ranks of what appear to be 'appropriate' experiences within this specific locality. But if this presumed continuum was a distortion, then we have evidence of a fragmented narrative already broken by the non-relationship between many Liverpudlians and the Beatles (for some, the group forever represented desertion). By the 1980s the inarticulate stereotype was clear: Liverpool was viewed as an 'edgy' city which stretched people's imaginations and critical sensibilities. One wonders these days whether either the surviving Beatles, or indeed the many thousands of Liverpudlians supposedly 'left behind' by the group, actually recognized themselves in such mono-representations. And this was the ironic reality that Liverpudlians had to confront: such images rang far more familiar with those across the world, than they did in Liverpool in 1984. Communication histories can, undoubtedly, tell us a great deal about how we are affected by such representations of place. Beatles histories are of course communication histories, but it is vital that we appreciate that one major part of the history of Beatles tourism at this crucial stage involves an important UK radio station.

Beatle City

Beatle City began as a Radio City initiative in 1981, when the radio station's managing director Terry Smith and his Board of Directors decided to purchase Beatles memorabilia from Sotheby's to create Liverpool's first Beatles tourist attraction. Radio City was by this time a highly successful commercial radio station in Liverpool, created after the introduction of the UK Sound Broadcasting Act of 1972. This Act allowed, for the first time in British broadcasting history, the legal operation of commercial radio. In 1974, Radio City (Sound of Merseyside) Ltd won the contract to broadcast as the independent local radio station for Liverpool and its surrounding areas, with studios at this stage based at Stanley Street, near Whitechapel in Liverpool City Centre. 194 Radio City launched on 21 October,

1974 with Stevie Wonder's 'You Are the Sunshine of My Life' (interestingly, not with a Beatles song) as the first disc played. As reflected in the name, the station originally broadcast on 194 metres medium wave from a transmitter at Rainford, near St Helens on the outskirts of Liverpool. The station was also awarded an FM (VHF) frequency of 96.7, but did not begin broadcasting on that frequency until a few months after its launch, owing to the transmitter being vandalized. In its inaugural years, Radio City was an extremely eclectic station musically, with a wide range of both popular music and classical genres being broadcast. To give just a few examples: Bill Bingham and Rob Jones played a great deal of interesting and unusual US funk, soul and disco of an evening; Phil Easton's 'Great Easton Express' was an excellent rock show; popular folkie Bob Buckle hosted a well-liked folk music programme; Joe Butler of the celebrated Liverpool country band the Hillsiders covered Liverpool's passion for country music; and Philip Duffy, choir master of the Metropolitan Cathedral, was an enlightened classical music presenter. However, as time moved on, the roster and range of music reduced and, in line with other commercial stations across the UK, the output came to be codified by the demographic desires of advertisers. Radio City's popularity among music aficionados was thus diminished and, following popular music's further fragmentation in the 1980s, the station never quite recovered its earlier popularity of the mid-to-late 1970s.

The first major auction of Beatles memorabilia took place at Sotheby's in December 1981 and was an expensive affair for the radio station, with Radio City managing director Terry Smith reportedly spending something like £750,000. Nevertheless, Smith was pleased and excited by his purchases, and looked forward to the next phase in creating a state-of-the-art exhibition space in a building in Seel Street, specially designed to house the collection. From January 1982 onwards Radio City's chairman Ken Medlock became increasingly committed to the Beatle City project and Terry Smith was allowed to bid for further items at an auction in New York in June 1982. By this time Radio City had decided to 'go public' and it was later stated in their prospectus that it was the Board's intention to use part of the money raised from their share issue of that year to finance the structure within which the exhibition would be sited. Further memorabilia purchases were made in December 1982 at another Sotheby's auction, following which, successful requests were made for loan items or donations from private individuals and collectors. A fourth round of purchases took place at another Sotheby's auction in September 1983. Between 1981 and 1984 a building housing a local motor trader's parts department was redesigned by local architect Fred O'Brien, and Beatle City gradually materialized. It duly opened in 1984 with a custom-designed exhibition space created by Colin Milnes, who had previously designed Coventry's innovative museum space, and visitor numbers were expected to be in the region of 300,000 people per annum. It has already been suggested that this figure was probably one of the greatest over-estimations in the history of early pop 'museumification', as several hitherto unforeseen factors came into play regarding this influential, yet somewhat abject Beatles heritage tourism project. Notwithstanding, the *Liverpool Echo*

was upbeat about the attraction's prospects during the International Garden Festival; they wrote in their IGF supplement:

> Beatlemania will help put the beat back in Mersey to coincide with next week's opening of the International Garden Festival [...] A spectacular audiovisual tribute to the Beatles can be found in the £2million Beatle City in Seel Street, featuring a unique collection of memorabilia and items used and worn by the group [...] The International Garden Festival is the hub of the 1984 events but there is plenty more on offer – if you have the energy.[3]

There is little doubt that Beatle City was viewed locally with a mixture of antagonism, ambivalence and downright confusion. Because of the combined mixed reputations of the Beatles, popular music and perhaps even Radio City as a commercial radio station among some locals, few Liverpudlians were to visit the attraction (but of course Radio City were not overly reliant upon this – they wanted 'tourists'). It has even been suggested to this writer that one major goal of Liverpool City Council at this time was to undermine this competing attraction, originating as it did from the entrepreneurial sector of the city. Of course, Beatle City could only be made sense of locally by having a role to play in the contemporary city. As it stood, it contained little poetic sensibility or authenticity at that specific time in Liverpool because it was not legitimizing or being legitimized by current issues. Mike Byrne recalls: 'The only local visitors were the relatively few die-hard Beatles fans who sat around the cafe area all day, with one cup of tea to drink, discussing the merits and de-merits of various Beatles songs and the latest Beatles "news".'[4] In retrospect it is remarkable that the very presence of a seemingly 'innocent' attraction such as Beatle City was seen by some as symbolizing a threat, but this was indeed the case.

Another more practical problem was Beatle City's chosen location, tucked away, as it was, in the club-land district of the city, several minutes' walk from the main business area with little or no passing trade. Radio City presumed that the location was a good one: 'The Beatle City premises are in Seel Street, in the heart of Liverpool's traditional clubland, only two minutes from the shopping centre and within easy walking distance of mainline and underground railways [...] Seel Street provides a sound Beatle pedigree, being close to the sites of numerous locations with significance in the Beatles' early careers.'[5] However, the presumption was ill thought-out, for this area was visually decaying, so that the advent of the attraction was not simply a case of bad timing, but also bad location. Beatles City had arrived during a contest for socio-spatial redefinition

[3] Unaccredited columnist (1984), 'Magical Magnet of the Fab Four', *International Garden Festival Grand Pre-Opening Supplement, Liverpool Echo*, 25 April.

[4] Mike Byrne to Mike Brocken, April 2012.

[5] White, Roger (ed.) (1984), *The Design Brief: Beatle City The Total Experience*, St Annes, Preston, Liverpool: Trans Press / Hargreaves Savory / Beatle city – press pack, p. 3.

in the city and was unable to compete owing to its skewed geographical location and concomitant inappropriate subject-matter. Even though the city centre shops were nearby, they were closed on Sundays; further, the area surrounding Beatle City was less than salubrious, being a mixture of industrial units, empty plots and (during the day) closed night clubs. Buddleias flourished in the broken mortar of adjacent buildings; there was, in fact, little to commend the area.

Those who came into the city of a Sunday, at that time the busiest day for tourist attractions, tended not to walk up to Seel Street. What few tourists could be found moved in and around the museums and galleries on William Brown Street, or else visited the riverside and/or ferries, and were possibly not in Liverpool for the Beatles, in any case. It was a case of ill-defined spatial delineations; there were no through-lines or grid patterns for the tourists to follow. Evidently, in the specific cultural geography of Liverpool in the mid-1980s, not every point in the city space could lay claims to being a 'central' space (even if it was geographically central). This was, in fact, a period when Liverpool was full of marginalized spaces, and the margins were more like endangered species than margin-based creative hubs, such as (say) the concurrent New York 'loft' communities. Under such conditions, it was hardly surprising that popular music historicization came, for some, to represent a pastiche of a chosen past. For certain locals, Beatle City seemed an utter irrelevance, for it pointed towards a time in Liverpool's past that appeared preferential and idealized and bore little relevance to the Liverpool of the present day. Why visit a place that depressingly suggests, either wittingly or unwittingly, that the modern world is tiresome? From the perspective of the mid-1980s for some, the Beatles and the 1960s must have seemed almost like a colourful death mask. Liverpudlian Beatles fan Hilda Smith later recalled to me that she: 'felt in a funny kind of way that Beatle City was sort of inappropriate. I know it sounds odd now but it seemed to be a bit insensitive – you know, with everything that was going on in the city.'[6]

We have already seen that the Cavern Walks development in Mathew Street also opened in 1984 (with the unveiling of a rather dubious statue of the Beatles by John Doubleday – at the time, Paul McCartney's brother Mike allegedly asked 'Which one's "our kid"?') and even here, at the heart of Beatles' activities, footfall was equally woeful. Retailers were difficult to install and customers even more difficult to locate. Another 'nail' in the Beatle City 'coffin' came in 1985 when the wife of Radio City's managing director Roger White was reported as stating that she hated Liverpool; as one might imagine, for Liverpudlians already sensitive to this new and seemingly worthless and ineffective initiative, this rapidly became folklore of some consequence. By July 1984, the lack of cash flow passing through Beatle City so alarmed the Radio City directors that a report was commissioned. Dr P.M. Williamson, on behalf of the radio station, created a document concerning local awareness and reactions to the arrival of the attraction; it made for uncomfortable reading. While Williamson suggested that, given its short period

6 Hilda Smith to Mike Brocken, February 2011.

of existence, the attraction had achieved a reasonable level of awareness amongst locals, he raised several points of alarm. For example, amongst those locals surveyed there was the general opinion that the attraction did not engender return trips. This was something of a blow, for such opinions clearly suggested that this space was not deemed authentic enough – even by local Beatles fans. Further, the report went on to suggest that most locals did not feel the need to visit Beatle City in the first place, and that there was a large cohort of Liverpool residents who did not actually support the presence of the attraction.

Williamson made several recommendations which he felt at this early stage in the attraction's history might alleviate the problems. But his ideas did little to understand, let alone describe, the issues of socio-spatial capital abounding in Liverpool at that time. While Williamson suggested there were variable ways of attracting more footfall, he seemed unaware of the long-standing issues surrounding the emplacement and positioning of the 'heritage' or legacy of the Beatles. While Radio City were undoubtedly regarded as an important conduit in the information sector, they were still 'commercial' in the old sense and competed for authenticity with BBC Radio Merseyside, the latter of which was funded from licence-payers' pockets, thus considered by some to be far less exploitative than their commercial counterparts. Such views 'from below' are at times almost beyond belief; historically, however , the visage one should at least consider is that, by the mid-1980s in Liverpool, an imaginary place in time ('the sixties'), when posited against the contemporary city, did not represent a paradigm of authenticity. Seemingly, Kuhn's 'cultural metamorphosis' was at an extremely formative stage indeed.

For example, Williamson naively suggested that the term 'Beatle City' should effectively belong to the city of Liverpool, rather than one single attraction. But precisely which Liverpudlians in 1984 might agree with such an assertion we never get to know. Williamson also posited that new visitors would require an audio guide and a sample of the exhibition in the foyer to encourage entry, but he was unable to determine exactly what should be 'told' and which voice might be 'telling' it. Williamson thought that the directors should consider offering a mini touring exhibition, local promotions and incentives via word-of-mouth, together with a change of signage. However, if the Beatles had 'deserted' Liverpool and as a consequence were thereafter held in suspicion, what might be the fortunes of a Beatles exhibition leaving the city? (And in any case, was not Beatles City intended to bring people *to* the city, not the other way around?) In retrospect, the report now appears deeply flawed: heavily guarded so as not to offend those commissioning it. It actually informs the Radio City directors of what they did not wish to know (that Beatle City was failing), and did so in a way as to cosset them, while not drawing attention to the most generative problem of all: that countless ordinary Liverpudlians lived in different spaces, for different reasons, below, beneath and/or away from Beatles authenticity and authority. Also that, for many outsiders, Liverpool was still associated with the, by then 40-year-old, model of a dangerous port in decline. It was therefore still extremely difficult to tempt that

Beatles fan, now perhaps approaching middle age, away from the suburbs of (say) north London to Liverpool for a day or so's pilgrimage. The kind of visibility that such an attraction was attempting to create for Liverpool was not essentially a Liverpudlian visibility and the question raised by many locals at that time was 'what is it doing here?' I recall one friend suggesting to me at that time that Beatle City should have gone to London because that was where the group made their international name after 'abandoning' Liverpool.

It was taken for granted by Radio City that Beatle City was in and of itself, a good idea. But the whole project clearly required far greater and deeper research to have been undertaken before even the first brick had been [re]laid. For some, Liverpool as a place had physically declined as a consequence of 1960s inflation-driven wages and prices. The traditions from which objects emerge and to which they refer must fulfill the cultural capital of the society within which they are being exhibited. By the mid-1980s, the era of the 1960s (and the Beatles) was regarded by many in Liverpool as one in which instability and disillusionment were engendered. Therefore, as makers of meaning in the present, such exclamatory objectification was actually devoid of cultural authenticity. Furthermore, a variety of mixed opinions from local Beatles fans about the Beatle City attraction also informs us that they were not necessarily interested in any Beatles museum culture. For some, a handful of Beatles-related 'things' placed in a glass case (which might only duplicate their own collections) was considered rather pointless. Two such examples illustrate this; first, local Beatles aficionado Les Parry stated:

> It's altogether an odd one. For me, it was immediately obvious that Beatle City came at the wrong time, was in the wrong place, and contained the wrong stuff. It couldn't have been more useless, if it tried. While I was by no means a Beatles expert, I knew a lot about this period and was actively seeking out bits and pieces I could afford via, for example, the back pages of *Record Collector* and that flea market type of place that was on the corner of Button Street and Victoria Street (I'd picked up a nice copy of *Mersey Beat* there, as I recall). Beatle City didn't really 'get it', and it didn't really get the fact that unlike me, many Liverpudlians were not in the least bit drawn to Beatles histories as a representation of their culture. I always thought that Billy Butler, the ex-Cavern deejay, understood this because he had moved into local broadcasting, and with Wally Scott his producer, came to be associated with cabaret, Motown, Irish country music and of course 'Hold Your Plums' – the comedy quiz show on radio that is regarded as iconic these days. In the 1980s this was 'Liverpool all over', really, at least as I saw it. And in an interesting turn of events, in the 1980s a lot of the other Merseybeat groups came to be considered more authentic than the Beatles, and a few reformed and gigged; it was as if they hadn't deserted the city, whereas the Beatles no longer 'belonged' – whether they were in a museum or not.[7]

[7] Les Parry to Mike Brocken, October 2013.

While (the late) Dave House, former proprietor of the now sadly-missed *Vinyl Grooveyard* record-collectors' emporium at Chester market, and a Beatles memorabilia dealer, commented:

> To be honest, as a professional record and memorabilia dealer I knew they had spent a lot of money, but I couldn't really see where it had gone. The Mini was a good buy, but I was never really very sure about some of the recordings – they didn't look genuine to me. In any case, it was one of those places where I felt a bit patronized. You know, as collectors and dealers we invest so much of our time in this stuff and get to know so much about it in general that to have a museum tell us what was memorable and worthwhile and what wasn't seemed a bit wrong to me. Beatles fans are very knowledgeable individuals and looking back I don't think Beatles City understood that at all.[8]

Such issues enveloped the initial growth and development of artefact-related Beatles tourism in Liverpool and, as one might imagine, matters did not immediately improve – especially for Beatle City. It was under such circumstances that the decision was made by the Radio City board of directors to relieve itself of the attraction, as soon as possible. As we have seen, in 1986 John Anton supposedly 'purchased' it. His initial intention was to move the memorabilia to the Garden Festival site, but other events were to overtake this plan. Anton had reportedly paid Radio City a £50,000 deposit for the Beatle City business – a fraction of what the memorabilia was worth at auction, of course. New manager Mike Byrne was informed that a figure of £125,000 was actually agreed for the business; however, the figure of £500,000 was later published in the local press at the time of Anton's trial.[9] As for the £50,000, Anton's up-front payment £12,500 sealed the deal, with the balance to be paid in monthly instalments. Byrne does know that the initial £12,500 did change hands, but as for the rest he cannot be sure.[10]

When one considers just how much was paid by Radio City for the memorabilia in 1981, what would now be considered to be extremely rare and valuable popular music assets had deteriorated massively in value: almost to the extent that they were considered liabilities. This is now very difficult to imagine, but it is broadly accurate to state that this was indeed the atmosphere and environment within which Mike Byrne came to directly involve himself in Beatles heritage tourism in 1986. Beatle City was not in the slightest what might be considered a 'going concern'. In fact, it was dangerously close to going out of business and liquidating its assets, for it was clearly unable to generate more capital to remain operational. Mike Byrne recalls that 'from the off' his wages were paid regularly by Anton (rather

[8] Dave House to Mike Brocken, October 2013.

[9] Neild, Larry (1991), 'Anton's Debts to Radio City', *Liverpool Echo*, 18 January.

[10] After Terry Smith apparently 'discovered by chance' that the exhibition was to leave for Dallas, Byrne thinks that he 'probably received more payments'.

than Radio City). He also recalls that takings at the attraction were usually only between £800 and £1,000 per month.

The Job at Beatle City

> Indications of the enormous latent interest and demand are clearly apparent in the success of the Cavern Mecca Beatles Centre in Mathew Street, the occasional concerts organized by Radio City and the Beatle Tours run by Merseyside County Council Tourism Department.
>
> (Roger White, 1984)

When Mike Byrne took over the day-to-day management of Beatle City, there were only two full-time staff, plus an AV (audio-visual) engineer. The latter's main employment was as a radio engineer for Radio City, but it was agreed that he could be called upon should there be any AV problems at Beatle City ('there were many' states Mike). Byrne immediately went into his by now well-rehearsed promotions mode, 'flyer-ing' the city centre and, whenever and wherever possible, enthusiastically advertising the attraction. He appeared regularly on local commercial radio attempting to excite the local community about this unique attraction, and also perhaps to eradicate prejudices concerning both John Anton and the Beatles. However, he was not only unable to convince locals about the business aspirations of the property developer, he could not assuage opinions about the Beatles as deserters, or the 1960s as a time of false hope. Calls to Radio City from listeners could be at times even-handed but also occasionally abusive. Additionally, Mike Byrne was unable to get his voice heard on the powerful BBC Radio Merseyside station because, to them, Beatle City was initially a Radio City enterprise, and the BBC refused to acknowledge the existence of their commercial competitor. Ultimately Byrne also found it very difficult to surmount intolerances concerning the very concept of tourism in Liverpool: 'At times I thought I was in a boxing match. I never realized that opposition was so vehement.' The one media source he could rely upon was that of his former employers *Merseymart*, but John Anton was by this time unable pay for publicity. Anton himself was becoming the talk of the town; the Beatles were symbols for many that Liverpool needed to 'move on', 'get new jobs' and 'get their heads out of the sixties', and tourism was considered almost laughable. For the present-day Beatles fan much of this must seem bizarre, but of course it is completely understandable within the complex contexts of Liverpool's mid-1980s spatiality. Mike Byrne had evidently set about his management with due diligence, and this included introducing himself to Samir Rihani at the newly created MDC/Liverpool Tourist Office. Rihani reportedly showed scant interest in a proposal to jointly co-ordinate a Beatles tourist strategy and, according to Byrne, tended to bracket-off Beatle City with what he thought were equally ineffective and culturally inauthentic 'pop' enterprises in

and around Mathew Street. The primary issues for those nascent 1980s Beatles tourist initiatives constantly revolved around the linked tropes of authenticity and authority, funding and business development. As far as Rihani was concerned, it appeared that not one of these ventures carried the required cultural capital.

Walk-up to Beatle City was duly woeful. A handful of foreign tourists making their way to Seel Street were just about all Byrne could look forward to. He could see, however, at times that they were disappointed and he was occasionally informed by visitors that they were not really looking for a Beatles museum, as such. Indeed a few stated to him directly that they did not wish to see their favourites placed in glass cases, for it limited their imaginations. He was eventually forced to close down the Beatle City cafe because, aside from the aforementioned 'Beatles freaks hanging out in there', few requests for food materialized and perishable stock (and money) was being wasted. Within a matter of weeks of Byrne's appointment, representatives from the Hard Rock Cafe came to view Beatle City. It was initially thought that they might have wished to purchase the attraction, but their interest only lay in obtaining the memorabilia. The problem was that Anton did not technically own all of it, for he had paid only nine-tenths of its sale value. Furthermore, Byrne had to reveal to the Hard Rock team that some items were only on loan to Beatle City (which immediately put them off) and that he was in rather delicate negotiations with the owners of the materials, following the change of proprietors from Radio City to Transworld. The Hard Rock people left Liverpool with their money still in their pockets. Had Anton paid up-front for the attraction, he would in all likelihood, have sold the memorabilia to Hard Rock Café. Such tentativeness informed Mike Byrne of two things: one, that at least his job was relatively safe for the foreseeable future; two, that his boss was still enduring the cash flow difficulties, which led to the closure of the Garden Festival site. 'Had he had the money in the bank to pay-off Radio City, he probably would have done so, to have cashed-in on the memorabilia. But this clearly wasn't the case and I suppose that his bank weren't interested in any more bridging loans, either.' That summer Transworld had advertised extensively on Radio City, running up a bill of £29,000, but by autumn 1986 Anton was forced to admit to Radio City that he could not continue with the purchase of Beatle City.

One interesting turn of events which did attract a little local interest to the venue that year was the purchase by Liverpool-based Beatles fans and record-collectors Steve Phillips, Eddie Porter and Trevor Hughes of the original 1959 Bedford Val Panorama Magical Mystery Tour motor coach. This came to be parked alongside the Beatle City building. The purchase was initially regarded as something of a coup and attracted the attention of the local media and a few curious Beatles people from around the country. It was hoped, perhaps rather optimistically, that the vehicle could be used for tours around Beatle sites; however, not only did none of the owners hold a PSV licence between them, but the coach was, by this time, almost thirty years old and rapidly deteriorating. For a while local coach company Maghull Coaches kept it in reasonable mechanical order; however, this too became an increasingly costly affair and rather depressingly the coach

never ventured out of Seel Street on guided tours. As it turned out the vehicle was eventually sold in 1988 to the Hard Rock Cafe and was shipped to the United States, where it was promptly disassembled. Hard Rock completely refurbished the vehicle; it took four months, 2,000 man-hours and a cost of $100,000 using vintage parts to replicate the original designs and details – money that clearly the enthusiasts in Liverpool simply did not have. Such expenditure clearly suggested that Liverpool's nascent Beatles tourist 'providers' were financially completely out of their league. The authentic Magical Mystery Tour bus subsequently toured Hard Rock venues right across the US, appearing periodically in cities such as New York City and Cleveland. Back in Liverpool (alongside the replica Cavern) several replica buses were purchased and repainted to cater for the increase in visitors.

Two further events that year which also briefly attracted a little local publicity for the attraction were the relaunch of Phil Boardman's 'Much Missed Man' single on Joe Flannery's locally based Mayfield record label,[11] and a Christmas carol concert by the Metropolitan Cathedral Choir led by Philip Duffy (an old school friend of Mike Byrne's from his St Edward's schooldays). Boardman was a promising local singer-songwriter who was being championed by local entrepreneur and friend of the Beatles Joe Flannery. During the Garden Festival, comedian Tom O'Connor's rendition of the IGF 'theme song' had been released locally on Mayfield and sold well (in thousands, in fact) at the festival site. Both events were well attended, although the purpose of the choral concert was to raise funds for their spring tour, rather than Beatle City's bank account. It was shortly afterwards that John Anton (by this time struggling to keep his business affairs on an even keel) introduced to the dwindling Beatle City staff, a man with long ginger hair, a 'new-fangled' mobile phone, and a black Mercedes car: John R Symons. Symons, another property developer based in London, had become the new proprietor of Beatle City, taking over Anton's debt to Radio City. Symons had been briefed by Anton about Mike Byrne's musical background, was also aware of Bernadette's involvement in tourism as a guide and he stated to Byrne that he had faith that Beatle City could be turned around. Mike severely doubted this but kept his thoughts to himself, willing to go along with the new boss as long as his wages continued to be paid. But Symons also declared almost immediately that he had plans, his intention being to tour the exhibition in the United States:

> Symons simply announced that he was the new boss and that the plan was to take the exhibition to America in six months' time, then eventually bring it back to Liverpool and consider a new site for the exhibition perhaps at the Albert Dock. Unbeknown to me at that stage of course was that Symons had no intention of bringing it back to Liverpool – 'just tour it for a while' he said 'and it will make plenty of money in the US and then we will bring it back'. I said OK because it

[11] Mayfield Records MA 103 Phil Boardman: 'Much Missed Man' (1983) – 45rpm vinyl: reissued 1986.

meant that I had some kind of a job – and I was excited by it all, to be honest, but I didn't trust him. I had picked up enough on the business side of things by this time to realize this all sounded very speculative. But it was the 1980s, I suppose and I presumed that lots of business ventures had started on rockier ground that this.[12]

Ensconced as he was at Beatle City, Byrne could see that much work needed to be done, not only at his own personal poisoned chalice, but also across this small sector of what we might now describe as the local Beatles tourist heritage industry. For example, Byrne could quite clearly see that Beatle City was located in the wrong area of Liverpool city centre and that his competitors in this small niche market were based on or close to the more 'authentic' Mathew Street. His thoughts also returned to the equally struggling Albert Dock complex, his own previous enthusiasms for the development, and 'those vaulted ceilings'. But he also held severe misgivings about the way Beatle City was 'museumify-ing' the Beatles and Merseybeat. Byrne recalled:

You would have to remember that in a way I was involved in my own museumification because I was intrinsically linked to all of this stuff: I was a Hurricanes fan, had my own band the Thunderbirds, joined Them Grimbles and then became a Roadrunner – so it felt to some degree like I was putting myself in a museum and I didn't really think it was appropriate that this was what should happen. I kept on asking myself questions while I was sitting there without any customers – why isn't it working? What could I do to make it different? What did Beatles fans actually want? How might I present it? All these questions were largely unanswered, but I thought that I would have done it in a very different way: I'd tried to create a bit of excitement – but there was no atmosphere in Beatle City, that was for sure![13]

One can almost visualize Mike Byrne considering such issues as he sat, mostly alone, in the empty – perhaps ghostly – spaces of Beatle City during the latter part of 1986 and the early, rather desolate months of 1987. Despite the trajectory of the Beatles and the legends surrounding it, surely Beatles fans wanted more than glass cases and artefacts: what they needed, he thought, was an 'experience'. Little did he realize that he himself was about to have the 'experience' of his life.

Dallas

On Sunday 7 July 1987, Beatle City finally closed its doors; but is was not simply because the business had failed. The closure was to prepare for the collection's

[12] Mike Byrne to Mike Brocken, March 2012.
[13] Ibid.

removal to the United States. By August, Mike Byrne, together with practically the entire Beatles collection at Beatle City (aside from the loaned materials whose owners did not wish them to travel outside the UK), was on his way to, of all places, Dallas, Texas, and the Seel Street site was quickly becoming history itself. The unique purpose-built exhibition space was left to rot, while the local fans accepted Hard Rock Café's modest bid for the Magical Mystery Tour bus, and that was removed. While Bernadette Byrne was busy with tour guiding by this time, and achieving her PSV licence while working with the Merseyside Tourism Board, Mike supervised the packing of fourteen large crates of Beatles memorabilia, including Ringo Starr's Mini with its double-sized petrol tank (apparently so that he could return from London to Liverpool without filling up), to be sent by PKM Distribution to Galveston thence Dallas. As Mike Byrne recalls:

> It all happened very quickly and the money must have come in quickly too, so it was probably at this time that South Fork Ranch [see below] showed their hand financially – otherwise I couldn't have imagined Symons being able to afford the transport costs, which were massive, about £6,000 I think, although the packers PKM from Kirkby didn't get paid, as I recall. No-one from Symons' side of things helped to pack – it was just myself, Bernadette [Mike's wife] and two part-timers plus the security guy from the car park – we'd kept the car parking going for a bit of cash flow and he was a great help in packing things. I was told that we were due to open in Dallas on the 7th August, but initially that was all – I was expected to be there as curator, manager, chief guide and the stuff was expected to be set-up and ready to go in the West End shopping mall in Dallas, and that was that. Symons arranged everything, but did everything behind people's backs. Meanwhile I don't know what Terry Smith must have thought about all of this valuable material disappearing from Liverpool – I still don't know.[14]

There were at least three financial investors involved with this removal, with perhaps ironically John Symons being the least able to access ongoing funds. Firstly, there was the West End Market Place in Dallas; this was the revitalized shopping mall, to where the exhibition was bound. In June of 1976, a local developer, Preston Carter Jr., invested millions of dollars in the 'West End Historic District' of Dallas to preserve its history. Old warehouses and other brick buildings were converted into restaurants and shops. The original Spaghetti Warehouse, opened in the West End warehouse district in 1972, is still one of the most popular restaurants in the West End today. Following the Spaghetti Warehouse example, Blackland Properties (now ECOM) purchased the Sunshine Biscuit Company building in 1983 and renovated it as the West End Market Place. This spurred further redevelopment of the area, which is now filled with diverse, one-of-a-kind restaurants and nightclubs. Mike remembers that:

[14] Ibid.

Between the West End Market Place and the warehouse next door was 'Dallas Alley', an entertainment area with a selection of bars, an 'original' American Diner and various music venues. Every taste in music was catered for: country, jazz, rock, and horror of horrors even a bar with 'duelling pianos'. This area was busy every night and had a strict alcohol policy, plastic glasses all contained within the 'Alley'. This was 1987 and I brought the idea back to Liverpool and tried to sell it to the Cavern area but nobody was interested.[15]

Back in the 1980s, such ideas were part of a link between the suburban shopping mall of the mid-twentieth century and a growth in a consideration of US heritage tourism. By the late 1970s and early 1980s, many traditional US suburban shopping centres were in financial difficulties. Years of recession, changing demographics in cities and towns right across the US, and the tendency towards much larger, rather vacuous stores had caused long-term problems for older shopping malls in less prosperous districts. This would continue to be ongoing issue for US retail over the following three decades, and is still a burning issue today. However, centres such as the West End development, in what were to be called heritage quarters were fortunate. They were able to adapt by being rearticulated as 'trendy' loft space areas. West End changed tenants, with one eye on a more leisure-based customer, and demolished existing provision to reconstruct a 'Dallas authenticity' around this urban space. Such 'thirding' of space was unique to its era. Previously, Dallas was not only seen as an ageing oil-based conurbation, but the place where President Kennedy had been assassinated. This reinvigoration, therefore, reinvented the west end of the city as a place of adventure and excitement; it could be described as a forerunner of the mutations between tourism ideas and retail spaces later interpreted in the US as 'power centres'. By the time of Mike Byrne's involvement in 1987, the mall was managed by Robert Boyd. Security was handled by an ex-sheriff and his right hand man, Jesus: 'I was given my own office and all the West End staff were very helpful and really excited to be hosting "Beatle City".'

The second major investor in the Beatles exhibition in Dallas was Terry Trippet of South Fork Ranch. On 17 May 1985 the *Los Angeles Times* had written:

What 'Dallas' Has Wrought

PARKER, Texas – The 1,300 folks fled the noise and bustle of Dallas for the tiny town of Parker, but now Southfork Ranch – setting for the 'Dallas' television show – has brought Parker a fair amount of noise and bustle itself.

Every day about 2,100 tourists, outnumbering the locals 2-to-1, trek to the town by car, bus and even horseback seeking the home of the mythical Ewing family of the 'Dallas' television show.

The custom built 8,500 square-foot, six-bedroom mansion used for the series is located on a 200-acre horse and cattle ranch formerly owned by Joe

[15] Ibid.

R. & Natalie Duncan who built what was to be 'Southfork' in 1970 from ideas picked up from their many visits to mansion and ranches around the country. When location scouts for the DALLAS series saw the Duncan's white four-post facade, the Ewing mansion was born. As a publicity stunt, the Duncans sold off a few of their acres to hungry DALLAS fans who craved their own chunk of the Ewing spread. The price tag was $25.00 a square foot. Their teenage sons sold Southfork tee-shirts out of an old Dodge van by the property's gate and by 1981 tourists were paying $4 to visit J.R.'s stomping grounds. After the Duncans sold their ranch, the new owner, Terry Trippet, who headed the Colin Commodore Ltd. partnership charged $6 each to each of the 500,000 tourists who visited Southfork. For $2,500 a night, one could sleep in J.R.'s upstairs bedroom and for a modest $2.00 charge one might sip tea on the balcony or eat a $13.95 breakfast of eggs, biscuits, and gravy (both Bobby's and J.R. Ewing's favorite dish).[16]

Since purchasing the house from the Duncan family (who apparently sold it because after the arrival of the *Dallas* TV series, they had lost their privacy), Terry Trippet had added a convention centre, a party pavilion, a rodeo ring, and several gift shops. He also added a brightly painted, red, white and blue oil rig which reportedly cost him $9 million dollars to purchase and erect. When the 183-foot rig was dedicated 1000 black helium-filled balloons floated from the top of it to symbolize a stream of gushing oil.[17] Trippet was able to financially guarantee the Beatle City exhibition in Dallas. Each of the three major investors was to receive one-third of all ticket sales and merchandise. Additionally, (to his credit) John Symons sought, and found, several substantial sponsors. British Caledonian Airlines, Lincoln-Mercury, Lotus Cars, plus the local Dallas Q102 radio station were all willing participants. Mike Byrne also recalls that Pepsi showed some interest in the project and that:

> Bernie [Mike's wife] was rather worried about it all but I was very excited – especially as the day for departure drew ever closer. Not long before leaving, Symons came to see me and stated that we were to be in the US for four months, including a visit to San Francisco and then we were to visit Japan! Blimey how much more exciting could it get? So I threw myself into it and handled all of the negotiations with PKM. Symons would turn up once each week sending faxes all over the place – typically 1980s![18]

[16] Unaccredited article (1985), 'What Dallas has Wrought', *Los Angeles Times*, 17 May; see also Giddens, Sally (1989), 'The Real J.R.', *D Magazine*.

[17] By 1 January 1991, control of this popular tourist attraction was taken over by Glenfed Financial Corporation because Trippet could no longer afford the mortgage payments. By 1992, the ranch had been purchased at auction for $2.6 million by Rex Maughan, an Arizona businessman.

[18] Mike Byrne to Mike Brocken, April, 2012.

The Byrnes' son Matthew was by this time a 17-year-old apprentice at RAF Sealand, near Chester, and their daughter Ali was 14 years old and a schoolgirl at Belvedere School for Girls in Liverpool. The plan was that, by the middle of August, Bernadette and the children would join Mike for a few weeks until it was time for them to return home. 'Symons wanted Bernie to be in Dallas the whole time I was there acting as a tour guide but that was impractical as she had the kids to look after, not to mention her own tours, which had slowly started to increase.'

Byrne arrived in the 90-plus degree heat of Dallas on 3 August 1987. He was immediately taken to the fourth floor of the West End Market Place where at that stage air conditioning had yet to be installed (or else it had broken) and the temperature was 107 degrees:

> I was like a wet rag for four days. I had twelve very willing and friendly Mexicans to carry up all of the artefacts to the fourth floor. Ten of them carried Ringo's Mini up the escalator – it was all done by hand, believe it or not. I then met three US collectors: Mark Navashek, Marc, and Doug Green. (Navashek was an ardent collector of autographs, Mark #2 had an amazing collection of album covers and Green was the memorabilia collector.) They had agreed to contribute to the collection and their stuff was thankfully already in place. Joanna West, the designer for the exhibit had already arranged this and had mounted everything. John Lennon's living room was in place (an early example, perhaps of US interest in Lennon as a youth), and all the show cases were built as we went along.[19]

Notwithstanding West's evident artistry, much of the decorating and creative materials only arrived after Mike. By the 7th of the month some of the paint was still a little damp, other areas had not been fully painted, and there was packing sawdust everywhere. ABC, NBC, CBS and all of the local stations in Texas were watching Symons and Robert Boyd of West End open the exhibition on time, while Mike Byrne and Joanna West were at the rear of the exhibition placing materials in cases, and their Mexican assistants were clearing up. It was a very successful opening weekend with an enormous walk-up, indicating to Byrne the difference between Liverpool's lack of interest in, and Dallas' passion for, the Beatles. He was to discover the next morning that the exhibition's opening had even made the front page of *USA Today*.

Reviews then began to pour out of the US press and they were all mostly positive – the only such exhibit in the world, Dallas had it, and so on and so forth. Some reporters did ask the question 'why Dallas?' Mike Byrne did not know the answer to this, but suspected that the offer of quick money, and the presence of Southfork Ranch, was possibly at the root of it all. There might have been bigger and better pickings on the West or East coasts of the US but he figured that the Dallas investors had offered Symons a quick kill, rather than a long-term

[19] Ibid.

investment. This would have suited the Englishman who, like his predecessor Anton, appeared to Byrne to be constantly short of cash (yet conversely always involved in 'big deals'). If the exhibition were to move to San Francisco, he thought, this would surely be yet another short-term deal. It was Byrne who dealt directly with Robert Boyd of the West End Market Place and he quickly worked out that West End also appeared desperate for cash flow. They had arranged ticketing for the exhibition via Ticketmaster so that the takings, less Ticketmaster's commission, flowed through their bank account first. Boyd was also keen to make sure that the merchandise agreement was followed to the letter, thus the product takings flowed through West End's accredited tills. Trippet of Southfork could also rest assured that ticket sales would come to him early because the Southfork attraction also dealt directly with Ticketmaster. However, both parties probably failed to take account of Ticketmaster's large rake-off; they were both left holding smaller percentages than they felt they were entitled. Meanwhile Symons was seeing very little money at all and, given his already somewhat parlous state, began to worry. One presumes that there were Beatle City bills to pay: perhaps part of the transportation, his acquired debts to Radio City, maybe even rates on the old Beatle City premises, Mike Byrne's wages and living expenses:

> As a part of the deal I was promised the use of a car. It took about 3 weeks to sort this out and eventually I was loaned quite a nice but aging 5-year old Audi. This was invaluable as I was able to take the family to Memphis and eventually use it to commute to my new temporary accommodation.[20]

By September 1987 Symons had still not received any remuneration for his investment. It also transpired that, via a new arrangement not known to West End, Trippet was now receiving all ticket sales through his account. He had informed Ticketmaster that all ticket receipts were to proceed through Southfork's books to boost his own takings. Therefore, other than merchandise sales, West End's cash flow had dried up. Symons was still receiving nothing at all, and Mike Byrne was worried about his salary. What made matters even more thorny was that earlier cash flow projections had not been met. This fall in walk-up might have been easily predicted: it was drawing towards the end of the summer holidays, the weather had been immeasurably hot and the West End did not have adequate air conditioning, and (as Byrne might have advised) any Beatles exhibition would not attract revisiting, at least on a regular basis. Unlike, say, a natural history museum or other attractions such as zoos or amusement parks, a Beatles exhibition in a hot shopping mall was probably, for visitors, something of a one-off.

Mike Byrne recalls being paid properly, at least to begin with, but after six weeks at the Sheraton Hotel in Dallas he received a letter informing him that the hotel bill was four weeks overdue. Symons blamed West End, West End blamed Southfork. Mike had been joined by Bernadette and their children in Dallas, but

[20] Ibid.

they returned for the school term. As soon as his family had returned to Liverpool, he began looking for alternative accommodation and found a Lexington Suites Motel on the highway out towards Dallas Airport. This was more suitable, for he did not wish to spend his free time around Symons, finding him to be too much of a '1980s "yuppie"' ('call me JR' was his usual introductory sentence):

> In my humble opinion, 'JR' was probably being screwed by a genuine cowboy [Terry Trippet] and there was nothing he could do about it. He was probably a little out of his league, if the truth be told and by September, as I recall, his assets had been frozen. I was locked out of the exhibition for a while during that month. Then matters were resolved until November, when I was due to fly home for a break.[21]

Before leaving for home in November, Symons informed Byrne that they were extending their run at Dallas into 1988. Back in Liverpool, Byrne visited Samir Rihani at the Merseyside Tourism Board, who confirmed to him that thus far no arrangements had been made by Symons to bring the exhibition back to Liverpool. This astounded Byrne for, despite the extended run, he had presumed that plans were well in hand to return to the city of Liverpool at a brand new exhibition space at the Albert Dock. Upon his return to Dallas, Mike ensured that he received his month's salary, plus a return flight home to celebrate Christmas. As soon as the cheque cleared, he flew back to the UK, arriving at Gatwick on Christmas Eve,1987. On the train from London to Liverpool, he made the personal decision not to return to Dallas, Texas – upon which, the train promptly broke down.

Summary

What always seems to be at stake in discussions concerning this postindustrial reinvention of work, space, place and lived time, is the issue of how we go about discussing the heterogeneity of lived space and recording complex discursive artistic activities. Historically, the decades of the 1970s and 1980s illuminate to us that foundational logics were under pressure and that emancipator projects came to dominate the processes involved in the reinvention of cities and towns, and the multitude of operations that we know as work. New ideas came to be, suggesting that all spaces, but especially reinvented and rearticulated built environments, were becoming every bit as important as industrialization. The significance of identifiable places representing specific pasts seems to us now to be a 'given', but in the eras discussed above a cultural and spatial heterogeneity in the form of pluralism came to challenge sense of identity. Indeed, by examining the tortuously slow development of Beatles tourism in Liverpool at this time, we can at least posit how identity was challenged and how it became more or less a floating

[21] Ibid.

signifier. Popular music heritage tourism and historicization helped to bring about changes in the organization of major cities and in the ways in which cities were imagined – not simply Liverpool, but also Dallas, Texas. One presumes that the question was asked on innumerable occasions 'why Dallas?' – to which the reply might have been 'why not?'

However, this was also part of how cities and city spaces were able to construct, to a certain degree, a new form of social reality. The Liverpool of the 1980s can be understood as a vast argumentative texture through which people threaded themselves, came and went, and constructed their own senses of reality. The wider social effects of space, together with new patterns of urban production of place, played a shaping role in the construction of a radical imaginary, in which popular music took on new forms and new functions. Beatle City failed, but we can see that ideological positions and a wide variety of mechanisms have to connect up before a collective sense of belonging via the representation of music and place can occur successfully.

Appearance acts as a signifier; so too does sound. But, as a language, popular music does not always 'speak' the same language to those outside it, and no matter how much it is suggested that it can be 'collective' or 'representative', music and musicians can be seen as 'emic': insiders with insider pursuits. Perhaps for Samir Rihani, popular music musicians were self-segregating with their own cultural capital and their own ways of behaving. As has already been suggested in this chapter, in Liverpool (as in many other places), popular music was (and still is) associated with hours and places of work not always fitting within mainstream life. For some, the life of a popular musician might have indicated one of impenetrable 'insider-ship', a hermetically sealed 'other' world of 'show biz kids' lacking the required cultural capital to promote Liverpool in the 'correct' manner. The socialization processes identified with popular music might have also been viewed by some as transient and disunified; producing some kind of coherence, perhaps, but only within narrowly defined social contexts. Certainly any representations of a popular music past also ask us to determine how we define our present. For some locals, such definitions were not acceptable. All such issues continue to be context-dependent; what people say, what values they hold dear, and how such values come to express a world view, all depends to some extent on the peculiarities of the situation. Popular music tourism in the name of the Beatles was potentially one of the greatest gifts to have been bestowed upon a city by its native sons, yet it appears from this historical perspective that, unlike the visitors to the West End Shopping Mall in Dallas, Liverpudlians had already decided that this particular bestowal was not at this time an acceptable part of Liverpool's cultural environment.

Chapter 6

'The Long and Winding Road'
to The Beatles Story

The kind of building [required] is one which encourages precisely the commodity aesthetics and the conformity of consciousness of a media-saturated society […] characterized by pluralism, anthropomorphic humanism, multivalence and […] 'double-coding'.

(Thomas Docherty, 1993: 266)

Back in Liverpool: Feasibility?

By the time the New Year of 1988 had arrived Mike Byrne was, like many of his fellow-Liverpudlians, officially unemployed. But he was determined to get back into self-employment and promote his concept of a permanent Beatles exhibition-cum-experience at the Albert Dock in Liverpool. Regular appointments were made by him to meet the Merseyside Tourism Board throughout January of that year. At these meetings Mike would make pitch after pitch for a Beatles exhibit at the Albert Dock, he would contest the charges of a lack of authenticity of the group, he would explain why Beatle City had failed, and he would provide evidence that there was a growing need to make financial use of this 'once in a lifetime opportunity'. But it all fell on deaf ears. He even provided evidence that uses of the moniker 'Merseyside' were ineffective. From his recent experiences in Dallas he had learnt that few people in the United States with interests in the Beatles had even heard of Merseyside:

> I argued almost to the point of distraction that one could not be in Dallas, Texas with a Beatles exhibit and tell everyone we had just arrived from 'Merseyside – the Birthplace of the Beatles'. They would say 'what about Liverpool?' But I couldn't get through to the tourism board at these meetings that that the Beatles were the 'unique selling point' that *Liverpool* had over Birmingham, Leeds, Manchester, etc. Memphis has Elvis, Stratford has Shakespeare; nobody seemed to want to listen.[1]

Byrne would often attend these meetings, accompanied by Dave Jones, the former taxi-driver who had set up Cavern City Tours with ex-teacher Bill Heckle. All of these entrepreneurs were deeply frustrated by the lack of tourist board proactivity. Rihani would simply repeat the mantra 'the Beatles are passé' at his

[1] Mike Byrne to Mike Brocken, April 2012.

newly appointed offices on the Albert Dock. There was little sense of progress: a decided lack of vision concerning a Beatles 'legacy' to the city; little or no strategy concerning how Liverpool could benefit globally via the Beatles 'brand'; little or nothing discussed concerning a retail development tie-in with heritage, such as Byrne had experienced in Dallas. Next-to-nothing productive ensued concerning how the Albert Dock and the riverfront might be linked to the rest of downtown Liverpool. Nothing was discussed concerning creative 'hubs' or 'clusters'. Liverpool's transport infrastructure was weak, with its airport and major railway station in economic and physical decline, yet there appeared few constructive suggestions, let alone solutions. Even if tourism were to somehow manifest itself overnight, there were not enough hotel rooms in the city to cope. Byrne now thinks that Rihani suggested a feasibility study to him to 'just get me out of his hair'. Whatever the reason, he was given a unique opportunity: to conduct (for the princely sum of £1,500) a pilot feasibility study concerning Beatles tourism; a few local gigs with backing tracks helped to supplement this rather meagre income. Meanwhile, Byrne found out from his contacts back in Dallas that all was not well. The exhibition had reopened in January, but was far from successful:

> From the information I got from my contacts, West End Market Place put a stop on Beatle City trading, and would not release the memorabilia or merchandise until Symons paid some money to cover their costs. I heard that Symons got a Scandinavian bank involved. They must have financed Symons with the memorabilia acting as insurance. I don't know what happened with Southfork. The exhibition was eventually shipped back to a shed near Heathrow Airport while Symons arranged with the Trocadero in London to house the exhibition with the new name 'Beatles Revolution'. It was a poor recreation of the Dallas exhibition without any 'wow' factor. Bernie and I went to see after it had been open a month. It was empty and after we had seen it we gave it 3 months. Predictably it closed about 3 months later. We then heard from various sources including Symons soon to be ex-wife that the bank was going to sell off the contents off in auctions – how sad.[2]

The collection was indeed broken up and sold off – to whom and where, Byrne does not know. After almost a decade, the artefacts purchased by Terry Smith for over £1 million had vanished, presumably to private collectors all over the world.

Mike Byrne commenced his feasibility study by not even knowing exactly what constituted a feasibility study, per se. He was informed by his father that it involved 'figures and finances with future projections'. As a matter of contingency, his father's accountant Chris Morland of Langton Morland (later accountants for The Beatles Story) was brought in as an advisor. Morland's suggestion was that Byrne's primary concern should be to display that sufficient cash flow could be generated; this, he argued, might convince the council that any investment from

[2] Ibid.

them would not be poured into a bottomless pit. Pam Wilshire and Ron Jones duly assisted in gathering tourist figures: how many people were visiting Liverpool and staying overnight; how many jobs were being created, and so on. Also (importantly) how many were visiting the city *because* of the Beatles (according to Byrne, this proved inconclusive). Of course it was simply impossible to provide statistics for those employed solely in tourism-related industries at this time because such businesses could not exclusively rely on tourism to survive. Byrne concedes that some figures were probably inventions: estimated guesswork that concocted stats from fractions suggested by central government data re domestic and overseas tourist contributions to GDP. He recalls visiting all local museums and galleries, in order to garner some available figures. All such data (but particularly the local materials) proved useful because, despite the Merseyside Tourism Board barely advertising the Beatles at all, they suggested that there might be evidence for a little optimism.

The sector had actually expanded a little: that year Cavern City Tours had asked Bernadette Byrne and Sheilagh Johnston (later manager of The Beatles Story) to help them in their own slowly expanding Beatles guiding venture and by the following year were operating a daily bus service of Beatles tours around the city of Liverpool. At least from Mike Byrne's perspective, he thought that CCT were brave and ambitious: 'They were always ready to give something a go and I admired them for that. Also if something didn't work, they stopped doing it so as not to lose money willy-nilly.' Throughout this period, however, Byrne was still not thinking that he would help bankroll such an attraction himself. His meetings with Merseyside Tourism Board, and occasionally Arrowcroft (the dock developers and landlords), continued to prove frustrating, 'but useful, at least as far as information gathering for the feasibility study was concerned'. For example, he learnt (as suspected) that between 1984 and 1988 there were almost no profits from any retail operations on the Albert Dock, and Arrowcroft were charging not only £25,000 per annum in rent, but also another £25,000 as a service charge. Businesses on the Albert Dock had to make at least £50,000 p.a. before even beginning to pay staff, which was an impossible situation.

Even so, Byrne was still convinced that the Albert Dock should be the prime location for a Beatles exhibition. After three months, the feasibility study was submitted during March 1988. The findings of the study appeared unequivocal as far as Beatles tourism was concerned. As a result of Byrne's research, he was convinced that a permanent Beatles exhibition was a long-term viable proposition, drawing in not only visitors with spending power, but also helping to create new types of jobs that relied upon information as a primary means of employment (guiding, retailing and suchlike). A survey conducted on behalf of Byrne's study in the Lime Street Tourist Information Centre was one of the most revealing aspects of this document. Submitted at the end of March 1988, it can be seen as a fascinating historical document in its own right.

The Feasibility Study

Following a short introduction, the report was divided into four chapters, followed by six appendixes. It was found that 44 per cent of people visiting Merseyside were influenced in their decision by Liverpool's association with the Beatles. The same survey illustrated that 46 per cent of these visitors (20 per cent of the total sample) were disappointed to find not a single existing Beatles attraction in the city (this was of course, post Beatle City). If one was to believe the visitor figures to the Albert Dock in 1988 of 3.5 million, then it seemed likely that something in the region of 700,000 visitors to the Dock attraction in 1988 were looking for something 'Beatles-related'. If 3.5 million visited the dock every year, the report suggested that the daily average might be in the region of 6,500. While the Albert Dock shop-owners had to endure seasonal variations from October through to March (and during this period they were fortunate to see 10 per cent of that figure and then only at weekends), Beatles-related tourists might give these non-seasonal figures a boost. The report also drew on earlier conceptualizations surrounding the failed Beatle City attraction. A visitor survey had been conducted in 1985, and while it was clear that Beatle City had not fulfilled its role in becoming a major attraction, and had ultimately failed as a business, the survey did show that during its existence it was 'the most popular attraction on Merseyside for day visitors, attracting 18% of all respondents to the survey'. Such information was useful and, while not in any way 'scientific', showed that Liverpool was probably missing out on millions of pounds, especially from day visitor trade.

The first chapter dealt with two important points: at point 1.3 there is a study-cum-questionnaire of Beatles-related tourism conducted at the Lime Street Merseyside Tourism Board shop and offices in March 1986, and at point 1.5 the failings of Beatle City are illustrated, both of which make fascinating reading. The results of the survey were very helpful to Mike Byrne's case for they suggested that over 500,000 visitors each year came to Liverpool directly as a consequence of the Beatles. Although these days this figure seems small, it must be remembered that Liverpool was barely a tourist attraction at all at this stage. In fact the information was even more unequivocal for it suggested that one-third of all 'pleasure visitors' staying overnight in Merseyside (i.e. not simply Liverpool) hotels stated that their prime reason for being in the city was the Beatles. This was significant information, for it appeared clear that hoteliers had already realized that their mid-to-late 1980s trading was supported to a large extent by popular music tourism.

Mike Byrne was able to provide several interesting contexts concerning the failure of Beatle City; for, while there did appear to be some measurable growth in tourism during that mid-1980s period (and that tourism initiatives included Beatles-related events and interest), Beatle City had failed. Byrne, via his direct involvement with Beatle City, was able to propose why this might have been the case and suggested, in so many words, that Radio City's mismanagement, a poor site location, and the attraction's speculative ownership led to its decline. However, he also cited other issues that would eventually resurface once his own The Beatles

Story attraction came to be established some years later: For example, the local resistance to all things Beatles, admission rates pitched too high, projections of visitor numbers grossly overestimated, and a non-changing exhibition; it was also suggested that any expectation of repeat visits would continue to be problematic, while the above were not dealt with. The interesting data drawn from the Beatle City example was that during its lifetime 30 per cent of all its visitors were non UK residents. So, the report identified several important areas that needed to be noted, if another such attraction was deemed viable. This section of the study concluded by stating:

> In 1986 ownership of the exhibition changed and the Albert Dock was suggested as a more desirable future location. In 1987 the exhibition moved, supposedly on a temporary basis to Dallas, Texas, where it ran for 5 months [...]. There was a suggestion that it may go to Japan, but at present it is still in America with no plans to bring it back to Liverpool [...] once the word has got around that Beatle City is no longer here it is extremely likely that the number of overseas visitors attracted by the Beatles connection will begin to gradually decline.[3]

Chapter two of the feasibility study dealt with the proposed location of the new exhibition. It was envisioned, of course, to be at the Albert Dock. Mike's interests in the complex contained a serious logic, for, as has already been suggested, the vaults of the Albert Dock, specifically those in the Britannia Pavilion, were very close in appearance to the original Cavern Club in Mathew Street. Coupled with this were the pre-existing shops and restaurants, plus the then-recent news that high street retailer Next had announced a move into the complex. The Tate Gallery was due to move to the Dock the following year, hoping to attract 500,000 more visitors than the 350,000 that had visited in 1987. This chapter also discussed the potential for memorabilia loans and key elements of the exhibition surrounding audiovisual materials. A recently announced £26 million investment which was to include Europe's largest indoor ice arena, a 12-screen cinema complex complete with IMAX, and an 80-bedroom quayside hotel (none of which transpired, at least in the development as suggested) was also cited, as was the fact that by 1990 it was estimated that the Albert Dock would have a living and working population of 4,000. The third chapter attempted to lay out a marketing strategy which also included a significant section concerning how a social compact could be sustained as times and contexts changed. This included The Beatles Story hosting an education department which would encourage local schools and colleges to visit, and for the potential of outreach (also discussed in appendix five). Chapter four included projected staffing levels in addition to a future projection for exhibition tours, based upon Williamson's earlier model for Beatle City. The report, therefore, brought together both contemporary and historical information. Byrne used, but

[3] Byrne, Mike (1988), *The Beatles – A Magical History Tour*; feasibility study commissioned by Merseyside Tourism Board.

in the light of first-hand knowledge of the failings of Beatle City also critiqued, Williamson's earlier Beatle City report.

Mike Byrne's own thoughts once more turned to the concept of an 'experience': something which was heavily criticized by cultural commentator Robert Hewison that very same year. Byrne's logic was that an experience would be less likely to fossilize local culture, time and space, and was more likely to work as an attraction. As we have seen, Beatle City failed to address the inherent conflict that arises when popular music is historicized. Making decisions based upon the long-term stewardship of popular music, and how changing tastes affect patterns of collecting, is paramount if popular music is to be represented correctly. Byrne later confirmed to this writer: 'As I've said, I couldn't imagine the Beatles as museum objects – I shuddered at the very thought, and also thought popular music and its artefacts needed a delicate balancing act to make the contemporary and the permanent cohabit.' On balance, the new direction Byrne suggested was a route toward sustainability: 'It was better, I thought, to develop a Liverpool-based exhibit that did not collect, and needed no endowment. I didn't think harpooning the Beatles, museum-style was the right approach.'[4] The key objective of Byrne's feasibility study was, at heart, the consideration that any Beatles exhibit was *primarily* a tourist attraction, and should eschew institutionalized museum space; this was in many respects verging on the revolutionary. If any main goal of a feasibility study is to assess the economic viability of the proposed business, then this was a very good document. The study attempted to answer the question: 'Does the idea make economic sense?' and included a review of all possible roadblocks that might stand in the way of success.

Byrne was hopeful that the study might force the Merseyside Tourism Board to assess whether or not such ideas were realistic. It might even, he thought, force them to begin formally evaluating which steps to take next regarding Beatles tourism. But this was not to be the case. Samir Rihani might have hired Mike Byrne as a consultant to conduct a feasibility study, but by being independent of the MTB, Byrne was not considered to be in a better position to provide an objective analysis of the proposed venture. Even though the study examined three key areas – market issues, technical and organizational requirements, and a financial overview – MTB were not willing to take the study one stage further: a business plan. They had little knowledge or experience of the *type* of industry that Byrne planned to enter. Significant questions might have been asked of the document, for it was undoubtedly rooted in the Williamson report of 1984: What were its primary features? What were its possible target markets? What demographic characteristics were discussed? How large were these markets? What was the financial break-even point? Was the market expected to grow in the future? Would the Merseyside Tourism Board be competing in a mature industry or a growth industry? But it received scant acknowledgement from the chief executive or members of his Board. Byrne now feels that the MTB 'never really had any intention of following

4 Mike Byrne to Mike Brocken, April 2013.

it through; they simply did not wish to be associated with the Beatles. I told them there and then that I would do it myself – I think someone sniggered.'

Byrne then pursued Samir Rihani for some kind of support or assistance in the development of a business pan. Although Rihani had commissioned the feasibility study, according to Byrne he 'had probably not read it; I think he thought it was just a way of keeping me out of his hair, but this strategy back-fired – I think I almost stalked him at one stage for assistance'. It was to no avail; at one meeting Rihani informed him 'the Beatles are passé'. At the same meeting he also learnt that one of his long-term allies, Ron Jones, had been demoted under Rihani's regime, which further convinced him that as long as Rihani was at the helm, the Beatles were strictly off the tourist agenda and that funding would not be forthcoming from the MTB. Pam Wilsher, however, carried on regardless, and here Byrne saw an ally who could feed him important information without her compromising her position; she dutifully confirmed her support by unofficially providing significant statistics, and by organizing Byrne's presence at British travel trade fairs. With the assistance of Wilsher, Byrne was also able to visit the important World Travel Market Fairs in London. He found this a very tough nut to crack: convincing tourist operators to include Liverpool in their catalogues and on their agendas, but finding the word 'Merseyside' a hindrance:

> Even in the UK 'Merseyside' was totally counterproductive to Liverpool and the Beatles – people thought Merseyside vague and unappealing and even though Liverpool had a mixed reputation, it was still the birthplace of the Beatles – Merseyside on the other hand expressed nothing. Many didn't even know where Merseyside actually was.[5]

'Merseyside'

The roots of this 'Merseyside' problem lay in the 1974 government redrawing of county boundaries. Whereas Liverpool once existed as a Lancashire town (and Birkenhead was in Cheshire), following the redrawing of these boundaries, a new administrative county was formed: Merseyside County Council. This was not a county in the old sense, where natural features such as rivers would signify boundaries, but was more a homogenized entity created up by civil servants to ease money collecting. MCC's powers lay in financial administration and towns and boroughs on both sides of the river Mersey, such as Birkenhead, Wallasey, Bootle, Liverpool and even, to the north, Southport came under its auspice. It was an unpopular, unwieldy invention and, locally, lacked practically any cultural capital, other than providing local government jobs. Speaking as a Liverpudlian, my memories of that time are that I cannot ever recall informing anybody that I was from 'Merseyside', for it was to me a meaningless term, connoting civil

[5] Ibid.

service bureaucracy rather than any real sense of place. It seemed to me to be a legacy of the 1960s 'big is beautiful' bland school of understanding regionality (and Liverpool was neither big, nor bland). When my family moved across the river Mersey to Birkenhead in 1971, I felt that I now belonged to a town that was in Cheshire, not Merseyside (after all, I thought, the very word 'Mersey' is Anglo-Saxon for 'boundary'). Even by the late 1980s the term carried little capital concerning the innate heterogeneity of the 'places' within its homogenizing moniker; for many it merely connoted BBC's local radio station: BBC Radio Merseyside.

The Merseyside Tourism Board was therefore, perhaps rather foolishly, constructed out of four different local authorities within this monolithic invention: Wirral, Liverpool, Knowsley and Sefton. All four had completely different demographic bases, thus different ideological agendas. For example, the town of Southport, known for its surrounding golf and holiday entertainment, was fiercely independent from Liverpool, yet became bracketed with this city as part of a 'Merseyside' tourism portmanteau; the Wirral peninsula, home to the two towns of Birkenhead and Wallasey, and myriad small villages, was also marketed as a 'riverine' Mersey-based attraction, which was odd when at least 60 per cent of its coastline lay along the Dee estuary and the Irish Sea. These days such logic almost beggars belief, but the Merseyside Tourism Board was undoubtedly constructed because not one of these four local authorities could, on their own, financially support tourism initiatives. While Southport enjoyed several world-class golf links, its promenade gardens and pier were in need of renovation; although the Wirral peninsula was a pleasant enough area, the towns of Birkenhead and Wallasey (the latter of which included the 'problem' former resort of New Brighton) were in places dilapidated; Bootle was struggling for any sense of identity, and the more Deeside-based towns such as West Kirby, Heswall and Neston tended to look towards Chester for their collective sense of identity.

Mike Byrne decided to go it alone; he set about designing and costing the much-needed attraction himself, and accountant Chris Morland duly helped him turn the feasibility study prepared for Merseyside Tourism Board into a workable business plan: this was ready by March 1989. Hard figures were required to convince potential investors, but these were few and far between owing to the aforementioned lack of co-ordination. The original projected budget for 'The Beatles Story' was £375,000 and the original investors were as follows: Phil Birtwistle of *Merseymart* stood for £100,000; Mike Byrne arranged a loan of £25,000 from his bank while his father also loaned him £15,000. Birtwistle knew Neville Kelly, an interior designer who also put in £50,000 (Neville's wife owned the locally renowned Waldman's fabric store in Kempston Street). Another business colleague of Birtwistle and Kelly, Clive Henderson, stood for £100,000. There was also the promise of a £60,000 grant from the English Tourist Board (it was supposed to be a loan but as far as anyone can tell it was never repaid). Mike next visited Peat Marwick McLintock, the respected accountants for Madame Tussaud's in London, just to see what they thought of his financial arrangements.

Tussaud's had the 'experience' element that he was looking for, so he thought that their accountants would at the very least be able to peruse his paperwork and tender constructive advice. They came back to him within a matter of days with chastening news: restricted by what they considered to be underfinancing the proposed Beatles attraction would most assuredly *not* make a profit for the foreseeable future:

> They bluntly informed me 'you simply can't build an exhibition for £375k to generate £650k – you have to double your estimate to £750k, so they clearly stated I needed far more capital investment. £375k won't buy a 'wow' factor. I had also always wanted to be in the Britannia Vaults at the Albert Dock – I suppose I was fascinated with the concept of the Albert Dock, but it was also very practical and even though I knew several businesses that had foundered down there I just knew in the fullness of time the place would make a profit – especially, of course if there was a Beatles attraction there. When the idea of renovating the Albert Dock was first conceived, Michael Heseltine or Arrowcroft were calling it the 'Covent Garden of the North'.[6]

Nevertheless promotion began with a series of flyers announcing that The Beatles Story would open in 1990. A trickle of publicity followed, but was it was remarkable how little interest was taken by the local media in the project at that stage. In any case, the flyers had ostensibly been prepared for the World Travel Market Fair in London for November 1989; however, because certain fees had not been paid by Merseyside Tourism Board regarding any representation from Liverpool, Byrne was unable to hand out or display these important promotional items. Meanwhile, the Byrnes had also come to realize that they were desperately short of investment funding. It was at this time that he decided to return to Merseyside Development Corporation to discuss matters – effectively over Samir Rihani's head. At one such MDC meeting towards the end of 1989 Byrne was informed, off the record, by a member of the MDC staff, John Flamson, that Alan Murray of Wembley Stadium Estates Limited was 'sniffing around' new visitor attractions in which to invest. (Byrne wonders now whether the information might have been leaked by Sir Philip Carter.) Wembley Ltd had already shown interest in the 'Needles' attraction on the Isle of Wight (which they eventually purchased) and a regional funding organization in the North West had got wind of a 'possible interest in something on Merseyside', as it was put.

Byrne duly made contact post-haste; A meeting was held in London at which Wembley's Alan Murray (also, as it happened, a Liverpudlian) became very enthused by The Beatles Story project. His director responsible for such investments was Brian Wolfson and he too expressed great interest, suggesting that Mike shared with himself, a vision that thus far he (Wolfson) had not come across in Liverpool. These two Wembley directors then travelled to Liverpool and

6 Mike Byrne to Mike Brocken, April 2013.

were shown the vaults in the Britannia Pavilion on the Albert Dock where The Beatles Story was to be sited; at that stage they were merely looking at rubble, and had to imagine this space filled with Beatles-related artefacts and happy tourists. Wembley were already aware that other big players such as Granada TV were on the dock site, and that the Tate Modern development was underway. Mike had already registered The Beatles Story Limited Company at Companies House to cater for the investment monies already raised (and the possibility of more to come), so Wembley could see that he was business-like and well informed. They accordingly made him an offer: for a 50 per cent interest, Wembley would become financially involved, plus require a casting vote. Mike returned to Liverpool and immediately went to see Birtwistle, Henderson and Kelly. He was being pressured by landlords Arrowcroft to begin building work as soon as possible. Further, at this stage, all expenses were coming out of his own pockets, and he felt under extreme pressure to complete the deal. So by December 1989, with his local investors convinced, the deal with Wembley Estates Ltd was sealed.

Peat Marwick McLintock's estimate of £750,000 of investment was now in place and Byrne was able (finally) to draw down some kind of salary. It was immediately made clear by Wembley that they felt that the Merseyside Tourism Board had got it badly wrong. Liverpool was now a postindustrial city and economic wealth could no longer rely on industrial production. The processes of creating a postindustrial Liverpool simply had to involve the migration from industry to service capital. These new sectors were highly volatile and speculative, yet would involve new flexible skills that Liverpudlians had to learn. The Beatles Story, they suggested, would play a central role in Liverpool's new approaches to knowledge, information, communication and affect. In this sense it can be seen as a truly key initiative to develop a brand framework for Liverpool based around the legacy of the Beatles. Alongside the equally innovative work undertaken by Cavern City Tours, The Beatles Story would create one of Liverpool's first clear postindustrial brands, against which all Beatles-related marketing and promotional activity would be measured. It would not be an exaggeration to suggest that (perhaps like the advent of LIPA in the mid-1990s) the arrival of The Beatles Story marked a seminal moment in the history of modern Liverpool; one in which the city finally began to slowly move towards a postindustrial, information-based economy.

Of course, almost immediately, Wembley asked Byrne and his fellow directors whether they had obtained permission from Apple for branding support and official sanction. Byrne (rather hastily) replied in the affirmative; he now admits to being 'economical with the truth'. Yes, he had already met with Neil Aspinall and Derek Taylor of Apple that previous summer of 1989, but the only thing that Aspinall stated was that he 'couldn't stop' Mike from doing what he was doing. This was, one supposes, the technical 'nod', but little else, and Byrne was nervous because he also knew that Neil Aspinall was, with good reason, litigious. When Byrne first contacted Apple, Derek Taylor had been the first to respond (apparently Aspinall would deflect everything onto Taylor in the first instance). Taylor was by this time rather ill, but was operating as a freelance consultant to Apple as Aspinall's

right-hand man. Aspinall *was* Apple and, at least as far as Mike Byrne could establish, the only other employee to speak of was an archivist by the name of Tom Hanley. The policy at Apple by this time was to authenticate, own, or control the movement of, anything related to the history of the Beatles; initially Taylor was unhelpful. He categorically stated that there could be no official approval and no official endorsement whatsoever from Apple concerning anything to do with the proposed attraction. This was a severe blow, but not altogether unexpected. Byrne was aware that ownership and copyright issues were at the centre of Apple's existence and he had already realized that that they were preparing even at this early stage to create the ultimate Beatles history of their own. It was for this reason that Aspinall had practically every popular music memorabilia auction or listing watched right across the world. Indeed, Apple had been anonymously either bidding for genuine items, or having items without verifiable provenance removed from auction.

It appeared that the entire *raison d'être* of Apple was now devoted to constructing one definitive authentic Beatles historical document, as would later be proven by the arrival of the Beatles *Anthology*. Apple was gobbling-up authentic memorabilia for which The Beatles Story did not even hold funds to bid. Mike Byrne informed Derek Taylor that this was all a rather different league from the sphere inhabited by The Beatles Story: all £750,000 was going towards creating a 'Beatles experience', which left pockets relatively empty for exhibition materials. He therefore reported that The Beatles Story was going to rely heavily on collectors to loan items, and also stated that he felt he was in the tourist industry, not the memorabilia business: his desires were to help regenerate Liverpool via the Beatles. Taylor was guardedly impressed and decided that Byrne should meet with Neil Aspinall:

> When previously meeting with Derek, we met in the crypt of St Martin's in the Field church – talk about secrecy! I was told to bring with us a 'wish list' in question form listed from numbers one to ten. He told me that he would score out of ten the likelihood of success of any of our requests. He told me that 'some things were likely to happen but other things were not likely to happen'; he was *that* vague, but I knew what he was on about. For example I already knew that the former Beatles were not getting on with each other and that they no longer had anything approaching what could be described as a collective or even united voice.[7]

For Taylor, the plan of an 'experience', rather than a 'museum' per se, was appealing. He strongly believed that placing the Beatles in a museum was not an adequate representation of their cultural authenticity; he felt equally fervently that to 'experience' the Beatles and the decade within which they emerged, was of greater significance. When Mike and his wife Bernadette finally got to meet with

[7] Ibid.

Neil Aspinall, the latter was late following a 'liquid lunch', and rather incoherent. Aspinall somewhat haphazardly explained that had been very reluctant to see Byrne because he had already experienced difficulties concerning the authenticity and ownership of several objects in the now defunct Beatle City. Aspinall was also troubled by the fact that the entire Beatle City collection had effectively 'evaporated' into thin air. He saw the plans for The Beatles Story, however, and loved them (as indeed had Derek Taylor) but he also repeated Taylor's comments that neither he nor the surviving Beatles were interested in being 'museum pieces'.

Byrne's passion to revive the city of Liverpool had affected the Apple man, however, and he was suitably impressed. Aspinall was also encouraged by the fact that Byrne was not what the Beatles and their entourage might have previously described as a 'suit' (this was prior to Wembley's involvement, of course) and although Aspinall could not admit to speaking on behalf of the ex-Beatles, he did show a great deal of awareness about their dismay concerning the general state of their home city. At the end of the meeting Aspinall was therefore guardedly supportive, but stated that because of issues to do with provenance, museumification and authenticity he could not provide any official letter of approval from Apple that could be shown to potential investors. Byrne would, evidently, have to convince any potential investor that Apple were in approval, but only via word-of-mouth at a meeting with a rather drunken titular head of Apple – which is not much upon which to base hundreds of thousands of pounds' worth of investment. Byrne now retrospectively thinks that Wembley's offer might have been less aggressive re the 50 per cent, share, had there been some kind of written and signed documentation from this meeting with Aspinall. In the fullness of time Neil Aspinall was to agree to allow The Beatles Story to display a selection of authentic photos of the Apple Boutique. This quiescence was quietly acknowledged by the management of The Beatles Story as an affirmative 'thumbs-up' for the attraction; but in the summer of 1989 this was still a long way off.

The Beatles Story

The Beatles Story (TBS) was initially scheduled to open at Easter 1990 but this date was soon put back to 1 May. All drawings were put into place rapidly and the building work commenced almost immediately. Stephen Quicke, who was in charge of the building work for Franklin Stafford Architects (they handled all of the Albert Dock designs), completed all necessary building requirements in double-quick time; additionally, Mike Byrne had already prepared the ground with his own plans – they were very close to the actual finished designs. Mike Loines of Chester-based Loines Furnival helped transpose the graphic designs into building specifications. Actually, when that first important meeting with Allan Murray of Wembley was held, Byrne already carried with him designs and drawings of various potential exhibition features such as the replica Cavern, a replica Star Club, and a Yellow Submarine:

The Star Club design was specifically aimed at the German market, but never happened. I still feel that this was important and should be done at The Beatles Story now. German visitors are always thrilled that Hamburg is recognized in the exhibition, but the Star Club has now gone and it would make a very good exhibition space. We built a feature of the Reeperbahn which had a facade of the Star Club and the Beatles 'live at the Star Club' playing in the background.[8]

Tarmac handled all of the heavy duty work. They too were already well-versed in building problems associated with this nineteenth-century dock building and to this very day their work in the Edward Pavilion is still a testament of carefully considered building preservation. Tarmac had to deal with tremendous damp and salt seepage from the brickwork walls and floors and had developed very sophisticated methods to cope with such eventualities. Mike Byrne found it all very exciting – especially when Tarmac had to break through an 8-foot thick wall to create the entrance stairs into the exhibition. However, he also recalls that he was on crutches for most of the time after falling off a stage in Ormskirk, Lancashire during one of his income-bolstering live performances.

Meanwhile, Peter Marwick's figures concerning a required figure of £750,000, plus his audited forward projection for takings, were coming under a further round of intense scrutiny. They had been initially based on the Albert Dock's visitor figures and Marwick therefore stated that a £6 per-head entrance fee would make a profit. But it was then discovered that such figures had been exaggerated and Marwick was also conscious that there existed local opposition to the entire Albert Dock complex. His original idea – that the admission should be the price of a cinema ticket, an interesting demographic approach based upon a real rather than imaginary projected market share – did not please all shareholders. Some felt that the attraction was underselling itself at such prices. Nevertheless the £6 admission was placed into the future revenue stream projections. Following Mike Byrne's previous experiences of observing vast merchandise sales in Dallas, it was decided that a strong retail arm of The Beatles Story should be established. The TBS board agreed that this should include all of the Beatles' recorded music on CD, cassette and vinyl. Byrne instigated meetings with EMI to that effect, but was horrified to find that they were not really interested in the attraction, and were not prepared to deal with him directly. EMI already had all major wholesale markets sewn up and were not prepared to deal with something akin to a regional record stall. Undeterred, Byrne approached a local wholesaler by the name of Ron Downing, who was based at South Road, Crosby, just to the north of Liverpool. Downing, who also ran his own limited-release label, was able to offer The Beatles Story a Beatles product at a fraction of the prices Mike expected to pay EMI, for Downing was on EMI's wholesale listings; a deal was duly completed.

Had he been solely reliant on The Beatles Story retainer, Byrne's personal finances would have been, by this time, in a mess. Although once the deal with

[8] Ibid.

Wembley was secured he was able to draw a small wage from the project, it was still not enough to pay the household bills. Therefore, what little spare time he had, involved his re-establishing an evening aerobics class (something that he had initially started as far back as 1985 with one of his former dancers from his cabaret days). This enterprise, entitled 'Body Shape', ran at St Edwards's School gym in Sandfield Park three nights per week and netted about £100 per week. Byrne was also occasionally 'back on the boards' after meeting Radio Merseyside presenter and cabaret singer Debbie Jones. Under the auspice of the 'Debbie Jones Show', they performed in and around the North West with a small revue, and were moderately successful. His last 'Body Shape' classes ended in 1990 for, by this time, The Beatles Story was close to opening and his wages improved: the £12,000 retainer was expanded to £24,000.

The directors of The Beatles Story moved towards their opening day relatively united. As managing director, Mike Byrne was constantly meeting with 'all sorts of people while Bernie was writing the narrative for the exhibition story'. Structural matters were left to Neville Kelly who was a club and pub designer. But once TBS opened that May of 1990, it was quite clear to all that the attraction was failing to meet its anticipated revenue projections. There had been a downturn in the economy and KPMG's revenue projections were unrealistic for what was by this time a deep economic recession. Towards the end of 1990, and notwithstanding The Beatles Story's critical success, the hitherto silent Wembley board members were querying the returns. Despite extremely encouraging reviews of the exhibition, tourists were not coming in the required numbers; of course the perennial problem concerning 'Liverpudlians versus the Beatles', not to mention 'Liverpudlians versus the Albert Dock', was also ever-present, so TBS could not rely on local loyalties. Byrne now recollects that during May, June and July takings were 'quite good', but by the time autumn and winter had arrived, the Albert Dock was once again 'deserted' by the seasonal variations in tourist walk-up; and questions were being asked by about the viability of the venture. The Beatles Story was obviously an integral part of the city's future, but when exactly would that future start? Was it, like Beatle City, 'dead in the water', or was it ahead of its time? A most interesting convergence in Liverpool between city space and its economy was beginning to take place, but ideology, the relationship between the real and the imagined, continued to dog progress; The Beatles Story soldiered on regardless, finally emerging into the twenty-first century well equipped to deal with the new textural reality of heritage tourism in Liverpool. In 2012, over 250,000 people visited The Beatles Story and/or took a trip on CCT's Magical Mystery Tour.

Comedia Consultancy

By the early months of 1991, leaks to the local press were suggesting that Liverpool's so-called desire to develop a culture-based tourist industry was yet again hidebound by political and ideological constrictions of thinking. The local

press started to ask questions for, once they had interviewed stall-holders and businesses on the Albert Dock, which now included Mike Byrne at The Beatles Story, the news was invariably not good. Comedia Consultancy (London-based but with an associate office in Liverpool: Charles Landry, Terry Boyle and Dr John Montgomery) were asked by Merseyside Taskforce to undertake a consultancy project between September and December 1990 concerning the scope of the culture industries sectors in the Liverpool economy. They were also asked to assess and outline a potential framework for future action regarding a tourist strategy for the city. While acknowledging that employment might be doubled in the tourism sector by the end of the century, the obstacles identified by Comedia were 'telling', indeed.

According to Comedia's two-volume report of their research findings, a 'credibility gap' regarding the city's cultural resources was evident. The defining obstacle in this case was not the lack of finance or the need for more money, but the actual and perceived weaknesses in the management of the city's existing cultural assets. For the writers, if the assets were managed in a more business-like way, external investment would follow, for all businesses could only be successful if seen as efficient and modern. Comedia also suggested that Liverpool's cultural assets were grossly undervalued within the city, and there were two related factors why this appeared to be the case. They argued that the 'case for Liverpool' being made by the city was far too selective in its approaches (in other words, which 'Liverpool' was being made available?) and insisted that those cultural assets that should have been centre-stage (such as, the document implied, Beatles-related attractions) were marginalized. Taken as a whole, they argued, the marketing of the city was lacking in any kind of flair, imagination or understanding of the diverse nature of (music) tourism in a global context. Secondly, because of this market failure, many key groups outside of the city (e.g. tourists, opinion-leaders, investors) did not really 'understand' Liverpool, especially while Liverpool continued to invoke an image of 'trouble and strife'. Comedia determined that while the city's nascent culture industries were offering the best possible opportunity of deflecting public opinion away from financial and social problems, they were concomitantly held in low esteem within Liverpool's administrative structures and, as a consequence were lacking any kind of co-ordinated thematic structure. It was further suggested that the very poor external promotion of the city's cultural asserts was a missed opportunity of immense proportions. This was, they argued, entirely counterproductive from two important perspectives: the city's public image within its boundaries was far less positive than it should be, and, across the UK, Liverpool was simply not regarded or recommended as a place to visit:

> The external promotions are run by bodies based in the city, and they take their cue – broadly speaking – from the local climate and attitudes [...] The singly most eloquent instance of this lack of status and 'clout' enjoyed by the city's cultural assets is to be found in the structures and actions of the City

Council. At a time when many other cities have allocated [both] substantial time and resources to the culture industries, LCC has scarcely begun to give these questions the importance they deserve.[9]

Within the structures of Liverpool City Council, there was clearly an advocacy problem of vast proportions, which had led to a lack of tourism infrastructure and investment. It was suggested that those managing the city's cultural assets pursued only a plethora of opposing lobbies and arguments, and that the point had now been reached where Liverpool had piled up a long wish list unlikely to transpire because each lobbyist was competing with every other for attention and resources. There was little common purpose, yet the overriding need to work closely together was evident. Indeed, 'in practice, what has happened is that Liverpool has seen a proliferation of single issue and "sectoral" lobbies: exactly the opposite of what we are proposing is needed in the current circumstances. This strikes us as being so counterproductive.'[10] Comedia had discovered that the city was in danger of failing its cultural assets on all counts. In the absence of a co-ordinated, collaborative approach management and image weaknesses prevailed, and such weaknesses were endemic and long-standing. But what was also apparent was that such ideas and attitudes could not survive in a world where social knowledge was becoming a direct force of production and interactivity was becoming increasingly central to labour activities. Comedia argued that cultural enterprises in all fields had to compete alongside a host of other industries and agendas. As a result, they stated, there was now a 'new premium attached to the professional management of assets and arguments. In the plainest terms, Liverpool had failed to recognize or act on this fact. Until it does – and is seen to do so – the present difficulties will continue.'[11]

The report was delivered in January 1991 to the Merseyside Taskforce (just as The Beatles Story was desperately struggling for footfall) and perhaps predictably fell on stony ground. The report was seen as disloyal to those who still felt that underlying 'givens' of cultural authenticity drawn from high art or the hard Left distinguished one cultural asset from another. Comedia suggested a complete reassessment of the actions thus far taken by Liverpool City Council. In their view, LCC were impoverishing their own communities while they ignored the communication aspects of affective labour, for the sake of worn-out symbols of Liverpool's cultural heritage. In plain terms, while Comedia discussed maximizing different elements of the city's cultural practices, such practices were not viewed by the Merseyside Taskforce as strengths. An aesthetic of cognitive mapping was suggested: awarding the individual visitor their own sense of authenticity – something which the Merseyside Taskforce had to respect and then to which it had

[9] Comedia Consultancy (1991), *The Cultural Industries in Liverpool: A Report to Merseyside Taskforce*, Volume 1, January, p. 35.
[10] Ibid., p. 37.
[11] Ibid., p. 38.

to respond. Comedia proposed that older kinds of ideologies and representations were no longer suitable in a world space of multinational information-based capital. This in essence suggested that the council should stand aside and allow entrepreneurs to take control. This would lead to an integration of the entire field of heritage tourism and bring together the various lobby groups into a united whole: sharing information and lowering individual profiles. All such issues had already been raised by Mike Byrne, Dave Jones and Bill Heckle repeatedly during various meetings with representatives and councillors from the appropriate authorities; however, all such ideas fell on deaf ears. Mike was not present at the Comedia presentation, but news was disclosed to him of a farcical situation with Comedia presenting their findings, together with two volumes of documented suggestions and evidence, but the consultancy document, like many before it, being placed on the shelf.

By 1991–92 it seemed clear to all those with the future interests of the city at heart that the fundamental issues bedevilling Liverpool City Council were as described by Comedia. However, there was also more to it that this: a lack of recognition by Liverpool that the processes of economic postmodernization had repositioned the labour market to such an extent that what might be described as 'affective labour' – the production of affects – had outstripped the material labour market, perhaps forever. The Beatles Story was a visible spatial attestation to this and, despite its initial weak trading (which would exponentially improve as the months passed), was, in all its visible inconvenience, not going away. Tourism was, by the mid-1990s, a simultaneously social, economic, cultural, environmental and political driver and was beginning to transfer capital between people and places at a rapid rate; in doing so it was influencing all social destinations. But, as Comedia suggested, Liverpool did not appear to want to be influenced.

This was in part to do with a myopic, narcissistic prejudice concerning a mono-identity and indigenous chauvinism. Bernadette Byrne even noticed this emanating from other tourist guides – one in particular would all but insult visitors (especially American) with his aggressive attitude. Under such circumstances, the prospects of revitalization and preservation were limited, at best. The intervention of local and national governments within such contexts, not least in the so-called promotion of Liverpool as a destination, was hidebound by attitudes towards the rest of the country, never mind a tourist. Even by the summer of 1993, with the Mathew Street festival approaching, there was little positive publicity emanating from Merseyside's government 'quangos'. For example, the Merseyside Taskforce, a part of the Merseyside Development Corporation which actually held the financial purse, intermittently issued a newspaper-cum-bulletin entitled *Taskforce*, yet the Summer 1993 edition of the paper, while headlining with 'Mersey's Royal Salute' for the 50th anniversary of the Battle of the Atlantic, carried not one single word to celebrate the popular music heritage of the city.[12] So, by the early-to-mid 1990s, what was certain to many of those involved in Beatles tourism was

12 *Merseyside Taskforce*, Summer 1993, published by Liverpool City Action Team.

that Liverpool's structural relationship with the tourist industry was weak; also, that a variety of differing rhetorical dialectics concerning power and hubris were driving this uncertainty. The crucial question to ask of these insecurities, was twofold: why was popular music tourism viewed as 'aberrant' and abhorrent as an answer to Liverpool's economic problems? And why was self-employment and entrepreneurialism subsumed beneath collectivist and quango-based rhetoric?

Mersey Partnership

Back in the autumn of 1992 the recession was biting and, as part of their programme of cuts in all public spending, central government had decided to cut the grant to the Merseyside Tourism Board. The 'Board' was fully aware of what was to come and by 13 November had sent out a letter to all colleagues informing them of their uncertain financial future. There was also news in the letter that a new promotional agency – the Mersey Partnership – was to be established with funding from both public and private sectors. However, the letter noted that the Mersey Partnership was not to place tourism at the centre of their activities, but rather to attempt to secure inwards investment. The day after an emergency meeting of the Merseyside Tourism Board (hereafter MTB) on 17 November, the *Liverpool Echo*'s business editor, Neil Hodgson, 'Echo' asked the headline question 'What Have We Done Wrong?' Over the six years of the lifetime of the 'Board', he reported, the annual number of visitors had, almost by accident, risen from 19 million to 29 million but, following this report a meeting was to be held to either dissolve the MTB, collaborate with a Liverpool City Council which was balking at any costs that might be incurred, or join the newly-touted Mersey Partnership, yet another government quango which had moved away from directly funding tourism towards attempting to secure inwards investment. By this time, Hodgson claimed, over 14,000 local jobs were dependent upon tourism and he quoted Pam Wilsher stating:

> It seems that as soon as we get anything that is successful, Liverpool can't cope with it. In 1984 we had the Tall Ships here and the International Garden Festival – everyone wanted to know about us, but the County Council was axed. It's taken us since 1986 to get back to where we were, but it's just like déjà vu. We've had another visit by the Tall Ships and now we're shooting ourselves in the foot again.[13]

According to Mike Byrne, the fact was that Sir Philip Carter, chair of the MTB, had lost not only his enthusiasm, but also the 'nod' from central government concerning the entire Merseyside tourist initiative, thus funding for the MTB was to be drastically cut. This agenda was of course somewhat inevitable and

[13] Pam Wilsher to Neil Hodgson (1992), 'What Have We Done Wrong?', *Liverpool Echo*, 18 November, p. 6.

ideological, for the then-Conservative government did not wish to prop up businesses with public money, when it could see even the merest glimpses of the possibilities of businesses 'going it alone'. Notwithstanding all of the factional and tribal shenanigans from councils and quangos, Liverpool's nascent tourist businessmen were, ironically, showing such business shoots; so it was Carter's job to begin to loosen central government's financial responsibilities. The important MTB meeting on the 19th that followed the above article was held to discuss the expiry of the three-year funding programme by Merseyside Development Corporation (MDC). The aforementioned Merseyside Task Force, which was by this time sanctioning all MDC grants, had blocked any further government payments – principally one of £270,000 – to MTB. Perhaps naturally at this stage of the city's development, Liverpool City Council together with the other local authorities only 'promised' what they could spare; in truth they still exhibited little enthusiasm for writing cheques for tourism – Comedia had evidently been correct.

A leak emerged suggesting there might be plans to merge the MTB with the then Wigan-based North West Tourism Board. This enraged local hoteliers who presumed that monies destined for Liverpool under the old system would now be diverted to (e.g.) Blackpool, and from an increasingly reduced pot, to boot. This scenario actually transpired; however, by and large at this pre-meeting stage, most criticisms seemed to be directed at the overall ineffectuality of the changes, rather than those of the MTB. For example, Paul Feather of the Feathers Hotel Group complained to Ian Herbert of the *Liverpool Daily Post*:

> change the organization but don't wreck it. The chief executive and the chairman, Sir Philip Carter, should be replaced by those with tourism expertise. There are so many cash problems. Knowsley and Liverpool authorities do not put any money into it. So many benefits from tourism in Merseyside but it is the hoteliers who are paying for it. There should be a concerted policy to secure funding from others as well.[14]

While all of this was positive, at least from an entrepreneurial perspective (and for Feather and his colleagues any visitors who paid their bills were good visitors), there were still antediluvian calls coming from the MTB condemning football and Beatles tourism! At the emergency MTB meeting on 17 November, from which both Neil Hodgson and Ian Herbert received their information, there were still voices who stated that the need for fresh leadership involved moving tourism away from 'traditional selling points of the Beatles and football'. Arthur Rothwell came to be the leading player in this respect. He was to be chairman of the proposed Mersey Partnership and, although not the most obvious front man for the city's tourism industry, came to control an important company that still trades to this day. However, he was not to play a major part in any absorption of the MTB

14 Paul Feather, cited in Herbert, Ian (1992), 'Holiday chiefs may be told: "wish you weren't here"', *Liverpool Daily Post*, 18 November.

within the soon-to-be-created Mersey Partnership for by the morning of Friday 20 November 1992 all had been made clear. The MTB was to be merged into the North West Tourism Board and the directors had decided to make chief executive Samir Rihani and four other senior staff redundant. The *Liverpool Daily Post*'s staff reporter Graeme Wilson quoted Sir Philip Carter as saying:

> The Merseyside Development Corporation said they would provide an annual grant of a maximum of £100,000 to the NWTB to promote Merseyside as a visitor destination as opposed to the grant of £270,000 which MTB received this year. The MTB board was, therefore, left with no option but to immediately reduce its staff and operations.[15]

There were many reservations about such a 'merger' for it was clear that the promotion of Merseyside would be reduced exponentially. Arthur Rothwell was able to stands at arm's length from this with the knowledge that his company, Liverpool City Region Local Enterprise Partnership, registered on 5th October 1992 with its registered office in Merseyside was ready to move into action.

Samir Rihani had effectively talked himself out of a job in any case, for, during that November (and before the important meeting on the 17th), his correspondence with chairman of the Commercial Members Consultative Committee, Paul Beesley (wherein he voiced his objections to the creation of the more financially free-standing Mersey Partnership without consultation) was unequivocal. Rihani bowed out gracefully enough, along with Visitor Services Manager Linda Carr, but what commercial damage his elitism and reticence had done to popular music tourism in Liverpool will never be fully known. It remained quite clear to all that Carter was taking orders directly from central government, that Rihani was specifically discriminatory, and that overall the locally-based government quangos showed little interest in, indeed resistance to, popular music and association football at the fulcrum of tourist enterprise. Meanwhile, without prejudice Rothwell had evidently seen that there was money to be made from such moves, but kept his own counsel – and good luck to him, for his success via his limited company showed that enterprise rather than funding was clearly the way forward. This was probably the only piece of good news to emerge from this 'night of the long knives' in November 1992, apart that is from Beatles fan Pam Wilsher being promoted to head up the vastly reduced MTB within the auspice of the North West Tourist Board. The *Liverpool Echo* was to comment in mid-December of that year:

Knocking our own success

> As we report on this page today, tourism has developed into one of Merseyside's success stories. It is a fiercely competitive business, and those who succeed in

¹⁵ Wilson, Graeme (1992), 'Hoteliers fear move to tourism board merger', *Liverpool Daily Post*, 20 November, p. 6.

bringing visitors here have had to work hard for their success. Now their future is in doubt, as the Merseyside Tourism Board faces crisis decisions over its own future. *Less successful rivals in other British resorts and cities must be both astonished and delighted.*[16]

The above *Liverpool Echo* editorial was clear: all of this mess was occurring while tourism was actually expanding. The ever-resourceful Mike Byrne had established the Waterfront Partnership business co-operative in an attempt to pull together all of the businesses in the Albert Dock in a marketing strategy. The businesses had duly joined forces in October 1992 to offer half-price entry for certain attractions from that month until May 1993, creating a voucher booklet in the process. This initiative was partly as a consequence of the promotions officer for Regional Railways (North East), Tony Hargrave, meeting Mike and Bernadette at a travel fair in London and Bernie having invited Hargrave to Liverpool. He told the *Liverpool Echo*'s Peter Grant:

> I must admit the media coverage had in the past made me stay away. I'd thought about other places such as Chester, Bradford, Manchester – but I eventually went to Liverpool in February this year and met Bernadette who is also a qualified tourist guide. I saw Penny Lane and drove along the Pier Head and was completely knocked out. Then, when I saw the whole of the Albert Dock – I was sold. This place is a WINNER.[17]

Following this visit, Hargrave arranged for 110 railways stations to advertise the positive side of Merseyside; regional radio stations were also organizing competitions courtesy of Regional Railways to visit the city of Liverpool, while Regional Railways were investing £30,000 of their own money in the poster campaign. All of this might sound like 'chicken feed' in the twenty-first century, but it was bearing fruit and was another example of local business knowhow in the face of local and national government stasis and ignorance. While Caroline Griffiths of the MTB was wryly bemoaning to Grant's colleague Neil Hodgson that 'The Partnership was supposed to unite different groups on Merseyside: all it has done so far is divide', Pam Wilsher added to her previous comments:

> The tourism trade probably can't believe how such a successful company like this [Merseyside Tourism Board] is being allowed to be brought down. We thought that the model we have here between the private and the public sector was the way the government was trying to push the industry, but it seems they're trying to replace us with an agency that will rely more on public sector funds.[18]

[16] Unaccredited editorial (1992), 'Comment', *Liverpool Echo*, 18 December.

[17] Grant, Peter (1992), 'Tourism Right On Track', *Liverpool Echo,* 18 November, p. 6.

[18] Caroline Griffiths and Pam Wilsher to Hodgson, Neil (1992), 'What Have We Done Wrong?', *Liverpool Echo*, 18 November, p. 6.

In the midst of this, Mike and Bernadette Byrne had quietly given up on any hopes of Merseyside Taskforce assistance, all but resigning themselves to 'going it alone'. Mike constructed a letter of complaint to Jill Shaw of the *Liverpool Daily Post*, but cannot recall whether it was actually sent or whether he resigned himself to the events as they unfolded. The draft of it still exists, however, and reads as follows:

> Sir,
>
> Following the scaremongering of Saturday's front page 'JOBS AT RISK IN TOURISM CRISIS', we feel it is imperative that the record is set straight. We speak, not as some external or political body, but as commercial tourism businesses based on Merseyside AND fee-paying members of Merseyside Tourism Board (MTB).
>
> The financial state in which MTB finds itself lies solely at the feet of the Chief Executive and the Board of Directors. For at least two years they have been fully aware that the public sector funds would not be available to anything like previous levels from April 1993; indeed it has always been the intention that MTB should be self-funding and financially viable by now.
>
> The 'facts' that really have to be put on record are:
>
> Of a total budget in excess of £600,000 MTB managed to spend almost £500,000 on administration and overheads.
>
> For at least two years the Consultative Committee of MTB (representing ordinary fee-paying members) have made it clear that the Tourist Information Centres at Albert Dock and Clayton Square should be self-financing (through quality merchandise and publications) – this year they will lose at least £60,000.
>
> Tourism on Merseyside is booming in spite of the current MTB situation. The Merseyside Conference Bureau; Liverpool's Historic Waterfront; Liverpool's Hoteliers Association and many other organisations are working together to ensure that tourism prospers throughout the area.
>
> The matter of the 'Mersey Partnership' is an absolute 'red herring'. The visitor business will move ahead in collaboration with the 'Partnership' or not as the case may be.
>
> This letter is written from London on the eve of the World Trade Market – the most important tourism forum in the annual calendar. Merseyside will be fully represented by not only MTB but others who feel passionately about the future of the visitor business to the area.[19]

The letter was signed by Ken Grundy, Chairman of Liverpool's Historic Waterfront, Mike Byrne, Managing Director of The Beatles Story, and Marie Butterworth, Chair of Merseyside Conference Bureau.

[19] In the 'Mike Byrne' file, Department of Music, Liverpool Hope University.

It can be seen that the mid-to-late 1990s was a crucial time for each and every entrepreneur who wished to develop both self-employment and employment through popular music and Beatles tourism. Faced with to rank intransigence and lack of committed funding, one-by-one each entrepreneur effectively decided to 'go it alone' and develop their businesses as 'going concerns'. Some failed, whereas others struggled on, working towards a time when their businesses might mature. Certainly, by the turn of the century, it was clear to all those involved in what was rapidly becoming a truly self-employed sector that real money and real employment might exist via attracting popular music tourism to the city of Liverpool. The aforementioned multi-dimensional contests for historical spatiality and identity were upon us and Liverpool (and perhaps the government of the United Kingdom) had finally started to recognize that fact. Due in no small measure to the entrepreneurialism of attractions such as The Beatles Story and the unending adventurism of Cavern City Tours, whose Mathew Street Festival was beginning to attract annually many thousands of people over the August Bank Holiday weekends, Liverpool had started to emerge as a genuine 'thirdspace'.

Summary: 'What Goes On?'

In the 1970s, sociologist Daniel Bell noticed that several of the largest and most advanced industrial societies had begun an economic transformation that signified a difference from others which relied on manufacturing and food production for their livelihoods. He called this postindustrial, meaning a society economically dependent upon service industries, and the manufacture of information and knowledge. In Bell's model, such postindustrial societies would provide more wealth and leisure than their predecessors and the work ethic popular in earlier industrialized societies would be de-emphasized. Sports, tourism and the entertainment and media industries, he suggested, would expand to meet new demands. Back in the 1960s, Marshall McLuhan had already predicted that the telecoms industry would soon reach across the world producing what he called a global community. While it has already been suggested that, thus far, there is little evidence of reduced or democratized workloads in this affective labour-based economy, even by Bell's time leisure was becoming increasingly significant as an economic stimulus and Western societies could barely function without telecommunications and internationalization. Retrospectively, it can now be seen that the required ingredients to attract the popular music tourist consisted of the ability to monitor and measure audiences, to sell them products, and to involve them commercially in their own senses of identity via careful emplacement and positioning. By the 1990s Liverpool was required to 'place' itself in the way that (e.g.) Memphis had done, and to put into position communications which reinforced senses of individual freedom. Liverpool also needed to join a cluster of cities and places that revolved around a hub of popular music fandom and a concomitant sense of structural resonance through 'the popular'.

In addition, Liverpool had to align its own tourism emplacement within a growing field of meaningful cultural geographic explorations, via a unified information- and knowledge-based service industry. By at least the mid-1980s (at a time when the city was immersed in perhaps its deepest cultural crisis of the twentieth century) a kind of trans-disciplinary diffusion of the human imagination had already commenced, with different kinds of popular music at the forefront of ad hoc disseminations concerning the world about us. Travel illuminated the conceptual significance of place, and was concomitantly starting to unpack differing forms of popular music to Western ears. For example, the concurrent emergence of 'world music' (as patronizing as it sounds, yet of great historical significance), new age music, and ambient house music as genres did not emerge co-incidentally, for each in their own way represented via cultural and spatial geography an opening up of the world through forms of popular music previously partly-hidden or (in the case of ambient house) even non-existent. Perhaps ironically, by the late 1980s literally thousands of Liverpudlians were actually leaving the city on musical holidays to listen to different sub-genres of house music on the island of Ibiza.

In global terms, popular culture tourism had already overtaken both Liverpool City Council and the Merseyside Taskforce. Tourist niches were becoming increasingly more focused across the country – and, indeed, the world. Literary tourism was taking visitors to places like the Lake District where Beatrix Potter and Wordsworth had resided, also to the moors of Haworth in West Yorkshire made famous by the Bronte sisters. A number of film and TV programmes were attracting people to various regions, such as those making a pilgrimage to Clough Williams-Ellis's Portmeirion to walk through 'The Village' of the TV series *The Prisoner*, or to North Yorkshire where one part of the county became 'James Herriot land' and another, 'Heartbeat country'. In an almost unrecognized and unrecognizable development, a cultural geography of sound and the senses had emerged, giving rise to an increasing number of travellers specifically targeting music as the prime motivator for travel. This was stimulated, not by any inherent social or historical desire to 'correct' previous spatial or musical histories, but more by an organic realization that social processes, social relations and social subjectivities, via the resources of popular culture, could not be abstracted from ordinary experiences.

As the young folk, blues and skiffle aficionados of the 1940s and 1950s might have informed us thirty-or-so years previously, one had to *find* this music and experience it, first-hand – whether that be in Ibiza, Havana, or even perhaps Liverpool. Furthermore, the post-WWII generation, the so-called 'baby boomers' born between the years 1946 and 1964, both valued and validated their collective pasts in the form of recent popular culture far more than previous generations had so done. This age group was more likely to devote their money (and the leisure time that comes with retirement) to touring places with which they had an emotional attachment: visiting Graceland, Memphis or Liverpool with the devotion of a near pilgrimage. Quite simply, as Connell and Gibson suggest, in

recent decades 'tourist sites such as those surrounding the life and times of Elvis Presley and the Beatles are the most visited and the most profitable of the tourist destinations appealing to travellers who came of age in the popular culture of the 1950s and 1960s'.[20] While increased fuel costs, together with environmental concerns, might have rendered that family vacation across the United States (so popular when this age group was growing up) a thing of the past, trips to cultural destinations or experiences at least partially replaced such road trips; naturally enough, the expectations of these tourists/visitors changed dramatically.

Thus, by the early 1990s music travelling had emerged as a visible tourist pursuit with deeply-held meanings, suggesting that one could interact with, not simply observe, real sounds and real people in and around real spaces. Significantly for Liverpool, Cavern City Tours and their allies were able to show that important spaces in the city could be prioritized, and they were able to combine time and sound together so that the past was not fixed, lifeless, and a mere background to the human drama of Beatles tourism. Thanks especially to the Mathew Street Festivals from 1993 onwards, the past could be re-enacted in the here and now. Popular music history could be socially produced in the present and, despite dereliction and rebuilding, the cultural geography of Liverpool was still real enough to engage in the very social drama within which Beatles histories had been made. Yet, still Liverpool seemed to hold out against such activities, perhaps reflecting not only a long-standing identity crisis, but also the social debris left behind by bureaucratic secondary relationships. The large-scale formal organizations put into place in the city to deal with the postindustrial society and its accompanying tourist revolution were so culturally and hierarchically impeded that they slowed the process down to a crawl. Weber[21] tells us that bureaucracies owe their existence to hierarchical structuring, impersonality, and formal rules and regulations – such was the Liverpool of the 1990s.

In myriad different ways, from the late 1980s onwards varying forms of popular music travel had become part of an important niche market right across the world; yet, tyhrough internal disunity and a lack of understanding of the marketplace, it became evident to most observers of popular music cultures that Liverpool was lagging far behind in this multi-dimensional contest for socio-spatial economics via popular music tourism. For another ten years, popular music heritage tourism had to effectively prove itself to Liverpool's city fathers in order for them, in turn, to recognize the city as a postindustrial and perhaps even postmodern city. The most important part of this process was to acknowledge that history was not merely a chronicle of a chosen past, but was intrinsically spatial and directly related to the needs to be in specific places to confirm personal and social identities. By 1995, the pioneers of local Beatles tourism entrepreneurialism

[20] Connell, John and Chris Gibson (2003), *Sound Tracks: Popular Music Identity and Place*, London: Routledge, p. 222.

[21] Weber, Max (1947), *The Theory of Social and Economic Organization*, New York [USA]: Free Press.

were joined by, first, the National Trust, then as time moved on, by the city itself in the form of Merseytravel, further transforming in the process both human and working relations in the city.

By the turn of the twentieth century academics were taking notice of such organic spatial developments. For example, in 2002 McKercher and du Cros were stating that a single, precise definition of cultural or heritage tourism may not be possible, and noted that, owing to the somewhat Presbyterian nature of cultural tourism across more recent years, 'there may be as many definitions as there are cultural tourists'. Nevertheless they divided the term into four loose but useful categories – derived, motivational, experiential, and operational[22] – depending on the uses made of the products or the experiences involved. None of these categories was discrete yet each suggested that people were making their own decisions regarding where and why they became cultural tourists. By 2007 Greg Richards[23] had cited the World Tourism Organization in 1985 arguing for a broad, widely encompassing definition, as 'all tourism trips can be considered as cultural tourism, because they […] raise the cultural level of the individual […] giving rise to new knowledge, experience, and encounters'.[24] Whatever the definitions, cultural tourism had become omnipresent. It was now the 'holy grail of quality tourism that cares for the culture it consumes while culturing the consumer'. Significantly, Richards also described 'a shift in focus from the "shining prizes" of the European Grand Tour of the past [mentioned above in Chapter 1] toward a broader range of heritage, popular culture, and living cultural attractions'.[25] Richards also cites Howie in that where cultural tourism was, in the past, associated with 'high culture and cultured people', it had broadened in scope from those 'shining prizes' to encompass sporting events (as a participant, not merely as spectator), music festivals, embedded experiences with distant indigenous peoples, and a host of other, non-traditional, cultural activities: it was in effect a spectacular spatial reflection of the postindustrial society predicted by Daniel Bell.

[22] McKercher, Bob and Hilary du Cros (2002), *Cultural Tourism: The partnership between tourism and cultural heritage management,* Binghampton, NY [USA]: Haworth, p. 3.
[23] Richards, Greg (ed.) (2007), *Cultural Tourism: Global and local perspectives,* Binghampton, NY (USA): Haworth.
[24] Ibid., p. 2.
[25] Ibid., p. 1.

Chapter 7

'Penny Lane is in my ears and in my eyes' – Case Studies: The National Trust, Beatle Streets

If the question of Being is to have its own history made transparent, then this hardened tradition must be loosened up

(Martin Heidegger, 1985: 40)

Any meaningful discussion of popular music tourism in the twenty-first century necessarily includes shifting demographic patterns. However, from a sociological perspective, it is important to note that social issues relating to age in this century reflect more than simply changing demographics. Popular music tourism carries with it sets of attitudes, values, beliefs, and narrative expectations. Such attitudes are also reflected by the built environment. What is at stake in a relationship between buildings and a popular music heritage is not only the significance of (say) performance space, but also those representing lived place. A 'Beatles-topography' of Liverpool provides the popular music tourist with an opportunity to behold; it also brings to bear on the tourist a kind of typology of place, which evokes a realization that all popular culture is inscribed by and through specific buildings; also, that buildings, in turn, embody in built form all kinds of histories of place. Through a kind of textural layering, idiosyncrasies of place come to find expression. This in popular music terms can be illuminating, for an examination of place involves a consideration of not only the human urban fabric and how this expresses where people lived, but also the physical urban fabric of a city and how this represents, for example, differences between places. The very styles and materials used in the creation of buildings suggest to us that a city is a living and breathing organism, constantly changing due to the echoing resonances of varied presence: they, like those who inhabit them, are texts. One might suggest that buildings are multifarious personifications of those who have used and/or occupied them and that, just perhaps, our imprints or echoes remain.

The National Trust

Cultural heritage tourism, at least according to the National Trust, is defined 'as travelling to experience the places artefacts and activities that authentically represent the stories and peoples of the past and present. It includes cultural,

historic and natural resources.'[1] Over recent years the Trust has extended assistance to cities who wish to develop their place in the heritage tourist marketplace, by providing a consulting service heritage tourism management and development. The Trust tracks national trends, provides training tools and programmes such as 'Share Your Heritage' and acts as advocates for national support. It can be clearly seen that the National Trust are now not only players but important facilitators in sustaining a heritage tourism marketplace. The National Trust was founded in the United Kingdom in 1895 and made its first acquisition that year, a stretch of Welsh coastline along the Irish Sea south of Bangor. At the time, in the midst of increased industrialization and urbanization, the mission of the Trust was to act as guardian for the nation in the acquisition and protection of threatened coastline, countryside and buildings, as stated in its official website.[2] The Trust operates effectively without government funding and is dependent upon membership dues, donations, bequests and commercial sales for its operating capital, which, in 2009, was just over £400 million. The largest sources of revenue are the subscriptions of its 3.5 million members (400,000 of whom are actually American) and entrance fees paid by the 14 million site visitors each year.

Dues range from £22 for an annual membership for an individual child or young adult to £85 for a family; lifetime memberships range up to £1,635 for a family; pensioners receive a substantial discount and special dues are available for overseas visitors. Corporate sponsors such as Cadbury, Virgin and Walkers, as well as private donors, add to the coffers. Bequests are frequently made to increase the Trust's properties: in the 1940s, author Beatrix Potter bequeathed 4,000 acres of land, cottages and farms in the northern Lake District; John Lennon's childhood and adolescent home 'Mendips' was purchased by Yoko Ono and donated to the Trust in 2002. The National Trust has ownership, operation, control and maintenance of over 700 miles of coastline and 600,000 acres of countryside. To date the Trust owns 300 homes and 40 castles; 149 museums and 5,150 prehistoric sites. Over 400 factories, 57 villages, 43 pubs, 12 lighthouses, 206 mills are also under the Trust's stewardship, while it maintains 76 nature preserves, 6 World Heritage sites and 2 goldmines.

The National Trust now offers bookings for tours of a registered site such a stately home, for working holidays, and for walks and rides through protected areas, as well as visits to farmers' markets and sheepdog and falconry shows, to say nothing of volunteering opportunities. It rents out holiday cottages, sponsors lectures and scholarships, and has online craft activity suggestions for rainy days. The Trust can be twittered, followed on Facebook, and viewed on Flickr; its videos can be seen on YouTube and, perhaps not surprisingly, it can be supported on eBay via purchases and charitable donations. Another major source of funding is gained from sales. The marketing of the United Kingdom by the Trust is impressive: from fudge, souvenir mugs and publications to maps, prints, and postcards, a wide

[1] http://www.nationaltrust.org/heritage_tourism/ (date accessed 13 November 2008).
[2] Ibid.

variety of products are sold onsite. The Trust's official website displays many gifts and accessories of every variety celebrating or commemorating the properties and activities of the organization. The list of ways 'history' and 'nature' can be packaged and sold is seemingly endless. The Trust's dominance in ownership, control, and maintenance of 'pieces' of Britain is completely unrivalled and, to many (most certainly its 3.5 million members, 4,000 employees,and 60,000 volunteers) that is unquestionably a good thing – but is it?

The extent to which the self-styled mission of the National Trust actually serves the best interests of the visitors and the best uses of the properties is of course open to debate, and not all subscribe to the view that preservation in and of itself is an unquestionably worthy goal. For many, the scope and size of the National Trust is evidence of something more than preservation, conservation and education; it represents for some, the extreme degree to which the industry of culture (or heritage) tourism has encroached on the reality of life as led by ordinary people on an everyday basis. Although its author was not a popular music scholar and even appeared rather unconcerned with happenings in Liverpool (albeit reporting that the city had become a 'test bed [for an] imaginary past, even as the same government elsewhere has allowed the present to decline'),[3] Robert Hewison's *The Heritage Industry: Britain in a Climate of Decline* placed Liverpool and the Beatles into an interesting relief in the late 1980s. Hewison commented that 'the past is getting closer [and] the chequered history of the Beatles Museum in Liverpool shows it is only just ahead of its time'.[4] For Hewison, such heritage-based tourist initiatives were, by this time, blots on the British landscape, and were helping to turn the country into the book's cover illustration of 'Dodo Brittanicus'. Indeed, with almost premeditated provocation, Hewison highlighted what he viewed as a creeping takeover of the present by the nostalgia of an imagined past. He set our apparent obsessions with yesterday within a context of cultural capital created by the contemporary British government to gloss over social and political decline. For Hewison, the National Trust was a 'patsy' for political decision-making and displayed to one and all that 'real' industries, such as mining, manufacturing, and shipping had been replaced by the industry of provision, which supplied a 'ready-made' trivialized:

> sanitized [past] packaged as nostalgia for the good old days. Jobs no longer serve to make 'things', but to serve the needs of tourists visiting to *see* where (and sometimes how) things were once made. Where there once existed a factory job, there is now a food service job at the snack shop of the museum on the old factory site.[5]

[3] Hewison, Robert (1987), *The Heritage Industry: Britain in a Climate of Decline*, London: Methuen, p. 99.
[4] Ibid., p. 83.
[5] Ibid.

It would have to be suggested that, while loaded with powerful writing, Hewison's work now appears somewhat rhetorical and dated. Yet it does make several important points that should keep us on our guard. For example, Hewison wished to draw attention towards a replacement of reality with what he sees as simulated and air-brushed representations. These, he argues, have assumed increasing political power because of the manner in which they have been presented. He cited the Beamish Open Air Museum as a neo-conservative view of the past. Such nostalgia-bound representations, he argued, disguised mere flights of the imagination as collective ideologies, and he alerted the reader to the manner in which a 'museumification' of British culture was becoming a keystone of a new mode of social regulation, designed to sustain an image of an imagined past. The economic uncertainties and cultural convulsions of post-war life made the past seem a pleasanter and safer place.

But how 'real' should such image of the past actually be, and who believes in them as reality, in any case? While Robert Hewison questioned the way institutions such as the National Trust were helping to create a past that 'never was', he did not question whether visitors did other than simply accept such illustrations at the intended 'face value', or whether they might have the potential for (e.g.) reading against the grain of meaning and the possibilitiy that they might even make up their own minds. Hewison was himself beguiled somewhat by the images of masses of people duped by pseudo-narratives of equally pseudo-histories. The problem with such views is that little account is taken of individual reception and imagination. Social agency is complex and, one might argue, empty. Humans are not put into the position of a chooser with no motive to choose. Also, once such issues as urban regeneration, cultural tourism and heritage, commerce and representation, and authority and authenticity become entrepreneurial, such affective informing and explaining requires very distinct, detailed and thick research in order to unpack all meanings.

More than a quarter of a century later, Hewison might have continued to argue that the process is even more sinister than the benign purchase of souvenirs would connote; tourists are now paying money to commemorate a visit to something sham and fake, because the past, of course, no longer exists and cannot be visited, let alone revisited. Recently, playwright Alan Bennett, writing in the *London Review of Books*, complained that he was 'required to buy into the role of reverential visitor' when he visited a National Trust site and said he disliked being 'informed about the room' by resident guides. He wrote: 'National Trust guides [...] assume that one wishes to be informed about the room or its furniture and pictures, which I don't always.' He also protested about seeing a 'table massively laid for a banquet' and 'massed ranks of family photos ranged on top of a grand piano' and stated: 'I have learned not to show too much interest as this invariably fetches the guide over, wanting to share his or her expertise.'[6]

6 Unaccredited *TravelMail* reporter (2012),'National Trust hits back at Alan Bennett's "extraordinarily elitist"' criticism', 5 November.

'Mendips' and 20 Forthlin Road

So, with respect to two of the Beatles' childhood homes, these days owned by the National Trust, several questions might be asked: What purpose is served by their preservation, restoration, and operation as museums open to public tours? Does the ability to walk through the rooms where John Lennon and Paul McCartney grew up provide any real insight regarding their music or their careers? Does standing in Lennon's bedroom shed any light on the possible origin of the lyric to (e.g.) 'I am the Walrus', or his later involvement in the peace movement? Is the fan enlightened by the experience of standing in the exact spot where Lennon and McCartney put the finishing touches to 'She Loves You'? Some would certainly point to the deep personal meaning a visit to the homes has for the tourists as sufficient justification to open them to view. Others, however, would argue that the purpose of a house is to provide shelter to the living, not to the dead or to those who have moved away, and that a better use of 'Mendips' and McCartney's former abode on Forthlin Road would be as private family homes, as in the days when the Smith family was raising their nephew and the widowed Jim McCartney was raising his two sons.

In 1995, the National Trust purchased the small terraced home at 20 Forthlin Road, Allerton in Liverpool, where Paul McCartney lived from 1955 to 1963, from the time he was 13 to 21. Shortly thereafter, in 2002, the Trust received 'Mendips' at 251 Menlove Avenue, Woolton, also in Liverpool, as a donation from John Lennon's widow, Yoko Ono; it had been Lennon's childhood home from the age of 5 until 23. Both homes were restored to a circa-1955 authenticity with the help of photographs, donations and recollections from family, friends, neighbours and (in the case of 'Mendips') former lodgers . Historical preservationists, whose job it is to know which type of cooker was used and what tiles were laid in any particular era, made sure the homes were refitted and refurbished to reflect not just the era, but the social and economic status of the Lennon and McCartney families. McCartney's mother had died just months after the family had moved into Forthlin Road, and the unfinished wallpaper in the living room remains – a reminder, perhaps, of unfulfilled dreams when they first moved in. Perhaps McCartney's father, raising two teenage sons alone, never quite found the time, money or heart to finish the job. Forthlin Road is a former Liverpool Corporation council house and the McCartneys moved there from Speke in 1955. It is typical of its kind: well constructed, perhaps modest in size but with a sizeable garden; perfectly adequate, in fact, for a family of (initially) two adults and two growing children. The quality of Liverpool's council housing stock was generally good and all houses were adequately maintained. It should also be emphasized that no disgrace accompanied those living in such properties. Not only were many Liverpudlians unable to afford to purchase their own home, but many never gave a second thought to doing so. My maternal grandparents lived in a council house in Birdwood Road, on the borders of West Derby and Norris Green; my granddad, I know, felt that it was the city's duty to house him after four years of fighting for his country in the Great War.

The home where John Lennon was raised by his aunt and uncle, Mary ('Mimi') and George Smith, is equally unremarkable but in a different way, for it is a classic example of the inter-war fringe development house which can be found in practically any suburban district of any town or city across the UK. It is larger than the McCartney's home, was owned (rather than rented) by George and Mimi Smith, and therefore reflects at least to some degree a level of middle-class comfort and perhaps a relative affluence (although some of the rooms were let to lodgers after the sudden death of Lennon's uncle in 1955). A full-time caretaker/custodian resides in each home – Colin Hall has had the position at 'Mendips' since 2003, when the property was first opened[7] – and both homes are open to public view with advance booking for the four-times-daily tours at a fee. Colin's wife Sylvia is the guide at Forthlin Road. No photographs of the interiors may be taken, but visitors line up to have their photograph taken outside John Lennon's front porch where the young 'Lennon & McCartney' songwriting team practised in exile, banished from the house by Lennon's aunt and guardian, who did not share his enthusiasm for rock or skiffle. Large numbers of visitors had been stopping by 'Mendips' since the Beatles' first brush with fame, when his Aunt Mimi had occasionally welcomed them in and offered them a cup of tea. It was not until Lennon's widow, Yoko Ono, purchased the home and donated it to the Trust, that the idea of combining the two properties into a 'two for one' tour deal emerged, which is how it is managed today. One tour undertaken by this writer in 2012 might help to elucidate more clearly what purpose is served by the houses' preservation, what is expected by touring fans of the Beatles and what, in turn, is involved in the 'telling'.

The methods used in this small case study were based on observational ethnography. Fetterman defines ethnography as 'the art and science of describing a group or culture'.[8] He also suggests that participant observation 'combines participation in the lives of the people under study with maintenance of a professional distance that allows adequate observation and recording of data'.[9] Ethnography is not the same as oral history; although they both begin with an engagement with the lives of others, an ethnographer tends to be interested in the present, whereas oral historians attempt to grapple with the past. The ethnographer wishes to generate understandings of culture through the representation of what might be described as an 'emic' perspective. This allows meanings to emerge from the ethnographic encounter, rather than imposing these from existing models (by contrast, an 'etic' perspective refers to a more distant, analytical orientation to experience). Oral history, on the other hand, collects memories and personal commentaries of historical significance largely through recorded interviews. An oral history interview generally consists of a well-prepared interviewer questioning an interviewee and recording their exchange in either a written, audio and/or video

[7] This was the case at the time of writing; in fact, the Halls now (2015) live away from 'Mendips'.

[8] Fetterman, D M (1998), *Ethnography Step by Step*, New York [USA]: SAGE, p. 1.

[9] Ibid., pp. 34–5.

format. Recordings of the interview can be transcribed, summarized, or indexed according to the matrix of the enquirer, who might also place material in a library or archive for future research.

The assembly point for the National Trust tour was (and still is) at Jury's Inn, a hotel across from the Albert Dock on Liverpool's waterfront. There were eleven tourists, plus myself, the day I took the tour (not quite fully booked) and these were made up (as far as I could determine) of families, couples and singles, none of whom appeared to be local to the area. A National Trust officer-driver took charge of the minibus circa 9.30 am and the tour departed Jury's Inn at 10 am. After a short drive from riverside Liverpool into leafier Menlove Avenue, the tour began with a visit to 'Mendips' where Colin Hall suggested that the tourists should take pictures first, because another group was following quickly behind them. Hall's focus was as much to do with the building as it was John Lennon, with an emphasis on how the spatiality of the building was directly influential upon the young Lennon. He related stories which interconnected with certain parts of the house; during this time the tourists were extremely quiet and attentive. Hall does not carry a Liverpool accent and this might have assisted one or two of the couples, for whom English was not their first language. The rooms and spaces were dealt with via a great deal of reverence and when Colin discussed how Lennon's mother Julia had died, his tone was almost religious. This was interesting, for over the past few decades baby boomers, who constitute a large percentage of visitors to 'Mendips' and Forthlin Road, dropped out of organized religion. Educated and relatively affluent, with strong consumerist values and eclecticism, many baby boomers associate Lennon with a secular spirituality. Both the decor in and colouring of each room were similarly helpful for they 'spoke' of a period in British history now long lost. Two children were present, however, and it was at this point that their attention began to wander. We were left for a short period to explore rooms, following which we signed and made comments in a visitors' book which would, we were informed, be read by Yoko Ono; it was perhaps not unlike signing a prayer book or lighting a candle. Making our way back to the mini-bus was an interesting affair and can only be described as similar to departing a funeral.

It was immediately apparent that the space occupied by ourselves was the principal motivation of the tour. Colin Hall used a kind of goal-directed linked guide from his reservoir of resources to create theatre. The different spaces encapsulated the materials and resources that were being used, each room brought items together with narrative which then enabled the space to envelop the visitors. Space therefore became a communication medium for the Lennon narrative. At 'Mendips' it was clear that the space offered was able to accrue itself to the social production of time. It was active as 'an immediate milieu and an originating presupposition, empirical and theorizable, instrumental, strategic, essential'.[10] Each linked space offered was inscribed with meaning and also created meaning,

[10] Soja, Edward W (1996), *Thirdspace: Journeys to Los Angeles and Other Real-and-Imagined Places*, Oxford: Blackwell, p. 45.

not only regarding Lennon's 'history' per se, but also by linking each space (therefore each narrative) to the other. Such meanings were, therefore 'emic' rather than 'etic': one had to be something of a Beatles fan to grasp them. For example, we seemed to be drawn into a narrative world that suggested a distinct lack of love, but the word 'love' was used in an interesting way, with Colin's grain of voice changing when the word was uttered, connoting an important geno text. 'Love' was both iconic and indexical, as a paradigmatic word: it symbolically related to Lennon's life in 'Mendips', but it also indexically-linked the 'knowing' visitor to his musical works with the Beatles, his involvement in the peace movement, and eventually to Yoko Ono. Indeed the word changed in meaning, as we moved from room to room.

The building resonated with a gloom, and this gloom was constructed out of historical oppositional tropes concerning the 1950s: post-WWII austerity mixed with a suburban climate; the generation gap, teenage juvenile delinquency, images of America versus British austerity, rock 'n' roll and skiffle as saviours, and so on and so forth. All of these discourses were representative of the composite account of rock 'n' roll, a chosen pathway via which one could thread one's way through the complexities of the post-WWII modern world without asking too many questions. One could observe the furniture and a cheap 1950s guitar, and draw one's own conclusions based upon this model of the past presented via the spaces, which in turn helped 'centre' historical knowledge. The problems of course are that such 'knowledge' is only a confirmation of verbal and non-verbal signs and symbols abounding across the 'accepted' mono-history of popular music, the Beatles and Liverpool. The non-verbal signifying sets in each room confirmed seemingly irreducible facts about Lennon, his aunt and uncle, Liverpool, and post-war Britain. They were nonetheless deeply generative and strategically placed as important visual paradigms within a fixed syntagmatic chain. As the visitor proceeded through that chain in a uni-directional pattern, the spaces confirmed preconceived signifiers in a processual manner, reminiscent of a 'good' novel. Such spatio-historical propositions were confirmed because the visitors with whom I attended the tours tended to share a belief in the historical schema, especially because it was presented within this specific building: it was unquestionable in an historical sense.

Aside from myself, all eleven participants were Caucasian, nine were adults and two were children, seven were female and four were male. This possible trend might suggest, for example, that white parents might adopt a role of introducing the Beatles to their children, also perhaps that one partner might have influenced the other, being drawn together by their fandom. This might also be an indicator as to why, for some, the Beatles music has endured through time. Another point to make was the absence of other races; such absences tend to reflect a white historical narrative: somewhat problematic and culturally imperialistic. Also, while the enthusiasm of the adult visitors was at times palpable, all information was received quietly and with little comment. Two different types of enthusiasm were detected by this writer: the most dominant being made up from an evident

pre-existing knowledge, a second ostensibly based on an interest brought about by one partner. There was in fact a third, which belonged to the two children: this was a total lack of any enthusiasm whatsoever; interestingly these two distracted children were British.

At 11.35 am we arrived at 20 Forthlin Road and were greeted by Colin Hall's wife, Sylvia, in the front garden of this former council house. A prominent feature here, not present at 'Mendips', was a display of photographs. These had been taken by Paul McCartney's brother Michael and clearly rang true, for Michael's principal hobby as a youth was photography. He was in fact awarded the larger of the two available bedrooms at that time because of his 'dark room' equipment. As with 'Mendips', the visitors were not, at first free to 'explore' the house but at the end of the tour were invited by Sylvia, to 'try the piano' in the living room. However, the tone of the tour was very different from that given at 'Mendips'. One might even suggest that it was impregnated with different sets of symbols, tones, metonyms, synecdoches and pretexts, confirming that (for example) Paul McCartney was still alive, that this was a relatively happy, lower middle-class household, that the aforementioned expressions of youth were encouraged, and that, in contradistinction from 'Mendips', Forthlin Road might have been a space to which the young Lennon 'escaped'. The two houses were, therefore conjoined in a narrative of personalities. Sylvia played a recording of McCartney poignantly discussing both happy and sad memories of life in Forthlin Road and then directed us to a photograph by Mike McCartney of John and Paul playing guitars in a specific corner of one room. This photo was hung precisely above the location in the photo, producing some very interesting visual rhetoric about the murdered Lennon as much as, if not more than, Paul McCartney – a shrine perhaps?

Interestingly, no such spatial considerations of the childhood homes of either George Harrison or Richard Starkey (Ringo Starr) have thus far taken place, at least on behalf of the National Trust. One presumes that their contributions to the Beatles narrative have not, in the eyes of the Trust, risen to the same compositional levels. Both Lennon and McCartney are regarded by the Trust as composers after the fashion of (say) Edward Elgar; therefore a 'historical' distance has been created by the Trust between John and Paul, and George and Ringo. This is in spite of oral evidence from families, friends and the Beatles themselves that many hours were spent rehearsing in the Harrisons' home at Upton Green, Speke (and being fed, courtesy of Mrs Harrison). George's parents openly welcomed them and encouraged their musical interests. Liverpool cultural ambassador Joe Flannery informed me:

> Yes, it's a bit inaccurate but maybe that's not really the point because although I personally know that George's house in Speke was used a lot and George's dad's record collection was important for George, too, nothing can be done about that. To be honest it might not be a good idea just at the moment to have tours that included Speke – for a variety of reasons. But I'm sure Paul would agree that there needs to be a coordinated effort to include George and Ringo in all of this.

> It's remiss that this hasn't been done so far – at least properly. But they do a very good job at 'Mendips' and Forthlin Road.[11]

This issue continues to be worthy of both historical and geographical note, for the National Trust states in their blurb that: 'this is your only opportunity to see inside the places where the Beatles met, composed, and rehearsed many of their earliest songs'.[12] Arguably, this is a little inaccurate.

The Trust's signifying language suggests that McCartney's former home is of historic value, not necessarily because he was a Beatle, but because this home was inhabited by an important composer (perhaps with the addition of Lennon, at times two). There appears a need to authorize physical space and, by doing so, authenticate a social experience, rendering Forthlin Road as a place that 'signifies "rooted-ness" as authenticity, as a kind of realism'.[13] But Forthlin Road also signifies a 'routedness' in that it presents a contextual proposition of travelling between Forthlin Road and 'Mendips'. We are invited to imagine the walk between the two houses: we are encouraged to immerse ourselves in the kind of 'freedom' that Sylvia presents to us in the name of John Lennon. Spaces within Forthlin Road therefore are specifically contrasted with the previous spaces at 'Mendips' via verbal and non-verbal signification, creating a 'new' and contrasting situation for the visitors to find themselves within. Fans have to be able to perceive confirmations of their notions that the two leading characters were very different. Beatles history therefore is morphed by a restructuring of signification within very specific spaces; so much so that the language and linguistic systems also have to be different within these different spaces. For this writer, there existed between these two National Trust properties linguistic systems which are utilized within very specific spatial surroundings, but also within the recognizable social practices of storytelling. This is not a criticism of either Colin or Sylvia Hall, who are both truly experts in their chosen field of narrative historians. It is instead, a recognition of how specific buildings in Liverpool's popular music tourism matrix can be pulled together to present what appears to be both a shared and different epistemological past. Such spaces are what Edward Soja might describe as 'thirdspace', where different spaces 'recall' different pasts within 'memories' bound by strategic hypotheses. According to what might be described as a positivist view of knowledge, the end of the tour did, for some present, mark the end of the inquiry – the point at which thought concerning Lennon and McCartney came to some kind of rest. However because we were invited to consider these two tours as a conversation that (in contrast with, say, a dialectic) aimed not at its own closure, but at some

[11] Joe Flannery in conversation with Mike Brocken, Stroud, June 2012.

[12] http://www.Nationaltrust.org.uk/beatles-childhood-homes, 'The Beatles Childhood Homes' (date accessed 20 October 2012).

[13] Street, John (1995), '[Dis]located? Rhetoric, Politics, Meaning and the Locality', in Will Straw et al. (eds), *Popular Music, Style and Identity*, Montreal [Canada]: The Centre for Research on Canadian Cultural Industries and Institutions, p. 256.

kind of continuation, the closing of the tour also offered the few, the prospect of further perhaps limitless investigations and episodes together with exciting and fruitful enquiries. Following the end of the tour, two couples decided to walk along Allerton Road and Menlove Avenue and back to 'Mendips' from Forthlin Road. It seemed to me that they wished to reappraise their dealings with the two homes by walking back into an objective world and reconsidering ideas from this 'new' (but not new) perspective. I do not know whether this was a commonplace occurrence (and did not ask Sylvia whether this was so), but I was unsurprised that it took place, for the liberty suggested by the language presented to us surrounding 'the popular' was convincingly linked with ideas of personal freedom and spontaneity.

Questions

It seems that the childhood homes of Beatles John Lennon and Sir Paul McCartney have been granted the same status, in the eye of the Trust, as Chartwell, the home of Sir Winston Churchill in Kent; as Runnymede, the site of the signing of Magna Carta in 1215; and Thomas Hardy's cottage in Dorset. But what (if anything) harmonizes such evident dissonance of spaces? What gives the National Trust the right to develop their thematic structures? The Trust is undoubtedly a political project, for it attempts to create a politics of space which is supposed to be recognized by its adherents as encapsulating a critical but recognizable historical analysis. These spaces represent different social lives, but at the same time, perhaps problematically, point towards lives that are seemingly 'unifying' to the fans, or to adherents of concepts upon which the project is built: 'great' people', geniuses, one-offs. How can this be correct? How can it be historically accurate? Surely, one might suggest, this is elitism and it could be argued that we are even witnessing with 'Mendips' and Forthlin Road merely a representation of the reinvention of the Grand Tour with ideological links being made spatially between reality and ideology, the lived and the conceived, the objective and the subjective.

But this is not strictly the case, for any 'tellings' within specific buildings bring together tactile associations: the physical place and the body together are able to resonate an environment in terms other than sight alone. This suggests a symbiotic relationship between inner and outer space which reminds us precisely how important spatial tactility is to the perception of time. For visitors to 'Mendips' and 20 Forthlin Road, a whole range of complementary sensory perceptions takes place: they experience light and dark, feelings of dryness or humidity, smells of must or the sanitary, they hear a narrative with connotative strategies. The palpable presence of the built environment presents our body senses with historical discourses and reverberating homologies. The built environment is therefore a matrix for the popular, allowing us to appreciate the differences between our real world and the ways we think about it, so that a popular music conceptual reality emerges: a construction of a genuine subjective epistemology literally drawn from the housing of human experience.

Phil Coppell and FAB Tours: Myth, History, Entertainment and a Transformed Subjectivity

Liverpool-based music heritage entrepreneurs of the twenty-first century, such as FAB Tours, Cavern City Tours, The Beatles Story and others, have been able to make a claim on work and time realities by adopting and displaying new mindsets concerning a previously regarded cultural palimpsest: the popular. By offering a working diagnostic tool of re-presenting the imagined 'then' with the here and now, prevailing business mindsets concerning music heritage are also delivering human-centric approaches for prosperity. Rooted in the reality of a tangible popular music heritage marketplace, such approaches have aligned businesses to 'historical' enquiry in order to accept specific challenges of operating in a low-income, but growth-potential city. The twin theme of integrating of local music heritage businesses with niche marketplace opportunities has moved such ventures from individual stories of success and/or failure (e.g. Cavern Mecca, Cavern City Tours, Beatle City) to a more echelon-based hierarchy of an approved local industry. Liverpool's popular music heritage-based metamorphosis has provided the popular music historian with a capstone example of how to collectively bring together popular music heritages within entrepreneurial discourses. The rhetoric of indigenous chauvinism achieved its political purpose in Liverpool: the city's business communities, in general were discounted in discussions concerning Liverpool popular music heritage, while an underworld 'other' was conveniently positioned in place of more productive discussions concerning what a local music industry might actually be. More generally, such chauvanisms created across Liverpool a lack of understanding of all entrepreneurial mindsets. One might define a mindset as a mental attitude, inclination or a fixed state of mind. However, a business way of thinking is not 'fixed', as such: appropriate mindsets are required for specific enterprises; having the mindset to change, given a changing business and cultural environment, is all-important.

The Coppells

Phil and Paula Coppell are two entrepreneurs in the Beatles tourism industry who have created their own private tour company, the aforementioned FAB Tours of Liverpool. They informed this writer that they 'go back a long way' as far as Beatles tourism is concerned and were not slow to cite several historical examples from the past in which the city did not recognize benefits from Beatles tourism. For example, Paula Coppell recalled one female Liverpool City councillor's famous statement from 1977 – 'what have the Beatles ever done for Liverpool?' – as a landmark, for (to paraphrase Paula) it helped to create a recognizable limbo characterized by conflict – something which came to alienate Liverpool musicians of the 1980s from their own popular past. The same (unnamed) city councillor also stated in 1977 that 'nobody is ever going to come to Liverpool because of

the Beatles' and Paula and Phil Coppell assert that, when Liverpool City Council finally opted to redevelop, piecemeal, the Harrington Street/Mathew Street area, which by the early 1980s was crumbling, 'the specific aim was to make it more difficult for tourists to get around'. Paula maintains:

> Whether conscious or not, it was quite obvious that such decisions resulted in a lack of parking for coaches, therefore forcing them to park illegally while being 'harassed' by the police for most of the ensuing decade. In fact all forms of vehicle parking in Liverpool – especially for those Beatles fans who wish to visit Mathew Street – is still something of a nightmare. The Council wanted the money that popular music tourists bring to the city (which is now considerable), but remain unwilling to deal with any form of traffic, whether by foot or vehicle; this continues to be something of an embarrassment for all tour guides but principally those dealing with the Beatles and Merseybeat.[14]

In another interview Phil Coppell cited an additional way in which the city council perhaps unwittingly limited tourist potential in the past. He spoke of the time when Liverpool's Speke Airport was first enlarged from an airfield to an airport (in the immediate post-WWII era). According to Coppell the council limited its development:

> Because, in previous decades, the city had made money from the ports. Even though they were not getting in nearly as many ships as they used to, they thought that with air travel available, they would get even less. The council was unable to see a changing world in which air travel would prevail, and the city lost out on having a major airport, which is now of course in Manchester.[15]

Paula concurred and her tone indicated that she did not believe this had changed to any great extent. She also asserted to this writer that in musical terms the city was torn between nostalgia and elitism. On the one hand, nostalgia acknowledged that the Beatles were a symbolic representation of change, and active agents in creating modes of expression that reflected what she described as 'real social experiences'; but, on the other, she thought that the elitism represented by Liverpool's attachment to the Beatles furthered a 'we are better than you' attitude. This, she claimed was redolent 'of the problems in the 1980s' which took their lead uncritically 'from the Derek Hattons of this world'. Phil took this further by suggesting that the appointment of Vasily Petrenko as conductor of the Royal Liverpool Philharmonic Orchestra contributed to this 'nostalgia-elitist quotient' by presenting classical music programmes that were representative of a divided Liverpool:

14 Paula Coppell to Mike Brocken, 2012.
15 Phil Coppell to Lucie Nedzel, July 2011, in Nedzel, Lucie (2011), *Beatles Tourism in Liverpool* – unpublished MA thesis, Liverpool Hope University.

When was the last time we heard a bit of Butterworth, Finzi or Percy Grainger at 'the Phil'? [the Royal Liverpool Philharmonic Hall] It's all heavy duty 19th century stuff which, I think, is what the Americans call 'attitudinal' and suggests that, say, English pastoralism isn't what we are about, we're 'better' than that and Liverpool isn't 'English' in the same sense of the word. I don't think that helps us at all, even though locally he's (Petrenko) regarded as a bit of a star.[16]

While Phil went on to discuss how popular music was helping Liverpool's locality to change both physically and ideologically, he also suggested that there was still a great deal of opposition to such changes from the 'old political rights and lefts of yesteryear'. The Coppells have opinions and feel that they should have their 'say' therefore they can be drawn into campaigns; states Phil: 'the business community does have principles and ideals as much as any other: especially when livelihoods come to be threatened by changes to the built environment'.

It is quite clear therefore that any study of proactive tourist entrepreneurs can aid the popular music researcher in a consideration of the networks of authenticities surrounding popular music presentation and re-presentation in Liverpool. As Sara Cohen has suggested, discussions surrounding the 'particular rather than the general, the concrete rather than the abstract',[17] are absolutely vital. Certainly, the interconnectedness of this newer breed of music-based money-makers in Liverpool, together with their need to draw from a popular music fount, reconceptualizes both the individual and the collective in terms of present-day economic circumstances. It should be noted, as Stanley Cohen suggested many years ago, that 'scapegoating and other types of hostility are more likely to occur in situations of maximum ambiguity'.[18] This network of alliances has assisted Liverpool to gradually move away from scapegoating popular music heritage tourism as 'inauthentic'. One such unambiguous proactive and money-making[19] issue in which the Coppells have recently involved themselves has been the 'Save Madryn Street!' campaign. Madryn Street lies in the Dingle area of Toxteth and it was at 9 Madryn Street where Richard Starkey was born on 7 July 1940.

Toxteth

The district of Toxteth was initially formed by the borders of the ancient township of Toxteth Park. There is some ambiguity as to the origin of the name. One theory

[16] Phil Coppell to Mike Brocken, May 2012.

[17] Cohen, Sara (1995), 'Localizing Sound', in W. Straw et al. (eds), *Popular Music: Style and Identity*, Montreal [Canada]: Centre for Research on Canadian Cultural Industries and Institutions, p. 65.

[18] Cohen, Stanley (1972, 1987), *Folk Devils and Moral Panics*, London: Blackwell, p. 193.

[19] 'Money-making' because it has led to further tours being sold by FAB Tours.

is that the etymology stems from 'Toki's landing-place'. Toxteth, however, is mentioned in the Domesday Book of 1086 appearing as 'Stochestede' – 'the stockaded or enclosed place' derived from the Anglo-Saxon *stocc* 'stake' and Anglo-Saxon *stede* 'place'. Part of late nineteenth- and twentieth-century Toxteth, the locale of Dingle is situated in the area where the old northern creek ran. The major road through the area, now Park Place and Park Road, was originally named Park Lane. This road ran from the Coffee House hostelry, which stood near Fairview Place, towards the Dingle, and the old Toxteth Chapel. As Liverpool rapidly expanded during the eighteenth and nineteenth centuries, the ancient park of Toxteth was slowly but surely urbanized. Large Georgian houses were built in the Canning Street area, followed later by even grander Victorian houses, especially along the tree-lined Princes Boulevard and around Princes Park itself (the present day Belvedere School properties are a good example of this). The Earl of Sefton made the land available for such development on 75-year leases and the district quickly became home to wealthy merchants of Liverpool, alongside a much larger indigent population housed in extremely modest and often badly-constructed terraces. By the twenty-first century, as Toxteth is belatedly considered for redevelopment, there are still great social and cultural contrasts represented by its built environment, with affluent houses reflecting the wealth of the district in Victorian Britain, and other dwellings clearly representing nineteenth- and twentieth-century deprivation.

Extensive regeneration has taken place in parts of Toxteth over the last few years, including the demolition of many Victorian terraces creating the possibility of new development opportunities. A partially successful attempt has been made by developers to attract a youthful middle-class population to the area, drawing in new residents from the vast number of graduates from Liverpool's three universities. Thus far, however, house and apartment prices have to a degree militated against this expansion, and following the 'credit crunch' of 2009 mortgages for such apartments are extraordinarily difficult to come by. One of the most recent schemes proposed, with a cost of £54 million, intends to oversee the clearance of those 11 streets near Princes Park with the local moniker of 'Welsh Streets'. This nickname came about because they were built and occupied by (mostly self-employed) Welsh construction workers around the turn of the twentieth century. The streets, historically a largely white area of Toxteth, were appropriately named after Welsh towns and villages and one such street is named Madryn Street.

Save Madryn Street!

Phil Coppell is Chairman of the 'Save Madryn Street Group'. As part of the failed Housing Market Renewal Initiative (HMRI), the Welsh Streets area of Liverpool, 444 houses in total including Ringo Starr's birthplace, are still (as I write this) under threat of demolition. The HMRI was a package of policies in the North of England aimed to address housing market failure (defined as housing which

in local markets was priced below the build cost, such that renovations were uneconomic and the sale of property would not generate sufficient funds). The plan involved investment into these areas of a total of £1.2bn up to 2008. There has been a fierce ongoing fight to prevent Liverpool City Council from demolishing the Welsh Streets and, according to Phil Coppell, robbing Beatle fans of 'yet another important connection to the "Fab Four"'. Coppell has been at the forefront of this campaign and has been interviewed by television and radio stations worldwide, as well as contributing to many newspaper and magazine articles in the fight to save Ringo's birthplace. However, it should also be stated that, for most of his young life in Liverpool, Richard Starkey lived at 10 Admiral Grove (he only spent his first five years in Madryn Street), which is not under threat of demolition. It has been argued by some Beatles historians that Madryn Street holds little, if any, historical value and would be better developed as an area for young people to climb onto the property ladder. It is also worth noting that other places in Britain where Ringo Starr has lived have already been demolished. For example, his house in London's Compton Avenue, where he resided from 1969 until 1973, was demolished to make way for a million pound-plus development.

The threat of demolition hanging over Starr's birthplace and one-time home provoked a dichotomized 'hue and cry', not necessarily throughout the Liverpool locality in which the house stands, but among Beatles fans all over the world. It had been suggested, for example, that the entire structure be taken apart brick by brick and reassembled in the Museum of Liverpool Life, opened in 2011. Ringo Starr's appearance on BBC's talk show *Friday Night with Jonathan Ross* in January 2008 changed everything, for he made what some locals saw as disparaging comments towards his old city, even though he had only one week previously made an appearance in Liverpool at the European Capital of Culture opening celebrations. Ben Turner of the *Liverpool Echo* wrote about the appearance on the 'Ross' show thus:

> Ringo Starr sparked fury this weekend after telling chat show host Jonathan Ross he misses 'nothing' about Liverpool. The [Liverpool] Echo was inundated with angry responses to Ringo's comments a week after the former Fab Four drummer launched our Capital of Culture celebrations.
>
> Today council leader Warren Bradley revealed he received calls about the ex-Beatle's comments on national television which he said were typical Ringo but 'not helpful'. The 67-year-old, who grew up in Toxteth, was among the guests on Friday night's Jonathan Ross show. Asked by Ross what he missed most about the city the drummer, promoting his new single Liverpool 8, laughed and eventually said apart from friends and family he missed 'nothing'. More than 1,500 furious readers visited our message boards over the weekend and many said they felt betrayed. Gemma Dunn from Allerton was so angry she called the Echo before the show had finished. She said: 'This was his opportunity to promote Liverpool as Capital of Culture. He was just self-indulgent and arrogant.' A week earlier Ringo sang 'Liverpool I left you but I never let you

down' from the top of St George's Hall during the People's Opening. In front of a capacity crowd at the new Echo Arena Ringo said he was 'this close' to moving back.

Another Echo reader said: 'I am disgusted by the way he mocked Liverpool after having the red carpet rolled out for him by the city only last week. He is happy enough to turn up here after 40 years to blatantly cash in on the city of culture tag but then slags the place off when he is safely back in London schmoozing with Jonathan Ross.'

Cllr Bradley, deputy chairman of Liverpool Culture Company, said: 'It's not helpful on national TV. But we saw at the press conference he did in Liverpool that's Ringo's style, to be flippant. He came to Liverpool and did a PR job for himself. And what we got from him being home paid dividends for us here and abroad. I'm not going to get hung up on it.'

Cllr Mike Storey, executive member for regeneration, said: 'It's hugely disappointing and sad. It's disappointing someone who came to lead Capital of Culture year should go away and be so negative about it.'

In an exclusive interview Ringo gave to the Echo in December he claimed: 'Even though we left, we never let Liverpool down and we're always still proud of that heritage.'[20]

The so-called 'offending' conversation on Ross's programme, went as follows:

Ross: "What do you miss about Liverpool when you're not there."
Ringo: (laughter)
Ross: "I didn't know that would get laughter ... Is there anything you miss about Liverpool?"
Ringo: "Er, no ... Look I love Liverpool. I was a child in Liverpool. I grew up in Liverpool. My family members are in Liverpool. But you know [...] I had to tell the audience as it was so excited that I was this close to coming back. But I had a great time up there at the weekend [during the opening ceremony]. I did."

Within a short space of time, there followed the (one supposes unrelated) news that English Heritage had decided not to voice disapproval concerning the demolition of 9 Madryn Street.

Despite the title (and concept) of his 2008 album *Liverpool 8*, Ringo Starr, has always had something of a love/hate relationship with the city of his birth. His lengthy stays in hospital as a child, coupled with his desire to join the Merchant Navy, and his intermittent work away from Liverpool as drummer with Rory Storm and the Hurricanes[21] and then as a member of the Beatles, contributed

[20] Turner, Ben (2008), '"Liverpool I Left You But I Never Let You Down"...says who, Ringo?', *Liverpool Echo*, 21 January.

[21] As suggested in the introduction to this work, Rory Storm and the Hurricanes could be repeatedly found playing summer seasons at Butlins Holiday Camp in Pwllheli

to his relative detachment from the usual Liverpool rhetoric of place to which many white Liverpudlians willingly attach themselves. Instead, it might be argued that Starr's attitude towards Liverpool displays a sense of honest, transformed subjectivity created via loss, lack, and absence; importantly such a position can also be seen to have underscored many Black Liverpudlian narratives of L8. The places around which both white and Black Liverpool 8 residents have defined their respective concepts of place are all but gone. For Black residents, Pitt Street was blitzed in 1941 and razed ten years later; for Starr, the attachment others might have felt to the Welsh Streets is not shared, because of his partial loss of childhood and his transience. For both parties, facsimiles are clearly and understandably unacceptable: Starr perhaps does not feel that he can be consigned back into a place where, according to standard Liverpool historical rhetoric and Beatles lyrics, he 'once belonged'. In fact, perhaps like many of his Black Liverpool 8 counterparts, he never truly 'belonged there' as such. So, perhaps via his ambivalence Starr intended to draw attention to the immense loss of social capital felt by so many from Liverpool 8: something that neither entrepreneurial nor State-sponsored 'heritage' discourses could reproduce. Certainly, for some Black Liverpudlians (who, it must be repeated, did not reside in the Welsh Streets en masse) such discussions concerning one house in which a Beatle happened to live for a few early years only served to emphasize their own increasing lack of visibility. Oludele Olasiende of the Liverpool 8-based River Niger Arts charitable trust informed this writer:

> Actually, unlike many from the area, I really love the Beatles, but it comes to something when the only discussion you get from Liverpool City Council about Liverpool 8 is when an ex-Beatle doesn't really want his old house to be saved – so what? I think that Ringo actually might have echoed a feeling across Liverpool 8, in that he might have thought that we should stop distracting ourselves from the real issues in the area by over-concentrating on Beatles heritage. I also thought that he was probably misquoted – after all he didn't say much of anything to Jonathan Ross on TV – but maybe he was saying something to the likes of Councillor Warren Bradley about giving some thought to the loss of networks as the area continues to depopulate – if so, I support him![22]

It perhaps should be reiterated that both John Lennon's and Paul McCartney's own boyhood homes, but not their actual birthplaces, are part of the National Trust (as I write George Harrison's is still being used as a home). Ringo's former home

in North Wales. Former Beatles Story proprietor Mike Byrne informed this writer that 'they were regarded as being a bit special, a cut above the other groups, because of their professionalism, showmanship, and the fact that they regularly obtained gigs away from Liverpool, such as at Butlin's – Rory, Johnny Guitar and Ringo were highly regarded in that respect'.

[22] Oludele Olasiende of River Niger Arts to Mike Brocken, May 2009.

receives daily visits from Beatle fans of all ages, and alongside Phil Coppell's vibrant campaign author/historian Sir Nicholas Pevsner argued that the house should be saved on the basis of its pre-Beatles architectural history. Nevertheless, while the 'Welsh Streets' appear on the cusp of a debate between fossilization and kineticism, for many locals the demolition remains socially contentious: the houses are fundamentally sound, renovation would be preferable and cheaper, and some degree of community-building might be fostered by their preservation. For this group, popular music heritage cannot, it seems, counter further losses of social or cultural capital, especially when Ringo Starr himself remains understandably ambivalent. However, such debates concerning popular music heritage at least evoke connotation, and whether Ringo Starr is more or less concerned about his former abode is probably irrelevant. Phil Coppell informed this writer that:

> All of the former Beatles houses should be saved: George's and Pete's as well, because the ability to complete a tour of Beatles dwellings is probably the most important priority for many Beatles visitors. Without this circle of buildings the very tour that brings in Liverpool possibly millions of pounds (and foreign currency, remember), is left wanting.[23]

This debate actually focuses directly upon the uses of popular music as heritage, the meanings behind such uses for entrepreneurs, the relationship between local communities and decision-makers, and the future of previously neglected areas such as Toxteth. Whatever one's opinion concerning the uses for which this house should be employed, the mindset of Phil Coppell and his campaign in suggesting that it is a potential money-maker has at the very least drawn attention to these important music business areas of activity and how they relate to a future Madryn Street. The linking of business, heritage culture and popular music has worked in a perhaps unique way: by foregrounding the aforementioned interconnectedness of this newer breed of music-based money-makers in Liverpool to 9 Madryn Street, we can see Coppell's campaign not as the case of heritage encapsulated by the Forthlin Road and 'Mendips' properties (saving the homes of great composers, as it were), but rather as potential capture for authorized Beatles tour guiding, thus profit, thus prosperity. Literally, for Phil Coppell the saving of Madryn Street helps move his industry towards completing a kind of 360 degree contract between the built environment surrounding the Beatles and the future prosperity of Liverpool. Thus, notwithstanding Ringo Starr's attempt to legitimately represent the 'real' experiences of transformed subjectivity concerning his Liverpool 8 past, Phil Coppell requires Madryn Street to help feed, represent and reconceptualize the individual and the collective experiences of both locals and visitors to Liverpool – and who can blame him?

[23] Phil Coppell to Mike Brocken, July 2012.

Summary

All historic places and iconic locations attract attention but debates do not appear to surround the validity of preserving country houses in quite the same way as they surround the more 'ordinary' built environment and the popular. Nevertheless, writers such as Robert Hewison have brought to bear through time a check on the uses and abuses of a national networks of ownership that appear 'in the name of' a national identity. But the word 'popular' still plays its part in people's understanding of place. While few would question a tourist wandering around an empty sporting venue such as Anfield or Goodison Park, that same person attempting to relive music history via attending a grave or an iconic photo shoot location appears to be categorized as an 'obsessive'. Although some such popular music places have been recognized as of significance (some with perhaps inappropriate plaques or statues), there still appears to be the problematic association between historicizing the built environment and its relationship with the popular: the durability of one seems to be affected adversely by the apparent ephemerality of the other. Thomas Docherty suggests that:

> The victors in history thus proceed in triumphal procession, bearing with them
> the spoils of their victory, including those documents which record, legitimise
> and corroborate the necessity of their victory. Such documents the victors call
> 'culture'. The historical materialist, unlike the historicist, is profoundly aware
> of what is being trampled underfoot in this process: the historical materialist
> remembers what the historicist ignores.[24]

Such, one might argue, is the relationship of pragmatic popular music histories with the histories surrounding hierarchical forms. Studies of everyday life and popular music activities (e.g. singing, reading, writing, talking, walking) suggest that *relationships* determine their terms (not the reverse): each individual is a locus for incoherent, contradictory and pluralistic communications. Perhaps while certain historians concern themselves with a kind of singular 'methodology-as-truth' approach, they are convincing themselves that they 'know' the past via their own pre-chosen methods, and that such methods can indeed appropriate popular music as if it were a toy (or not, as the case may be). However, the guiding of Colin and Sylvia Hall is perhaps historical in perhaps the purest sense: it shows to us that, while social agents may indeed appear in apparently concrete situations, and are constituted by precise discursive information networks, the reception of such information within these specific places cannot be limited by this grounding. Because of this, affective affiliations which do not presuppose the overconfidence of a proleptic pronouncement (i.e. that this is the way to do it, and it should always be this way) are relentlessly proposed. Popular music is evidently a spatial

 [24] Docherty, Thomas (1993), 'Postmodernism: An Introduction', in *Postmodernism: A Reader*, London: Harvester Wheatsheaf, p. 11.

horizon, across which affiliations and disaffiliations may occur; therefore a *range* of criteria for choosing how one considers popular music heritage tourism must be approximated. By doing so, we can clearly see that all meanings given to music are kinetic though time and space.

Furthermore, the traditions according to which the Save Madryn Street! campaign attempts to define itself cannot be singular. Therefore historically the popular is gloriously 'directionless' and amorphous. Various itinerant meanings can be scrutinized for their inherent contextual authenticities and values. We appropriate, rearticulate and give new meanings to the generative structures around us. These exist within a syntagmatic framework of connotations that refract, not reflect, and continue to ask questions about politicized values and authentications across British society in relationship with heritage, place and space. The radical (let us say) 'relationalist' status of Beatles heritage tourism widens relational logics so much that it opens up pathways towards new conceptualization of how we might live our lives. It suggests new possibilities, new relations, and introduces ambiguity.

The very history of the Beatles on its own developed in a way not simply of its own. It was rooted/routed in a built environment in Liverpool that permitted it to take shape in a certain way. Popular music's relationship with the built environment, therefore, asks us to consider questions about how places have come to be, how relational logics exist between places, and how communities recognize such issues and believe in something. Local canons of rationality and their relationship with global issues concerning the popular cannot be reduced to a single standard. They invite us to consider the processes of living in the world today, not simply yesterday.

Chapter 8

'Is there anybody going to listen to my story?' – Guiding, Cavern City Tours, the Replica Cavern and Horizons

Shortly before his death, John Lennon shocked his fans by disclosing to *Rolling Stone* magazine that he enjoyed easy-listening at home throughout the day while Yoko Ono was out on business.

(Joseph Lanza, 2004: 204)

As a tour guide in Liverpool for perhaps more years that he cares to recall, and more latterly concentrating almost exclusively upon popular music histories, it came as an interesting experience for Phil Coppell to find in April 2012 his diary booked full of *Titanic* tours around the 100 years' commemoration of the vessel's sinking. Tourists to Liverpool cannot be easily compartmentalized, for all visitors arrive in Liverpool for a wide variety of reasons – some personal, familial, nostalgic, etc. for Liverpool 'exports' many people to the four corners of the word; others to do with the iconography surrounding Liverpool's built environment and its maritime history; still more (and in ever-growing numbers) fans of popular music genres such as Merseybeat, and in particular devotees of the Beatles. However, it had never previously occurred to Coppell to effectively search for a link between the two historically significant events of the sinking of the *Titanic* and the rise of the Beatles, for there appeared to be none. Yet, when one delves into what purposes a function myth appears to have in people's lives, then such uses can inform us of not only how myths actually function and are essential requirements of the human imagination, but also how they can be told in such a way as to be 'crowd pleasers'. While John Tosh states that 'Myth-making about the past, however desirable the end it may serve, is incompatible with learning from the past'.[1] if the past is constantly with us in the present, then we can actually learn something about both; about, let us say, the desires and needs of those who wish to have a myth delivered to them in order to fulfil their needs and desires as devoted tourists. Even urban myths are real in one sense, for they are actually accounts of realistic life experiences. They are not facts, as such, but rather 'plausible stories' aimed at the imagination.

Liverpool is now an imagined and/or mythologized city on several levels. It continues to exist in the real world but also finds itself in a curious nether-world between a place created by propaganda of the present and a dramatization of a

[1] Tosh, John (1984, 1991), *The Pursuit of History: Aims, Methods and New Directions in the Study of Modern History*, London: Longmans p. 21.

past that may or may not have existed – but does this actually matter? Under such circumstances, the 'ways of telling' any function myth come into play to serve the direct imaginations of those who wish to celebrate their own sense of self via the creation of attachments to a city, which may or may not replicate these imaginings. So although Tosh continues to state that 'The historian has a significant negative function in undermining myths which simplify or distort popular interpretations of the past',[2] it could be argued that a tour guide uses historicity (i.e. the genuineness of an event) of the past in conjunction with specific modes of 'telling'.

This 'telling' is not unrelated to the historian's quest for correcting myths about our own society or city, but perhaps only up to a point. More relevant, perhaps is the ability to remove oneself from one's own assumptions and to step into the 'imagined' shoes of others – some of whom inherit different traditions about history. One might argue that 'telling' in this way has been under-researched in the pursuit of history because it highlights the issue of making adoptive kinship real via myth, while also acknowledging a real use and distinctiveness for that act. The popular music tour guide can place the visitor at ease, and the history-cum-myth 'lesson' can therefore begin. As Jan Harold Brunvand states:

> we do not concentrate on the form or content of our folklore; instead we simply listen to information that others tell us and then pass it on – more or else accurately – to other listeners. In this stream of unselfconscious oral tradition the information that acquires a clear story line is called narrative folklore, and those stories alleged to be true are legends. [...] It works about the same way whether the legendary plot concerns a dragon in a cave or a mouse in a Coke bottle.[3]

Liverpool attracts countless US citizens every year and it could be argued that, on one level, some Americans see function myth *as* history in the first place, never mind when one considers issues to do with either the *Titanic*, the Beatles (or both). Function myth, as far as the national history of the United States is concerned, is an integral part of its nationhood and should never be underestimated. The 'American Dream' functions as a myth within US political discourse by providing hope to citizens and reinforcing beliefs in the (usually white) protestant work ethic, meritocracy and the symbolic West. The US myth of mobility via westward travel, the exoticism of the West and the importance of self-sustaining cities has greatly contributed to the image of successively San Francisco, California and, most importantly ,the United States as places of freedom. Of course this is mostly legend, for to (say) a Mexican-American population San Francisco can also stand for Imperialism, marginalization and loss of hope.[4] But the ability to reframe

 [2] Ibid.
 [3] Brunvand, Jan Harold (1981), *The Vanishing Hitchhiker: American Urban Legends and their Meanings*, London: W.W. Norton, p. 1.
 [4] One is reminded of the scene in Mel Brooks' film *Blazing Saddles* when the Black pioneers are not allowed to join the 'white folks' wagon train. They have to form their own

the 'American Dream' is considered an important aspect of American life and such re-framing can be entirely selective. Take, for example, what Coppell describes as 'the almost deification of the US John Lennon': an individual who stereotypically wished to escape the 'Old World' to live in the 'New', fought against prejudice, but was then martyred. This seems to fit several function myths at one and the same time, presenting the US with a collective sense of ownership through which the function myth of the 'American Dream' can be maintained, rather than challenged (Lennon, as a Liverpudlian, inherited the oxymoron of both polarities, of course). Even the most cursory examination of Lennon texts, post-December 1980, reveals dominance by American and American-based writers. Further, however, there is also a dominance of American mythologies of the variable histories of the Beatles.

For example: that John Lennon was unquestionably 'political' in the universal sense; that he was also uncontestably a 'genius' of some sorts; and that his post-Beatles life in the US was more historically 'meaningful' than his existence during the Beatles 'era'. Further, that the British had oddly undervalued him. All of this is of course understandable: Lennon's death in the US not only produced a sense of collective rock guilt, but also moderated that guilt with a confidence concerning Lennon's chosen place of abode. Indeed, Walter Podrazik informed Larry Kane that:

> the other Beatles had places in America, but John made it clear through his immigration struggle that America was his choice. He loved the freedoms and so desperately wanted to live here. In the view of many, John had become an American by his dedicated decision to fight to stay here.[5]

This view, of course, runs contra to testimonies from both BBC broadcaster Andy Peebles and John Lennon's Liverpool-based friend Joe Flannery. Both spoke with Lennon shortly before his death in December 1980, and have subsequently suggested that John informed them (independently) of his preparations to return home to the UK for, at the very least, a tour; Flannery states:

> My surprise at his comments came about because it seemed to me that the Press were always at pains to suggest how happy he was in the United States. John however told me wanted to return to the UK at least with a tour in mind. He even suggested that Clive [Epstein] and I should book the QE2 for his return to the city and that I should fly out to New York, when the time came to return with him on the liner. I was flattered but mentioned to him that I wondered whether the QE2 could actually get down the Mersey. 'Look into it' John shouted 'I want to come home in a blaze of glory; when you've done it you and Clive [Epstein]

'circle' (of one wagon) when the 'Indians' attack.
 [5] Cited in Kane, Larry (2005), *Lennon Revealed*, Philadelphia [USA]: Running Press, pp. 124–5.

can join me on the liner'. In retrospect I suppose I would have discovered that the QE2 could indeed have weighed anchor in the Mersey, but of course we were never to find out.[6]

Therefore such mythologies have led to misunderstandings and misinterpretations of John Lennon and the Beatles not only as a British, but also Northern English, manifestation. Such concepts are visible to Phil Coppell 'on an almost daily basis'. He suggested to this writer that, to paraphrase, the Beatles' specifically class-based Liverpudlian upbringing in a city geographically in the North West of England, but not necessarily consistently delineated as such by its own inhabitants, has frequently been all but ignored, or perhaps even wilfully misinterpreted by many tourists in favour of the pervading stereotype which makes a cultural 'claim' on, and displays a sense of ownership of, John Lennon from the United States; Coppell further stated: 'What emerges from my tours is the need for a prescription of the Beatles: everything has to appear in the right historical order, but is all only a tentative and shadowy resemblance of the real thing!'[7]

Such American claims have therefore led to an interesting and enigmatic indifference to many British readings of the Beatles, together with the milieu of popular culture from which they emerged, and the cultural and critical regionalism and indigenous chauvinism that surrounded and effectively 'produced' them as individuals. This perhaps more variegated and variable status of the group in the United Kingdom, and indeed their home city of Liverpool, has seldom been addressed fully by the canon-led Beatles writers for fear of exposing the complexities and ambiguities of Beatles' reception. Yet in spite of this, US tourists it seems (according to Coppell) for the most part cling to the myth and, accordingly need to be catered-for. One explanation is that that the John Lennon dream endures because it can be reconceptualized. According to Coppell, 'Many people holding such ideas visit Liverpool'.

In his work *Creative Mythology*, the renowned US philosopher of religion Joseph Campbell tends to agree with the above model and he suggests that, at least from this social perspective, myth is 'the validation and maintenance of an established order'[8] and that parables embedded with morals attempt to teach us how we should behave – in other words, what one considers to be model behaviour, and what is acceptable. But in the same work Campbell also chooses to quote equally renowned US philosopher John Dewey, who suggests that an individual's *real* experiences should guide their behaviour more than any handed-down social rules: 'A philosophy of experience will accept at its full value the fact that social and moral existences are, like physical existences, in

[6] Flannery, Joe, with Mike Brocken (2013), *Brian Epstein, The Beatles and Me: Standing in the Wings*, Stroud: The History Press, p. 256.

[7] Phil Coppell to Mike Brocken, May 2012.

[8] Campbell, Joseph (r. 2011), *Creative Mythology (The Masks of God)*, London: Souvenir Press, p. 621.

a state of continuous if obscure change. It will not try to cover up the fact of inevitable modification, and will make no attempt to set fixed limits to the extent of changes that are to occur.' Campbell proposes that 'the individual is now on his own'.[9] So perhaps like historian John Tosh, Joseph Campbell mistrusts certain social functions of mythology and myth-telling. However, according to Campbell there is also a 'Psychological Sphere' in which myth operates and it is this aspect of myth-telling that relates most closely to the role of the tour guide. *This* is the aspect of mythology where stories symbolize important points in an individual's life, with the purpose of 'centering and harmonization of the individual'.[10] Most stories speak to us as individuals exactly to the extent that we see ourselves in them. Campbell is comfortable with this rather than the social aspect of myth, writing: 'Since in the world of time every man lives but one life, it is in himself that he must search for the secret of the Garden'.[11]

In other words, stories that help us to look for answers and guidance from within ourselves can, with the help of the appropriate symbolism, tap into a valid source: one's self, which according to Campbell happens to contain 'all of the universe', in any case. All myths depend upon continued oral dissemination and the retention though time and space of important strategic motifs. So, while myths ceaselessly change, at the centre lies a stable core. 'Tellers' of these tales are aware of their roles as performers as well as deliverers. The demeanour of a 'teller' is orchestrated, and the delivery carefully considered. Performance therefore lies at the heart of such 'telling', for not everybody can tell stories that people want to hear. Less active tellers might report rather than entertain, whereas more active tellers recreate and reinvent, as they so choose. It could be argued that this form of praxis, rather than imparting historical knowledge per se is the primary function of the tour guide. Let us look at one example of this by suggesting, as Phil Coppell did during his Titanic Tours of 2012, a link between the *Titanic* and the Beatles – one that can, of course, never be proven but nevertheless serves as an interesting function myth. Consider this short 'telling' of tragedy and ill-fortune, bearing in mind at all times this is a continuum created by social and psychological myth-telling. I accompanied Phil Coppell on one such tour, recorded his narrative and, with his full permission edited it down into literary language. The introductory narrative began, as follows:

> Thomas Henry Ismay was born in 1837 – the same year that Prince Victoria became Queen – and one might suggest was a 'real Victorian'. He was born in Maryport in Cumbria and his father, Joseph, who died when Thomas was 12, was a successful ship builder and owner. At 16 he joined the Liverpool firm of Imrie Tomlinson as an apprentice ships agent. At 19 he spent a year at sea, sailing to South America. At 21 he reached his majority and formed a partnership

[9] Ibid.
[10] Ibid., p. 623.
[11] Ibid.

with a retired Captain Philip Nelson, who owned the *Anne Nelson* named after his wife. They opened an office in Water Street, Liverpool and the business was a success. The first '*Titanic* myth' is that Ismay founded the White Star Line but he did not, for the name, flag and goodwill was purchased when the line ran into financial difficulties following the collapse of the Bank of Liverpool. Yet even English Heritage perpetuates this myth by stating on the Blue Plaque on his house at Beach Lawn in Waterloo near Liverpool: *Thomas Henry Ismay 1837–1899 Founder of the White Star Line lived here.*

One might suggest that this myth serves a very real social function of continuity – the aforementioned 'isomorphism'; Coppell continued:

> Over a game of billiards with Gustav Schwade, another Liverpool Merchant, it was suggested he get involved in the North Atlantic trade; Schwade explained that his nephew Gustav Wolff had gone into the ship building business in Belfast with Edward Harland and if Ismay had his ship built by Belfast's Harland and Wolff, he would financially support Ismay. Ismay agreed and the first ship launched in 1871 was the *Oceanic*. Harland and Wolff built all the White Star Line ships, with one exception. The deal was Harland and Wolff would not build ships for White Star competitors and White Star would not have ships built by any other company. As it turned out they became one linked company.

Visitors to Liverpool are therefore informed that White Star, under Thomas Ismay's leadership, became the most successful British transatlantic shipping line. Thomas Henry Ismay died in 1899 and his son J. Bruce Ismay took over the full running of the company. Bruce Ismay sold White Star Line to J.P. Morgan in 1904, but remained as Chairman. It was Ismay who commissioned the building of the *Titanic* because of increased competition from Cunard. When the vessel was launched in 1911 it was the biggest moving object on the planet. The *Titanic* was quite naturally registered in Liverpool but did *not*, of course, sail from Liverpool. Coppell commented that: 'From this guide's experience it was very interesting to find that while "Titanic visitors"' were fully aware of this fact, they did not wish it to be so. One informed me that she "'blotted this out, because it made the story far more romantic" [her words], and it saved her the money of travelling to Southampton'. The most enduring myth is that the *Titanic* was built to be unsinkable. In James Cameron's film of the same name the heroine's mother looks up at the ship from the dock in Southampton and remarks: 'So, this is the ship they say is unsinkable'. This is perhaps one of the greatest mythologies surrounding the *Titanic* narrative, suggests Richard Howells:

> It is not true that everyone thought this. It's a retrospective myth, and it makes a better story. If a man in his pride builds an unsinkable ship like Prometheus stealing the fire from the gods [...] it makes perfect mythical sense that God

would be so angry at such an affront that he would sink the ship on its maiden outing.[12]

So, contrary to popular interpretation, the White Star Line not once made any substantive claims that the *Titanic* was unsinkable, and nobody really talked about the ship's unsinkability until after the event and: 'history turned into myth within hours and certainly days of the sinking',[13] argues Howells. In fact, *Titanic* was dubbed 'ship of dreams' by many of the newspapers at the time (and it was certainly that). The vast majority of the passengers were migrants, sailing for what they dreamt was a new and better life in the new world, the United States.

Following this introductory narrative, visitors were then informed by Coppell that a great friend of John Lennon's, Joe Flannery, had informed the *Beatles, Popular Music and Society* MA class in 2011 (of which Coppell was a member) that John and Joe would occasionally sit at the Pier Head looking towards the Irish Sea, whereupon John would tell him that he wished to be 'over there' (meaning the United States). So perhaps in a similar way John Lennon, stated Coppell to the visitors, when he went to the United States for the first time in 1964, was also fulfilling a lifetime dream of being a success in the new world. Visitors were then strategically informed that both the dreams of the majority of *Titanic* immigrants and the dreams of John Lennon would end in disaster. The timing of this comment was significant, for it came after several minutes of a discussion concerning how the variable *Titanic* histories that the visitors presumably already 'knew' could and should be contested for historical veracity. It was at this moment (for this writer), via the inclusion of John Lennon, such a way of 'telling' seemed to function psychologically as a consolidation for US citizens of their own myth of nationhood – in one fell swoop, as it were.

For the all-important Beatles connection, visitors were then informed that Alfred Lennon, known as Freddie, *might* have worked as a merchant seaman on a White Star Line ship; but the tourists seemed to ignore the word 'might'. There is no written evidence of this, of course, for crew lists were destroyed when Cunard took over the White Star Line in 1934; there is a little rhetorical oral testimony, however.[14] Via his own maritime narrative, Coppell asserted to the tour group:

> One of the great Lennon myths, in my opinion, is that John Lennon was deserted by his father; he was not, as Albert Goldman suggests, John was deserted by his mother Julia. His parents had married in December 1938 and John was born in October 1940, while his father was away at sea. Over the next four years, this being wartime, Freddie only spent three months in Liverpool and the rest of

[12] Howells, Richard (2012), 'One Hundred Years of the Titanic on Film', *The Historical Journal of Film, Radio and Television*, 32/ 1, March, pp. 73–93.

[13] Ibid.

[14] See Claire Evans' 'Conversations with Uncle Charlie [Lennon]', BBC Radio Merseyside programme, broadcast September 1999.

the time he was at sea mostly on convoys. Freddie arrived back in Liverpool in November 1944 to find his wife pregnant by a Welsh soldier, and this child Victoria was born in June 1945 and given up for adoption.

He continued:

> John was being cared for by his mother's elder sister Mimi Smith, (nee Mary Elizabeth Stanley). Freddie Lennon had to return to sea and it would be 18 months before he was back in Liverpool, by which time John was living in Woolton with his aunt Mimi and her husband George, while Julia was living with a waiter, Bobby Dykins. Freddie offered to take John to New Zealand with him and start a new life there and his mother Julia did not object, but when she left him with his father John ran after his mother. The 22nd June 1946 was the last time that Freddie saw John until he was a famous Beatle. His mother Julia left her sister Mimi to bring up John only seeing him on her occasional visits to Mimi, despite living close by. John did not become close to his mother until after the age of 13, when he became a frequent visitor to her home. Julia was knocked down and killed by a car driven by an off-duty Police Officer, and the young John was devastated; he would later say 'I lost my mother twice, once when I was a child of five and then again when I was seventeen, it made me very, very bitter.'

Such a [dis]connected series of conjectures and mythology can be easily made by the guide for, as we have suggested, the 'Psychological Sphere' is of great significance in myth-telling. The story symbolizes critical points in an individual's life, with the purpose of the aforementioned 'centring and harmonizing' around in this case the invisible Alfred Lennon.

Storyteller Hugh Lupton, who is widely known on the contemporary UK folk and traditional music scenes, has for the past three decades been telling stories in schools, theatres, prisons, hospices, universities, festivals, and fairs. In Lupton's *Something Understood* for BBC Radio 4 in February 2005, he summed up the role of myth:

> The function of myth is to tell the truth. Not the everyday truth that is the opposite of lying, but the truth that can't be told any other way. Countless intelligences have precipitated the stories. Countless voices have worked on them, shaping them and adjusting them and refining them, clothing them in the picture language that lodges in our memories. They are as durable and resilient as the words that carry them. They are a gift from the past, but they are only worth anything if they can speak to the present. Our job is to retell and reinterpret them, to let them lead us into the questions and mysteries and silences that words can only point towards.[15]

[15] Lupton, Hugh (2005), 'Something Understood', *BBC Radio 4*, broadcast February 2005.

Phil Coppell concluded his tour by stating that the *Titanic* 'never made it to America, whereas John Lennon did, but disaster, in the shape of a crazed fan was waiting there for him'. These two seemingly unrelated stories and histories are therefore undeniably linked: to Liverpool, via being routed in past events, to the shortcomings of institutions such as White Star and/or the music industry, to human misjudgment and rank bad luck. In any age and with any subject a skilled storyteller plays with ideas. If members of an audience respond, stories are repeated and exaggerated. Legends flourish, but such legends will contain important symbols of our cultures and reflections of our experiences. In this way function myth contributes to the 'thirdspace' of Liverpool and by doing so helps to sustain the very economy of Liverpool.

A Day with Australian 'Beatles' Tourists

There are many ways one might go about embarking upon and then delivering a small ethnographic-based sample of popular music tourism in Liverpool but perhaps the best choice would be that of observation. Popular music anthropologists advise that direct participation, close observation, and a level of detailed qualitative study is absolutely essential. They also suggest that theoretical frameworks concerning social and cultural studies are vital to help us understand the nature of our enquiry. Hammersley and Atkinson also propose that one should not embark upon anything to which one already feels one knows the answer, and that open-mindedness is essential.[16] In *Karaoke Nights: An Ethnographic Rhapsody*, Rob Drew looks at ethnography as a way of understanding self-made performers and audiences and how the process of 'becoming' is an important feature of interpersonal interaction.[17] One valid comparison with Drew might be to consider Blue Badge Guide Phil Coppell as an entertainer and his visitor group as an 'audience'. While the image of 20–30 tourists standing listening to a guide on the corner of (say) Liverpool's James Street is seldom given the moniker of 'performance and audience', this is nevertheless an important image to consider. It is especially significant if one concedes that the imagery conveyed by a tour guide is not essentially historical in the 'pure' sense (see above) but rather a mixture of history, myth, rhetoric and *performance* in and of itself, to meet the needs and requirements of visitors and their a priori generic assumptions concerning their 'imagined city', place and people. One great problem for any ethnographic study is that (to paraphrase Berger and Del Negro) reflexive self-awareness is inescapable and always plays a role in an interactive study.[18] Berger

[16] Hammersley, Martin and Paul Atkinson (1994), *Ethnography: Principles in Practice*, London: Routledge.

[17] Drew, Rob (2001), *Karaoke Nights: An Ethnographic Rhapsody*, London: Altamira.

[18] Berger, Harris M. and Giovanna Del Negro (2004), *Identity and Everyday Life: Essays in the Study of Folklore, Music and Popular Culture*, Middletown CT [USA]: Wesleyan University Press.

and Del Negro suggest that this can be a problem for those ethnographers who wish to remain 'at a distance'; however, in this particular case such close reflexivity was vital to observe, and is linked to an understanding that the performer (or in this case 'guide') needs to be reactive to the overall milieu established by the genre-based realities of a tour, so that the requirements of an 'audience' are acknowledged: the provision of a symbolically memorable and entertaining experience.

It would be fair to state that Britain is now the sixth most popular holiday destination for all regular international travellers. According to the national tourism agency VisitBritain, in 2011 the number of visitors was 30.7 million, who contributed nearly £18 billion to the British economy, making tourism a major industry. Visitors choose many ways to visit: as individuals or as part of a group, 'doing their own thing' or taking an organized package holiday such as a cruise or a railway trip. Often we think of package holidays as a means of dispatching British tourists abroad, however in more recent years this process actually started to reverse, with many foreign travellers now booking packages in the UK. The UK Music report *Wish You Were Here*,[19] published in 2012, stated that the North West of England is now the second largest region after London, in terms of music tourism in Britain. Total music tourism spending in the North West was worth something like £285 million that year. It directly sustained, they reported, over 3,600 jobs. There is one consistently popular way of touring Britain and Ireland, including the North West of England, and that is the coach trip; there are many companies offering such coach tours of Britain and Ireland, at a variety of prices. This writer decided to shadow Phil Coppell and consider his guiding of a specific coach party of visitors on a tour which regularly spends one night in Liverpool. The group was made up exclusively of Australians, all white and all of European descent.

The youngest was 41 years, while the eldest was 78. The gender split was almost even, with slightly more women than men. Certain assumptions can be made about the social standing of these people because clearly they can afford the cost of the trip and the time to travel so far. For many, this is a fulfilment of a life-time ambition to visit the land of their forefathers and to see the city from which millions migrated to the New World and the Antipodes. It appeared from my observational distance that most of the passengers were reasonably well-educated with fair-good knowledge of British history and culture (both were being taught in Australian schools up to the early-1990s). English remains their mother tongue and they appeared even to have a similar sense of humour to their British-born contemporaries, if their reaction to local stories and anecdotes was anything to go by. This point was of interest to Phil Coppell, who deals predominantly with North American tourists. He declared that 'they [Americans] are much more literal in their interpretation of the commentary – they don't often "do irony" but the Aussies get the gags'.[20]

[19] Editors, the (2012), *Wish You Were Here*, report prepared by UK Music for the tourist industry, London: UK Music.
[20] Phil Coppell to Mike Brocken, June 2012.

This was a first-class tour in an air-conditioned luxury coach. There was an accompanying Travel Director whose job it was to make sure that the tour ran smoothly and the itinerary was adhered to, as well as ensuring that the passengers enjoyed the holiday. The group went on to travel across the UK and Ireland over the course of following weeks. This, then, is what might have been previously described in former tourism-based vernacular as a 'sightseeing tour', diachronically and synchronically relating to the needs and requirements of the tour arranger as much as the tourists themselves. Each guided trip is in a way 'interrelated' so that a measure of continuity can be offered across the board. It is therefore rather like a tour in the entertainment sense, where each stop provides an 'entertainer' of sorts to fit the requirements of the 'tour genre'. On this particular occasion 47 passengers chose to take the Liverpool optional with Coppell as their tour guide, the tour lasted 2 hours and took place between 8.30 am and 10.30 am. In explanation, Coppell subsequently commented to this writer via email:

> The Liverpool tour is optional and is sold by the Travel Director so that passengers do have the choice of taking the optional or spending the morning in Liverpool at leisure. Perhaps such is the popularity of Liverpool as a destination in 2012 that, on this occasion only 2 people did not take the optional tour. In my position as the 'selected' (chosen by the tour operators) Tour Guide I am on the microphone and the commentary means that there are not many opportunities for people to ask questions when the coach is moving. Visitors tend to save up their questions for when we are stopped at a venue such as the Anglican Cathedral or The Cavern Club. This means that the questions raised have a particular significance to the individual because they have had opportunity to be distracted or to forget what prompted the question in the first place. Occasionally an individual will feel so strongly about the question that they want to raise that they interrupt the commentary by shouting out during the tour, this is the exception rather than the rule because there is a generally accepted etiquette regarding 'correct' behaviour on board such tours.[21]

This Tour

The visitors were late, having enjoyed an inclusive meal at The Noble House in Fenwick Street the previous evening. They had not arrived at Jury's Inn near the Albert Dock where the tour was due to start until well after 8 am and some were somewhat 'worse for wear'. It was raining heavily and the first question Coppell was asked as people were boarding the coach was 'Is there really a drought on?' The next statement was 'So you're our Beatles expert, have you met any of them?' Great credibility is attached to personal association and Phil informed the group in a matter-of-fact delivery that he had indeed met both Paul McCartney and

[21] Email correspondence between Phil Coppell and Mike Brocken, 1 June 2012.

Ringo Starr, in addition to George Martin and Yoko Ono (all of which is correct). The drive from Jury's Inn was via the new riverside access road and it was at this stage that the famous ferry was sighted by some passengers. Phil explained that this was the longest established ferry service in the world and also the subject of the Gerry and the Pacemakers song 'Ferry Cross the Mersey' – one passenger immediately shouted out 'I saw him last year' and Phil was able to confirm that Gerry Marsden had indeed conducted a tour of Australia and New Zealand in 2011. He later informed this writer: 'In order to consider my role as entertainer more than historian, I mentioned that I had recently spoken to Gerry at a local golf club while he was waiting to tee-off. Local credibility enhances my standing with the group.'[22]

The coach motored past the Albert Dock and stopped at the Pier Head, where up until 1967 many people had used Liverpool as an exit point for Australia. These migrants were called '£10 Poms' (the cost of their passage, so keen were the Australian Government to get people to live in Australia). One woman immediately shouted 'I left Liverpool when I was three, do you know Abbotsford Road?' Phil informed her he did: 'It is in Norris Green about five miles from here.' She was surprised by this and at the end of the tour she and her husband hired a taxi to take them to Abbotsford Road. She did not know the number of the house, but explained excitedly she would at least see the road where she was born. She was very emotional and told this writer that she would try to find out more about her birthplace, for she had previously thought all the houses from that district had been demolished. (I found this interesting, for the district of Norris Green is actually a long way from demolition.) From the Pier Head the route of the tour took us along Tithebarn Street, which passes Exchange Street East, and passengers could see the sign 'Queen' on one building in Dale Street. Coppell explained that this was the sign that inspired Freddie Mercury to call the band 'Queen', which received the response 'Is that true?' 'Yes' he confirmed as he further informed the group that Freddie had been the lead singer of a Liverpool-based band called Ibex (which was true) before joining what became Queen; if they did not believe him, he advised them to 'pop into Liverpool University where Brian May is an honorary Vice-Chancellor, not because of his guitar playing, but because he is a Doctor of Astrophysics'. The tale was mostly apocryphal, but added to the concept of Liverpool as a 'music city' and cheered up the by now 'recovering' visitors.

Our next stop was at the junction of Mathew Street and North John Street; on this occasion due to the poor weather conditions the coach came to a halt outside the Hard Day's Night Hotel, the closest point to Mathew Street on North John Street that was available (a coach cannot safely negotiate Mathew Street). Coppell informed me that he would phone the driver to return to pick up the passengers at the end of our visit to the replica Cavern – he stated 'the coach would have to park-up elsewhere or else run around the block for half an hour – what a pain this city can be!' He then explained to the passengers that, as the Cavern was not open to the public at this time, he had arranged for them a 'private visit'. They were

[22] Phil Coppell to Mike Brocken, June 2012.

mightily impressed; he also informed them that those who wished to do so, were free to stand on the Cavern stage and have their photographs taken. This further excited the group. 'Also', he shouted, 'there will be the opportunity to purchase Cavern memorabilia.' He added this casually so as not to suggest that this was a pre-arranged deal with CCT owners (which it was). Before the passengers alighted he related a brief history of the Cavern and also told the visitors in a more authoritarian tone that Liverpool as a city was in the Guinness Book of Records: more singers and bands from Liverpool have enjoyed number one hit records than from any other city in the world, they were told (this is arguable and depends upon where one considers Liverpool's perimeters to be). He remarked in a humorous tone that the first Liverpudlian to enjoy a number one hit was Lita Roza; nobody recalled her name until he sang 'How much is […] ' and the group immediately re-joined '[…] that doggy in the window'. He did not inform the group that Roza was in fact a Black Liverpudlian. The walk from the coach to the Cavern was almost tortuously slow, as photograph-taking dominated, perhaps showing the current trend of people needing to photograph 'all they see'. One lady stated 'I think I am taking a thousand photographs a day, I have bought seven new camera cards and the tour is only half way over'. I noticed Phil glancing at his iPhone, surreptitiously checking the time.

Another tourist asked (presumably thinking that this was the original club/ building) 'Is it still used as a club?' Our guide gently explained that major popular music artists still play the Cavern and, removing from his pocket a photograph taken during Adele's show in 2011, confirmed this (in fact very few major artists play the Cavern Club and more recent popular music stars are probably unaware of the significance of the venue). Phil Coppell has conducted this tour literally hundreds of times, perhaps even a thousand, and he stated to me on the walk down Mathew Street from North John Street that he liked this tour because it allowed him to talk without the use of a microphone; this 'changes the whole tone of the tour and allows people to ask me questions, and to get more involved'. Various members of the party felt that they could now approach him, and were asking him questions, the most repeated being 'Is this where the Beatles played?'; I counted this query being posited at least seven times before we entered the club. A local standing in Mathew Street recognized Phil and shouted a 'hi', which he acknowledged in a friendly manner. This also appeared to please the tourists, perhaps awarding him an authenticity of place, in their eyes. As this is a *replica* of the Cavern built a little distance from the original, the tourists happily accepted his explanation that the replica was built using the same bricks (this is simply not true, for the original brickwork was mostly used as in-fill on the original cellar, which is still located beneath Mathew Street).

Once in the Cavern, the highlight was having a photograph taken on the stage in a 'karaoke' pose; all the visitors seemed to want this and one could feel an excitement further build. It was also at this time that the group, who were mostly what might be described as 'baby boomers', began to open up a little, informing both Phil and myself of their own Beatle experiences back home. Several told Phil

that they saw the Beatles when they visited Melbourne on the 1964 tour (I wondered whether they were now providing him with anecdotal material). Not one person from this group witnessed them in concert, but either saw them at the airport, driving through Melbourne, or as one person said 'leaning out the window of the hotel' (perhaps this was all seen on TV, I mused). Interestingly, one man stated that his parents 'would not waste money getting him a ticket to see the Beatles'. They were now it seemed fully engaged in this generic guiding entertainment and it became quite evident to this writer that the Cavern visit was an important sequential device in their entire tour of the UK. It allowed them to voice opinions, and to literally *engage* in the process. Performance is communication; however, in this particular case communication certainly appeared to be performance. This audience was fully aware of the importance of the communicator/performer Phil Coppell and it seemed that very real concepts of Beatles and Merseybeat were contained within his delivery. Therefore, as a consequence, the processes of telling and hearing became the most interesting part of the ethnography for this observer.

There were no performance-related outputs as such (unless one considered the karaoke poses to be so), so the processes and what arose might be conceived as 'praxis'. This is not the oft-repeated Marxist concept of incorrectly collapsing theory and practice into something described as 'praxis', but rather describes the interface between theorization and practice in people's minds. This might be described as a form of intervention via praxis. Coppell's praxis intervention model worked on the mindset potential of those participating. Obviously, the organizer (travel director) and expert (Phil Coppell) were willing participants in such an event for such praxis intervention aims to lead its members through a participant objectification process – in other words reducing complexity to the status of a singular object, and perhaps thinking of an emotion as if it actually existed. Both processes were witnessed by this writer and my experience suggested that I was observing a tour group willingly taking themselves into an audience mode via intervention praxis. For example, as Coppell spent time taking photographs of people on the stage (with their own phones and cameras), those who had already enjoyed that particular experience watched and applauded before finding their way to the club bar and the various cases of memorabilia.

There then developed a whirlwind of purchasing – as if people were effectively 'applauding' our guide as part of this process. One lady informed me that 'between us we have got eight kids and they are all Beatle fans, so we have got to get them a T-shirt each from the Cavern'. Another customer wanted T-shirts in different bags: 'a Cavern bag means I don't need to wrap it and they get two gifts for the price of one'. From our arrival in the Cavern until the final customer had been served lasted only 45 minutes – the average length of a popular music 'set', one might suggest; there were no complaints about the time spent in the replica Cavern, or even the walk up Mathew Street back to the coach in torrential rain. When all the passengers were back on board Phil thanked them for contributing to the economy of Liverpool and their response was unequivocal: 'thanks for arranging the special visit'. Time was now against us as the route took us along Victoria Street, past the

Mersey Tunnel, onto Dale Street and up to Lime Street to see The Empire Theatre, with its Beatle connections, and St George's Hall which, stated Phil (correctly), was used in the Robert Downey Jnr. and Jude Law film *Sherlock Holmes*. At some speed the coach moved towards Mount Pleasant, past the Metropolitan Cathedral, and along Hope Street. As the coach paused near 'the suitcases' artwork next to the Liverpool Institute for Performing Arts on Hope Street, Phil's 'telling' of the LIPA, and Liverpool College of Art stories further emphasized Beatle connections, as one might expect.

The coach stopped at the Anglican Cathedral, where due to the heavy rain we hurriedly made our way to the main door. Coppell once again stylistically 'told' his brief libretto of the Cathedral as the group was taken into the cathedral shop. The stained glass windows of coats of arms of the countries who contributed to the building of the Cathedral were evident. Strategically, the first coat of arms discussed was that of Australia. The group were then told that they could take photographs or, if they wish, buy postcards before continuing with the tour. Ten minutes were allowed for purchases and photographs; this became 30 minutes as so many were keen to buy souvenirs and photograph the Cathedral. Coppell leaned to this writer at one stage and whispered: 'Success! [...] without the Cavern experience I suspect that this would not have been quite so enthusiastic.' While waiting he was asked several times 'How long did it take to build?' and 'Did he design anything else?' When the group is mustered he showed them the red telephone box also designed by Giles Gilbert Scott – 'the smallest structure inside the largest', he explained. Back on the coach we headed back to Jury's Inn via Chinatown. Along the way Phil 'told' them that Paul McCartney had sadly missed their visit, but if they would like to send him a postcard he would give them Paul's address in Heswall, 'over the water, on the Wirral' – which he did. This was well received. Getting off the coach, responses ran from 'I didn't know what to expect, but I didn't expect this, it [Liverpool] is much bigger than I expected' to 'why did we not visit the football ground?' (oddly, without any mention of which team's ground, exactly). 'It is too far out of the city and would take too long to get there' was Phil's robust answer. He was to later state to this writer: 'without fail on every tour, and this tour was no exception, I am asked "Where's Abbey Road"? My answer of "London" seems to satisfy that odd query.' This particular performance ended for another day, with appreciative applause.

While several writers have correctly considered the ethnography of stage performance to be of considerable interest to the popular music studies researcher (via proxemics, gesture, tone of voice, material, and so on), at least from my own experience of shadowing Phil Coppell, the processes of intervention praxis in the delivery and communication of popular music myth and history certainly requires further detailed and academic investigation. How one entertains a small, attentive crowd, how one sets a scene, how one then invites the audience in via a dialogue of telling, and how one receives responses from audiences (ranging from spending money to occasional applause) suggests that the role the guide plays as primarily an entertainer is a vital part of Liverpool's popular music heritage tourism mindset.

Further, the entrepreneurial mindsets of Phil and Paula Coppell evidently 'tell' us a great deal about the partially hidden profile of popular music entrepreneurship in Liverpool. Popular music tourism in Liverpool is both embedded within an active and productive culture of self-employment and propelled by the need to keep Liverpool afloat via a spatial social history that has hitherto been all but ignored by the historical stereotypes put before the city in previous eras. And if a great deal of this kind of advocacy has historically been derived from the spaces of stage and drama (consider the renowned K.C. Marshall Hall), why not popular music guiding? In fact, perhaps one might argue that tour guiding is not what it is because of its content, but because of its context – i.e. because it is contextually and spatially 'framed'. Phil Coppell's narratives of the legacy of the Beatles suggest to us that the relationship between 'appearance' and 'disappearance' is of great value. The connections between such polarities are of notable significance, for making the disappeared 'reappear' via the evocation of a 'presence' is a powerful storytelling strategy. These narratives of origin and disappearance have now led to an understanding in Liverpool of the myriad ways in which humanity engages with both past and present environments; popular music heritage's survival and progress in Liverpool is one consequence of this understanding.

Cavern City Tours

This writer has also been observing the growth and development of Cavern City Tours for approximately thirty years, and it is to this company that this work now turns. If any group of entrepreneurs can be credited with an understanding of the relationship between popular music disappearance and reappearance, between heritage and place, and has then been able to use such understanding to develop practical solutions to cope with entrenched ideologies, it has been Cavern City Tours (CCT). This work, therefore, would be incomplete without a short discussion of perhaps the greatest of all self-employed survivors in the Beatles tourism industry. The combined driving force behind CCT is Dave Jones and Bill Heckle. Via their different sub-businesses, they have made a significant contribution to the creation of a successful Beatles visitor experience in Liverpool. These business interests include the replica Cavern Club, the Cavern Pub, The Magical Mystery Tour, and the Annual International Beatles Convention. They were also the brains behind the Hard Day's Night Hotel (the world's first Beatles-themed hotel) and the Mathew Street Festival, which at one stage grew into Europe's largest free open air popular music festival, regularly attracting over 400,000 visitors to the city every August Bank Holiday weekend.

Their names and contributions have been briefly mentioned in earlier chapters; however, it should be emphasized that during the troubled years between 1984 and 1990 Cavern City Tours began as a small independent Beatles tour-guiding enterprise and exponentially expanded in the face of enormous oppositions from local government. We have already seen that as early as 1984 they had organized

an 11-day festival celebrating the music of the Beatles. By 1990 they were advising MPL regarding the lack of sales for the McCartney concert at the Liverpool Docks that year; as a consequence they became the official ticket agent for all Paul McCartney concerts held in Liverpool. By 1991 they were operating a daily bus service of Beatles tours around the city of Liverpool and acquired the Cavern Club and Cavern Pub in Mathew Street. In 1993 the first Mathew Street Festival was held attracting over 20,000 people into Mathew Street for 7 hours of free music from 65 bands from around the world. In 1994 Cavern City Tours were voted Merseyside Tour Operator of the Year and company directors Bill Heckle and Dave Jones were presented with the Whitbread/*Liverpool Echo* Special Award for their services to Liverpool's nascent tourism industry. (The winner of this award the previous year was actually Sir Paul McCartney.) Continuous growth, mixed with continual intransigence from Liverpool City Council has meant that CCT's portfolio has expanded despite being dogged by poor communications with and funding difficulties from Liverpool's city fathers.

Nevertheless, the umbrella group of Cavern City Tours has continued to develop and branch out into new areas, and has largely succeeded in placing itself in the epicentre of Beatles tourism across the world. For example, in 2008, collaborations with Paul Mullins Destination Learning were established, in order to provide an educational service across the region. Working for the Liverpool City Region's Tourist Board, Mullins was previously involved with strategic planning, workforce and business development, and collaborative projects. Between 2005 and 2008 he created the business model for Liverpool's Convention Bureau which was responsible for handling and managing large events and conferences coming to the city such as the MTV European Music awards. He also established Liverpool City Regions Tourist Board's commercial tourism arm which specialized in creating joint ventures with the city's private sector tourism businesses. There has also been the creation of The Cavern Rock School, a Saturday programme for aspiring young musicians. Thus, on different occasions, thriving scenes have existed in both the Cavern Club and Cavern Pub, with live music seven days a week attracting some of the biggest names in the music industry – including Paul McCartney.

Bill Heckle and Dave Jones have therefore been in the forefront of Liverpool's Beatles tourism industry for nearly three decades. When asked in 2011 by Liverpool Hope post-graduate researcher Lucie Nedzel whether they thought that Liverpool City Council would ever change their view of the industry, the partners answered without hesitation, in the negative. Over the years Heckle and Jones have sent numerous reports to the council explaining how the industry has been beneficial for Liverpool but, according to the partners, these were largely ignored. At one point, according to Phil Coppell, Dave Jones invited all ninety members of the council on the Magical Mystery Tour, hoping that they might change their opinion once they experienced it for themselves. Only two members turned up, and for one it was mandatory.[23] It thus became clear to Jones and Heckle at an

[23] Email correspondence between Phil Coppell and Mike Brocken, May 2012.

early stage that Liverpool City Council was simply not interested in attempting to understand the Beatles tourist industry. From Lucie Nedzel's research (now some three years old, of course), it appeared that among the very few ways in which the council has helped CCT was via the provision of a small amount of money each year to the Mathew Street Festival. Between 1993 and 1996 the council donated a fixed sum of just £5,000 to each festival. By 1996 the festival had expanded and CCT requested £10,000, but did not receive it. The council stated that they would only be awarding £5,000 and, since the festival used the streets of the city, they had decided that CCT needed a licence to use these streets, which would cost them an extra £10,000. CCT could not pay this amount, and accordingly the festival did not happen that year. These days both Bill Heckle and Dave Jones are on reasonably good terms with Liverpool City Council, but during the mid-1990s the relationship was strained to say the least. Although Heckle believes that the council still does not fully understand the industry, he appears relatively content with the relationship as it stands at present.

Arguments and opinions still abound across the sector concerning what authentic Beatles experiences should involve. Bill Heckle expressed to this writer a discontent with several current Beatles-related businesses, wanting the industry to have what he describes as a touch of 'class'. Heckle believes that certain venues detracted from the industry's potential sophistication. Nonetheless, all venues across the 'Beatles quarter' contribute in their own ways to a seemingly endless number of pathways in which popular music tourism feeds into the local and regional economy, and it could be argued that the Friday/Saturday night hordes of drunken hen and stag parties in Mathew Street bear little bear little resemblance to the daytime curious visiting Beatles fan. It therefore continues to be a challenge for the researcher to measure the industry's impacts in any concrete fashion. Aside from attempting to work out which businesses to actually study, other problems arise. For example, after a Mathew Street Festival one year, CCT, Liverpool City Council, and the regional tourist board each attempted to measure the economic impact created. The methods used largely consisted of ethnography – interviewing participants and locals – and the results varied greatly. Perhaps this lack of quantifiable value is another reason for the council's previous lack of interest in the industry. Maybe, on the other hand, they have realized that the private sector deals with such tourism disparately and from a position of variable economic positions and variegated perspectives. In spite of economic challenges (the current economic climate in 2013/14 possibly presenting the greatest challenges of all), Liverpool's entrepreneurs do appear to be better placed to deal with such vagaries, highs and lows, and year-by-year tourist deviations, than at any time previous.

The management of Cavern City Tours is evidently aware of the need to continuously satisfy and exceed tourist expectation. Although the company has been extremely profitable in the past couple of years, they are still constantly improving and reworking their brand. When Bill Heckle was asked what he hoped for the future, he replied that he wants Liverpool's tourist base to continue growing. When he started the company he and Dave Jones were typically self-employed:

basically completing all of the required work in every sub-department of the company. These days, as CCT has grown, they have brought in specialists from different fields of tourism, music education and brand marketing, together with identifiable accounting specialists. CCT have recognized the need for precise branding and are attempting to create a recognized popular music tourist brand for both themselves and Liverpool that can be directly associated with the Beatles 'brand'. A brand, often defined as an intangible asset, can be the most valuable asset in a company's balance sheet. Brand owners manage their brands carefully to create shareholder value, and brand valuation is an important management technique that ascribes a money value to a brand, and allows marketing investment to be managed to maximize shareholder value. Heckle expects to expand both his brand and his team in the coming years to include even more specialists. This includes the development of 'official' taxi tours, minibus tours, and perhaps a Cavern Diner. Furthermore, Cavern City Tours have recently been discussing a policy with Liverpool City Council concerning Beatles copyrights, for it is felt that in 18 years' time there might be a (remote) possibility that Beatles music moves into the public domain, at least in Europe.

'Open-Ended' Nights in the Replica Cavern

Ernest Laclau tells us that the relationship between a specific foundation and what it actually founds is very different from a symbolic representation and that which is being symbolized. If, in our case, the Beatles and Merseybeat were 'founded' in a given place and space during a given period of time (let us say between 1960 and 1963) logic informs us that there will always be a determining system which represents some kind of relationship between the founding agency and the founded entity. In Liverpool, this foundational relationship persists but certain places and spaces have disappeared though time, whereas others have reverted to conventional usage. However, Laclau goes on to inform us that, as far as symbolic representation is concerned, no such deterministic logic exists and chains and patterns of authentic 'signifieds' can be reproduced almost indefinitely. Laclau states: 'The former is a relation of delimitation and determination, i.e. fixation. The latter is an open-ended horizon.'[24] Perhaps more than anything this latter concept of an open-ended horizon is what has come to define the absolute authenticity of the replica Cavern Club, as re-established by Cavern City Tours.

More than fifty years after the first Beatles covers resonated across the Cavern Club, the replica of the most famous club in the world, as it is often called, attracts hundreds of visitors every day. Even though purists are aware that this is not the original Cavern Club, this replica, rebuilt a few yards from the place where the Fab Four performed 292 times, remains a particular must-see of the tourist-scene of

[24] Laclau, Ernesto (1993), 'Politics and the Limits of Modernity', in Thomas Docherty (ed.), *Postmodernism: A Reader*, London: Harvester Wheatsheaf, p. 342.

Liverpool. It appears that everyone seems to want to immortalize their 'coming', both in taking pictures and writing their name on the emblematic walls of the place. Indeed one might describe such enthusiasm as almost 'religious'. One might even suggest that the replica Cavern fulfills a greater purpose than its predecessor for it stands at that contraposition between foundation and horizon, so important to the imagination. Had the original Cavern survived it might exist for the tourist as far too unified and totalized by its foundation. Under such circumstances the ability to represent the imagination's 'thirdspace' might have been inadequate, for its existence would be to forever drive the fan/tourist back to a defining authenticity that may have existed only as a transitory moment. The original Cavern therefore would have over-unified 'facts' from the past, at the expense of experience between foundation and horizon.

If one sits in the Cavern, even for less than an hour, one can observe a multiplicity of people of all ages and from different backgrounds all together around a common passion: the Beatles. The basic question any researcher might ask is quite simply: Who are these people who venture for a few minutes or a few hours in what is undeniably one of the best-known cellars on the planet? The answers to such a question are complex indeed, for visitors derive their interests from a multitude of differing backgrounds and for a variety of different reasons. For example, one of my 2013–14 MA students, Diane (a former radio producer from France and a Beatles fan), told me:

> Actually, prior to my coming to live in Liverpool, I was one of these tourists. This makes my observations of even more interest to me, because I can now see with perhaps different eyes the way in which Beatles tourists are attracted to the city. I was a young French girl fascinated by the Beatles and made my first pilgrimage on the occasion of the Beatle Week 2010. I was twenty-six years old. Even though I was conscious of the fact that the Cavern Club was a replica and that I would meet no Beatle there, the atmosphere of the place was interestingly and perhaps paradoxically authentic. The thing that hit me, I think, more than anything else that day, was the incredible number of people who crowded in this dark cave. In France, my status as a fan of the Beatles is still seen as rather strange. Besides being young, I was female, which seems to perplex my fellow citizens – why her? Why the Beatles? However in the Cavern, for the first time I did not feel alone. There was a sense of communality that stretched right across these apparent strangers. I felt as if there was a bond. The second thing that struck me during my first Cavern visit was the diversity of the visitors. First of all, this was a geographical diversity. I was surprised to see so many Japanese and Australians, Latin Americans, Russians and Chinese! As Europeans, it is not difficult to go to Liverpool. The trip is relatively fast and is not very expensive. However, I never would have thought so many people who have not hesitated to spend so much money and energy to get to the place that gave rise to the Beatles

and try to perhaps relive that period at the' location' where it started fifty years previously – even though, of course this was a 'replica'.[25]

Diane's impressions during this first visit were surrounding the considerable age ranges of those communing in the Cavern Club. For her, there did not appear to be anything relating to a generation gap, something that was of course very important when the Beatles actually broke through to national and international fame.

Today, for Diane, the Cavern has become her 'neighbourhood pub' – something that was impossible during the original club's lifetime. She visits to relax after a day's work and finds herself observing others within the venue. She recalled to me a Japanese fan of about 50 years in a trance-like state for several hours, closing his eyes and dropping his head to the live covers of Beatles music. Diane stated 'It was clear that he was enjoying the time of his life through the music and perhaps even through his presence at the Cavern Club being able to hear (in this case) these live covers of John Lennon songs in that space'. She also recalled a Chilean family being there, a few hours after she had taken their photograph at The Beatles Story attraction (where she is gainfully employed):

> He told me he was a true aficionado of the Beatles, it was not his first visit and he had already brought his sons last year. However, he told me he was very surprised to see his girls' enthusiasm. They were usually interested only in contemporary music such as Rihanna or Lady Gaga. But they appeared totally enveloped by the atmosphere of the Cavern Club. They sang and danced without restraint: 'immersed' in a culture.[26]

Diane's own relatives from France were persuaded by her to accompany her to the Cavern They were not basically 'fans' of the group but enjoyed the atmosphere, nonetheless. This is interesting for this must happen to other families; it might be the case that sometimes non-fans can be made aware of the musical quality of the work of the Beatles simply by visiting the replica Cavern – perhaps the venue can even turn them into fans. In reality, places such as the twenty-first-century Cavern create an affective ambiguity. Signifiers are less fixed than one might at first imagine. There are multiplicities, not fixities, within this popular music 'thirdspace': part of a phenomenon of symbolic representation.

There are several interesting local characters amongst the regulars in the venue, some of whom appear to be 'at odds' with the general tenor of local ambivalence regarding the significance of the Beatles. One such local I have met on several occasions is Stuart. Born locally in 1943, he returns to the Cavern Club virtually every week and recently celebrated his seventieth birthday there. Like myself, Stuart has therefore experienced both the real and the replica Caverns. If asked, he relates and compares many anecdotes about the place, such as the times

[25] 'Diane' to Mike Brocken, December 2013.
[26] Ibid.

when he saw the Beatles live. He loves to recall such occasions for tourists and is undeniably attached to the place: almost part of the fabric, one might say. Like Stuart, the majority of regulars are perhaps over 50 years of age. Among these there is also Mike. Mike is 60 years old and in one week's observation during the summer of 2013 I saw him there every day. He arrives typically in the late afternoon and leaves by the middle of the evening after having spoken to various foreign tourists present in the club. In one visit made by Diane to the Cavern, she noted the presence of a man who, every Thursday evening, just sits alone by the speaker right in front of the stage. Diane informed me:

> He seems to live in a myth-world created around memories of the Beatles. However, approaching him, I was marked by his kindness. On one occasion, he also vigilantly monitored a bag from a girl who dared to give it to him to 'mind' while she danced. While this man sadly seems the perfect embodiment of the 'Nowhere Man' by John Lennon he appears to have built up some kind of trust.[27]

In contrast with the variety of tourists who flock daily to the Cavern, these regulars tend to retain a 'club' or 'pub' concept of a place where people met regularly to pursue their common (meaningful) interests. The dissolution of the foundation myth does not entirely remove it, as such. For some the foundation myth is present but exists in a continuum between the founding and the horizon: at a point in which the symbolic confers authority upon it.

Summary

We have seen that Liverpool was initially very slow to understand the opportunities presented by its association with Beatles tourism, but is now the fifth most visited city in the UK by international visitors. Overall, in 2013 Liverpool welcomed over 32 million visitors, who proceeded to spend £2.3 billion. This supports between 20,000 and 30,000 jobs in the city – both directly and indirectly. According to Liverpool City Region LEP, something approaching one million visitors stated that the Beatles were their main reason for visiting the city. This is now a city of the twenty-first century which has finally recognized that culture and heritage are at the heart of its destination marketing. Both FAB Tours and Cavern City Tours must be doing something right.

Throughout these small case studies presented here, one specific issue appears abundantly clear: that many of those involved in aspects of Beatles tourism have important investments in not only the music, but also in the stories, in the places, and in their own sense of self. An integrated and 'centred' subjectivity has emerged amongst guides, linked with acknowledged specialist entrepreneurialism. This entrepreneurial sense of freedom (something that has always been at the very

[27] Ibid.

heart of what it means to be Liverpudlian) promises a positive work-based liberty arising from the internal organization of the mind to 'tell' things in the appropriate way, at the appropriate time. Such positive liberty, whether expressed via a Phil Coppell tour or an evening in the replica Cavern, is one result of an achievement of a state of mind which has triumphed over time, one in which historical and business decisions are cohesive, workable and relatively stable. Yet such decisions are not 'historical' in the old oppositional sense of the word. To be entrepreneurially free in this sense is to be emancipated from Liverpool's previous critical judgments which condemned all popular music heritage tourism as irrational, apolitical and self-absorbed.

One logical conclusion to be drawn from such emancipation is that work-based freedom can be found if one effectively trains and qualifies as a professional with good resources and good mindsets. This long march towards enterprise autonomy in Liverpool has taken place relatively organically, for as Liverpool has tended to find its place tentatively, so it has opened up spaces slowly and made its heritage enterprise less susceptible to external determination. This pursuit of an integrated subjectivity has seen Liverpool's relationship with Beatles historiography and historicity rise far above expectancy. Liverpool has in fact arrived in a roundabout way at a point of convergence between popular music enterprise and tradition.

So, popular music tourism in Liverpool has provided both theoretical and practical models for us to analyse the interdependence between human beings and their physical environment. One might even go so far as to suggest, that in the case of Liverpool, the Beatles have provided us with two of the most important (connected) factors concerning the reinvention of city space: new forms of labour, and a rearticulation of the built environment. It would have been impossible to imagine, half a century ago, that four young popular musicians would be able to leave such a legacy to a city so entrenched within a syndrome of political, oppositional and social decline. Yet this is what they have done. As suggested previously, perhaps the Beatles' legacy will be seen in time to have encompassed human ecological and environment reinventions equally as much as, if not more than, those related to popular music-based ingenuity.

Chapter 9

'Come Together': A Future Industry?

We are in a global race in our world today, a race in which Liverpool is not just competing with Barcelona and Hamburg; you're competing with Beijing and Jakarta. Some countries will make it and others will fall behind, and I am determined that Britain and cities like Liverpool will make it [...]

(Prime Minister David Cameron)[1]

Branding and the Beatles

The first registered brand in the United Kingdom was the Bass Brewery's 'red triangle'.[2] The word 'branding' in this case referred to wooden beer barrels being literally branded with a manufacturer's name or logo. It is now, of course, common in the contemporary music industry to find artists endorsed by a brand or carrying a brand. According to Mike King, 'aligning themselves with artists through branding provides companies with the opportunity to bring relevancy to their brand and open a line of communication to another generation of consumers'.[3] Fortunately, Apple Corps was able to manage both the Beatles brand and legacy following the group's break-up. Apple came to be established by the Beatles in 1968 and was meant to be 'a place where people with talent could go, rather than begging for a break from big business'.[4] There was actually a sound financial reason behind the establishment of Apple, however. According to Debbie Winardi,[5] the Beatles as a business were faced with the options to either capitalize their revenue or hand it to the government in taxation. Thus, they chose to establish a company which comprised several divisions; these included recording, publishing, electronics, films, a studio and a retail outlet. The retail and electronics divisions were soon closed down (by 1968 and 1969, respectively), to be followed by Apple Studios in 1975. Notwithstanding, Gary Burns informs us that, right up to the present day, 'the Apple record label still exists and has belatedly and perhaps surprisingly

[1] Quoted in *Liverpool, A Cultural Capital* (2014), Liverpool: Culture Liverpool, p. 3.

[2] This was the first trademark to be registered in the UK (1876) and was for 'Bass Pale Ale'. The company also registered a red diamond (Burton Ale) and a brown diamond (Porter and Extra Stout).

[3] King, Mike (2009), *Music Marketing – Press, Promotion, Distribution, and Retail*, Boston [USA]: Berklee Press, p. 20.

[4] Spizer, Bruce (2003), 'Apple Records', in Kenneth Womack (ed.) (r. 2013), *The Cambridge Companion to the Beatles*, Cambridge: University Press, p. 143.

[5] Winardi, Debbie (2013), *How The Beatles Have Evolved into a Brand that Ensures Longevity*, unpublished MA dissertation, Liverpool: Liverpool Hope University Dept of Music.

become an effective vehicle for the ongoing commercial exploitation of Beatles product..[6] Moreover, the company also 'administers the catalogue of Beatles releases [and] holds the licensing rights for the brand and music, and has approval rights for the master recordings'.[7] So, while it might be argued that, at least from this historical distance, the entire Apple project appeared at times to be hippie self-indulgence of the worst kind, there were methods to this apparent 'madness'. The promotion and preservation of a Beatles legacy was always going to require at least some vestige of an enterprise infrastructure. This was provided by the skeletal frame of Apple, and in person by Neil Aspinall. Following the death of Brian Epstein in August 1967, the Beatles had asked Aspinall, their ex-road manager and personal assistant, to take over the management of Apple Corps. Relieved of his road management duties by the Beatles coming off the road in 1966, it was Aspinall who accompanied John Lennon and Paul McCartney to New York on 11 May 1968, to announce the formation of Apple to the American press and media. Aspinall later spoke of these business arrangements as ad hoc and without contracts concerning either his present or future management of Apple.[8]

In addition to Apple, two other companies have played important roles in the promotion and preservation of the Beatles brand. The most obvious of these is the Beatles' former record label, EMI, to whom they were signed in 1962. The company continued to release 'new' Beatles albums long after the band disintegrated, by both repackaging previously released material and reformatting albums. Since 2012, however, EMI, once the world's biggest recording company, has effectively ceased to exist (other than as a 'brand' of authenticity and a back catalogue copyright-holder). The company, once a constituent of the FTSE 100 Index, came to face extensive financial troubles and, $4 billion in debt, was acquired in February 2011 by the financial services corporation Citigroup. Citigroup's ownership was only temporary, and in November 2011 it announced that it would sell EMI's music arm to Vivendi's Universal Music Group for $1.9 billion, and EMI's publishing business to the Sony/ATV consortium for circa $2.2 billion. Vivendi Universal is now able to release the Beatles' recorded-sound back catalogue as and when they feel appropriate. The second company is, of course, Sony/ATV, who now owns the publishing rights of the Beatles catalogue. This company exists as a result of a merger between Sony Corporation and ATV. Michael Jackson purchased the latter for $47.5 million in 1985, ATV having previously purchased Dick James' Northern Songs and come to own the publishing rights to more than 250 Beatles songs. At the time of Jackson's purchase, Paul McCartney and Yoko Ono were

[6] Burns, Gary (2013), 'Beatles News: Product Line Extensions and the Rock Canon', in Kenneth Womack (ed.), *The Cambridge Companion to the Beatles,* Cambridge: University Press, p. 222.

[7] http://www.bbc.co.uk/news/business-19800654, 'The Beatles at 50: From Fab Four to fabulously wealthy' (date accessed 8 September 2013).

[8] See Granados, Stefan (2004), *Those Were the Days*, London: Cherry Red Books, p. 19.

both intending to bid for the catalogue but Ono, believing it worth no more than $20 million, would not proceed beyond that figure. In 1995 Sony paid Jackson $150 million to merge the companies.[9]

Winardi[10] also reminds us that the Beatles' filmic outputs have played a significant role in both their contemporary and 'posthumous' careers. Burns suggests that 'film production provided a more efficient means of public exposure than touring or making exclusive television appearances throughout the world, and was ultimately far less time-consuming for a group of the Beatles' global popularity'.[11] Renowned Beatles film scholar Bob Neaverson argues that 'perhaps more than any other broadcast media, their films were vital in communicating and showcasing the group's ever changing array of images, attitudes, ideas and musical styles'.[12] Therefore, by creating a film catalogue, the Beatles were able to extend their image both spatially and time-wise: to a wider array of audiences all over the world within a relatively short period of time, but also to different generations over a longer timeline. In addition, adds Neaverson, 'the films also facilitated the sales of a number of other licensed tie-in products external to the cinema-going experience.'[13] The Beatles were also undoubtedly pioneers of music video. Their first videos were basically 'semi-diegetic promos shot by Joe McGrath for "I Feel Fine", "Day Tripper", "We Can Work It Out", "Ticket to Ride", and "Help!"'[14] These videotapes were 'the first independently produced pop promos made specifically for international distribution, thus pre-empting the arrival of the contemporary pop video age',[15] thus creating an audio-visual compact between group and viewer: a kind of auratic logo, perhaps.

Any logo is a crucial visual element of a brand. A logo allows people to recognize the brand, usually in an instant. The Beatles' logo itself is relatively simple: the word 'THE BEATLES' in 'Times New Roman' font with a larger B and a 'drop-T'. This logo was effectively created by Ivor Arbiter and first appeared on Ringo Starr's drum kit in 1963. Arbiter owned the 'Drum City' music instrument shop in London, and Ringo and his manager Brian Epstein visited Arbiter for a new set of drums. Arbiter agreed to give Ringo the new drum kit, free of charge, on condition that he received Ringo's old drum kit in part-exchange and that the name Ludwig appeared on the bass drum head. Epstein agreed to this, as long as the Beatles' name would also be featured on the bass drum. It was then, according

 [9] http://content.time.com/time/arts/article/0,8599,1908185,00.html, 'Michael Jackson's Estate: Saved by the Beatles' (date accessed 8 September, 2013).

 [10] Winardi (2013), *How The Beatles Have Evolved into a Brand that Ensures Longevity*.

 [11] Neaverson, Bob (2000), 'The Beatles' Films and Their Impact', in Ian Inglis (ed.) (2000), *The Beatles, Popular Music, and Society*, London: Macmillan, p. 100.

 [12] Ibid., p. 101.

 [13] Ibid., p. 100.

 [14] Ibid., p. 103.

 [15] Ibid., p. 100.

to some sources, that Arbiter created the famous Beatles logo with the drop-T.[16] Nevertheless, this logo was curiously not incorporated into either the Beatles' original albums or their early merchandise range; in fact, Apple only finally registered this important logo in the 1990s,[17] after it appeared on the retrospective Beatles compilation *Past Masters,* released in 1988. These days, however, the logo is incorporated into every Beatles-licensed product.

We have seen in the past decades that unreleased materials (unfinished takes, demos, radio performances, and so on) have been plundered to create new Beatles albums such as the *Live at the BBC* volumes and the Beatles' own *Anthology* set. Previously released materials are also subject to remastering and are re-released as different formats are developed. The latter of these include albums such as *Let It Be ... Naked*, *Love* and *1,* with *Let It Be ... Naked* proving, at least for this writer, to be something of a disaster. Gary Burns, however, discusses the overall significance of *1*, proposing that 'a package like this can serve to introduce the band to a new generation of fans and as a handy career-spanning summary even for fans who already own some or all of the original albums'.[18] According to Burns, this continuity of Beatles releases ensures that the Beatles' music remains heard throughout the decades and 'despite the band's unfortunate dissolution, it must also be said that the break-up was a commercial success, producing numerous hit singles and albums, perhaps in greater number than a united band would have achieved'.[19] In addition, after Apple finally ended its long-running dispute with Apple Inc. in 2007,[20] it was only a matter of time before Beatles songs became available for online downloads on iTunes. When this finally happened in November 2010, within 48 hours, 28 of the top 100 and 16 of the top 50 albums on iTunes were Beatles recordings.[21]

[16] http://www.beatlesbible.com/features/drop-t-logo/, 'The Beatles Drop-T Logo' (date accessed 22 October 2013).

[17] Ibid.

[18] Burns (2013), 'Beatles News: Product Line Extensions and the Rock Canon', p. 220.

[19] Ibid., p. 221

[20] The dispute lasted almost 30 years. For example, in 1978 Neil Aspinall instigated the first of three lawsuits on behalf of Apple Corps against Apple Computer, Inc. for infringement of trademark. The first was settled in 1981 with an amount of £41,000 being paid to Apple Corps by Apple Computer. As a condition of the settlement, Apple Computer was allowed to use its logo as long as it did not enter the music business. The second suit with Apple Computer arose in 1989, when Apple Corps sued Apple Computer over its Apple II GS (which included a professional music synthesizer chip), claiming violation of that 1981 settlement agreement. In 1991, a settlement of £13.5 million was reached. In September 2003, Apple Corps again sued Apple Computer, Inc. This concerned the introduction of the iTunes Music Store and the iPod. This trial, however, resulted in a victory for Apple Computer, Inc.

[21] http://www.bbc.co.uk/news/business-19800654, 'The Beatles at 50: From Fab Four to fabulously wealthy' (date accessed 8 September 2013).

Of course Beatles-related income streams do not simply emerge from record sales, but also from the licensing and commercial exploitation of this brand via the use of their songs. Simply put, licensing means the granting and collecting of royalties from the use of a song, whereas exploitation means getting other artists interested in recording a songwriter's work. While there are few problems associated with the latter, with artists always willing to cover a Beatles 'classic', the former has raised issues concerning whether Beatles songs should be licensed to advertise a product. There are, of course, several types of licences – for example, mechanical licences, synchronization licences (songs are synchronized to visual images, typically for use in films, TV programmes, and commercials), print licences and performing rights licences, among others. In 1987, 'Revolution' was used in a Nike advertisement after an agreement was reached between Sony/ ATV and EMI-Capitol Records and a payment of $500,000 was made.[22] However, Sony/ATV asked for permission to do so only from Yoko Ono and they failed to consult Apple on behalf of the three surviving ex-Beatles. As a result, Apple filed for a lawsuit against the use of the song.[23] According to Apple in July 1987: 'the Beatles position is that they don't sing jingles to peddle sneakers, beer, pantyhose or anything else [...] They wrote and recorded these songs as artists and not as pitchmen for any product.'[24] Arguably, the use of any song in an advertisement can actually contribute positively to an artist, as long as it is relevant to the artist's image. In this particular case Yoko Ono believed that the commercial was 'making John's music accessible to a new generation'.[25] But, as has been suggested by Aaron Linde, Apple continue to be the key decision-makers and 'any licensing agreements for the Beatles' catalog would first have to be cleared by Apple Corps'[26] So, while the Universal multinational which owns the Beatles' master recordings, would wish to synchronically exploit this brand as much as possible (especially in the light of declining direct sales), Apple have the final say concerning with whom or what the music can be synchronized. It is because of this multifaceted hierarchy that Beatles songs are seldom heard on films or TV. As Ben Sisario from *The New York Times* states: 'Beatles songs rarely appear on film and television both because of their pride and because of the complex checklist of approval needed.'[27] One

22 http://pophistorydig.com/?p=702, 'Nike & The Beatles' (date accessed 22 August 2013).
23 http://www.nytimes.com/1987/08/05/arts/nike-calls-beatles-suit-groundless.html, 'Nike Calls Beatles Suit Groundless' (date accessed 12 August 2013).
24 http://www.huffingtonpost.com/shawn-amos/roll-up-for-the-magical-b_b_279680. html, 'Roll Up for the Magical Beatles Marketing Tour' (date accessed 15 October 2013).
25 http://www.nytimes.com/1987/08/05/arts/nike-calls-beatles-suit-groundless.html, 'Nike Calls Beatles Suit Groundless' (date accessed 12 August 2013).
26 http://www.shacknews.com/article/53257/rock-band-guitar-hero-publishers, 'Rock Band, Guitar Hero Publishers Vying for Beatles Licensing Agreement' (date accessed 8 September 2013).
27 http://www.nytimes.com/2013/08/15/business/media/licensing-plan-gives-fresh-plays-to-beatles.html?_r=1& , 'Licensing Plan Gives Fresh Plays to Beatles' (date accessed

case in point illustrates this well: in 2012 the producers of *Mad Men* reportedly paid $250,000 (£155,000) to use only a small section of 'Tomorrow Never Knows' in one episode. Ben Sisario and David Itzcoff also reported Apple Corps head Jeff Jones stating in an email that, in his recent experiences as Head of Apple, it was the very first time that a Beatles song had been licensed in this way.[28]

Apple's licensing is not merely limited to the music of the Beatles. Tom Blackett suggests that 'licensing is the granting of a right to use a brand in relation to similar goods or services. However, the licensor must retain control over the quality of the goods and services produced by the licensee and marketed under the brands.'[29] The Beatles' moniker has been commonly found in a range of merchandise since the 'Beatlemania' days of the 1960s[30] and it seems the range is ever-widening. Brands includes a clothing line by Ben Sherman,[31] 'The Yellow Submarine Eyewear Collection' by Mounted Memories™,[32] and others such as *The Beatles Rock Band* video game, *The Beatles Monopoly™*, and a *Ben & Jerry's* ice-cream flavour entitled 'Imagine Whirled Peace'.[33] In June 2013, it was reported that Apple had signed an agreement with Bravado, the merchandising unit of Universal Music, and ended a deal with Live Nation.[34] The report states that 'one idea Bravado pitched to Apple Corps [was] adding to the hang tags of Beatles apparel codes that would get the buyer free streams of the group's music'.[35] Additionally, 'Bravado is planning to have the merchandise sold in key retailers and back it with big ad campaign'.[36] The extra income generated from

8 September 2013).

[28]　See Ben Sisario and David Itzkoff (2012), 'How Mad Men Landed the Beatles: All You Need is Love (and $250,000), *ArtsBeat*, 7 May: http://artsbeat.blogs.nytimes.com /2012/05/07/how-mad-men-landed-the-beatles-all-you-need-is-love-and-250000/?_php=tr ue&_type=blogs&_r=0 (date accessed 27 March 2014).

[29]　Blackett, Tom (2004.), 'What is a Brand?', in Rita Clifton, John Simmons et al. (r. 2004), *Brands and Branding*, Princeton: Bloomberg Press, p. 24.

[30]　Davies, Hunter (1996), 'Beatlemania', in David M. Haugen (ed.) (2005), *The Beatles*, Detroit: Thomas Gale, p. 71.

[31]　http://www.licensemag.com/license-global/ben-sherman-launches-beatles-clot hing-line, 'Ben Sherman Launches The Beatles Clothing Line' (date accessed 8 September 2013).

[32]　http://www.businesswire.com/news/home/20100722005063/en/Mounted-Memories%E2%84%A2-Signs-Licensing-Agreement-Live-Nation, 'Mounted Memories™ Signs Licensing Agreement with Live Nation Merchandise to Produce Framed Presentations Featuring The Beatles' (date accessed 8 September 2013).

[33]　http://www.bbc.co.uk/news/business-19800654, 'The Beatles at 50: From Fab Four to fabulously wealthy' (date accessed 8 September 2013).

[34]　http://www.universalmusic.com/corporate/detail/2229, 'Universal Music Group (UMG) Closes EMI Recorded Music Acquisition' (date accessed: 8 September 2013).

[35]　http://nypost.com/2013/06/12/the-fabric-four/, 'The Fabric Four' (date accessed 8 September 2013).

[36]　Ibid.

such merchandise sales should not be taken lightly. Claire Atkinson proposes that 'for some artists, including Bob Marley and the Rolling Stones, merchandising is far more lucrative than music sales'.[37] For the Beatles, it has been reported that 'global sales of Beatles' merchandise are estimated to be between $10 million and $20 million a year',[38] thanks in part to the Las Vegas show *Love* by Cirque du Soleil. In 2006 the Beatles brand was expanded into this circus-style show and, in conjunction, a new Beatles album of the same name was successfully launched (consisting of remixed Beatles songs by George Martin and his son, Giles). The show was awarded a Grammy in 2012 for 'Best Long Form Music Video'.

The above information, largely provided by Liverpool Hope post-graduate Debbie Winardi, clearly displays to us how technology has completely changed not only the music business as we have come to know it, but also the ways in which music interacts and synchronizes with other forms, such as media and advertising. The customers now acquire products and services in new interactive ways. It is surely time to rethink the ways in which, traditionally, popular music and popular music heritage tourism across the world has been doing business thus far, so that new relationships can be developed. In the case of the 'Liverpool>Beatles tourism' niche, branding has now become a priority issue, for it may provide the city with an almost one-off direct opportunity to develop a relationship with what has clearly emerged as the strongest global musical brand in (music) history. Creative Industries minister Ed Vaizey stated in 2014 that 'the huge financial contribution to the UK economy by the millions of music tourists to the UK annually makes it very clear that when combined, the music and tourism industries are powerful drivers for growth'.[39]

Liverpool: A Brand?

Heritage cannot, of course, be branded in the same way as above, for it is far too difficult to pin down. As far as popular music has been concerned, Liverpool City Council instead took the decision many years ago to support a branded event entitled 'Sound City', which over the years attempted to draw together showcase events, music-business movers and shakers, and conference speakers into the city for concerts, seminars and discussions concerning how to get into the music business. It began well in the 1990s but has, on reflection, been rather less than successful. Not only has it been perennially difficult to showcase Liverpool's music talent that does not fit into the guitar-based stereotypes, but in recent years events within the music business have overtaken the very concept. One delegate from the Midlands of England, who wished to remain anonymous, informed me in 2013: 'quite simply there is no longer a music business as is represented

[37] Ibid.
[38] Ibid.
[39] Quoted in to the Editors (2014), *Imagine: The Value of the Music Heritage Tourism in the UK*, London: UK Music, p. 2.

here; instead there are myriad music micro-businesses fighting for space. As for the record business, that probably died with the Beatles! I've learnt nothing in Liverpool this week: this event in its present form is no longer viable.'[40] So the 'Sound City' matrix and brand has now organically dated. To its credit, Liverpool Sound City did attempt to address this issue in May 2014 when the UK Music report *Imagine: The Value of Music Heritage Tourism in the UK* was launched at the Hilton Hotel; however, for many of those present at the launch, it seemed like the organizers of the event were actually playing a game of catch-up with music tourism. For years Sound City openly repudiated the legacy of the Beatles, creating artificial oppositions which suggested that Liverpool should effectively 'move on' and 'get out of the '60s'. While there was quite clearly some kind of logic to this, I personally felt it was unhelpful and actually very hurtful to many of those who were involved in Beatles tourism. After several years of attending regularly as a member of the Institute of Popular Music team, I consciously made a decision not to revisit Sound City. The afternoon in May 2014 was therefore what one might describe as 'educational'.

By the turn of the twenty-first century a wide range of questions had been raised in the arena of postindustrial urban space concerning Liverpool's relationship with the Beatles, their brand and their legacy. A new phase of consolidation thus began, building upon the issues that the tourism debates and experiments of the 1980s and 1990s had unearthed. A recognizable and effectively 'branded' guiding had started to emerge to cope with the 'thirdspace' and tourist gaze, one that was in effect seeking to explain complexities in terms of structures and systems required to tell a story and sustain an industry and self-employment. This involved the selection of facts: recognizable and 'down to earth' so as to cement a Liverpool 'experience' in an enjoyable way. Thus the entrepreneurs became committed to the goal of redefining Beatles tourism in the wake of the polemics of the 1980s and 1990s, and to attach the name of Liverpool to the aforesaid lucrative Beatles brand, rather than earlier unsuccessful efforts of attaching the Beatles to Liverpool as a place and 'branding' popular music in Liverpool via Sound City. Pam Wilsher states:

> As well as a huge draw for tourists [the Beatles] are, along with football, key in generative positive media coverage, in attracting new businesses to locate in the area, and in helping to open Liverpool up to new markets. When we're at trade fairs the Beatles are extremely useful in making new contacts and breaking down language and cultural barriers [...] Part of our strategy in this area has been to develop creative programming, such as the Liverpool International Music Festival, which reinforces our status as a heritage and cultural hub. As well as attracting new visitors to the city, the festivals, music, and cultural events have a huge positive value media-wise too.[41]

[40] Unnamed Sound City delegate to Mike Brocken, December 2013.
[41] Quoted in *Imagine: The Value of the Music Heritage Tourism in the UK*, London: UK Music, p. 12.

Further, such players have now come to appreciate that these activities can lead to a cultural redefining of the city and that such redefinitions could be pursued in terms of emphasizing the Beatles legacy *to* the city (again, not the other way around): foregrounding employment, advocating research, and committing to further development. For example, by 2014 Bill Heckle and Dave Jones of Cavern City Tours, together with Judith Feather of the City Council, had commenced developing proposals for a strategic review of Beatles tourism which, it was intended, would help reveal that a Beatles industry will be at the locus of both global *and* local attention for the city. By creating a Beatles-related 'brand' around and within the city, the experience of visiting Liverpool would be part the very fabric of the Beatles brand. In this way, the visitor/audience would be able to see a structure in place not simply for them, but for both visitors and residents of the future. From a city in the 1980s which represented an unfocused ideological opposition to enterprise, Liverpool City Council in 2014 was now declaring:

> Enterprise, People and Place are the three interlocking themes underpinning the SIF (Strategic Investment Framework). The belief is that investment in the built environment and infrastructure of the city will create opportunities for people and places to flourish, driving the creation of more high value jobs, attracting inward investment and encouraging new businesses to establish and thrive [...] Culture ultimately has to engage with the mass of the people if it is to realize its aspiration to be a dynamic force in the life of the city and a driver for regeneration and economic success. Cultural organizations in this particular city have a strong recognition of the need to reach out, to ensure accessibility beyond compliance [...] The public, private and third sectors, working together in partnership, will help to create and nurture the conditions in which the city's economy can develop and culture and heritage can thrive.[42]

Such strategic statements simply could not have originated from Liverpool City Council, back in the 1980s. Embracing mass culture, access, the private sector and 'thirdspace' was too great a paradigm shift at that time for political thinkers of both the political Left and Right. One might argue, however, that the current generation of Beatles heritage tourist entrepreneurs has become successful precisely because of the almost constant opening and reopening of issues concerning the value of popular music histories. This has made more-recent council officials recoil from the methods and approaches previously adopted by their predecessors in the early 1990s. The response from Liverpool City Council is now, it seems, to reinstall the meaningful connotations of the popular into a city from whence they originated and derived meaning. Judith Feather, Divisional Manager for Events and Cultural Infrastructure Culture Liverpool, informed this writer in December of 2013 that the city wished to commission an independent economic study of the legacy of

[42] *Liverpool, A Cultural Capital: Culture Liverpool Action Plan 2014–2018*, Liverpool: Culture Liverpool.

the Beatles, and the value of the Beatles brand to Liverpool, and to look at a co-ordinated strategic approach for the future direction of the industry. The city, according to Judith, now recognized the need to co-ordinate its approaches, and to build upon what had been largely driven by entrepreneurs.

Over the past forty or so years, complaints about the social irresponsibility of Liverpool's council officials have been almost without number. Such complaints typically concerned the council's tendency to marginalize themselves in the face of growing realizations from those they were governing that the global economy had changed. However, the Locum Destination Consultancy report of 2005 also picked up on the fact that, even though the local industry players were knowledgeable and enthusiastic, they were still fighting different battles from different corners. To paraphrase: Locum had realized the significance of a partnership route and suggested that not only did the industry cluster need to talk more directly and recurrently to Liverpool City Council, they also needed to talk to each other. The report identified a clear need for co-ordinated management, and a single point of contact to present a unified visage:

> It is important therefore that the Beatles Industry Group metamorphoses from its current somewhat disparate state into a well-organised business cluster with strong leadership and effective co-ordinating mechanisms; the major brands simply aren't going to play ball, without a strong managed and focused operation in Liverpool.[43]

Both brand and visual identity are still somewhat lacking in Liverpool. As Mike Jones of the Institute of Popular Music at the University of Liverpool stated at a meeting also attended by this writer with Judith Feather and Bill Heckle 'one walks out of Lime Street station and still wonders where the Beatles are, as part of the tourist industry in the city is concerned'.[44] Despite replies of attempts to remain 'low key' there still continues to be a lack of decision-making and clarity of purpose on the part of the council and a lack of a joined-up strategy-making on the part of the Beatles industry players confirming a unified strategy and brand.

In some respects this is hardly surprising, for we have seen that it is not always easy to define, create or enlarge 'music' tourism per se, especially since agreeing to its development has a lot to do with matters other than music: cultural, economic, iconographic and political phenomena all play important parts. Music tourism manifests itself in different and differing ways, and there is still perhaps no one 'typical' music tourist. Liverpool provides us with a very good example of such diversification, for although popular music tourism is often homogenized into those pilgrims appearing in their numbers to pay homage to the Beatles, we must remember that other musical devotees arrive in the city every week to consider

[43] The Editors (2005), *Report For Liverpool Culture Company and Beatles Industry Group*, Haywards Heath: Locum Destination Consulting, pp. 75–6.

[44] Mike Jones, comment at LCC meeting, December 2013.

other musical activities from different eras. One such tourist informed this writer that he 'arrived on the quiet, in a funny kind of way. I'm a fan and collector of the Sex Pistols – who for me were just as important as the Beatles. They played Eric's in 1976 but I don't expect to be led by the nose around Mathew Street as a consequence. I just want to have a good day in Liverpool and tick off another venue played by my heroes.'[45]

To the Future

So what of the future? Liverpool's cultural action plan for 2014–18 acknowledges that Liverpool is home to a wide variety of cultural organizations and that cultural businesses are now at the fulcrum of the city's key income streams. The Arts and Cultural Investment Programme (ACIP) which has helped many organizations over the past four years, financially, is now at an end, and the city has to reconsider how it is to define and prioritize the way forward for Liverpool as a postindustrial space. During 2014 Liverpool City Council intends to invest more than £3 million in support of cultural organizations – this will be provided by the new Culture Liverpool Investment Programme (CLIP). However £3 million is something of a 'drop in the ocean' and this core funding will inevitably be spread extremely thinly across the sector, leaving businesses again to carry most of the financial can – and Liverpool without a recognizable 'brand'. One consequence of this was that Mike Jones of the Institute of Popular Music and myself were both asked in January 2014, if we would be interested in being commissioned to conduct the aforementioned strategic review of the Beatles heritage tourism industry in Liverpool.

This request for a strategic review came about following a series of meetings between Liverpool City Council, Liverpool Beatles industry stakeholders and Apple Corps in late 2013. There is an agreement between the authority and the stakeholders that there exists a need for local economic assessment and a comprehensive review of what might be described as a Beatles industry within the city of Liverpool. There is little doubt that the council now understands that the Beatles are now a cornerstone image of Liverpool's concept of a brand, therefore visitor appeal, but the ways to go about consolidating this potential important signifier still appear confused. The Beatles continue to be the major visitor marketing stimulus, and a significant driver of growth in Liverpool's visitor markets. There is in 2014 a broad range of Beatles-related information products operated by both private and public interests in the city, but they remain uncoordinated and non-branded. But it is also recognized that the Beatles-related visitor experience in Liverpool should be better delivered and should brand itself in an 'official' recognized (and recognizable) way. The stakeholders therefore felt that there a need existed for a higher quality, integrated and coordinated experience, and

[45] Tim Cox to Mike Brocken, August 2012.

that a strategic review – the Beatles Industry Strategic Review (BISR) – should be undertaken. It all sounded very promising; however, just as agreement was being reached concerning the progression of this strategic review in January 2014, severe cuts were announced and the initiative was put on the 'back burner' once again. Judith Feather's retirement followed in February. Mike Jones, however, alongside colleagues from the Institute of Cultural Capital at Liverpool John Moores University, was asked by Bill Heckle and Council officials to continue to gather data and conduct interviews; it seems that projected BISR might still be alive.

The Review: Towards a Beatles-Liverpool 'brand'?

It's taken us a while to work out the value that the Beatles bring to Liverpool, and the opportunities in promoting the city around the world on the back of them, but we're now very good at making the most of this link.

(Pam Wilsher, 2014)[46]

While all of the language emanating from Culture Liverpool (the former Liverpool Culture Company) appears extremely positive and well-founded, there is little doubt that current budget forecasts for Liverpool from central government are bleak; rather vague and valueless expressions such as 'percent for art', 'sponsorship', self-financing events', and so on are already being coined. It seems logical therefore that, irrespective of any Liverpool City Council direct involvement, the legacy of the Beatles should continue in the hands of the self-employed. After all, even in 2005 the total provisional budget allocation from the Liverpool Culture Company was only £1 million for the five years commencing 2005/6. The Beatles Industry Cluster requires consolidation in order to strengthen its portfolio. Therefore partner organizations, dedicated frameworks, agreed ethics, confidentiality agreements, and perhaps even a dedicated independently-funded Beatles tourism office linked directly to the Beatles Industry Group in a formal way, might be one of the ways ahead, so that the existing mechanisms of Liverpool City Council (and NML Liverpool), their changing offices, their reducing funding, and their position as subject to the vagaries of central funding are sidestepped. Further, the individual Beatles providers should create a single charitable trust, or perhaps several, so that they can bid independently or together for funding from a wide variety of sources such as The Paul Hamlyn Trust or the Heritage Lottery Fund. Greater moves to create more academic partnerships, work-based learning schemes, functional archives and ethnography projects should be undertaken urgently. This would be at little cost and yet provide the city with a 'serious' academic profile concerning popular music while not deterring the fun aspect of the city. Any core Beatles Industry Group (BIG) would have to meet and monitor

46 Quoted in *Imagine: The Value of Music Heritage Tourism in the UK*, p. 12.

regularly, with membership being a financial requirement and shared associate membership being offered to Beatles-related groups in other cities or aspiring ones in the city of Liverpool.

To help this combination, one might recommend that there should be an agreement to prioritize myriad *variable* histories of the post-WWII era, rather than agree to one mono-history – which has led in the past to a singular, yet directionless and faction-based historical narrative. The BIG should agree to be advised by popular music historians with specific specialisms in Beatles and Merseybeat-related histories, and local historians without a priori 'angles'. This might help to re-emphasize the point that ongoing research should be an integral part of the BIG portfolio and should be respected as a vital contributory factor to the retention of a historical legacy in which nobody has the first or last word. Students and local history groups should get involved in research, survey, and focus groups to produce top quality research, historical abstracts, documents, monographs and works to codify the history of Liverpool's relationship with the Beatles. Historical knowledge clearly has its limits but, as John Tosh suggests:

> the variety and unpredictability of individual behaviour [...] demand qualities of empathy and intuition in the enquirer as well as logical and critical skills. And whereas scientists can often create their own data by experiment, historians are time and again confronted by gaps in the evidence which they can make good only by developing a sensitivity as to what might have happened, derived from an imagined picture which has taken shape in the course of becoming immersed in the surviving documentation.[47]

One might suggest that such developments would help establish spaces to interact as colleagues and learn from each other. Such communities of practice would help create legitimate participations from those both at the centre and the periphery of such activities, for dialogue surely drives communities forward. According to cognitive anthropologists Jean Lave and Etienne Wenger, any group of people who share a craft and/or a profession can evolve naturally because of common interests in a particular domain, It is through the process of sharing information and experiences with the group that members learn from each other, and have an opportunity to develop themselves both personally and professionally. The productive capacities of such power via mutual engagement have yet to be discussed fully in Liverpool because of the city's own history of struggle, yet it might be argued that power-in-spaces works very well. Joint enterprise, shared repertoires of practice, and self-sustaining hubs of activity have all come to define a domain of knowledge and shared experiences.

For example, both Cavern City Tours (Mathew Street) and The Beatles Story (the Albert Dock) have a strong awareness of the topographical inscription of the

47 Tosh, John (1984, 1991), *The Pursuit of History: Aims, Methods and New Directions in the Study of Modern History,* London: Longman, pp. 139–40.

Beatles and, as a consequence, have an interesting perspective on how one goes about creating a legacy of the group, spatially. Both providers engaged in a very useful 'Business of the Beatles' symposium at Liverpool Hope University in June 2014 and it was clear to those attending that such joint activities inscribed the city spaces with meaningful expressions of collaboration, which in turn, created the potential to change the way things are done. A fully coordinated BIG might consider (e.g.) funding bids for other significant popular music spaces without recourse to LCC funding that are now in danger of being lost – such as the Jacaranda and the surrounding area in Slater Street, the Blue Angel Club, the Knotty Ash Village Hall, etc. At times, locating land and property ownership in Liverpool can be quite a problem and LCC could be of some assistance here. Some of these feasibility studies might suggest that the building or space does not contribute to the Beatles legacy productively, and might as a consequence be abandoned, as a legacy-heritage project, but this would be a decision made by BIG and their respective funders, should a bid prove to be interesting enough to the funders and/or successful. Research into how Totnes in Devon has introduced its own spatial currency should also be undertaken, for a 'Beatles £', available at a BIG tourist shop-cum-office and to be spent only at Beatles attractions, could be something worth considering in relationship to keeping important Beatles-related cash flow with registered and approved agencies.

There need to be far greater links with education. Liverpool's music provision to schools is now very poor and riven with elitism and should be reco-ordinated to include specific school provision concerning popular music histories. The Beatles Story do this very well via their 'Discovery Zone' and variations on this model should be applied throughout the sector. Local schools should be able to visit the Discovery Zone free-of-charge, so that there is inculcated a long-standing appreciation of the Beatles as part of the city's heritage. Musical models abroad – such as the teachings of Tango in Buenos Aires, jazz and blues in Chicago, samba and jazz in Havana, and so on – should be studied and considered as models that could be used on Merseyside. Although the RLPO 'In Harmony' scheme has been relatively successful, it does have its problems: the music being used does not really relate to young people's immediate experiences. This project's focus has been more related to children relaxing, rather than learning a classical canon; however, it has brought with it, problems of elitism and short-termism. There should be fully harmonized educational practical systems in place to sustain Liverpool's musical authenticity via its popular music canon. Music educationalist Alan Richards ruefully recalled:

> It was Capital of Culture Year [2008] and my project, supported by BBC Radio Merseyside, was in full-swing, the objective being to record and produce a number of schools in the area singing and performing either self-penned compositions or a collective song composed by myself. The *Educational Music* project as it was called required my team and myself to visit schools that had asked to be involved and teach them professional recording techniques and a

little about performance. We recorded in the school premises with a mobile unit and each session lasted approximately 3 hours. Everyone thoroughly enjoyed the event, but my problem was with the key individuals from the Liverpool Music Services for schools. Without naming names (but without their help the project would not have been as successful), I had to arrange clandestine meetings with these people, as the Music Services for schools at the time was disbanded and these talented and dedicated people were moved far and wide in to other departments and told not to be involved in any school music projects. It was laughable, because I could not send them emails to their workplace as these were being checked by senior staff and on one occasion, an individual I was dealing with, was reprimanded and warned not to deal with any music arrangements when my email to them was discovered.

Therefore, all my communication with them was done to private email addresses, their homes etc and one meeting I had with a former schools music coordinator who wished to be involved with us, was held in very clandestine circumstances at the Adelphi Hotel and the woman was terrified that she would be found out helping with the schools. It reminded me of a CIA or MI5 drama on TV!!! The other three areas that were involved: Sefton, Knowsley, and Wirral had no such problems, and their Music Services for Schools people were always most helpful. It just amazed me that even in the Capital of Culture year and with a BBC supported Educational Music for schools, Liverpool City Council did not encourage or help to promote or support their own operatives in that field. It reminds me of previous discussions about other areas of local entertainment and tourism in Liverpool, where the council just can't seem to see the 'wood for the trees' on such valuable cultural capital that is available to them in the City.[48]

Regular focus groups with undergraduate and post-graduate researchers might be established and direct links such as those established between Liverpool Hope and TBS should be pursued. There should be an open access popular music archive, a popular music research team, and popular music monographs published by and through the BIG and LCC.

To perhaps aid this and concomitantly keep some kind of investment in the city's self-employed, Culture Liverpool should ring-fence an expenditure budget – perhaps a seed budget – in order to assist where possible financially and to guide BIG (especially in the aforesaid property and land ownership issues). There might possibly be an experienced full-time coordinator established within the Culture Company to do this on a daily basis (i.e. not part-time) and to also referee all BIG stories back to a marketing department in Culture Liverpool. Finally – and perhaps this is the most logical but also most difficult of all to guarantee – there should be a hotel tax, ring-fenced for Beatles tourism. This would of course be a matter for the national Treasury, but one might investigate whether LCC has the legal means to raise such a tax within its city boundaries. In fact, one might suggest

[48] Alan Richards of 'Creative Music in Education' to Mike Brocken, December 2013.

that the very way central government funds and/or draws funds from cities such as Liverpool requires immediate re-examination. Both Liverpool's central funding and the rates paid by Liverpool to central government are partly a consequence of the rateable value of its buildings. But the commercial uses made of these spaces in the twenty-first century are no longer related to their uses at the time of rating. Some commercial rates in Liverpool are based upon models stretching back to the mid-1950s with large Victorian buildings housing informationalized industry-trading requiring little more than an office, and a desk: something needs to be done post-haste. Much thought needs to be given to reassess such buildings, the enterprises within, and the value of partially redundant and ageing commercial premises. Liverpool is a wealth-creation city, but the amounts of money provided by central government and drawn from the city harm wealth creation.

We can see that at least three types of affective labour have driven Liverpool's service sector towards the stage where the Beatles legacy is starting to become embedded in the consciousness of the people of Liverpool, while at the same time bringing Liverpool into the information economy. One primary type of this marketplace is a mode of production that has incorporated communication, knowledge, 'telling' as well as technologies in a way that has gradually transformed the processes of employment and production themselves. Manufacturing is now a service and Liverpool does not have to rely upon manufacturing goods and items as part of their Beatles affective labour industries. A second type of labour that the legacy of the Beatles has left to Liverpool can be broken down, on the one hand, into creative and intelligent manipulation of information and, on the other, symbolic resonant tasks. Real money can be brought in from both the production of knowledge and the use of symbolic signifiers. Thirdly, another type of affective labour that has been left to the city by the Beatles involves the presentation and manipulation of affects, requiring virtual or actual proximity of human contact. These three types of employment have yet to be fully realized in Liverpool, but they are now driving the postmodernization of the city.

The fact that Beatles-related informationization, together with a concomitant shift towards services, has come to dominate Liverpool's real marketplace should not worry us, or lead us back towards the idea that such a service marketplace is in any way temporary. All business is of course temporary to one extent or another, but the Beatles have unwittingly left Liverpool an enormous legacy – one so big, in fact, the reply to the question 'What have the Beatles ever done for us?' should be 'Only changed the entire *raison d'être* of your city for you!' The collapse of modernization in the city was indeed tragic and the consequences are still being felt today; but the key issue related to this collapse was that industrialization can no longer be seen as the key to economic advancement and competition for cities such as Liverpool. Competition for Liverpool, however, has resurfaced via the information-based reinvention of production and for this Liverpudlians should be truly grateful to the Beatles. As previously suggested, while anybody can harp on about their great musical legacy, perhaps their greatest legacy of all was to affectively redefine their home city, in a state of what appeared to be terminal

decline, and to provide information- and knowledge-based materials from which Liverpudlians could earn a living without capital investment, without industrial processes and without formal qualifications.

Of course it is extremely difficult to define precisely where Beatles-related heritage tourism will be going. However, crucially, in addition to their musical-cum-cultural role, the Beatles legacy will continue to be an important act of consumption involving complex rituals, rites of passage and responses. A powerful emotive role is still played by the symbolic presence of the group in contemporary society, but especially in the minds of those travelling to Liverpool. Just how long this will continue to be the case is of course anybody's guess, for popular culture is forever kinetic, and will continue to be so. Beatles tourism, therefore, must clearly become an increasingly discretionary activity, and contemporary fashions must increasingly play a part in its mutating existence. All of the various forms of Beatles knowledge and information now exist within the networks of a global market and under the prowess of international production of services; perhaps this is one reason why we should no longer describe such enterprise as 'industrial', as such.

The arguments over the authenticity of Beatles tourism in Liverpool are contingent of questions concerning the fundamental civil, political, ethical and cultural roles of both popular music and cities in our time. The great British Marxist historian Eric Hobsbawm argued many years ago that the Industrial Revolution marked the most fundamental transformation in the history of the world. He described, for example, Britain's rise as the world's first industrial power, its decline from the temporary dominance of the technological pioneer, and the effect such peaks and troughs had on the lives of the British people. It was indeed a masterly survey of the major economic developments of the past 250 years, but Hobsbawm made several crucial errors concerning leisure. His concern over social control and his adherence to Marxist thought meant that he was forever to view leisure pursuits as 'inauthentic'. Whether he was considering Marconi's radio, the motor industry or the Music Hall, he felt that there were only limited ways in which one could analyse issues to do with leisure. Hobsbawm did concede that during the 1960s recorded sound and popular media could generate authentic responses, but he was still hidebound by the concept that a mass-consumption society was led by the false consciousness of its largest mass market:

> The truth was that a mass-consumption society is dominated by its biggest market, which in Britain was that of the working class. As production and styles of life were therefore democratized, not to say proletarianized, much of the workers' former isolation melted away; or rather the pattern of isolationism was reversed. No longer did the workers have to accept goods or enjoyments essentially produced for other people; for an idealized petty-bourgeois 'little am' [...] for a degenerate version of the middle-class matinee-going (as in most of popular music), or by a moralizing teacher (as in the BBC).
>
> Henceforth it was their demand which dominated commercially, even in their taste and style which pressed upward into the culture of the non-working

classes; triumphantly in the Liverpool-accented tones of an entirely new pop music, indirectly in the vogue for authentic working-class themes and backgrounds which swept not only TV but even that bourgeois stronghold of the theatre [...][49]

A plausible account, no doubt, with some irrefutable historical facts contained within. Yet this comment, redolent of opinions in Liverpool in the intervening years, is also largely rhetoric. While Hobsbawm evidently attempted to look beyond fellow Marxist Theodor Adorno for an understanding of meaning and value, he could still not bring himself to write about the potential of leisure-based co-creativity, rather than simply potentially meaningful collective working-class consumer marketplaces. His writing still evokes a reluctance to accept consumerism as an authentic site for discourse, apart that is from when he sees popular music as part of a vanguard of authentic working-class representation breaking through, as it were, from the 'bottom up'. For Hobsbawm, credit for this activity cannot fall at the feet of the industry, technology is still viewed as a manipulator, and nothing is mentioned about the impact of popular music reception and interpretation as an arbiter; there is nothing to speak of concerning the consumer as a cognizant co-creator of taste. One might even suggest that he got it wrong as far as the Beatles were concerned, for it is indeed debatable whether they were ever on any lower social rungs related to working-class consciousness. Yet this is precisely the rhetoric of authenticity that has been partly at work in Liverpool between 1970 and the present day: perhaps what might be described as a search for, and then invention of, a new 'tradition'.

The tradition, should we choose to find it, lies in the increasing flexibility of popular music to explain meaning (both physically and corporeally). Now we have passed the first decade of the new century it can also be seen that popular culture, communication via electronic media and the uses values to which we put such developments (such as popular music tourism in post-industrial cities) is moving us further and further away from the models of history so described by Hobsbawm (and, of course, Adorno). For example, in Liverpool we have a popular music tourism market no longer subject to any great extent to the protestations of historians cleaving to an ideology that clearly misunderstood early twentieth-century impacts of popular music technology. Such writers, however noble and erudite they might be, should not be used as models for a comprehension of our new co-creative universe. Such achievements appear to demonstrate, at least to this writer, a critical potential of a local or plural conception of tradition and heritage. In a world in which the distance between 'reality' and 'appearance' has been dramatically reduced, the interpretation of experience in its own right is a field of invention, perhaps even a field which does not subordinate itself to any commanding opposition.

[49] Hobsbawm, Eric (1969, r.1978), *Industry and Empire*, Harmondsworth: Pelican, pp. 283–4.

Issues concerning housing in Liverpool are still ones that needs to be sensitively handled. Many dwellings have been abandoned; whereas specific districts are experiencing substantial out-flows of residents with very few people coming in. The main debate is whether to conserve or to demolish large amounts of the poor-quality housing stock in these affected districts (see the discussion in Chapter 7 concerning Toxteth and Madryn Street). Tourism, however, is contributing to such debates in a vibrant way, suggesting that solutions to housing difficulties in certain specific locations can be resolved via a serious consideration of the Beatles marketplace. It is evident that remarketing ventures for the city region, if combined with issues concerning preservation and management of Liverpool's built heritage, can move the city forward. Such are a few of the key issues related to 'this' Liverpool in contradistinction with the various 'other Liverpools' of the past; it is clear that issues concerning popular heritage (as opposed to big building heritage) are now being addressed in a proactive way. Liverpool remains a city of great social and economic divisions but its very kineticism is gradually moving the equally kinetic population away from a somewhat synchronic past and, via reuse and regeneration, is diachronically moving towards a different future: one where the Beatles are considered as a key element of cultural, economic and spatial regeneration, not simply a famous popular music group (who no longer exist), who once played at the Cavern Club (which is no longer there) in Mathew Street, Liverpool.

There is obviously still a gap between what we would like to do as researchers of popular music tourism and what can be done: not least because of the recurrent problems of funding. However, the level of agreement between city council officers and Beatles entrepreneurs concerning the importance of the Beatles brand to Liverpool does suggest a significant paradigm shift from narratives highlighted within this volume. What was perhaps most striking at the two meetings attended by myself concerning the proposed social compact, was the agreement from both sides that the legacy of the Beatles was far more than simply musical. It was, in fact ,one of the greatest possible gifts of the modern era: a legacy of 'thirdspace' bestowed in perpetuity upon the citizens of a city. The implications of our discussions were not therefore whether there should be a unified entrepreneurial-civic contract concerning this Beatles legacy, but when it should begin to take place. But, if popular music has its own long and varied histories of relations between the local and the global, craft and entrepreneurship, effect and affect, we also need to at least attempt to understand such relationships, not condemn them. This thesis of this research-based text has suggested that the historicization and contextualization of the legacy of the Beatles to Liverpool requires ongoing re-evaluation and reconsideration. Not only regarding the spatial histories in the city throughout the latter half of the twentieth century and the first decade of the twenty-first, but also as a way to understand our personal, imagined relationships with artefacts, values and places. It has been suggested that the disciplines of history, social studies, economics and politics need to be re-evaluated in order to release the heritage of the Beatles from the shackles of imposed value-ridden statements, ideologies, and histories in which all popular music is placed at

counterpoint to the norms and traditions of society. It has also been suggested that closer investigations of 'tellers' and their modes of interaction with others – especially in specific spaces – needs to be awarded serious value as historical narratives about the modern world, in their own right.

It has become increasingly clear to this researcher that the search for the sociology of the popular music consumer-as-tourist is far from complete, but can lead us to a position of understanding how and why our imaginings are directly linked to realities, and that these have grown more complex as the world has grown more complex. Our realities cannot be reduced to a singular ideology, just as our experiences cannot be reduced to a singular mono-history. In Liverpool, studies to understand the Beatles' impact and enduring popularity have been bogged down by a failed political rhetoric; by not getting beyond theorizing about the dualism between the imaginary and the real, such rhetoric could not come close to understanding the cartography of 'thirdspace' cognitive 'quality' moments. The ways such moments are stored and cherished by people actually direct them towards important live-giving experiences, which in turn, lead towards special awareness(es), friendships, compatibilities, understandings: even perhaps improved mental and physical health.

Future research on Beatles tourism in Liverpool will have to respect such aesthetics of the mind. In fact, it could be argued that a respect for a kind of pedagogical popular culture in which self-learning via travelling is at the heart of people's meanings should be more fully acknowledged. If we are sure that we should endow popular music and the individual subject with new heightened senses of their real and imagined places in a global system, then we simply have to respect this enormously complex representational dialectic, and consider radically new forms of understandings to do it justice. Future research will have to hold a self-evident truth: that the world of multinational capital can achieve at times breakthroughs (as yet unimaginable) in representations of our lived experiences: whether intended or not. Our repositioning as individuals cannot be reduced to the means of production or to rhetoric surrounding imagined 'masses'. There have been sizeable qualitative and qualitative changes in the many forms of popular music and popular music studies that have emerged since the paradigm shift of recorded sound first brought new possibilities to us. The constraints wrought by oppositional ideologies upon our direct communication with 'the popular' marginalized the creative spatialized interpretation of popular music: we were called fanatics, compulsives, obsessives. But such fandom does not simply respond to music spaces and places, it *creates* them. As the Beatles might have once sung, such spaces should be allowed to 'Come Together' – developing around a hub of communities of practice.

Bibliography

Principal Research Sources Used

Adams, Roy (2004), *Hard Nights: My Life in Liverpool Clubland – High Dives to Low Dives, the Cavern and Nightlife*, www.cavernmanpublications [UK]

Armstrong, Mark (ed.) (2013), 'Interviews: A Chat with Merseytravel', *Liverpool Chamber* 40, Autumn

Atkinson, Peter (2010), 'The Beatles and the Broadcasting of British Cultural Revolution, 1958–63', in Jerzy Jarniewicz and Alina Kwiatkowska (eds), *Fifty Years With The Beatles: The Impact of the Beatles on Contemporary Culture*, Lodz [Poland]: University Press

Bacon, David and Norman Maslov (1982), *The Beatles' England: There Are Places I'll Remember*, Columbus [USA]: Columbus Books/TABS and San Francisco [USA]: 910 Press

Baxter, Lew (2005), *My Beatles Hell: The Tragical History Tour of Beryl Adams*, Birkenhead: Guy Woodland

Bedford, David (2009, r. 2011), *Liddypool: Birthplace of the Beatles*, London: Dalton Watson

Belchem, John (2006), 'Celebrating Liverpool', in John Belchem (ed.), *Liverpool 800: Culture, Character and History*, Liverpool: University Press

Brabazon, Tara (1993), 'From Penny Lane to Dollar Drive: Liverpool Tourism and Beatle-led Recovery', *Public History Review* 2, pp. 108–24

———— (2002), 'We're One Short for the Crossing: Abbey Road and Popular Memory', *Transformations* 3

Bradshaw, George (1863), *Bradshaw's Handbook 1.2.3.4.*, Oxford: Old House: 2012 reprinted edition

Brocken, Michael (1995), *Some Other Guys! Some Theories about Signification: Beatles Cover Versions*, Liverpool: IPM/Mayfield

———— (2010), *Other Voices: Hidden Histories of Liverpool's Popular Music Scenes, 1930s–1970s*, Farnham: Ashgate

———— (2011), 'The Blues and Gospel Train, Johnny Hamp and Granada TV – Masters of Reality', in Ian Inglis (ed.), *Popular Music and British Television*, Farnham: Ashgate

Brocken, Michael and Melissa Davis (2012), *The Beatles Bibliography: A New Guide To The Literature*, Manitou Springs [USA]: The Beatle Works Ltd

Brown, Jacqueline Nassy (2005), *Dropping Anchor, Setting Sail: Geographies of Race in Black Liverpool*, Princeton [USA]: University Press

Charters, David (2005), 'A privilege to report on a city of style, talent and tradition', *Daily Post*, 10 June

Cohen, Sara (1992), Rock Culture in Liverpool, Oxford: University Press

———— (1995) 'Localizing Sound', in W. Straw et al. (eds), *Popular Music: Style and Identity*, Montreal [Canada]: Centre for Research on Canadian Cultural Industries and Institutions

———— (2007), *Decline, Renewal and the City in Popular Music Culture: Beyond The Beatles*, Aldershot: Ashgate

Cohen, Sara and Kevin McManus (1991), *Harmonious Relations: Popular Music in Family Life on Merseyside*, Liverpool: National Museums & Galleries

Connolly, Ray (2009), 'Beatleology', *Daily Mail Online*, updated 7 March

Cornelius, John (1982, r. 2001), *Liverpool 8*, Liverpool: Liverpool University Press

Craig, Ian (1978), 'Liverpool, like the future, is a place where they do things differently', *Liverpool Echo Citizen's Guide '78*, Liverpool: Liverpool Echo

Davies, Hunter (1996), 'Beatlemania', in David M. Haugen (ed.) (2005), *The Beatles*, Detroit: Thomas Gale

———— (2009), 'From Me to University', *The Guardian*, 4 March

Du Noyer, Paul (2005), *Liverpool Wondrous Place: Music from the Cavern to Cream*, London: Virgin

Dutch Fans (1982), *Lots of Liverpool*, Holland: Beatles Unlimited Special

Evans, Mike (1975), *Nothing To Get Hung About*, monograph included in Ron Jones, *The Beatles Collection*

Evans, Mike and Ron Jones (1981), *In the Footsteps of The Beatles*, Liverpool: The City of Liverpool Public Relations Office/GB Tourist Development Office

Flannery, Joe with Mike Brocken (2013), *Brian Epstein, The Beatles and Me: Standing in the Wings*, Stroud: The History Press

Fulper-Smith, Shawn and Marylin (1982), 'Cavern Mecca: The Battle Goes On', *Beatlefan* 4/2, February/March, Georgia [USA]: Beatlefan

Granados, Stefan (2004), *Those Were the Days*, London: Cherry Red Books

Grant, Peter (1992), 'Tourism Right On Track', *Liverpool Echo*, 18 November

Guy, Peter, (2009), 'Will Sergeant and The Liverpool International Festival of Psychedelia – a beginner's guide to psychedelia', *Liverpool Echo*, 17 September

Harry, Bill (1984), *The Beatles: Catalogue for Beatle City*, Liverpool: Radio City – opened April 1984

———— (2009), *Liverpool: Bigger Than The Beatles*, Liverpool: Trinity Mirror

———— (2011), *In My Life: Lennon's Liverpool*, Liverpool: Trinity Mirror

Haslam, John and Michael O'Leary (eds) (1963), *Mersey Beat Spots: A Guide to Liverpool's Beat Clubs*, Liverpool: XYZ Press

Herbert, Ian (1992), 'Holiday chiefs may be told: 'wish you weren't here', *Liverpool Daily Post*, 18 November

Hodgson, Neil (1992), 'What Have We Done Wrong?', *Liverpool Echo*, 18 November

Hope, David (1973), 'Cavern Club to Close', *Liverpool Echo*, 28 May

Hughes, Liz and Jim (eds) (1981), *Official Souvenir Programme Liverpool's 1st Annual Mersey Beatle Extravaganza, 29th August*, Liverpool: Cavern Mecca

———— (1983), 'Editorial', *Cavern Mecca*, January

Inglis, Ian (2010), 'Here, There and Everywhere: Introducing the Beatles', in Ian Inglis (ed.), *Popular Music and Television in Britain*, Farnham: Ashgate

Jones, Catherine (2011), 'Home of the Beatles and Elvis join forces as Liverpool and Memphis create a network of Rock 'n' Soul mates', *Liverpool Echo*, 21 June

Jones, Ron [compiler, ed.] (1975), *The Beatles Collection*, Liverpool: City of Liverpool Public Relations Dept.

Kaijser, Lars (2010), 'Authority Among Fragments; Reflections on Representing the Beatles in a Tourist Setting', in Jerzy Jarniewicz and Alina Kwiatkowska (eds) (2010), *Fifty Years With The Beatles: The Impact of the Beatles on Contemporary Culture*, Lodz [Poland]: University Press

Kruse, Robert (2003), 'Imagining Strawberry Fields as a Place of Pilgrimage, *Area* 35/2 June

Lees, Audrey M (1974), *Merseyside Facts and Figures*, Liverpool: Merseyside County Planning Department

Leigh, Spencer (2002), *Sweeping the Blues Away: A Celebration of the Merseysippi Jazz Band*, Liverpool: IPM

———— (2008), *The Cavern: The Most Famous Club in the World*, London: SAF Publishing

———— (2012), *The Beatles in Liverpool*, London: Omnibus

Lewis, David (2010), *The Beatles' Liverpool Landscapes*, Derby: Derby Books

Long, Cathy (ed.) et al. (1997), *Liverpool Beat Route: The Merseyside Music Trail*, Liverpool: IPM

McIver, Glen (2009), 'Liverpool's Rialto: Remembering the Romance', *Participations: Journal of Audience and Reception Studies* 6/2, November, www.participations.org

Marsden, Gerry (1963), 'Nashville-on-Mersey', in Jack Fishman (ed.), *The Official Radio Luxembourg Book of Record Stars*, London and Manchester: Souvenir Press/World Distributors

Neild, Larry (1991), 'Anton's Debts to Radio City', *Liverpool Echo*, 18 January

———— (1991), 'Anton Firm Unaware of Subsidy: MDC gave £4.50 for each garden site visitor', *Liverpool Echo*, 22 January

———— (1991), 'Anton "feather in cap" of Bank Manager', *Liverpool Echo*, 24 January

———— (1991), 'Festival Site "Could Have Been Saved"', *Liverpool Echo*, 25 January

———— (1991), 'Crash Firm "Promised 149-Year Site Lease"', *Liverpool Echo*, 29 January

———— (1991), 'Anton "Quizzed" Deputy Leader on Site Costs', *Liverpool Echo*, 30 January

———— (1991), 'Anton Trial Told of £200,000 House Boom', *Liverpool Echo*, 1 February

———— (1991), 'Anton Failed on His Payments', *Liverpool Echo*, 5 February
———— (1991), 'Queen's House "Used in Loan Attempt"', *Liverpool Echo*, 7 February
———— (1991), 'Anton Trial Told How Files on Deals Were Removed', *Liverpool Echo*, 2 March
———— (1991), 'Anton Cleared on 8 Charges', *Liverpool Echo*, 7 March
O'Brien, Ray (2001, 2003), *There Are Places I'll Remember: The Beatles' Early Venues in and around Merseyside*, 2 volumes, Wallasey: Imprint; later republished in Liverpool by the Bluecoat Press as one volume
O'Mahoney, Michael (1931), *Ways and Byeways of Liverpool*, Liverpool: Daily Post Printers
Roach, Kevin (2011), *The McCartneys: In The Town Where They Were Born*, Liverpool: Trinity Mirror
Ruck, Shelly (2012), 'Press Release: The Beatles Story and Liverpool Hope University Partnership', September
Ruck, Shelley and Michael Brocken (2013), *The University and The Beatles Story*, Gem Case Studies 10, Gillingham: Group for Education in Museums
The National Trust (2004), *20 Forthlin Road*, Swindon: Beacon Press
———— (2004), *Mendips*, Swindon: Beacon Press
Thompson, Phil (1994, 2007), *The Best of Cellars: The Story of the Famous Cavern Club*, Liverpool: Bluecoat Press; reissued by The History Press, Stroud
Townshend, Mark (2005), 'Racism? It's endemic here', *Observer*, 12 December
Turner, Ben (2008), '"Liverpool I Left You But I Never Let You Down"... says who, Ringo?', *Liverpool Echo*, 21 January
Unaccredited article (1984), 'Bringing dead dockland to life', *The Times*, 27 January
———— (1985), 'What Dallas has Wrought', *Los Angeles Times*, 17 May
Unaccredited columnist (1984), 'Magical Magnet of the Fab Four', *International Garden Festival Grand Pre-Opening Supplement*, *Liverpool Echo*, 25 April
———— [probably Larry Neild] (1991), 'Anton Had Plans for Re-Launch of Ferry', *Liverpool Echo*, 24 January
———— [probably Larry Neild] (1991), 'Court Told of Anton's Winning Way: Better than Saatchi and Saatchi', *Liverpool Echo*, 6 February
Unaccredited editor (1904), 'Bass, Ratcliff & Gretton Ltd Excursion to Liverpool and New Brighton Friday July 15th, 1904'
———— (1984), *Festival Guide: Liverpool International Garden Festival: Liverpool '84*, Liverpool: Merseyside Development Corporation
Unaccredited editor/s, foreword by Paul Du Noyer (2007), *Sound City* brochure, Liverpool: Liverpool Culture Company and Liverpool City Council
Unaccredited editorial (1992), 'Comment', *Liverpool Echo*, 18 December
Unaccredited staff writer (1979), 'Beatles May Come Home – Officials in Turmoil', *Merseyside Late Extra*, 1 June
Williams, Allan and William Marshall (1975, 1976), *The Man Who Gave the Beatles Away*, London: Elm Tree

Willis Pitts, Paul, with Cassandra Silk and Vima Wolfman (2000), *Liverpool, The Fifth Beatle – An African-American Odyssey*, London: Am-Oz-En Press
Wilson, Graeme (1992), 'Hoteliers fear move to tourism board merger', *Liverpool Daily Post*, 20 November

Other Works Consulted

Allan, Adrian R (1986), *The Building of Abercromby Square*, Liverpool: The University of Liverpool; first appeared in the *University of Liverpool Recorder* in three parts, 1984–86
Berger, Harris M. and Giovanna Del Negro (2004), *Identity and Everyday Life: Essays in the Study of Folklore, Music and Popular Culture*, Middletown CT [USA]: Wesleyan University Press
Bhabha, Homi (1994), *The Location of Culture*, London: Routledge
Blackett, Tom (2004), 'What is a Brand?' in Rita Clifton, John Simmons et al., *Brands and Branding*, Princeton [USA]: Bloomberg Press
Brocken, Michael (2003), *The British Folk Revival 1944–2002*, Aldershot: Ashgate
Brunvand, Jan Harold (1981), *The Vanishing Hitchhiker: American Urban Legends and their Meanings*, London: W.W. Norton
Burns, Gary (2013), 'Beatles News: Product Line Extensions and the Rock Canon', in Kenneth Womack (ed.), *The Cambridge Companion to the Beatles,* Cambridge: University Press
Campbell, Joseph (r. 2011), *Creative Mythology (The Masks of God)*, London: Souvenir Press
Carr, E.H. (1987), *What Is History?* Harmonsdworth: Penguin
Cohen, Stanley (1972, 1987), *Folk Devils and Moral Panics*, London: Blackwell
Cohn, Nick (1969), *AWopBopaLooBop ALopBamBoom: Pop From The Beginning*, London: Paladin
Connell, John and Chris Gibson (2003), *Sound Tracks: Popular Music Identity and Place*, London: Routledge
——— (2005), *Music and Tourism: On the Road*, London: Channel View
Cowie and Cowie – see Hembry, Phyllis
Debord, Guy (1995), *Society of the Spectacle*, New York [USA]: Zone Books
Dennis, Ferdinand (1988), *Behind the Frontlines: Journey into Afro-Britain*, London: Victor Gollancz
Docherty, Thomas (1993), 'Postmodernism: An Introduction', in Thomas Docherty (ed.), *Postmodernism: A Reader*, London: Harvester Wheatsheaf
Drew, Rob (2001), *Karaoke Nights: An Ethnographic Rhapsody*, London: Altamira
Eisenberg, Evan (1987), *The Recording Angel: Explorations in Phonography*, London: McGraw-Hill
Elliot, Anthony (1999), *The Mourning of John Lennon*, Berkeley [USA]: University of California Press

Farson, Daniel (1998), *Never a Normal Man: An Autobiography*, London: Harper Collins

Fetterman, D.M. (1998), *Ethnography: Step by Step*, New York [USA]: SAGE

Fishman, Jack (ed.), *The Official Radio Luxembourg Book of Record Stars*, London and Manchester: Souvenir Press/World Distributors

Gandy, Matthew (2008), 'Of Time and the City', sleeve-notes to Terence Davies, *Of Time and the City*, London: BFI / Hurricane City Films / Digital Departures

Giddens, Sally (1989), 'The Real J.R.', *D Magazine*

Granville, A.B. (1841), *The Spas of England, Vol. 1. Northern Spas*, London: Henry Colburn

Goldman, Albert, (2001), *The Lives of John Lennon*, Chicago [USA]: Chicago Review Press

Griffiths, Niall (2008), *Real Liverpool*, Bridgend: Poetry Wales Press

Hall, Stuart and Paddy Whannel (1964), *The Popular Arts*, London: Hutchinson Educational

Hammersley, Martin and Paul Atkinson (1994), *Ethnography: Principles in Practice*, London: Routledge

Harry, Bill (1984), *The Beatles Volume 3: Paperback Writers, The History of the Beatles in Print*, London: Virgin

Heidegger, M. (1967), *Being and Time*, Oxford: Blackwell

Hembry, Phyllis, edited and completed by Leonard W. Cowie and Evelyn E. Cowie (1997), *British Spas from 1815 to the Present*, Cranbury [USA]: Associated University Presses

Hewison, Robert (1987), *The Heritage Industry: Britain in a Climate of Decline*, London: Methuen

Hewison, Robert (1988), *In Anger: Culture in the Cold War 1945–69*, London: Paladin

Hill, C.P. (1985), *British Economic and Social History 1700–1982*, London: Edward Arnold

Hobsbawm, E.J. (1969, 1978), *Industry and Empire,* Harmondsworth: Pelican

Hoggart, Richard (1957), *The Uses of Literacy*, London: Chatto and Windus

Hopkins, Harry (1964), *The New Look: A Social History of The Forties and Fifties in Britain*, London: Secker and Warburg

Howell Williams, Peter (1971), *Liverpolitana: A Miscellany of People and Places*, Liverpool: Merseyside Civic Society

Howells, Richard (2012), 'One Hundred Years of the Titanic on Film', *The Historical Journal of Film, Radio and Television* 32/1, March

Howie, F. (2000), 'Establishing the common ground: tourism, ordinary places, grey-areas and environmental quality in Edinburgh, Scotland', in G. Richards and D. Hall (eds), *Tourism and Sustainable Community Development*, London: Routledge

Jack, Ian (ed.) (2001), *Granta: The Magazine of New Writing* 76, Winter – Music, London: Granta

Jarniewicz, Jerzy and Alina Kwiatkowska (eds) (2010), *Fifty Years With The Beatles: The Impact of the Beatles on Contemporary Culture*, Lodz [Poland]: University Press

Jenkins, Keith (1991), *Re-thinking History*, London: Routledge

Kamenka, Eugene (ed.) (1983), *The Portable Karl Marx*, London: Viking Penguin

Kane, Larry (2005), *Lennon Revealed*, Philadelphia [USA]: Running Press

Kaplan, E.A. (1988), *Rocking Around the Clock: music, television, postmodernism, and consumer culture*, London: Methuen

Karubian, Sara (2009), '360° Deals: An Industry Reaction to the Devaluation of Recorded Music,' *Southern California Interdisciplinary Law Journal* 18/2

Katz, Donald (1994), *Just Do It: The Nike Spirit in the Corporate World*, New York [USA]: Random House

King, Mike (2009), *Music Marketing – Press, Promotion, Distribution, and Retail*, Boston [USA]: Berklee Press

Kuhn, Thomas (1962, r. 1996), *The Structure of Scientific Revolution; third edition*, Chicago: University of Chicago Press

Laclau, Ernesto (1993), 'Politics and the Limits of Modernity', in Thomas Docherty (ed.), *Postmodernism: A Reader*, London: Harvester Wheatsheaf

Laing, Dave (1969), *The Sound of Our Time*, London: Sheed and Ward

Lanza, Joseph (r. 2004), *Elevator Music: A Surreal History of Muzak, Easy Listening and Other Moodsong*, Ann Arbor [USA]: University of Michigan Press

Leigh, Spencer (1984), *Let's Go Down The Cavern: the Story of Liverpool's Merseybeat*, London: Vermilion

——— (1991), *Speaking Words of Wisdom, Reflections on the Beatles*, Liverpool: Cavern City Tours

Lave, Jean and Etienne Wenger, (1991), *Situated Learning: Legitimate Peripheral Participation,* Cambridge: University Press

Longhurst, Brian (2007), *Popular Music and Society*, Cambridge: Polity

Mabey, Richard (1969), *The Pop Process*, London: Hutchinson Educational

McKercher, Bob and Hilary du Cros (2002), *Cultural Tourism: The partnership between tourism and cultural heritage management*, Binghampton [USA]: Haworth

Mandel, Ernest (1978), *Late Capitalism*, London: Verso

Marshall, Lee (2013), 'The 360 Deal and the "New" Music Industry', *European Journal of Cultural Studies* 16/1

Melly, George (1970), *Revolt into Style: The Pop Arts in Britain*, Harmondsworth: Penguin

Murden, John (2006), '"City of Change and Challenge": Liverpool Since 1945', in John Belchem (ed.), *Liverpool 800: Culture, Character and History*, Liverpool: University Press

Neaverson, Bob (2000), 'The Beatles' Films and Their Impact', in Ian Inglis (ed.) (2000), *The Beatles, Popular Music, and Society*, London: Macmillan

Nuttall, Jeff (1969), *Bomb Culture*, London: Paladin

O'Connor, Freddy (1990), *Liverpool: Our City, Our Heritage*, Liverpool: Printfine/ O'Connor

Persig, Robert (1974, 1999), *Zen and the Art of Motorcycle Maintenance: An Enquiry into Values*, London: Vintage

Pye, Ken (2010), *Discover Liverpool*, Liverpool: Trinity Mirror

Reynolds, Simon (1990; r. 2011), *Blissed Out: The Raptures of Rock*, Kindle edition published by Rock's Back Pages

Richards, Greg (ed.) (2007), *Cultural Tourism: Global and Local Perspectives*, Binghampton [USA]: Haworth

Scarth, Alan (2009), *Titanic and Liverpool*, Liverpool: National Museums Liverpool

Shuker, Roy (2002), *Popular Music, The Key Concepts*, London : Routledge

———— (2010), *Wax Trash and Vinyl Treasures: Record Collecting as a Social Practice*, Farnham: Ashgate

Singh, L.K. (2008), 'Issues in Tourism Industry', in *Fundamental of Tourism and Travel*, Delhi [India]: Isha

Smith, Melanie (2003), *Issues in Cultural Tourism Studies*, London: Routledge

———— (2006), *Tourism, Culture and Regeneration*, London: CABI

Soja, Edward W. (1996), *Thirdspace: Journeys to Los Angeles and Other Real-and-Imagined Places*, Oxford: Blackwell

Spizer, Bruce (2003), 'Apple Records', in Kenneth Womack (ed.) (r. 2013), *The Cambridge Companion to the Beatles*, Cambridge: University Press

Storey, John (2000), *Cultural Theory, Popular Culture: An Introduction*, London: Longmans

Street, John (1995), '[Dis]located? Rhetoric, Politics, Meaning and the Locality', in Will Straw et al. (eds), *Popular Music, Style and Indentity*, Montreal [Canada]: The Centre for Research on Canadian Cultural Industries and Institutions

Sykes, Bill (2012), *Sit Down! Listen To This! The Roger Eagle Story*, Manchester: Empire

Tafari, Levi (2006), *From the Page to the Stage*, Liverpool: Headland

Tighe, Anthony (2008), 'The Arts/Tourism Partnership', in *Journal of Travel Research* 1, August

Tosh, John (1984, 1991), *The Pursuit of History: Aims, Methods and New Directions in the Study of Modern History,* London: Longman

Unaccredited *TravelMail* reporter (2012), 'National Trust hits back at Alan Bennett's "extraordinarily elitist" criticism', 5 November

Urry, John (1990), *The Tourist Gaze: Leisure and Travel in Contemporary Society*, New York [USA]: SAGE

Van El, Alannah (1993), *Growing Up on Talacre Beach: Unique Experiences of Life in the Old Boathouse on the Dee Estuary in North Wales*, Vancouver [Canada]: Seas Star Press

Ward, David (2007), 'The Beatles to James Bulger', *Guardian*, 17 November

———— (2008), 'Liverpool moves out of the shadows with a little help from its friends', *Guardian*, 1 January

Weber, Max (1947), *The Theory of Social and Economic Organization*, New York [USA]: Free Press

Wenger, Etienne (1998), *Communities of Practice: Learning, Meaning, and Identity*, Cambridge: University Press

Whittington-Egan, Richard (1955), *Liverpool Colonnade*, Liverpool: Philip, Son & Nephew

——— (1957), *Liverpool Roundabout*, Liverpool: Philip, Son & Nephew

Reports and Unpublished Works

Anderson, Alexander (1984), *Mersey Waterfront: Unique Development Opportunities*, Liverpool: Merseyside Development Corporation

Anton, John (1986), *Transworld Festival Gardens Information Pack*, Liverpool: Transworld

Beatle City Dallas: Beatle City The Original Liverpool Experience – 1987 Program

Byrne, Mike (1988), *The Beatles – A Magical History Tour*; feasibility study commissioned by Merseyside Tourism Board

City of Liverpool Development Plan: Town Map Programme Map, Written Statement – Town and Country Planning Act, 1947

Comedia Consultancy (1991), *The Cultural Industries in Liverpool: A Report to Merseyside Taskforce*, Volumes 1 and 2

Editors, the (2005), *Report For Liverpool Culture Company and Beatles Industry Group*; *Music and Beatles Tourism in the City of Liverpool,* Haywards Heath: Locum Destination Consulting

——— (2012), *Wish You Were Here*, report prepared by UK Music for the tourist industry, London: UK Music

——— (2014), *Imagine: The Value of Music Heritage Tourism in the UK*, London: UK Music

Gartz, Georg (1998), *'Eight Days a Week': Liverpool in Koln, a cultural project in September 1998*: George Gartz / Jurgen Kisters

Higginson, Steve (2013), *Liverpool: Time and Work*, unpublished research in progress

Holcroft, Alan (1996), *Visitors to Merseyside: Report of the 1995 Survey*, Liverpool: Merseyside Information Service, August

Jacques, Yolanda (1992), *Mersey Ferries: Visitor Survey for North West Tourist Board*

Liverpool, A Cultural Capital: Culture Liverpool Action Plan 2014–2018, Liverpool: Culture Liverpool

Liverpool and Merseyside Official Red Book for 1956, issue 56, Liverpool: Littlebury Bros

Liverpool City Council (1987), *Liverpool City Centre Strategy Review*, November

McGriskin, Steve (1996), *Liverpool's Mathew Street Music Festival; Business Plan 1995–1996*, Liverpool: Cavern City Tours

Marquis, F.J. (1916), *Handbook of Employments in Liverpool*, Liverpool: Education Committee

Merseyside Task Force, Summer 1993, published by Liverpool City Action Team

Mignon, Jeannie, Beatle City and West End Market Place (1987), *Yeah! Yeah! Yeah! Beatle City Comes to Dallas: Dallas is Only US Stop for Liverpool Exhibition*, press release dated 21 July 1987

Nedzel, Lucie S. (2011), *Beatles Tourism in Liverpool: Structure, Performance and Potential,* unpublished MA dissertation, Liverpool: Liverpool Hope University Dept of Music

Unaccredited editor/s (2014), *Liverpool, A Cultural Capital* (2014), Liverpool: Culture Liverpool

Unaccredited writer (1988), *North West Area Shortbreak Holdays Research – Summary Report*, London: MaS Research, Marketing & Consultancy / BTA/ ETB Research Services

——— (1992), *The Five Year Plan*, Liverpool: Liverpool City Challenge BY14

Vaughan, R. and K. Wilkes (1986), *An Economic Impact Study of Tourist and Associated Arts Developments in Merseyside*, Liverpool: Merseyside Arts / DRV Research BY33

White, Roger (ed.) (1984), *The Design Brief: Beatle City the Total Experience*, St Annes, Preston, Liverpool: Trans Press / Hargreaves Savory / Beatle city – press pack BY17

Williamson, P.M. (1984), *BEATLE CITY: Awareness and Reactions – a report on behalf of Radio City Liverpool*

Willis, Jeffrey (1991), *Visitors to Merseyside: Report of the 1990 Survey Volume 1*, Liverpool: Merseyside Information Service

Winardi, Debbie, (2013), *How The Beatles Have Evolved into a Brand that Ensures Longevity*, unpublished MA dissertation, Liverpool: Liverpool Hope University Dept of Music

DVD, Film, Radio

Cash, Tony [prod.] (1970), *Anatomy of Pop*, BBC Television, a series of five programmes, broadcast on BBC 1, beginning 10 January 1971

Cotterill, Dave, Mike Morris and Paul Lysaght (2007), *Liverpool's Cunard Yanks*, Liverpool: Souled Out Films, www.souledoutfilms.co.uk

Evans, Claire (1999), 'Conversations with Uncle Charlie [Lennon]', *BBC Radio Merseyside*, broadcast September 1999

Farson, Daniel (1963), *Beat City*, London: ATV-Rediffusion, broadcast 24 December 1963

Lupton, Hugh (2005), 'Something Understood', *BBC Radio 4*, broadcast February 2005

Palmer, Tony [dir] (1977), *All You Need is Love: The Story of Popular Music*, London Weekend Television, first broadcast 1977

Putnam, David and Sanford Lieberman (prods) (1973), *That'll be the Day*, London: Goodtimes Enterprises
——— (1974), *Stardust*, London: Goodtimes Enterprises
Unaccredited DVD editors (2007), *Liverpool on Film 1897 to 1967*, North West Film Archive, Manchester Metropolitan University, Liverpool Record Office, North West Vision, NWFA07

Webography

http://ec.europa.eu/culture/our-programmes-and-actions/doc413_en.htm – re Capital of Culture (date accessed 21 August 2009)
'Beatle Fans' Pilgrimage on Abbey Road Anniversary' (CBS News): p://www. youtube.com/watch?v=S4lA8gyQF5Y&NR=1&feature=fvwp (date accessed 9 August 2010)
Clickliverpool.com
http://www.iexplore.com (date accessed 15 September 2010)
'Desperate situation finds historic British Beatles landmark facing closure': http:// www.examiner.com/beatles-in-national/desperate-situation-finds-historic-british-beatles-landmark-facing-closure?cid=examiner-email (date accessed 19 October 2010)
Edgycities.com
The National Trust: Official website: http://www.nationaltrust.org.uk (date accessed 8 October 2012)
http://www.Nationaltrust.org.uk/beatles-childhood-homes, 'The Beatles Childhood Homes' (date accessed 20 October, 2012)
http://www.nytimes.com/1987/08/05/arts/nike-calls-beatles-suit-groundless.html, 'Nike Calls Beatles Suit Groundless' (date accessed 12 August 2013)
'Nike Calls Beatles Suit Groundless': http://www.nytimes.com/1987/08/05/arts/ nike-calls-beatles-suit-groundless.html (date accessed 12 August 2013)
'Nike & The Beatles': http://pophistorydig.com/?p=702 (date accessed 22 August 2013)
http://content.time.com/time/arts/article/0,8599,1908185,00.html, 'Michael Jackson's Estate: Saved by the Beatles' (date accessed 8 September 2013)
'Ben Sherman Launches The Beatles Clothing Line': http://www.licensemag.com/ license-global/ben-sherman-launches-beatles-clothing-line (date accessed 8 September 2013)
'Universal Music Group (UMG) Closes EMI Recorded Music Acquisition': http:// www.universalmusic.com/corporate/detail/2229 (date accessed 8 September 2013)
'Mounted Memories™ Signs Licensing Agreement with Live Nation Merchandise to Produce Framed Presentations Featuring The Beatles': http:// www.businesswire.com/news/home/20100722005063/en/MountedMem

ories%E2%84%A2-Signs-Licensing-Agreement-Live-Nation (date accessed 8 September 2013)

'Licensing Plan Gives Fresh Plays to Beatles': http://www.nytimes.com/2013 /08/15/business/media/licensing-plan-gives-fresh-plays-to-beatles.html?_r=1& (date accessed 10 September 2013)

'The Fabric Four': http://nypost.com/2013/06/12/the-fabric-four/ (date accessed 17 September 2013)

http://www.huffingtonpost.com/shawn-amos/roll-up-for-the-magical-b_b_2796 80.html, 'Roll Up for the Magical Beatles Marketing Tour' (date accessed 15 October 2013)

'The Beatles at 50: From Fab Four to fabulously wealthy': http://www.bbc.co.uk/ news/business-19800654 (date accessed 18 October 2013)

http://www.beatlesbible.com/features/drop-t-logo/, 'The Beatles Drop-T Logo' (date accessed 22 October 2013)

'100 Greatest Beatles Songs': http://www.rollingstone.com/music/lists/100-greate st-beatles-songs-20110919/yesterday-19691231 (date accessed 22 October 2013)

'The 10 Most Covered Songs': http://www.independent.co.uk/arts-entertainment/ music/features/the-10-most-covered-songs-1052165.html (date accessed 22 October 2013)

'The Beatles And Cirque du Soleil documentary "All Together Now" wins Grammy Award': http://www.cirquedusoleil.com/en/press/news/2010/all-tog ether-now-wins-grammy-award.aspx (date accessed 22 October 2013)

Boulter, Roy (2008), http://www.caughtbytheriver.net/2008/11/the-sound-of-time-and-the-city/ (date accessed 10 December 2013)

Ben Sisario and David Itzkoff (2012), 'How Mad Men Landed the Beatles: All You Need is Love (and $250,000)', *ArtsBeat*, 7 May http://artsbeat.blogs.nytimes.co m/2012/05/07/how-mad-men-landed-the-beatles-all-you-need-is-love-and-250000/?_php=true&_type=blogs&_r=0 (date accessed 27 March 2014)

Index

Best wishes
and thanks for
all your support

Mike Brockell